PHOTOGRAPHY AND ART

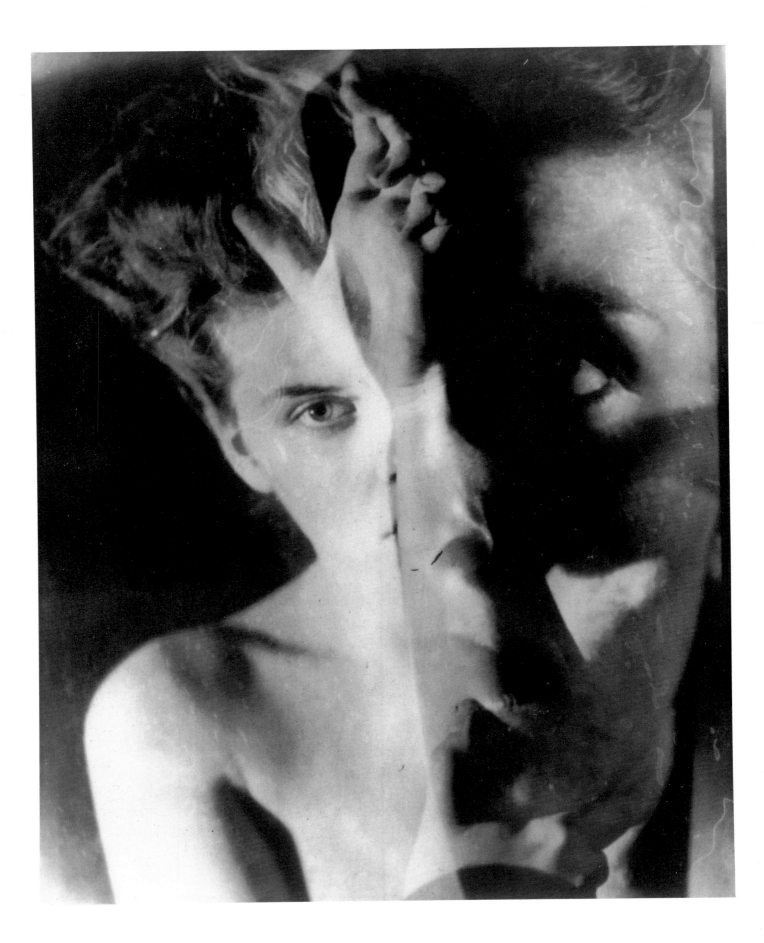

Andy Grundberg
Kathleen McCarthy Gauss

PHOTOGRAPHY and ART

Interactions Since 1946

Museum of Art, Fort Lauderdale
Los Angeles County Museum of Art
Abbeville Press, Publishers, New York

This catalogue was published on the occasion of the exhibition
"Photography and Art: Interactions Since 1946."

Los Angeles County Museum of Art
 Los Angeles, California
 June 4, 1987–August 30, 1987

Museum of Art, Fort Lauderdale, Florida
 October 15, 1987–January 24, 1988

Queens Museum, Flushing, New York
 February 13, 1988–April 3, 1988

Des Moines Art Center, Des Moines, Iowa
 May 6, 1988–June 26, 1988

A substantial portion of chapter 7, "Camera Culture in a Postmodern Age," was adapted from "The Crisis of the Real," published in *Views*, the quarterly journal of the Photographic Resource Center at Boston University, with funds from the Reva and David Logan Grants in Support of New Writing on Photography.

This exhibition was made possible through the generous support of Barnett Bank, South Florida, N.A.

FRONT COVER: Lucas Samaras. *Photo-Transformation 11/1/73*. 1973.

BACK COVER: Bart Parker. *Tomatoe Picture*. 1977.

FRONTISPIECE: Val Telberg. *Unmasking at Midnight*. 1948.

Editor: Susan Weiley
Designer: Gerald Pryor

Library of Congress Cataloging in Publication Data
Grundberg, Andy.
 Photography and art.

 Exhibition schedule: Los Angeles County Museum of Art, Los Angeles, California, June 4, 1987–August 30, 1987; Museum of Art, Fort Lauderdale, Florida, October 15, 1987–January 24, 1988; Queens Museum, Flushing, New York, February 13, 1988–April 3, 1988; Des Moines Art Center, Des Moines, Iowa, May 6, 1988–June 26, 1988.
 Bibliography: p.
 Includes index.
 1. Photography, Artistic—Exhibitions. 2. Art and Photography—Exhibitions. I. Gauss, Kathleen McCarthy. II. Los Angeles County Museum of Art. III. Museum of Art, Fort Lauderdale. IV. Title.
TR646.U6F654 1987 779′.97′0904 86-32104
ISBN 0-89659-683-4
ISBN 0-89659-679-6 (pbk.)

First edition

Contents

Directors' Foreword

It is with great pleasure that we join in presenting *Photography and Art: Interactions Since 1946*. This exhibition of over three hundred works by more than one hundred artists illustrates the radical break of photography from its traditional purist aesthetics and role as the objective recorder of the world, and traces its development as a contemporary art medium in the last forty years. The exhibition examines the work of individuals who successively widened the definition of photography and who were interested in the medium in order to make art, engaging the same issues that other areas of the visual arts addressed.

Today, the idea that photography is too tied to worldly appearances to function as a creative art medium is as outdated as the notion that painting's only legitimate subject is the expression of the qualities of paint. As the exhibition *Photography and Art: Interactions Since 1946* makes clear, the belief in the independence of mediums in the visual arts has been challenged by an equally strong belief in their interdependence. The last forty years of practice in photography demonstrate that as a medium it is provocatively expressive. And the last forty years of painting and sculpture show that photography's presence in the world, and its function as a purveyor of mass-media imagery, have not gone unnoticed. Not only has photography become integral to the visual arts, it has moved to the very forefront of art making.

We would like to express our gratitude to Andy Grundberg, guest curator, Museum of Art, Fort Lauderdale, and Kathleen McCarthy Gauss, curator of photography, Los Angeles County Museum of Art, who organized the exhibition and authored the catalogue essays. We are indebted to the many lenders without whose support this exhibition would not be possible.

The exhibition and catalogue have been made possible by a generous grant from the Barnett Bank of South Florida, N.A.

George S. Bolge
Executive Director
Museum of Art, Fort Lauderdale

Earl A. Powell, III
Director
Los Angeles County Museum of Art

Preface

Photography and Art: Interactions Since 1946 charts the emergence of photography as a vital force in contemporary art since the end of World War II. As the medium has become increasingly allied with the issues and concerns of the visual arts as a whole, it has turned away from its traditional role as a functional tool, one relegated to the literal, objective depiction of reality. Photographers seeking to escape tradition, as well as artists trained in other areas who have seen in photography a wealth of untapped possibilities, have expanded its very definition. This shift within photography from a putatively documentary mode to more overtly personal, experimental, and ideational forms has had a major influence on the art of our times.

In illustrating the pictorial evolution of photography intended to be seen as art, we have tried to reveal its generally unacknowledged interaction with art movements chiefly identified with painting, such as Abstract Expressionism. Furthermore, we have included work that has escaped, or been written out of, the prevailing accounts of postwar art. This applies both to photography, where a modernist notion of "the photographic" has put blinders on the view of the medium's wide range of uses and functions, and to art as a whole, where even today the critical domain is structured as if photography were merely an overly persistent, annoying next-door neighbor. By bringing into focus work from the two "worlds" of photography and art, we hope to show how their concerns have been more alike than modernist scripture would have us believe.

Another intention of this book, and of the exhibition that accompanies it, is to show the enormous influence photographic imagery has had on the more traditional, and supposedly more plastic, visual arts of painting, sculpture, drawing, and printmaking. Visual culture today is so suffused with photographic images that no artist can totally banish their trace from his or her work. Certain artists may pretend to ignore photography's impact, but such a stance—one taken by many of today's neo-expressionist painters—is at heart a reaction to the medium's overwhelming presence.

Photography's ubiquitous presence is not an art-world anomaly but a cultural fact. From the first half-tone reproductions at the end of the nineteenth century to the illustrated magazines, newspapers, books, films, television, and video of today, the images of photography have so saturated our culture that they now constitute a simulacrum of the real world—and thus not only provide us with knowledge of things

beyond our immediate experience, but also supply and structure experience itself. As a consequence the photographic image has become a powerful cultural determinant, one of increasing interest to all the arts.

Photography and Art is structured to best articulate how the functions and uses of photographic images have been expanded, altered, and reconsidered over the last forty years. It does not purport to be a new history of post–World War II photography, however, any more than it can claim to document the full extent of the art world's involvement with photographic images and their cultural manifestations. What it represents is an attempt to recognize an alternative practice in both art and photography that is responsive to, and interactive with, outside influence.

All curators' perceptions necessarily are shaped by their lives. In our case, we share some perspectives and not others. For example, each of us lives in a large city with a large art community of its own, but we reside at opposite ends of the country. We have chosen to make our different perspectives explicit by sharing the essays in this volume; following a joint introduction, the authorship alternates for each chapter. Accompanying each chapter is a selection of images pertinent to its theme.

Because our essays were written independently, there are areas where our accounts overlap, and there are areas where they proffer divergent points of view. To help keep such overlaps to a minimum, however, we first organized the diversity of our material into rough categories. These categories are a matter of convenience; the artists shown here resist pigeonholing, and the evidence of their work suggests that all have a unique way of seeing the world.

Compared to other types of photography, what distinguishes the works shown here is the artists' disinterest in photographic record-making per se, or in the purposeful, straightforward depiction of scenes, objects, or individuals. Portraiture and landscapes, street photography, political and other polemical works, and personal narratives are among the types of photography excluded from the purview of this project. In addition, we have had to face practical limitations on the size of the exhibition, and thus cannot claim to be inclusive even within the scope of our ambitions. Other curators might well illustrate the same thesis using different artists.

We have not, for example, included Diane Arbus, Lee Friedlander, or Garry Winogrand, believing that their achievements, however well regarded in art circles, are primarily documentary in nature. Nor have we included so-called Photorealist painters such as Audrey Flack or Richard Estes, believing that the style they helped develop forecloses, rather than promotes, an interaction with photography. Furthermore, we have limited our choices to works that utilize photosensitive or photomechanically reproduced materials, thus leaving out a wide range of painting and drawing that is referenced to photographic imagery, without making use of it.

As we have stated, photography evolved from both within and without. There are those included here who, despite years in the field of photography, are unknown beyond it; and there are seminal artists known for their work in other mediums who have also contributed significantly to photography's artistic growth, but who have yet to be acknowledged by photographers. Early on we decided to choose work that utilizes photography without regard for whether its maker identified with the label "photographer" or "artist."

And although *Photography and Art* concentrates on the interactions of photography and art in the United States, certain European artists are included whose work was significant for its time and has had a large influence on artists in this country.

As a final note, while *Photography and Art* reflects the exhibition it accompanies, it is not organized in as strict a chronological progression, focusing instead on theoretical issues pertaining to the art. Consequently, the reproductions have been placed adjacent to essays that address ideas and issues related to the art. The curators wish to eschew any simplistic categorization of artists that might be construed from the format. It is not our intent to establish facile labels, but rather to illustrate the evolution of a contemporary art medium.

Acknowledgments

An exhibition and publication of this scope and complexity could not have been accomplished without the contributions of many individuals and the cooperation of many institutions. We would like to express our special gratitude to the following:

At the Museum of Art, Fort Lauderdale, to Elliott B. Barnett and the Board of Trustees, Executive Director George S. Bolge, Richard K. Davis, and the staff, for providing resources and support necessary for such a large undertaking, and to Professor Sam Hunter, Exhibitions Consultant, for his initial enthusiasm and unstinting assistance throughout the development of this project.

At the Los Angeles County Museum of Art, to Dr. Earl A. Powell, Director, and the Board of Trustees, for their enthusiastic encouragement and support of the exhibition, and to the numerous staff members who helped bring this cooperative endeavor to fruition: former Assistant Director Myrna Smoot, Registrar Renee Montgomery and Assistant Registrar Lisa Kalem, Exhibitions Coordinator John Passi, Assistant Director James Peoples and his Operations staff, Paper Conservator Victoria Blyth-Hill, Photographer Steve Oliver, Press Officer Pamela Leavitt and her staff, Managing Editor Mitch Tuchman, and James Kenion and the Technical Services staff.

In addition, a very special commendation must go to the staff members of the Department of Photography at the Los Angeles County Museum of Art, Sheryl Conkleton and Juliana Leung, for their outstanding diligence, their good humor, and their attention to the extraordinary volume of details encountered at every stage of the exhibition and catalogue. Their thoroughness and professionalism have been greatly appreciated by the curators. They compiled the artists' biographies that appear on these pages.

In New York, to Sarah McFadden, for her capable assistance in locating and securing works for the exhibition, and to Alice Rose George, for gathering materials for reproduction. Both carried out their tasks with great dispatch and distinction, and with enviable equanimity. And to Julia Scully, for her support and constant counsel, heartfelt thanks.

At Abbeville Press, to Regina Kahney, Sharon Gallagher, and the staff for their roles in producing such a handsome volume, which not only accompanies the exhibition but also has a life of its own. In addition, our special gratitude to Susan Weiley, whose keen eye and firm hand provided guidance and balance throughout the editing process; to David Frankel, for his thoughtful suggestions concerning the essays; and to Gerald Pryor, for his skillful design.

We have been fortunate to have had the cooperation of the lenders to the exhibition, and of numerous other collectors, galleries, and private dealers who facilitated our search for sometimes obscure pictures. The artists involved have been remarkably cooperative and forebearing as well. It is impossible to name all of those who helped, but we would like to specifically thank for their assistance in our researches Peter C. Bunnell of the Minor White Archive at Princeton University; Weston Naef and Gordon Baldwin at the J. Paul Getty Museum in Malibu, California; Terence Pitts and Lawrence Fong at the Center for Creative Photography in Tucson; Anne W. Tucker and Maggie Olvey of the Museum of Fine Arts, Houston; and Nathan Lyons and the Visual Studies Workshop in Rochester, New York.

For sage counsel, apt advice, and conversations that were especially valuable, our appreciation to John Baldessari, Janet Borden, John Coplans, Darryl Curran, Robert Fichter, John Gibson, Charles Hagen, Marvin Heiferman, Robert Heinecken, Susan Kismaric, Richard Kuhlenschmidt, Peter MacGill, Laurence Miller, Janelle Reiring, John Rudy, Brent Sikkema, Joan Simon, Aaron Siskind, Carol Squiers, John Upton, and Helene Winer. We were saddened by the death of Henry Holmes Smith before the completion of the exhibition, having benefited from his opinions and recollections during the early stages of its development.

Finally, we are grateful for the financial support of the Barnett Bank, Fort Lauderdale, whose generous assistance has made this exhibition possible, and the Ralph M. Parsons Foundation, for a grant that supports, in part, the photography program of the Los Angeles County Museum of Art. — *A.G.* and *K.M.G.*

Photography and Art

List of Illustrations

Photographs have been grouped into portfolios following each chapter, as indicated in the following list. The arrangement is chronological within each section, and for the most part reflects the order in which photographers are discussed in each chapter. For additional references to text or photographs, please see the index.

Introduction

In the past decade photography has attained a prominence in the art world that is unprecedented in its 150 years of existence. In both artistic practice and critical theory, the photographic image has been recognized as a significant influence on the artists and art of our time. Equally important, it has been incorporated into the ongoing discourse of the visual arts and into the existing structures of the art marketplace. The interest in photography as a form of art did not come about suddenly, however; it evolved in tandem with the evolution of the medium itself. Today the integration of photography and the other visual arts has advanced to the point that it no longer seems appropriate to distinguish them as two categories of expression, or to view photography as a medium unto itself.

Such a distinction may have been unnecessary in the first place. For the photography of the twentieth century cannot be explained without reference to the other visual arts, nor can this century's painting, drawing, printmaking, and sculpture be understood without reference to the photographic image and its cultural context. This idea goes against the widely held modernist premise that each medium has its own discrete, self-generating aesthetic. While modernism was predicated on the notion that each medium had unique, independent qualities, the exploitation of which was an aesthetic hallmark, today, in retrospect, it is clear that neither the so-called plastic arts nor photography ever existed in isolation from the other.

Photography's interaction with the visual arts goes back to its beginnings. Whether or not Paul Delaroche exclaimed that "From today, painting is dead," as some accounts would have us believe, there is no disputing that, beginning in 1839, with the announcement to the world of its discovery, photography has had a profound effect on the practice and theory of art. At the same time, however, photography itself was profoundly influenced by the methods and styles of depiction that were then in vogue. In its efforts to be taken seriously, which is to say in its aspirations to be considered a form of art, it adopted and adapted the conventions of the painting of the day. As the dominant style of painting has changed over the years, from naturalism to Im-

pressionism, from Cubism to Abstract Expressionism, the style of that branch of photography that aspired to be art has changed along with it.

This is not exactly news. Aaron Scharf's *Art and Photography* (1969) and Van Deren Coke's *The Painter and the Photograph: From Delacroix to Warhol* (1972) have demonstrated how heavily nineteenth-century painters were influenced by photography. Peter Galassi's *Before Photography* (1981) and André Jammes and Eugenia Parry Janis's *The Art of French Calotype* (1982) have suggested how important the precedents of painting were to the pioneers of early photography.

Nevertheless, it came to pass in the first half of this century that photography and painting were seen to have totally separate agendas. Under the tenets of modernism, each medium was supposed to follow its own inherent qualities and capabilities without external reference—either to other means of picture-making, or to the world itself. This modernist agenda has been the lens through which the art of the second half of the twentieth century has been seen. Unfortunately, it has distorted reality considerably, acting more like a filter than a lens.

The interaction of photography and art was one of modernism's greatest repressions. Obviously it is impossible to explain Purism in photography without reference to Purist painting, or to understand Paul Strand's 1922 photograph of the mechanism of his Akeley movie camera without reference to the wider machine aesthetic of the time. Nevertheless, the historians and critics of the era believed, and in some cases continue to believe, that something intrinsic to photography—that which is called the "photographic"—inheres in the pictures of high modernism of the 1920s and 1930s.

The notion of the photographic has been perpetuated in late modernist practices primarily through the advocacy of John Szarkowski at the Museum of Modern Art, whose book *The Photographer's Eye* (1966) is an explicit statement of, even recipe for, what constitutes the photographic. Szarkowski's classification system owes not a little to art-historical methodology as developed in the arena of painting and sculpture, yet it manages to exclude any reference to analogies in other mediums. The taxonomy is both self-sufficient and hermetic. What histories we have of post–World War II photography are based on this exclusion.[1]

To assess the aesthetic contributions of the works shown here, it is useful to view them in relation to the prevailing practice of photography as it existed prior to 1946. While much experimental and idiosyncratic photography was done between the wars, especially in Europe, by far the dominant conception of photography's role was as a provider of documentary images, which were assumed to embody objective fact. The expectation that the photograph was a visual record or report had been reinforced through numerous channels since the 1920s, and was solidified in the United States starting in 1936 with the publication of *Life.* The dominance of this "realist" style, which held sway through the Depression and the war years, was such that it even was encouraged by Ansel Adams, who observed that the highest function

of the medium "will be to relate the world of nature to the world of man, and man to men in the fullest meaning of the term."[2]

The taste for unsentimental objectivity and unromantic precision, together with the spread of photographically illustrated magazines, brought a rise in status for the photojournalist, who brought home heroic images of war, scenes of human suffering, and images of everyday life, foreign and domestic. *Life, Look,* and the other picture magazines helped foster an aesthetic that valued the "decisive moment" of human events. At the same time, the Farm Security Administration was commissioning photographers to document the condition of the farmer, and their pictures stand as landmarks of the documentary practice of the period. In New York the Photo League was formed to help fight social injustices by documenting the conditions of the poor and the overlooked human aspects of urban life. The camera was viewed as the most persuasive medium to record the human condition and effect social change. The documentary movement in photography was part of a wider interest in social realism in the other arts, but it was unique inasmuch as photography was believed to bear a special connection with reality. Realism was seen as being the art of photography.

Photography was quite naturally conscripted during the war for documentary purposes, further strengthening the reportorial role as the medium's dominant purpose. By 1945 this role was thoroughly entrenched, understood, and indeed expected. Consequently, for photographers as well as their audience, it eclipsed all others. Photography was for factual record-making, not for individual expression.

Breaking with the dominant documentary mode could not have been easy, but as the postwar years began it became clear that a growing number of photographers were interested more in the expression of their personal visions than in objectively recording the world. Their spiritual leader was Alfred Stieglitz, who throughout the 1930s and 1940s remained adamant that works of art had the right to speak for themselves, and that artists had the right to refuse to address an audience beyond themselves. Thus began the fundamental shift in the relation of photography to the world of art that we are tracing here.

One of the salutary consequences of the widening sphere of photography has been the increasing participation of women artists. Perhaps in part because of a disinclination for topographic landscape record-making or social-documentary street photography, women have been drawn to using the camera for personal expression and visual experimentation. They were perhaps more sympathetic to synthetic ways of working, which involved a freer use of camera images and a willingness to incorporate other mediums and sensibilities into their picture-making. The canon and tradition of the predominantly male masters of the medium were not as persuasive to women, perhaps because they were less obsessed by technical precision and purity of means. They were, however, more ready to adopt various materials and techniques to achieve pictorial solutions.

Such experimentation was fostered by the introduction of photographic education into colleges and schools. Where photography instruction had once been confined to a handful of specialized schools scattered across the country, the consequences of the G.I. Bill and an enthusiasm for photography as a visual medium spurred a rapid growth in the teaching of photography after the war. In the realm of higher education, photography often was incorporated into art departments, where interaction with painting and the other arts was inevitable. Within the groves of academe, photography's visual potentials were more highly valued than its reportorial function.

As photographers both male and female questioned the limitations placed on photography, and looked to the other visual arts for inspiration, the medium gradually began to move closer to the aims and issues of the art world. These photographers recognized that photography was a viable medium for contemporary artists beyond the dictates of lenticular representation. The realist, social documentary, and humanist sensibility of the 1930s and early 1940s gave way, first to a reliance on abstraction and metaphoric imagery, and then to the radical use of cultural flotsam, manipulation, process experimentation, combinations of images and texts, fabricated studio works, and purposeful illusionism. Photography as an art came into its own, and this is the story of that process. — A.G. and K.M.G.

1.

The Enduring Modernist Impulse

The year 1946 marks not only the first full year of the postwar era in Western culture, but also the end of an era in the medium of photography. For it was in that year that two of the most important figures in twentieth-century photography died: Alfred Stieglitz (b. 1864) and László Moholy-Nagy (b. 1895). Both men are well known and justly admired for their photographs, but of at least equal consequence were the roles they played in shaping the practice and the critical climate of what we now call "art photography."

Today the term "art photography" often is used pejoratively, the implication being that as a category it excludes work expressing either profound beliefs or a commitment to social change. But for Stieglitz, photography as an art form was expressive of man's deepest yearnings and nature's most eloquent truths. For Moholy, photography was the cornerstone of no less than a "new vision"; it was a radical instrument for reshaping individual consciousness and hence social reality. As advocates, enthusiasts, theorists, and exemplars of new ways of seeing, the two men decisively molded the shape that photography assumed in the 1940s, 1950s, and 1960s. If their aesthetic seems presently in eclipse, overwhelmed by our current fascination with popular imagery, pastiche, and dissembling, it nevertheless represented, for most of the postwar years, photography's most recognized and widely developed claim for being perceived as an art.

Stieglitz's contribution to the development of the modern art and photography of this century is well known. He helped introduce work by the modern artists Brancusi, Braque, Cézanne, Matisse, and Picasso, as well as African art, to an American audience, and later championed American modernist painters such as Georgia O'Keeffe, Marsden Hartley, John Marin, and Arthur Dove. From his successive power bases—as editor of *Camera Notes,* the journal of the Camera Club of New York (1897–1902); as editor and publisher of *Camera Work* (1903–17); and as owner and director of 291 Gallery, The Intimate Gallery, and An American Place—he set not only the tone but also the style of modern photography. He championed in turn the genre-style

naturalism of P. H. Emerson, the ethereal tonalism and *Japonisme* of the Photo-Secession, and finally the sharp-focus, unvarnished style known as Purism.

Purism was the first style in photography to be based on an aesthetic that claimed complete independence from the styles of painting and the other visual arts—hence the idea that it was "pure." Photographers subscribing to this aesthetic abandoned Pictorialism because they saw it as enslaved to contemporary painting styles. For Pictorialism's gauzy, atmospheric poetics they substituted direct, detailed description. They rejected the soft surface of platinum papers and began to use the standard commercial papers of the day, without embellishment. Rather than limit the tonalities of their pictures, they sought to convey a full range of tones, from deepest black to opalescent white. In the Purist aesthetic we find the essence of photographic modernism: the conviction that photography is an art different from painting and the other visual arts, and that it has its own unique qualities, the cultivation of which is the proper activity of the photographer. As Edward Weston wrote in 1940, "Before photography could take its rightful place among the graphic arts, it had to be recognized as a new and independent medium, containing its own unique potentialities and limitations, and demanding therefore a new standard of criticism based on the principles and properties of the photographic process."[1]

Weston's call for a "new standard of criticism" is a typical modernist position, one carried into our own times by, among others, the critic A. D. Coleman, who wrote in 1975 that the limitations in the discussion of photography were due to "the lack of a functional vocabulary for the criticism of photography."[2] It seemed inconceivable to these writers that the tools of criticism used in the art world might be usefully applied to photography without modification.

Stieglitz's conversion to photographic modernism was heralded by his publishing Paul Strand's photographs in *Camera Work* in 1917. Strand's pioneering images dispensed with pretty effects, hand manipulation, and fey subject matter. Beginning in 1915–16, they had also begun to acquire the look of Cubist abstraction. For Strand these first Purist pictures were marked by the presence of what he called "photographic" qualities—that is to say, they were true to the qualities inherent in the medium, and required no "artistic" enhancement such as the handwork of which the Pictorialists were so fond. By insisting on the purely "photographic," Strand sought to give photography the same independence that painting had found in Cubism. As Stieglitz had put it earlier:

> The arts equally have distinct departments, and unless photography has its own possibilities of expression, separate from those of the other arts, it is merely a process, not an art; but granted that it is an art, reliance should be placed unreservedly upon those possibilities, that they may be made to yield the fullest results.[3]

The "photographic" became the foundation on which photography's modernism was built. It would serve as a rationale for many styles, providing

legitimacy for pictures as divergent from Strand's as those by Henri Cartier-Bresson and Walker Evans. Its cultivation became the hallmark of serious aesthetic intentions. Only today, with hindsight, can we see that this emphasis on the "photographic" was merely a modernist invention, one required by the modernist belief in the necessity for discrete art mediums that was so adeptly summarized by Stieglitz.

But for Stieglitz, the Purist insistence on the photographic was not alone sufficient to fuel photography's rise to the status of a full-fledged art form. Creative photography also needed to possess at least the possibility for self-expression. Stieglitz's version of a critical theory to support this need developed slowly throughout the 1920s, and was spelled out in articles, correspondence, and in his own photographs, the most famous of which are his pictures of clouds, which he titled "Equivalents." In his theory of the Equivalent, Stieglitz sought to link photographic form, the natural universe, and his own "vision of life" in an alliance somewhat akin to the Christian notion of transubstantiation, whereby bread and wine, while keeping their own appearance, are mystically transformed into the body and blood of Christ. To accomplish this union in his own work, Stieglitz turned to abstraction. As Sarah Greenough has written, "Stieglitz's challenge, and his accomplishment in the 1920s, was to reconcile abstraction and photography, to find a means whereby he could abstractly express himself while still respecting the inherent characteristics of photography."[4]

Of the photographers who answered Stieglitz's call for a new, robust, and essentially American photography, Edward Weston is perhaps the most exemplary. Lacking any formal art education, and trained to make photographic portraits in the fuzzy Pictorialist manner, Weston dramatically converted to the Purist style in the early 1920s, at approximately the same time as did his friend and colleague Ansel Adams. For Weston, the goal of his art became seeing "the *Thing Itself* . . . the quintessence revealed . . . to photograph a rock, have it look like a rock, but be *more* than a rock."[5] To achieve his vision, Weston often relied on abstractionist compositions. Weston's reputation rests on the spare, precise, almost floating close-ups of vegetables and female nudes that he made in the 1930s—pictures that reduce both human and inanimate forms to their bare essentials. Despite their suggestiveness, which is a consequence of the abstract elements they contain, Weston for the rest of his career fought any interpretation that alluded to any sexual or erotic content. His point was not that peppers and shells resembled female genitals, but that peppers and shells and genitals, when pared to their essence, all share similar forms.

By the time he had begun making his forlorn landscapes of Point Lobos in the 1940s, however, Weston had moved further away from his subjects and on to a new stylistic conception of the medium—one in which abstraction played less of a role, or at least no longer depended on a close-up relation to the subject. Instead, the world begins to reveal its essential form even at a distance. What is remarkable about these pictures of the late 1940s

is not just Weston's self-assured trust in the camera's ability to limn the world; it is the extent to which he organized the landscape to be as suggestive of the essence of nature as the shapes and texture of the curves of the human body and the folds of a bell pepper.

The irony is that the photographs that resulted from Weston's, Stieglitz's, and Strand's attempts to reconcile form and expression by purportedly "photographic" means closely resemble the abstractionist painting of their day, including the works of O'Keeffe, Hartley, Dove, and the other American abstract painters Stieglitz championed. Like these artists, the photographers were greatly influenced by Picasso and Braque's Cubism, and they, too, sought out machines, urban scenes, and close-up fragments of nature as their subject matter.[6] Photography, in short, seems once again to have progressed along the same path as painting, even as it rendered lip service to its own independence.

Even such an operatic photographer as Ansel Adams was not immune to abstractionist composition in the cause of helping photographs be considered art. This is evident in about half of the twelve pictures in his *Portfolio I* (1948), and even in several pictures in *Portfolio II* (1950), which is ostensibly devoted to "National Parks and Monuments." Such pictures are radically different from the sweeping, inclusive compositions for which Adams subsequently became famous, but they show the pervasive impact of Stieglitz's Equivalents theory, which by 1946 had become less theory than doctrine. Stieglitz had shown Adams's images at An American Place in 1936. Indeed, Adams's *Portfolio I* is dedicated to Stieglitz, and the dedication is a pastiche of Stieglitz's overblown rhetoric: "Art must reach further than impression or self-revelation. Art, said Alfred Stieglitz, is the affirmation of life."

Adams's foreword to the portfolio also reveals another critical belief of the time: that a photograph's true subject was beyond the reach of language or even rational thought. "Expressions without doctrines," Adams called his pictures, adding, "My photographs are presented here as ends in themselves, images of the endless moments of the world." (Apparently Adams did not recognize that this statement in itself constituted a doctrine.) Adams's refusal to espouse an aesthetic doctrine or theory is symptomatic of photographic modernism's aversion to critical intrusions, and to language in general. The notion that the best photographs are ineffable is part and parcel of the theory of the Equivalent: because of the picture's dependence on abstraction, and because of its maker's disavowal of any specific meaning, overt or otherwise, one can speak only about "endless moments of the world."

This did not stop the inheritors of Stieglitz's legacy from writing about photography, of course. In 1952, Minor White began to be a leading critical voice in photography when he cofounded and became the editor of the new magazine *Aperture*, which, like Stieglitz's *Camera Work*, took as its mission the promotion of art photography. While strikingly catholic in the choice of pictures he reproduced in the magazine, White preferred work that mir-

rored his own preoccupations with spirituality, mystical thought, and the psychology of perception. Among the photographers working in a sympathetic vein during the 1950s and into the 1960s were Wynn Bullock, Paul Caponigro, and Frederick Sommer, all of whom could claim to be "straight" photographers while investigating subject matter that lay beyond the descriptive powers of the camera. White's own photographs represent an apogee of abstractionism in the Purist style of his friends Adams and Weston, and they rely in part on the existence of a "creative audience"—viewers who are willing to decipher meaning from their ambiguous forms.

However, White's most enduring contribution, in the light of subsequent directions photography has taken, was his insistence on seeing photographic images as signs like any others, capable of combining into new and more complex meanings. By sequencing his pictures, as he did in "Intimations of Disaster" (1952), he created a narrative structure in which images substitute for words. However, unlike the prevailing *Life* magazine-style photo-essay of the time, the nineteen prints of "Intimations of Disaster" do not conspire to give a single message; instead, their "code" is multivalent, accessible to a variety of interpretations. In addition, White interspersed words and photographs in his work, as in his book *Mirrors Messages Manifestations* (1969), and as an editor/curator he combined the work of various photographers under the rubric of a single theme, as in *Light*[7] (1968) and *Be-ing Without Clothes* (1970). Such an approach to photographic meaning may have violated the sanctity of the individual image in the eyes of some Purists, but it anticipated, and in some sense influenced, the attitude toward photographs that would come to prominence in the 1970s.

As a result of the influence of *Aperture*—which until well into the 1970s remained the sole American magazine devoted to art photography—and of his own charismatic personality, Minor White could well be said to represent the forefront of photography as an art throughout the cold-war years. But he was not alone in his interest in photographs that flirted with abstraction. In 1953 the editors of *Life* devoted a major portion of two consecutive issues of the magazine to Ernst Haas's painterly, abstractionist color views of New York City. Even earlier, in 1951, the Museum of Modern Art had presented an exhibition called "Abstraction in Photography." Among those included in this show of 103 photographs were Ansel Adams, Alfred Stieglitz, Paul Strand, and Edward Weston, as might be expected, as well as Diane Arbus, Eugène Atget, Harry Callahan, Carlotta Corpron, the painter Ralston Crawford, Walker Evans, Robert Frank, Lotte Jacobi, László Moholy-Nagy, Eliot Porter, Man Ray, Arthur Siegel, Aaron Siskind, and Val Telberg. Clearly the list of those interested in abstraction was both wide and diverse.

At the same time, American painting had achieved international recognition with the rise of the New York School, and Abstract Expressionism had become the dominant art-world style of the day. Thus for White, as for Stieglitz earlier, any claim to represent a style that was essentially "photographic" or otherwise unique to the medium appears, in retrospect, problem-

atic. Indeed, White's criticism is marked by an unresolved conflict between the need to situate photography as an independent, modernist art form and the simultaneous need to rationalize it as an advanced medium by referencing it to the avant-garde of painting and sculpture.

The checklist to the Modern's exhibition "Abstraction in Photography" reveals how widespread the influence of abstractionist style had become by as early as 1951, but it conceals an underlying division between those art photographers working in the lineage of Stieglitz's Equivalent theory—in essence, the American strain of modernism in photography—and those indebted to the practice and theory of European modernism, as derived from the Russian Constructivists and elaborated at the German Bauhaus. For in fact there were two modernisms at work in photography in the aftermath of World War II, and of these two movements the European was to prove at least as influential in the formulation of the claims that photography was an art equal to the older, more firmly established visual arts.

The widespread and vitalizing influence of European modernist photography in the United States is testimony to the strength of the ideas and ideals of László Moholy-Nagy, the designer, painter, and photographer who brought the spirit of the Bauhaus to America. Moholy's aesthetic theories afforded photography a place of distinction; consequently, the school that he founded in Chicago in 1937 as the New Bauhaus School of Design (later to become the Institute of Design) became a crucible for a new brand of photography with claims to be art.

During Moholy's years at the German Bauhaus (1923–28), he taught the school's basic design course and metal workshop, designed and wrote about typography, edited and designed the Bauhaus Books series and wrote one of its volumes, *Painting, Photography, Film*. In addition he produced, in collaboration with his first wife, Lucia, his first photograms—cameraless images that record the patterns of objects placed directly on the surface of photographic paper, and of the light source used to illuminate them. And he developed a startling conception of modern art and design, one in which vision was a key construct and photography an all-important aspect. "In the photographic camera we have the most reliable aid to a beginning of objective vision. Everyone will be compelled to see that which is optically true, is explicable in its own terms, is objective, before he can arrive at any possible subjective position," Moholy wrote in *Painting, Photography, Film*. His own photograms, photomontages, negative prints, and bird's-eye views reflect this conviction.

While Moholy saw the goal of "objective vision" as no less than a revolution in popular consciousness—he shared Bauhaus founder Walter Gropius's sense of social mission, along with his unbridled idealism—he was at

heart a formalist. Hans Wingler has summarized Moholy's position in his book *The Bauhaus:*

> What Moholy-Nagy demanded and depicted in his numerous pub-
> lications was the esthetic experience, the vision of a new unity of
> art and technology, and the way to the realization of an optical
> culture, born from a specific visual awareness. For Moholy-Nagy
> as an artist, questions of form were primary.[7]

Moholy saw light as an essential of form, the *sine qua non* of the "new vision" of "optical culture." Photography was not only an objective means of materializing light, but also a medium that unified art and technology. Instead of reshaping the culture by placing new materials and products at its disposal, as the socialist faction of the Bauhaus advocated, Moholy aimed at redeeming society by educating everyone to develop an enlightened way of seeing.

It should be clear that what Moholy meant by "vision" is radically different from Stieglitz's conception of the same word. For the Purists, vision was an intuitive, expressionistic, and individual response to the world, best conveyed through sharp-focus photographs. Moholy was not interested in elevating a certain class of photographers above the *hoi polloi* of Sunday snapshooters. Rather, he saw photography as something to be investigated, a medium that posed specific formal questions, a means to a democratic, revitalized society. His "new vision" concerned itself with process and with first principles of light and space, rather than with artistic signature or immediate social utility. For expressionism he substituted experimentation.

Moholy's influence is evident in the work of the early teachers at the school, including Gyorgy Kepes, Arthur Siegel, and Henry Holmes Smith. All made photographs that can be deemed abstractionist, but the images are not so much Rorschach blots of the photographers' souls as they are records of the experimental process of producing them. Siegel, especially, followed Moholy's pedagogic program for photography, working with double exposures, projected light, and color. The same experimental repertory was followed by Harry Callahan, who arrived to teach at the then-renamed Institute of Design in 1946, shortly before Moholy's death. However, Callahan managed to imbue his pictures, no matter how experimental, with the strength of his own view of the world, alternating between intimate descriptions of his wife and daughter and street scenes of Chicago buildings and pedestrians. Callahan's early interest in the appearance of women in mass-media reproduction led to photographs of photographs that seem as at home in the 1980s as they do in the 1950s, when they were made (for example, *Collages*, ca. 1956). Also, Callahan's color slides taken in the 1940s foreshadow by some twenty years the large-scale entry of color into the province of art photography.

Moholy's almost ecclesiastical zeal for formal experimentation was spread across the country through his lectures and workshops, and by the apostolic efforts of former colleagues and students. Among those affected was Carlotta Corpron, who taught photography at the Texas Woman's University in Denton from 1935 to 1968. Her experiments with reflections, warped per-

spective, and drawing with light, done in the mid- to late 1940s, grew out of her contact with Gyorgy Kepes and Moholy, both of whom had journeyed to Denton to teach. She in turn had her students make photograms and construct light modulators, two of Moholy's favorite pedagogical devices. The legacy of the original Bauhaus also reached these shores via European émigrés other than Moholy. Lotte Jacobi, an established portrait photographer when she came to the United States from Berlin in 1935, learned the photogram technique from an artist in 1946 and proceeded over the next several years to produce her "photogenics"—abstractions suggestive of waves or sand dunes—using war-surplus enlarging paper.[8]

Inevitably, the strands of the European and American modernist traditions intertwined and overlapped, in some cases becoming indistinguishable from each other. This is especially true of the work of Aaron Siskind. Siskind, an English teacher turned documentary photographer turned abstractionist, was hired by Callahan to teach at the Institute of Design in 1951, five years after Moholy's death. Siskind arrived in Chicago from New York, where he was accustomed to socializing with Abstract Expressionist painters, and where he had already developed a photographic style akin to the work of Franz Kline and other painters. But he adopted the school's formalist methodology without complaint, and even added to the formal problems regularly assigned to students. His own work, with its flattened space and evidences of calligraphic notation, continued to be simultaneously formalist, in the Bauhaus sense, and at least suggestive of the expressionist aims of Stieglitz and his followers.

In the mid-1950s Callahan and Siskind started a graduate program, and the work of their graduate students exemplifies the best aspirations of formalist photography throughout the 1950s and 1960s. While there may be no "Institute of Design style" in the strictest sense, clearly the careers of photographers as diverse as Joseph Jachna, Ken Josephson, and Ray K. Metzker reveal the influence of Moholy's formal rigor and attention to design, as mediated by the more personally inflected approach of their teachers Callahan and Siskind.

Jachna, who received an M.S. in photography from the Institute of Design in 1961, is best known for his 1970 landscapes done in Door County, Wisconsin, which interpolate the photographer's own hand and mirrors in front of the lens. Like much Institute of Design photography, these pictures evidence a curiosity about the differences between actual and photographic space, yet they also bear a resemblance to the body art and performance art that was fascinating the New York art world at the same time. Josephson's witty comments on the visual culture of postcards, done in the late 1960s and early 1970s, also combine concerns of both the photography world and the art world, pointing out the arbitrariness of perspectival space at the same time that they register the artist's attention to the given-image universe.

Ray K. Metzker's career has spanned a number of significant formal concerns, from graphic street photography to diptychs of Atlantic City, N.J.,

sunbathers, but his *chefs d'oeuvre* are his "Composites," large images constructed from a number of prints and/or exposures. In his composite *Long Gone* (ca. 1965) one roll of film has been printed in its entirety as a single strip. In *Penn Center* (1966), a more typical example, a number of overlapped exposures have been printed and assembled to form a grid of dancing shapes and shadows. In ambition, scale, and technique Metzker's "Composites" seem more attuned to printmaking practice than conventional photographic practice. Apparently responsive to Robert Rauschenberg's and Andy Warhol's somewhat earlier use of photographic imagery in large-scale silkscreens, Metzker presents the photograph as an object for the wall—unlike the vast majority of photographers at the time, who intended their images for reproduction.

Other Institute of Design–trained photographers have taken a similarly unfettered approach to the photograph, using it as the raw material for experiments with printmaking procedures and unconventional techniques. John Wood's use of collage and drawing, William Larson's teleprinter transmissions, Barbara Blondeau's Muybridge-inspired strip images, Keith Smith's fascination with Xerography and bookmaking, Tom Barrow's collaged Verifax matrixes—all suggest how the Institute of Design's attitude of formal experimentation and investigation eventually helped bring photography into a dialogue with contemporary painting, printmaking, and sculpture. Unfortunately, however, these works were seen, and appeared radical, only within the relatively proscribed bounds of the photography world of the period, and remained virtually unknown to the larger art world.

This isolation, which until the 1970s was the condition of most fine-art photography, had two main causes. One was rooted in the traditional distance that the plastic arts have kept from photography, which has been seen as either an interloper on or a usurper of their established turf; the other sprang from the photography world's insecurity about its own modernity. Modernism's fundamental tenet—that painting be about painting, sculpture about sculpture, and photography about photography—kept photography separate and unequal; and photographers, in their urge to be taken seriously as artists, happily contributed to their own impoverishment. It was not until the 1970s, in fact, that a real marketplace for photography as a fine art became established. However, before that, something gave photography unprecedented attention in the art world: artists began to see the photographic image as an important facet of the visual universe, and to use it in work that was not intended to be "photographic." — A.G.

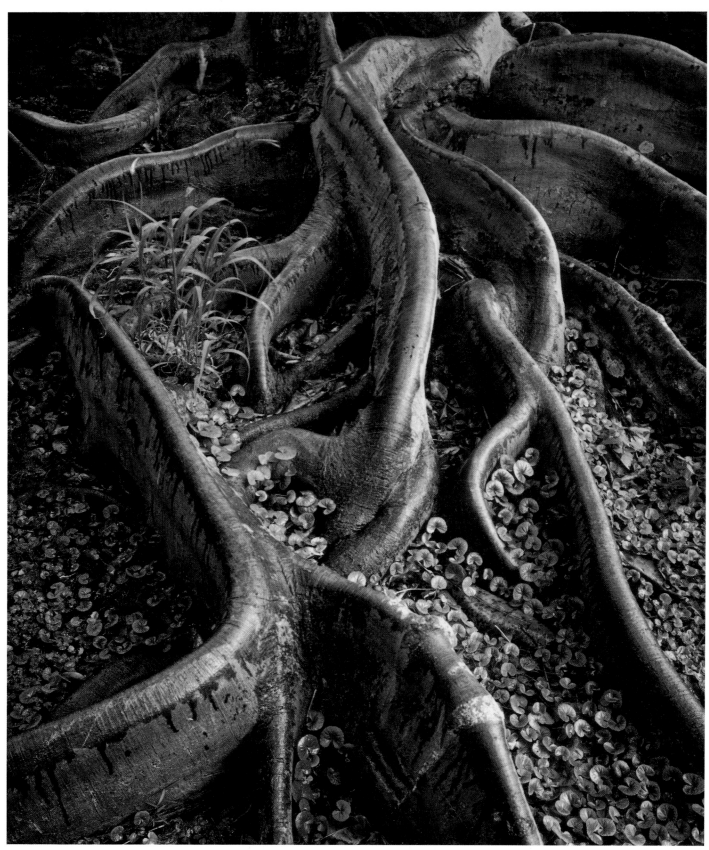

Ansel Adams
Roots, Foster Gardens, Honolulu, Hawaii. 1948
Gelatin-silver print
7½ x 6³⁄₁₆ in.
Collection of Marjorie and Leonard Vernon, Los Angeles

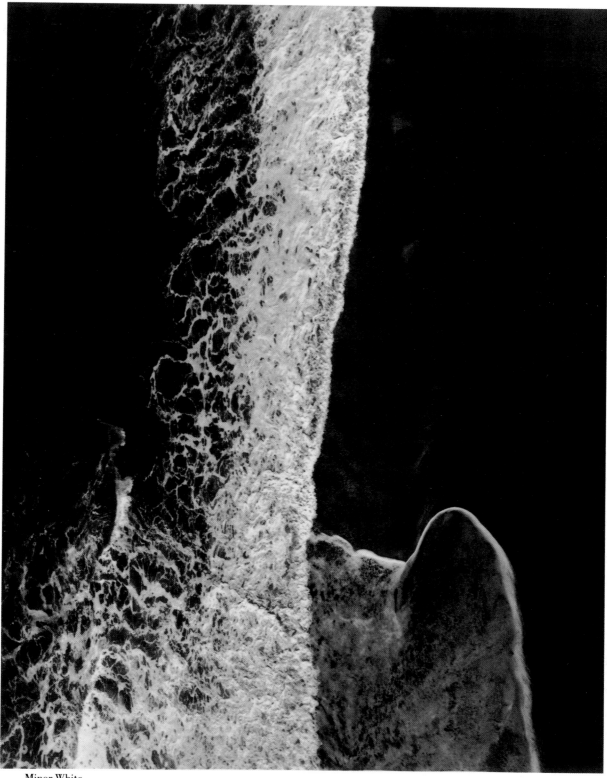

Minor White
Surf Vertical, San Mateo County. 1947
Gelatin-silver print, 4¾ x 3¾ in.
Courtesy of the Art Museum, Princeton University
The Minor White Archive

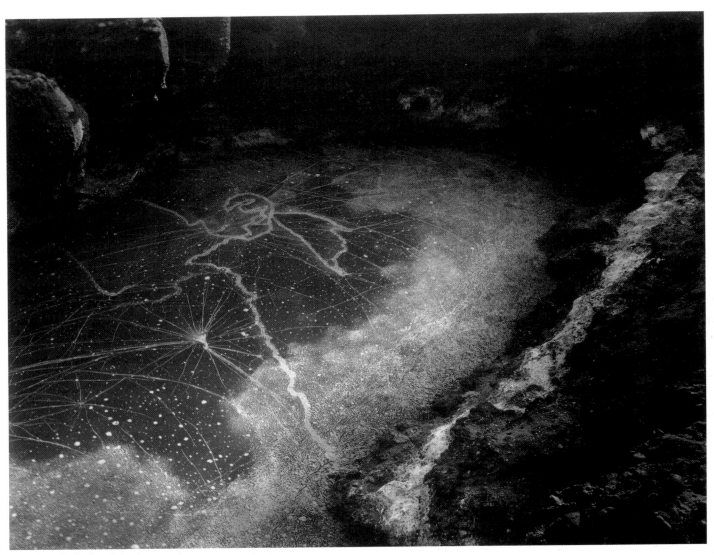

Wynn Bullock
Tide Pool. 1957
Gelatin-silver print
9½ x 7½ in.
Wynn and Edna Bullock Trust

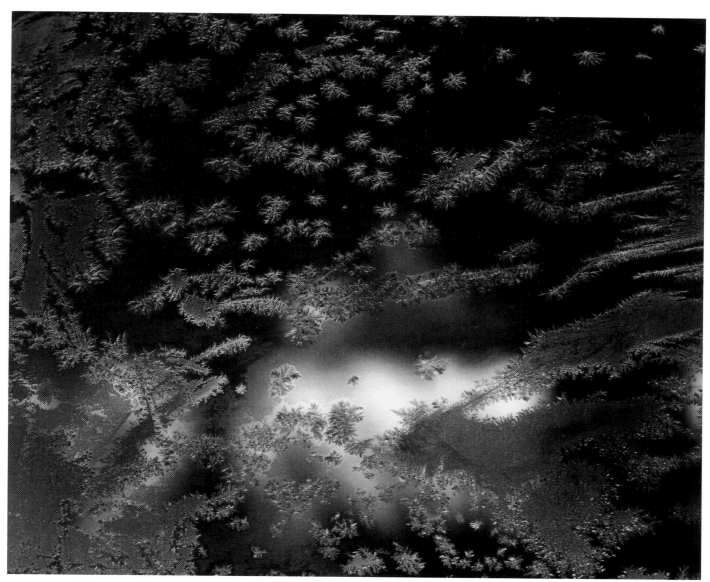

Paul Caponigro
Frosted Window, MA., from Portfolio 11. 1957
Gelatin-silver print
7³/₁₆ x 9³/₁₆ in.
Collection of Marjorie and Leonard Vernon, Los Angeles

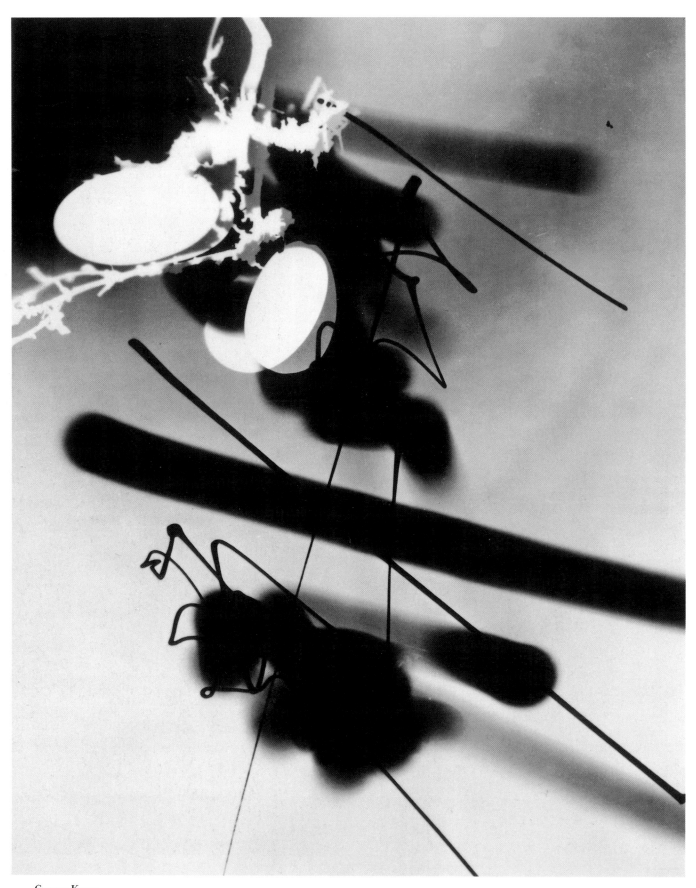

Gyorgy Kepes
Untitled. 1948
Gelatin-silver print
13⅛ x 10¼ in.
Courtesy of Brent Sikkema, Vision Gallery, Boston

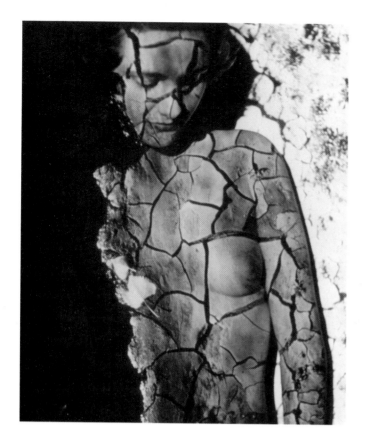

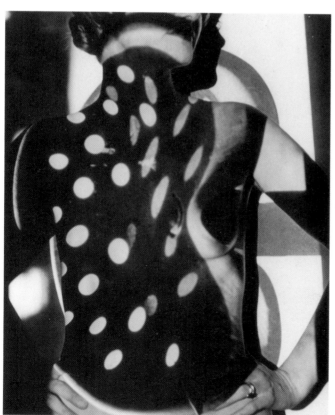

Arthur Siegel
Nude and Projection. 1948
Four gelatin-silver prints
9⅞ x 7⅞ in. each
Edwynn Houk Gallery, Chicago

Henry Holmes Smith
Light Study. 1946
Dye-imbibition print
10 x 13¼ in.
Collection of the Smith Family Trust

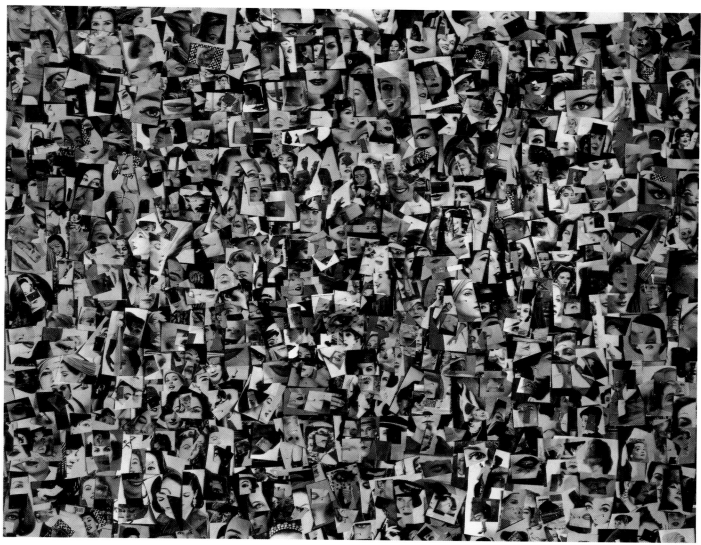

Harry Callahan
Collages. ca. 1956
Gelatin-silver print
8 x 10 in.
Courtesy of the Pace MacGill Gallery, New York

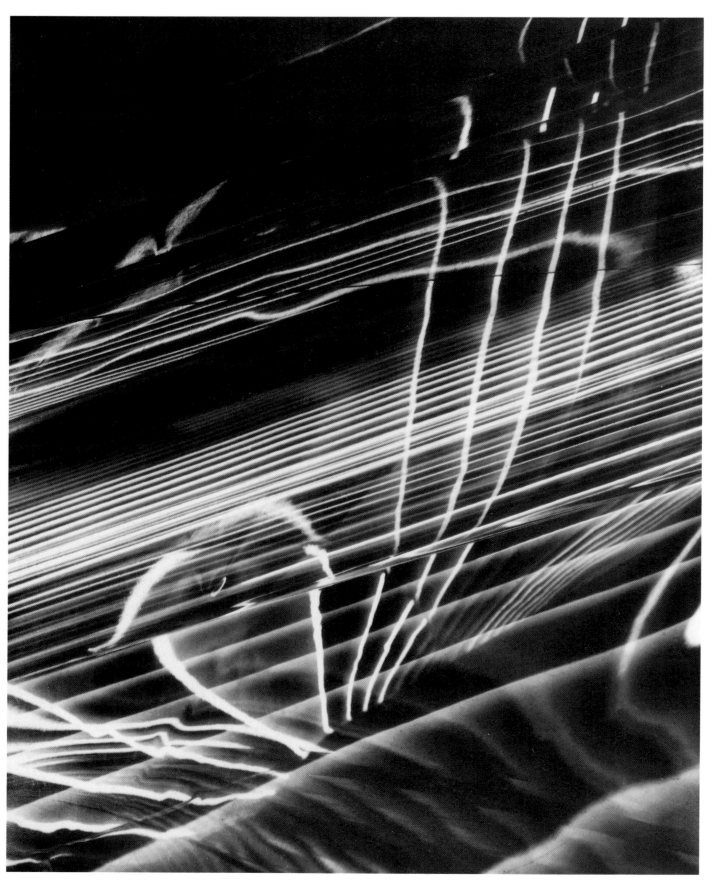

Carlotta Corpron
Fluid Light Design. ca. 1947
Gelatin-silver print, 13⅝ x 10⅝ in.
Collection of Barry Fellman, Exposure, Fine Art, Miami

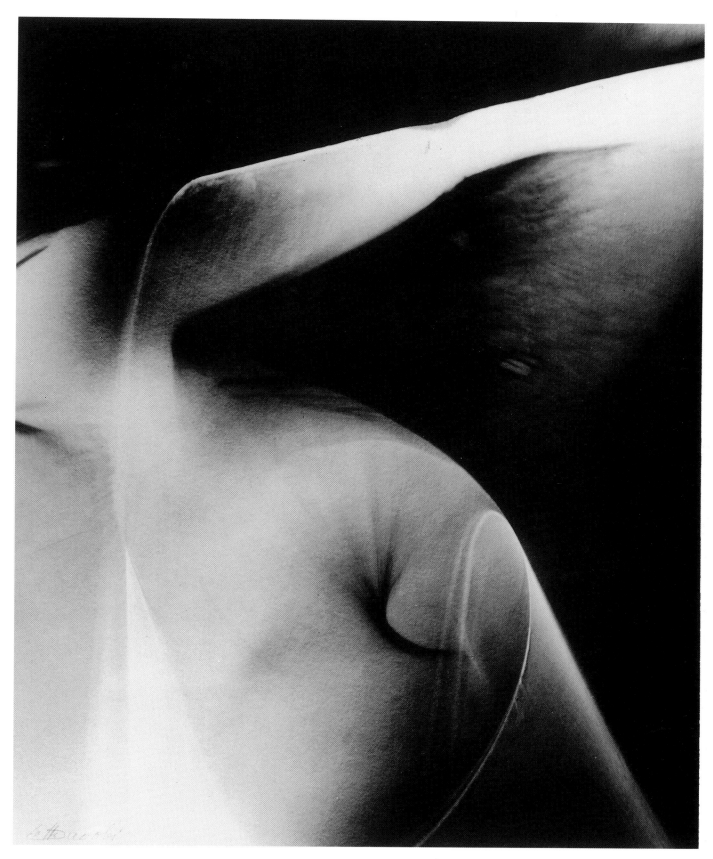

Lotte Jacobi
Untitled Photogenic. 1946–55
Gelatin-silver print
8⅞ x 7¹⁄₁₆ in.
Los Angeles County Museum of Art
Ralph M. Parsons Fund

Aaron Siskind
Untitled. 1948
Gelatin-silver print
8⅜ x 13½ in.
Los Angeles County Museum of Art
Anonymous gift

Syl Labrot
Untitled. ca. 1960
Dye-imbibition print
12 x 15⅞ in.
Courtesy of the Visual Studies Workshop, Rochester

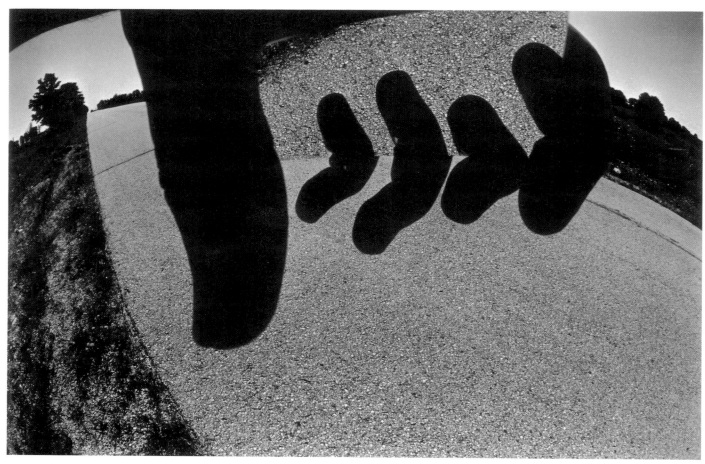

Joseph Jachna
Door County,
from the series *Door County Landscapes.* 1970
Gelatin-silver print
8 x 12 in.
Collection of the artist

2.

Surrealism, Symbolism, and the Fictional Photograph

The field of photography has by and large been dominated by the documentary approach, with its concern for particularity of details, its humanist orientation, and its emphasis on the provision of the narrative, the report, the representation of the real. But in the 1940s a type of photography emerged that repudiated the medium's supposedly obligatory documentary role. With its surreal imagery, it not only labored against the established aesthetic and purpose of the documentary, but it was in large measure founded upon an assault on what had been considered the essence of photography—its credibility as a simulacrum, a bona fide representation of the truth. Seeking to suggest a different reality, many photographers attacked through their imagery the idea of the certitude and "objectivity" of photographic evidence. Paradoxically, the success of their work revolved upon its exploitation of the common, a priori acceptance of the photographic image as true. They were struggling against the power of the photograph to persuade the viewer that it is an accurate visual document of some thing or scene that has existed in the world; at the same time, it was that very power that made their "invented" images compelling. Because it is a supposedly "objective" record of reality, the photograph remains convincing, even when it expresses symbolic or imaginative knowledge or truth, or the realm of the unconscious.

The visual language of their paradoxical images, which juxtaposed unrelated objects and elements in what seemed an assault on both rationality and our understanding that photographic evidence is empirical, sprang in part from the writers of the Surrealist movement. In the 1930s, in both painting and photography, Surrealism had considerably less impact in the United States than in Europe. But several of the émigré artists who left Europe for New York during the early part of World War II brought with them its intellectual theory and style. In America this new visual language, which was based on emotion and psychology, myth and fantasy, joined with abstraction to forge a provocative and inventive rebellion. American painters like Arshile Gorky, Adolph Gottlieb, William Baziotes, and others became influenced by

such European artists as Max Ernst, André Breton, and André Masson. The Surrealists' interest in automatism passed into American art through the idea of a painting gesture void of rational intention and purposeful representation. This direction was matched in the photographic realm, not in a painterly way, but in an expunging of the objective in favor of biomorphic and symbolic forms.

The interest in emotional and implicit meanings manifested by these experimental photographers was a radical departure from the empiricism, rationalism, and realism that had dominated photography in the United States for several decades. Some of these photographers had no commitment to the heritage and tradition of photography, and elements of their work mirrored contemporaneous developments in art. They subordinated the precise, descriptive, documentary capability of the photographic image to the allegorical, the spiritual, and the psychological. Where the reportorial photographer captured the moment, whether dramatic or quotidian, these photographers expressed a more timeless, ethereal imagery, one clearly separate from the material realm of life in the mid-twentieth century. With this change, photography relinquished some of its isolationist position, borrowing ideas and means from literature, painting, and film. This radical break demanded a more expansive definition of photography.

It should be recalled that photography at this time had no Cedar Bar, no spirited critics or galleries, no patron such as Peggy Guggenheim to herald its achievements. While New York during the 1940s became an active milieu for painters (and for photographers working in the documentary vein), there was still no community or strong focal point for those photographers who chose more radical paths. What critical support there was for nondocumentary photography came from people such as Beaumont and Nancy Newhall, Edward Weston, and Ansel Adams, but their focus was on classic, pure abstractionist work. The endeavor of many practitioners, then, was a relatively solitary one, with little financial reward and next to no audience.

In American photography, the Surrealist impulse was not as strictly limited to a narrow period as it was in American painting. After 1948, when most émigré artists had returned to Europe, painters in this country on the whole abandoned Surrealism, and by the mid-1950s it had become a superseded style.[1] In photography, on the other hand, the perennial requirement that the image be firmly grounded in an earthy reality posed a constant standard against which to rebel, and Surrealism offered the means. This attack on photographic veracity, then, is not confined to the 1940s but extends through the 1950s, the 1960s, and even into the work of artists of the 1980s. While these photographers share no single style, common belief, or orientation, in one way or another the transcendence of photographic truth, and the pursuit of a symbolic or interpretive imagery, is key to all. They looked to photography for a language much richer than that required for the passive recounting of mundane fact. And photography proved uniquely suited to the propagation of Surrealist images. Commingling life and death, the real and the imaginary,

the past and the future, the communicable and the incommunicable, it admirably fulfilled the aims of Surrealism; according to Breton, its ability to integrate these states persuasively made possible a resolution beyond that normally seen in reality.[2]

Another way in which these photographs differed from documentary images lay in their conception not as images intended for mass reproduction and a popular audience, but rather as the product of a personal, esoteric, and sometimes eccentric vision. These photographers were unquestionably affected by the spirit of the times, one in which personal vision and the search for a truth within the artist triumphed over external reality. This response to the sense of the *intrinsic* over that of the *extrinsic* is quite apparent in the painting of the postwar years, and it was carried over into the smaller quarters of photography. In part, the photographers who effected it were rebelling against the inherent empiricism of the modern machine image, which was analytic, rational, objective, and utterly reliable. To them, the factual record left no room for interpretation, for the cerebral or the emotional. They saw the detached objectivity of the *Neue Sachlichkeit* photography of the 1920s and beyond—with its orientation toward straight, lenticular observation—as too restrictive a code, for it precluded the psychological, the metaphoric, the intuitive, and the mysterious—qualities that had been evident in the work of modernist painters in America for decades.[3]

The subjective aspect of nonobjective imagery, seemingly so antithetical to the photographic image, was of as much interest to photographers as to painters. But it is instructive to recall that their struggle mirrored the same problem that painters had confronted decades earlier—the need to move beyond social realism, to revolt against representation and against art with a social purpose.

As early as 1916, Willard Huntington Wright, an energetic art critic and a contributor to *Camera Work*, wrote in a review of an exhibition of paintings that "a great work of art need not contain any recognizable objects. Provided it gives the sensation of rhythmically balanced form in three dimensions, it will have accomplished all that the greatest masters have ever striven for." He also observed, "Were realism the object of art, painting would always be infinitely inferior to life—a mere simulacrum of our daily existence, ever inadequate in its illusions," and, "Our minds call for a more forceful emotion than the simple imitation of life can give. We require problems, inspirations, incentives."[4] The clash Wright discerns between abstraction and realism, the classic struggle of modernism, eventually made its way into photography, with photographers demanding the same latitude that had been accorded painters.[5] Philosophical and intellectual interests supplanted simple pictorial interests, just as they did in the artistic and literary work of the time. By the late 1940s, heroic individualism with a private, introspective orientation was well established in painting; certain photographers sought to extend this attitude to photography as well, abandoning its functional and commercial uses in favor of a personal vision.

The photographs of Clarence John Laughlin give full rein to Surrealism, and to the disruption of photographic realism. Laughlin's attention to the vast potential of photography to articulate a sense of otherworldliness emerged as early as 1935. Fantasy and enigma were integral to his work, whether in the theatrical tableaux he set among the decaying ruins of the South, or in the haunting examples of antebellum southern architecture in his book *Ghosts Along the Mississippi* (1948). Though his images are decidedly influenced by his literary interests, for example French Symbolist poetry, Laughlin had a minimal education, and he was self-taught in photography. He was an anomaly, belonging to no coterie of like-minded artists. The romanticism of his photographs ran counter, for example, to the Purist, straight-photography aesthetic of Weston and Adams. He demanded a more sophisticated visual mode than simple representation: for him the physical object was "merely a stepping stone to an inner world, where the object, with the help of subconscious drive and focused perceptions, becomes transmuted into a symbol whose life is beyond the life of the objects we know."[6] The effects of light and time, and the enigmatic nature of reality, are recurrent themes in his work. An evocative poetry and an underlying concern with the metaphysical are also characteristic.

More than most photographers, Laughlin imbued his imagery with a palpably romantic mood by using a full mise-en-scène. Some of his images have a disturbing quality, illustrating what he called the unreality of the real and the reality of the unreal;[7] he was perhaps one of the most dream-oriented of all photographers, and certain of his works have a sense of the unnatural, as well as a deep melancholy. His images are rich but mysterious allegories, with a sexual undercurrent. Laughlin experimented with the processes of photography, making adroit use of montage to undermine realism and to reinforce a sense of spirituality. He occasionally used double exposure to overlay images, making their connections explicit and suggesting a place for them in a continuum of time and the subconscious. His photographs are redolent with nostalgia and decadence. They draw on the languor and the myth of the Old South, its heavy atmosphere and pervasive sense of history. Though in a sense timeless, these images share in the South's fascination with memory and the past; to express time and decline, they focus on decay and ruin, conveying the feeling of a lost world, a greater order now past. These romantic devices, which establish a narrative and emotional basis for the photographs, preclude the possibility that these might be objective views. Laughlin's images are temples for the subconscious.

The viewer's reading of the photographs is determined in part by Laughlin's evocative titles—for example, *Possessed by the Past, Bird of the Death Dream, The Eye That Never Sleeps, Victorian Phantasms, The Apparition*. These textual elements suggest narrative directions for the images, and reinforce their ambiguity and their elegiac aura. Laughlin's titles underscore his demand that his work function metaphorically; the titles effectively erase the particularity of the photographs, infusing them with symbolic meaning. Laughlin's pictures

subvert the authority of photography as an accurate record of precise visual data. Somehow, they seem to describe something beyond or different from what is actually depicted. A certain kind of theatricality is key in this process:[8] the shadowy settings of these images evoke a surreal realm, haunting and dreamlike; and the atmospheric lighting and misty auras, the props and the costumes of the models, are similarly conceived. Laughlin's work offers no formalist arrays, no crisp precision of composition, nothing modern. A large number of his photographs document buildings, for he was a ceaseless chronicler of American architecture, but even these relatively straightforward endeavors reveal his sensibility through their concentration on Victorian and antebellum structures in decline.

Laughlin's group entitled "Poems of the Inner World" perhaps best expresses his particular mythology of desires, anxieties, frustrations, dilemmas. Beneath these highly symbolic pictures one senses a psychological substructure of confusion, want, and fear—the drama of our time, which Laughlin arrived at through subconscious intuitions. For him the "thing" was not merely itself—as Weston had so emphatically represented it—but rather a symbol, a key to another, less certain world. He was a singular figure, one whose notion of photography was visionary and wholly his own. For a long time his highly mannered images seemed out of date, divergent as they were from formalist modernism and the aesthetic of straight photography, but they have ultimately proven enormously influential in their demonstration of the medium's potential for poetic symbolism, and in showing that photography need not be confined to recording the knowable world.

Although British photographer Bill Brandt is known for his social documentary work, such as his book *The English at Home*, he also produced a startling series of nudes that reflected both his turn from the reportorial and his earlier apprenticeship with Man Ray. His fascination with the surreal is apparent in other works, but it is most pronounced in his nudes. Brandt's figures are situated in an empty, barren space, which is quite unlike Laughlin's romantic settings. They are dreamlike, but with a disturbing edge. The stark contrast in the black-and-white images works in tandem with their spareness, suggesting existential issues. Much like André Kertész's "Distortions," a magisterial series of Surrealist nudes from the early 1930s, Brandt's nudes rely on optical distortions to transport the figures from reality; however, Brandt often increased the effect through retouching. His interest in spatial representation is emphasized by his use of an extremely wide-angle lens to establish the form.

The photographs of Val Telberg illustrate a more strident modernist sensibility than Laughlin's. Telberg began montaging negatives in 1945,[9] combining them according to various influences—among them Jean Cocteau and other poets, and Surrealist painting. Like Laughlin, he was interested in the evocation of another time and place beyond the literal: in his words, "I try to invent a completely unreal world, new, free and truthful, so that the real world can be seen in perspective and comparison."[10] His photographs are far less dependent on reality than Laughlin's, however; while many of them in

fact relate to his childhood in Russia and China, they engage in a Caligari-like distortion of the real world. Throughout his montage works Telberg freely combines disparate images, sometimes using as many as four or five of them to increase the visual and symbolic density of the final print. Radical shifts in scale suggest the operations of memory, or introduce subthemes or tangential relationships within the overall picture. The photographs are a synthesis of a bold sense of abstraction and a narrative sensibility reminiscent of certain European art, although Telberg did not come from an art-world background.

To dissolve the prosaic realism of his images, Telberg exploits the feeling of unreality made possible by some of the processes of photography. The use of negative images suggests a dreamlike state of vision of remembrance, eliminating depth-of-field and abstracting figures into flat, ethereal silhouettes. Some of the works are solarized, giving them an eerie look. Furthermore, Telberg's recombinations of fragments of negative often take place rather spontaneously;[11] unlike Laughlin, he has no programmatic preconceptions.

An emphatic cinematic quality emerges from the structures of interlocking planes of imagery in Telberg's works. He became intrigued with film during the 1940s (especially with the experimental work of Maya Deren and Frances Lee[12]), and it began to make its presence felt in his photography around 1950. His pictures are not unlike sequences of film footage compressed and collaged rather than played out over time. He has often used implicitly narrative images, and these, juxtaposed with details from other negatives, set them in a narrative context that mirrors the overall work. The way the viewer segues from element to element in one of his pictures recalls the cinematic techniques of the cut and the dissolve. A Telberg work condenses the syntax of film into one extraordinarily dense and detailed frame, with the viewer determining whether the scene moves forward, backward, or both. And by allowing negatives to overlap during the printing process, the artist allows what appear as projected images to play over some of his subjects, creating an odd, flattened background.

In addition, Telberg's pictures often have a striking graphic quality, which combines with their deliberate confusion of the grounding of the image to set interpretation ricocheting freely. Sometimes, for example, the imagery is literally upside down—a cobblestone road may appear as the sky—and in general the complex montage fragments the background, the imagery melding together as if from various intertwined and interlocking layers, each only partially discernible. This mélange makes its own contribution to the works' evocation of a dream state, a place of haunting, disturbing bits, of shifting scale and focus, of variable light and darkness, of imbalances, and of a constantly changing sense of vision. The figures in these photographs are subordinated to the demands of the composition; the nudes, for example, lose their eroticism in the cacophony of details. All of this may suggest a concern with abstraction, and in fact the structures of some of the compositions are substantially abstract. Formal abstraction is not a key consideration for Telberg,

however—he is more interested in the description of a particular unreal world. Once Anaïs Nin described his work as a "spiritual X-ray" in which man seems at times lost in ruins, or among thick walls, or before doors leading nowhere, while beyond and above, in a realm of fairy tale and fantasy out of his grasp, the child's dream is still at play, or old age moves on to other spheres.[13] Telberg's free use of montage, his dynamic poetic imagery, and the brilliant formal richness of his work are unique.

Frederick Sommer has been active in photography from the 1930s on, and numerous of his works from before 1945 reveal themes that he has continued to examine for decades. Like many photographers, he came to the field after training in another specialty—landscape architecture—though he has also pursued drawing and painting (and he continues to draw). Although influenced by Weston and Stieglitz, he sought more complex meaning and structure in his work; the unarticulated rather than the literal fact was his interest. Sommer has expressed a detachment from the Surrealist movement, regarding it as a spent force.[14] His work shows many correspondences to Surrealism, however, for example the juxtaposition of seemingly disparate items, the attention to the revelations of the unconscious, and the search for hidden meanings and insights. Sommer investigates a kind of hyperreality—his images are not so much fictive, or distortions of reality, as disturbingly true.

Sommer's photographs are quiet, yet loaded. These are secretive works, more reticent than expressive; as Minor White observed, "a superficial glance at his pictures reveals about as much as a locked trunk at its contents."[15] Sommer is concerned with the spiritual, the subjective, the symbolic, yet his photography conveys a harsh reality. His truncated subjects—including animal carcasses and parts—have a nightmarish quality about them. The appeal of the grotesque, the putrescent, has often been observed in his photographs;[16] the effect, however, is to raise questions about existence and temporal reality, and image by image the questions gather strength, from the early works such as *Untitled* (*Chicken Parts*) (1939) through the later paint-on-cellophane abstractions of the late 1950s. Sommer's photographs of assemblages that he has constructed are his more intriguing work, both boldly and subtly combining found matter—again, often manifesting decrepitude and decay—with fragments of old engravings and bits of other assorted materials into complex, enigmatic compositions.[17] Exquisitely printed and compressed into a small scale, these compositions are very rich and defy immediate deciphering. Their dense visual information yields a wealth of relationships that both describe the present and suggest a past now in decline. Although they are more cerebral than intuitive in their impact, in this sense the images are romantic. Their precision and sense of privacy gives them an affinity to Cornell's constructions, in which forgotten bits are dredged up and then reassembled into new objects.

During the 1950s and the 1960s Sommer increasingly addressed abstraction, working with paint-on-cellophane and cut-paper constructions; the latter, in their sly interplay of light and tone, and of two and three dimensions,

are reminiscent of Francis Joseph Bruguière's studies of light. But Sommer's greatest success lies in his depiction of the factual, in work that is neither fantastic nor heavy-handed, neither theatrically surreal nor artificially romantic. Nor are his images suffused with sentimental memories or mired in the past, though they make use of it. Sommer provides a bridge between the realism of Weston and the expressive montage process of photographers like Telberg. Yet Telberg's discordant modernism is antithetical to Sommer's delicately detached assemblages, in which a primary subject always dominates.

After the 1940s, the photographer most responsible for opening the medium's evocative, metaphorical possibilities was certainly Minor White. White took a theoretical approach to photography, and his theories recognized the potential of the camera for personal expression that incorporates spiritual or psychological symbolism. His ideas and presence were nationally disseminated through *Aperture*. The magazine posited several critical changes in how the photograph might be considered, shifting attention away from its role as a simple record of a subject and substituting the possibility of a deeper reading. The magazine recognized the value of symbol and metaphor, and made important connections between photography and other visual art forms.[18] It was devoted to the idea of photography as a method of personal vision, an idea White articulately championed both through the magazine itself and in his own photographic work. And he garnered students and acolytes of his way of thinking who in turn helped spread his style, influence, and philosophy.[19]

Modern art had shown a longstanding interest in the spiritual, especially as an element of abstraction. In 1911 Wassily Kandinsky's pioneering polemic "Concerning the Spiritual in Art" had called for an expression of the spiritual inner life in nonliteral, abstract terms, released from the confining demands of representation and informed by a larger, ineffable, immaterial stimulus. "The relationships in art," the painter wrote, "are not necessarily ones of outward form, but are founded on inner sympathy of meaning. I value only those artists who are really artists, that is who consciously or unconsciously, in an entirely original form, embody the expression of their inner life. Form is the outward expression of this inner meaning."[20] Kandinsky's ideas were highly relevant to White's. But it was Stieglitz's notion of the "Equivalent" that was the real basis for his work, theories, and teachings. The emphasis on the metaphoric in Stieglitz's work from the 1920s on engendered a more theoretical basis for photographic imagery than that implicit in the documentary mode, and also brought with it an attention to formal abstraction and to spiritual content. More than Stieglitz, White was able to incorporate the principle of the Equivalent into his images. Perhaps more important, he introduced it to others, disseminating the concept widely in the field of photography beginning in the 1950s.

White's concern in his photography with a sub-rosa sensibility, an unfathomable consciousness, is akin to the interests reflected in Surrealist painting, though the two processes of picture-making are actually antipodal. The

results, however, are similar—White's is a visionary, meditative imagery, often derived from nature but released from descriptive function. And key to both is the use of metaphor as a vehicle to move beyond immediate reality to the unconscious.[21] There is also a resemblance between some of White's photographs and some of Weston's, but this is superficial. The insistent reductiveness of White's images suggests an urge to portray something far more indefinable than "the Thing itself" to which Weston was so attentive. Weston, of course, was much closer than White to the *Neue Sachlichkeit,* with its concern for realism, precision, and fact; he sought the essence of the object, its natural and physical being. White was more interested in its suggestive capabilities, its immaterial properties. This escape from the tyranny of the literal was a key achievement of his work.

It is not accidental that many of Minor White's photographs are grisaille analogs to Adolph Gottlieb, Clyfford Still, and even Mark Tobey. He participated in the new spirit in American art after World War II. His year studying with Meyer Schapiro in New York during 1945–46 could only have helped draw his attention to the change in the air in American art.

As White himself observed, his photographs have a haikulike quality in their understated simplicity, but they also reflect the naturalism and mysticism of much of the painting of the period—for example the work of Mark Tobey and other painters concerned with biomorphic Surrealist abstraction. Yet White shrewdly observed that abstraction in photography, while seemingly related to that in painting, actually emerges from an entirely different impetus—from an editing or excerpting of material extant in the world rather than from personal invention or from a completely open selection of motifs. Armed with this awareness, he was able to mitigate the reality and particularity of his subjects more than other photographers in the abstract vein, for example Aaron Siskind. Where Siskind maintained the image as a somewhat discrete fragment extracted from the world, White, through an ambiguity of depth, a flattening of the subject, and a minimizing of its presence, was able to push the subject photographed further into symbolism. Through this dissolution he achieved free visual metaphors that liberated the image from preexisting meaning and context.

White's concern with spirituality, his attention to the inner "landscape," in his word, brought him in contact with Zen Buddhism, with the mystical ideas of Georges Gurdjieff, and with the concepts of psychology. These nonvisual interests also reflect the orientation of the Beat movement, which was contemporaneous with his 1950s work, and which was also capable of seeing a transcendent significance in common objects. White enjoyed the lyricism and economy of poetry, and his early attention to the metaphors of poetic language was a springboard for his subsequent visual experiments. But for all his spiritual concerns, he subscribed to the traditional purism of photographic practice. His images are only slightly enlarged from their negatives, modest in size, pristine, and exquisitely printed with the kind of attention to technique that results in rich blacks and a crisp rendering of detail. White es-

chewed any manipulation of the negative or print, preferring the ready-made ciphers of nature. He had an academic training in biology, and he was also no doubt influenced by the naturalism of Weston and Ansel Adams. Again, this approach sets itself apart from Siskind's urbanized abstractions. The geometric formalism and technical experimentation of Chicago's Institute of Design were diametrically opposed to White's metaphysical sensibility.

It was White who developed the technique of grouping images to form nonnarrative sequences according to a highly personal process of selection and ordering—a photographic version of automatism, perhaps, and in any case reflecting the authority of the modernist artist's subjectivity. The Zen influence is apparent in some work in this form, particularly the ten images that make up the sequence "The Sound of One Hand Clapping" (1957–62). For White the photograph was an expression of unarticulated apprehensions and nuances of thought and feeling. Through abstraction one could abandon one's preconceptions and explore the self. The act of reading a photograph, of engaging in a subjective investigation of it for personal meaning, was to White an essential methodology. Urging that camera images held transcendent meaning and expression, he released the photograph from the burden of representational function, claiming for it a sublimity matching that announced in the painting of the period. White has a place in the tradition of spiritual awareness that runs from the art of the early twentieth century up through the work of the Abstract Expressionists, and beyond.

The California coast region seems to foster a reverential attitude toward nature, if we can take the work of Weston, Adams, White, and others who worked around them as evidence. The photographs of another West Coast photographer, Wynn Bullock, also address nature, leaning toward White's vision of a spiritual cosmos manifested in it. Bullock's work also shows an attention to existential issues. His images might be called "lyric," an apt term considering his early training and accomplishment in the field of music.[22] His involvement with this nonliteral art form no doubt was crucial in helping him to establish a sense of the expressive and evocative in his photography, and to develop an intuitive use of the medium. His images realize a connection between the inner world and the outer, and thus are perhaps more simply expressive than White's, which have a more sophisticated symbology attached to them.

As a student of Edward Kaminski[23] at the Los Angeles Art Center School, in the late 1930s, Bullock explored much the same experimental techniques pursued by photographers in Chicago's Institute of Design. Through much of the 1940s and in his later work he would utilize such processes as solarization, reticulation, multiple negatives, double exposures, and reversal, though his work late in the decade and through the mid-1950s was in the vein of straight photography. Throughout, he focused on the emotional and imaginative potential of the camera image, and particularly on the mystery of nature. He was heavily influenced by Weston, but like White he sought a more transcendent and expressive solution than Weston's work offered. For Bul-

lock the physical world was only the visible aspect of a more intriguing dimension of space and time, a continuum where past, present, and future blended, transcending the restrictions of the immediate reality. In this dimension the greater, more abstract meanings of physical appearances became clear, while the particularity of those appearances faded in importance. (Obviously, theories of this sort stand opposed to photojournalism's notion of the "decisive moment.") Such ideas fascinated Bullock for years.[24] He rejected the specificity of the event, seeking images with a sense of timelessness. He felt that his images were symbols for another dimension, but noted "the symbol is not the thing symbolized."[25] Out of this issue he developed an interest in perception and language; for him the camera was more a tool of the brain than of the eye. To see Bullock's photographs as simple depictions of their subject matter is to read them superficially, without due consideration for the intellectual climate in which he lived or for the quality of his own mind.

While Siskind was a key investigator of abstraction as symbol, it was Minor White who truly opened the doors of perception, influencing a generation of younger photographers. The expressive use of photography, a use both abstract and metaphoric, introduced by the photographers we have discussed was followed throughout the 1950s and into the 1960s by the work of many more photographers influenced by White, including Nathan Lyons, Walter Chappell, and Carl Chiarenza. They too sought to liberate photography from ordinary appearances, taking White's work a step further toward classic modernist abstraction. Symbolism and the need for active interpretation are key in these photographers' images, which draw on both a theosophical kind of mysticism and a biomorphic formalism.

The essential element of an image, Lyons noted, is a fusion of intellect and emotion. The issue is its associative power, that is, its ability to express knowledge beyond the time and local condition of its making. Lyons and the others felt that the photograph could isolate an inner reality that paralleled the physical world. The flat, painterly images, details excerpted from nature in their work, are not to be seen as illustrative of the thing represented, but as points of departure.[26] The influence of Eastern religions, and the investigation of consciousness and awareness rather than of literal data, typify these photographs. Like White, photographers such as Lyons, Chappell, and Chiarenza use the camera intuitively, in a way somewhat akin to automatism, in order to form a "relationship between the human mind and Nature." "As a language," Chappell wrote, "these images are made to be received at once, intuitively, and directly, instead of word after word, serially, as occurs in spoken and written language."[27]

Thus nature was merely the basis for, not the subject of, these studies. Weston's objectivity had been supplanted by a desire for images that could carry a meaning more covert, more complex, than the meaning immediately implied by the literal subject. Like Purist photographs, these works

make use of brilliant blacks and exquisite printing. Where the painter can make use of thick impasto, or heavy trailing arcs of pigment, the photographer is bound to the flat surface; the photograph, however, can reveal great changes in texture, form, and light, and this is the case in these pictures. Mere fragments and bits of matter are transformed through the grisaille palette of black-and-white film into cosmic abstracted vignettes, which were utterly opposed to the pedestrian imagery of daily life in the late 1950s and early 1960s, when the style of this work took shape. In the context of the transition from the Eisenhower era to the years of the "new frontier," this introspective use of photography can be seen as a search for new visual language and meanings for the medium, a push toward new boundaries. Undoubtedly, the work of these photographers was also influenced by the period's literature, particularly the writing of the Beats, which raised existential questions and inquired about another kind of reality and consciousness beyond daily existence.

The 1950s was the last decade to allow a true avant-garde spirit before the advent of commercialism in the 1960s. The ideas of the unconscious and of the spiritual provided the theoretical basis for much of the painting of the period, and also proved well-suited to photography. This emotional, intuitive approach was the artistic spirit of the times, a renunciation of the overwhelming postwar explosion of rank materialism. In the works of artists like Lyons, photography, like painting, was repudiating its anecdotal role in relation to the material world, its role as an inventory-taker, in favor of a self-determined, spiritually rich vision.

Independently of these works, the spirit of Surrealism continued in photography, for example in the experimental approach of Edmund Teske. An older man than Lyons, Teske spent a year working for Frank Lloyd Wright at Taliesin, Wisconsin, in 1936–37, and a year teaching photography at Chicago's New Bauhaus in 1937–38 under Moholy-Nagy. In spite of his formalist background, his photographs from the late 1950s are markedly personal and lyrical in content and style. Like Telberg, Teske has worked with montage, but the sense of unreality in his work derives from an additional exploitation of the essence of the photographic process, an extension of experimentation not only to the imagery of the photograph but also to the materials and chemistry of the medium. After working with montage for many years, Teske became interested in a further disruption of the literal realism of the photograph; he was looking for a means of achieving both a surreal atmosphere and more abstract pictorial structures. In 1958 he developed a "duotone solarization" process that accomplished all his experimental goals. A unique toning and solarization method that partially reversed positive and negative in the print, it combined the standard black-and-white palette, until relatively recently considered obligatory in serious photography, with a deep, rich, coppery-brown tonality. The flattening out of sections of the picture and of the overall field, the quality of the tonal range, and the shimmering surfaces give his subjects the abstraction he sought. His design sensibility

is apparent in many of his early solarized studies of plants and flowers.

Teske's more recent, 1970s work shows a melancholic repetition of certain key icons, indicating the special importance of these images to him. This very personal iconography suggests not so much a distorted or fantastic vision as a long, lingering focus on memories of people and places in his life. The linkages proposed by his montages are simple compared to Telberg's strident aggregations of jarring fragments, and his pictures have much of the quality of linear narrative. He achieves his vision more through process and presentation than through the intricacies of a complex montage.[28] Teske's works have a strong formal element that mitigates the saccharine atmosphere of his compositions; his images are often built around a dominant central subject. An investigation of his own psyche and introspective vision are hallmarks of his work. His images are wholly different from Laughlin's romantic, programmatic narratives and allegorical scenes: Teske offers his viewer a deeply personal recollection rather than phantasms of mystery.

Like the other artists under discussion, Teske has never been interested in photography's function as a literal record. He has sought to radicalize the medium in form and content. He has worked largely alone, in Los Angeles, selling and exhibiting sporadically, but he did benefit from a friendship with Man Ray, whose own work had earlier established perimeters of experimentation with content and process in photography. In a sense, Teske served as the link between the experimentalism that has characterized Los Angeles photography during the past several decades and that of the mainline of experimentation during the 1930s and 1940s at Moholy-Nagy's Institute of Design.

While the documentary mode still maintained much of its hegemony in the early 1960s, it was tempered in part by an increasing interest in abstraction, whether of a formalist or a metaphoric kind. Both of these approaches, however, tended to preserve the Purist strictures of straight photography, with its insistence on the crisp, unmanipulated, single image. Yet as early as the late 1950s Jerry Uelsmann, who had studied with White and then with Henry Holmes Smith, was becoming dissatisfied with the restrictions of the single image, and had begun to explore the technique of combining more than one negative in a composite print. Part of the impetus was simply the urge for invention, but Uelsmann also wanted to disrupt the mere rote printing of extant negatives. He wanted to make photography a more interactive process, expanding the period of creation beyond the fall of the shutter.

Uelsmann's photographs are enigmatic combinations of images brought together in a perplexing *trompe l'oeil.* The components of his photographs seem dissimilar, but they have an association for him; like Teske, he works from a position in which memories are key. The subtle interconnections he proposes between his pictorial elements relocate them from the plane of their everyday existence to another, more evocative level on which they gain new meaning and suggestiveness (which is reinforced by the works' titles).

The use of negative images and of extreme contrasts in scale also contributes to this alteration of his subjects' normality, making them more imaginary and fantastic. Uelsmann's works from the 1970s show increasing sophistication as he masters his subtle printing technique; unlike other photographers working with montage, he never creates obviously overlapping images. Rather, the joins are seamless and highly deceptive.

All Uelsmann's images imply a narrative, but he leaves it to the viewer to interpret what it might be. He records a private realm, not so much his own personality—his works don't seem autobiographical—as one open to everyone. The mysticism of his photographs, for example, is undercut by the presence of familiar objects and elements. Uelsmann's work constitutes a revolt against the lenticular empiricism of the camera, its use as an instrument of factual record, in favor of a vision of the photograph as an intellectual and sensory image. Natural settings are frequent in his works, grounding the subject in a timeless, unmechanized surround, and Uelsmann invokes certain questions about nature as a world beyond empirical evidence. Mystery, then, is an essential aspect of his work, as is symbolism. Uelsmann has been interpreted as a constructor of myths because of his flawless fabrication of a mythical realm.[29]

The implied narratives in work by artists such as Uelsmann receive more emphatic form in the photographs of Duane Michals. Unlike Uelsmann, Michals usually offers no fantastic imagery, choosing more quotidian moments of ordinary life. More important, he uses sequential images to construct his narratives. Unlike White's sequences of images, which do not form truly linear progressions, Michals's works utilize complex structures that indicate a sequence of events and the passage of time. He sees himself as a kind of visual fiction-writer, a figure quite different from photographers like Robert Frank and Henri Cartier-Bresson, who are more akin to "reporters."[30] This fictional role, of course, again refutes the assumed objectivity of photography.

Michals's sequences are highly cinematic in nature, reading like a series of discrete frames excerpted from a film. They have the narrative qualities of a story with a beginning, middle, and end; principal characters; and a set for the action. But Michals hones his narratives to the smallest possible number of frames, presenting his fictions with great economy. He acknowledges that he contrives his sequences out of a need to create his own world, one in which he can control gesture and action rather than being merely a spectator.[31] These *tableaux vivants* are based on sketches he has made; the scenes are preconceived, set up, and shot, and the men and women in his photographs are precisely like actors in a drama that he has scripted, a methodology that would gain strength during the 1980s.[32] This *auteur* role in photography, incorporating a full-scale staging of the image, was not without precedent in the 1960s, when Michals began to develop it, but it was unusual. His work signaled fundamental attitudinal changes in the notion of the photographer, who was moving from observer or editor to author. Those changes would become more pronounced during the 1970s.

Initially, Michals's serial images were quite simple, but they have become more complex as he has progressed. Inherent in all his scenarios is a sense of artifice and drama. By denying actual events in favor of his own fabrications, he reinforces the notion of fiction at the same time he consciously exploits the presumed truth of the photographic record. Like some of the other photographers who have toyed with the camera image's illusion of reality, Michals is romantic and retrospective; he admits that his work presents his own emotions, irrespective of its subject.[33] Many of his images have an obviously spiritual theme, consciously invoking Christian imagery and stories: in *The Spirit Leaves the Body* (1968), for example, he addresses the idea of the continuing life of the intangible spirit, a theme to which he returns in *Death Comes to the Old Lady* (1969). Michals's use of fable, allegory, and visual parable had no parallel in the contemporaneous photography of the 1960s, and he was also singular in that his allegorical tales were set in modern life.

Michals's first serial work, *The Woman Is Frightened by the Door* (1966), looked to the sinister possibilities of ordinary inanimate objects. Some such conflict is evident in almost all his narratives, which often have the personal nature of dreams. This feeling of intimacy is reinforced by the diminutive scale of the works; Michals is concerned with the issue of privacy, and he wishes his viewers to engage his photographs in a private way, so that the images may reveal themselves and function at their most suggestive level. He is interested not in the depiction of reality but in the pursuit of the insubstantial and invisible, of spirit and dream. For Michals, reality is a superficial mask for the more complex issues of life. Or, as he has observed of himself, "I am a reflection photographing other reflections within a reflection."[34]

Despite the reinforcement of documentary photography's strength during the 1960s through ideas such as that of "the social landscape," a movement in the photography of the time that was described and supported in a number of exhibitions, an interest in using this factual medium to elucidate a nonvisual domain continued to grow, for example in the work of Ralph Gibson. But where earlier nonliteral photographers had employed rich, romantic settings or visually complex, densely symbolic systems of imagery to evoke the mysterious, Gibson's remarkable photographs, as provocative and haunting as any, are accomplished with great economy. His compositions are pared to bare essentials, with all superfluous detail eliminated from the picture frame. Groups of Gibson's images have been published together as coherent, almost novelistic collections, for example *The Somnambulist* (1970). This group succinctly reflects the Minimalist current prevalent in the art of the period; yet Minimalism was not so much Gibson's end as his means of reducing the baggage of worldly particularity and of heightening the sense of the dream setting. The lightness of the images yields the transitory feeling of a passing moment. In their suggestion of rarefied insubstantiality and temporality, the subjects register as uncertain visual impressions more than as tactile, dimensional matter.

Like Gibson's other groups, works of *The Somnambulist* again grapple with the supposed obligation of the photograph to portray factual reality. Gibson considers the possibility of a separate world available through dreams, which in his images gain supremacy over waking, rational consciousness. His pursuit of the "other side" offers access to an emotional realm that he posits, in a brief prologue he wrote for the book, as offering a legitimate state of awareness; here too he remarks that his images are indeed exploratory ones, in search of another dimension.[35] To this end, Gibson uses lighting, montage, and other Surrealist tropes to create the feeling of a consciousness beyond reason. He imparts a sinister quality to common locations. Fragments of complete scenes and other truncated compositions reinforce the sense of narrative, enigmatic as it may be.

Ostensibly photographs of the landscape, the "Door County" group made by Joseph Jachna during 1969 and 1970 are complex combinations of fact and optical illusion. As in his earlier work, the images have a haikulike quality in their attention to nature and their rigorous simplicity. And again as in his earlier photographs, the spiritual quality created by the unique capabilities of camera and lens to render the ineffable is of prime importance.

Jachna's training at the Institute of Design is apparent in the superlative printing of his work, in the subtle tonalities and rich blacks that give them their quiet strength. The visual dissembling he creates through the use of reflections, and the flattening of space and lenticular distortion that he applies, create strong abstractions of grays and blacks. Jachna's graphic sensibility is evident in the plays on shifting scale that result from his juxtapositions of near and far: each image prominently includes a hand or fingers holding a reflective disc, creating a puzzling permutation of the landscape. In this context, the stark Minimalism of his style adds to the perplexity of his compositions. These are highly formal images, with a pervasive ritualistic feeling about them, as if we were observing a private ceremony. The hand appears quite detached, not at all as in Ken Josephson's images of his own extended arm and hand, and this detachment makes its own contribution to the shift these photographs effect between rational data and illusion. The disc seems to capture a fragment of nature or the landscape, but it is revealed to us with exactly the same clarity through which the remainder of the photograph renders the direct world. Jachna shows that the lens is not a neutral observer, and that even the landscape can offer a distortion of reality.

A similar kind of corruption of the rational world is seen in the photographic constructions that Douglas Prince began in the late 1960s. These works are fabricated boxes in which several images—on transparent film, not paper—stand one in front of the other in a three-dimensional composition. The multilayered photographs' heightened sense of depth, and the eerie hovering qualities of their subjects, contribute a psychological aura to Prince's objects, mitigating his pictures' sense of reality, an effect reinforced by the emptiness of the spaces and by the radiant lighting. Removed from the flat, opaque paper of the print, the photograph assumes a different life. By

using the superimposition of images that his boxes afford to make objects appear to float in space, Prince contravenes reality, creating associative imagery that forcibly engages the imagination. His apparitionlike figures and forms have a ghostly evanescence, giving the images a melancholic tone. Like Michals's sequenced photographs, these works are intimate in scale; they are to be viewed in a private, contemplative manner.

For close to two decades, Lucas Samaras has addressed the autobiographic mode in photography, continuing in the stream of experimental form that he first adopted in his work as a painter and sculptor. In the late 1960s Samaras made a series of photographic self-portraits he calls "Auto-Polaroids." Close-up images of himself bound up, these photographs documented a private event, and served as a reminder of his interest in body art. In the "Auto-Polaroids" Samaras physically manipulated his own face and body to alter his appearance; in his later photographs, he was able to transpose that manipulative instinct to the materials of the medium itself. In 1973 he began the "Photo-Transformations" series, one-of-a-kind color self-portraits using the Polaroid SX-70 camera, and the results propose extreme alterations of reality through ingenious alterations of the process of photography. The fact that these diminutive *trompe l'oeil* images are instantaneous Polaroid prints, which offer no negative to be tampered with—and thus, it would seem, no possibility of after-the-fact darkroom pyrotechnics—and that there is no apparent defacing or manipulation of the print surface, lends a powerful veracity to the final photographs.[36]

The presentation of the diminutive (3¼ by 3¼ inches) "Photo-Transformations" series in deep mats lends a fetishistic quality, an unworldly appearance to the work. Samaras's body seems to explode, or his mouth to yawn too far open; the horrifying reality these images declare is not that of a normal man, but of one satanically transformed. This brutal severing of everyday reality is completely without the polite etiquette of Teske, Laughlin, or Michals. Samaras's haunting, disturbing visions of the supernatural are not unlike Hollywood's most sophisticated special effects. A disturbing Dorian Gray–like portrait of man as hidden monster is revealed; the distortions in the "Photo-Transformations" series suggest the experience of psychedelic drugs, an experience of fantastically expanded and corrupted imagination. Samaras's title refers to the transformation of truth and reality as much as to the alteration of the photograph itself, and the economy of his manipulations further contributes to the success of these devious works. Their pristine condition almost dupes us into believing what we see, engendering an intellectual conflict between our ideas of the possible or impossible and the seemingly incontrovertible photographic evidence. Yet in the end we acknowledge the fraudulent nature of what we optically perceive, recognizing that the photographs are skillful prevarication.

Samaras performs for the camera, building upon his early training in acting with Stella Adler.[37] But although he is narcissistic in his attention to himself as subject, he does not indulge in self-flattery. The figurative focus

and broad gestural style of the "Photo-Transformations," coupled with their overwhelming raw emotion, give them an expressionistic appearance. Like Samaras's other performance-oriented images, the "Photo-Transformations" were executed in the artist's studio, but their modest domestic setting rather than detracting from their power helps to ground the fantastic in the real world. The figure in these images has the dynamism of a nuclear blast, with a visible aura expanding outward. Demonic figures and fragments are caught in hellish waves of viscous matter, or in the undulations of intense heat. These Surrealistic tableaux eschew any romantic, nostalgic reality, instead offering a very contemporary, hallucinatory transformation from man to beast, and a feeling of fear and anxiety toward the unknown. The use of colored gels and of lighting directed upward from the floor contributes to the eerie atmosphere of supernatural occurrence within normal existence.

Samaras's experimentation with the basic processes of film and development in these works is akin to the radical assault that had been taking place in photography during the preceding years; a number of artists, dissatisfied with the strictures of the black-and-white print, had been seeking to employ the materials and processes of the medium in new and innovative ways.

Since the early 1960s, Bruce Conner has worked in assemblage, collage, sculpture, painting, and performance, as well as in photography, where his sylphlike photograms reflect his explorations of the effects of light on film. These works are also the ideal distillation of the concept of positive and negative space, which he has explored in drawings. Conner has invoked the mysterious since his work of the 1950s and the "Angels," as he calls this group of large photograms from the mid-1970s, carry on his spiritual investigation. They are negative silhouettes, all but the earliest monumental in size. The photogram, product of a classic experimental process of creating photographic images without the mediation of a camera, takes on a startling presence when increased to human proportions.[38] Conner's "Angels" illustrate the investigations of scale that would emerge more fully in the photography of the 1980s, when many others began to circumvent the limitations of preset photographic-paper sizes by shifting to rolls of paper, thereby producing works several yards long.

The figures of the "Angels" are like wrapped mummies, their legs narrow, the details of their bodies obscure. By using a deep-black background Conner suggests a cosmic void, an effect that works in tandem with the blankness of the figures to suggest ghostly appearances, apparitional forms from the distant past or unforeseen future. They are like the silhouettes or shadows left by an atomic blast, radiating an unearthly glow. For Conner the images are the result of a private performance of which only the energy, the body's aura, remains.[39] His disinterest in descriptive representation is clear; he is after the sense of a mystical life force rather than the common facts.

The spiritual was not a widespread interest in the photography of the 1970s, when it was overwhelmed by formalist interests. Certain artists were again investigating the intuitive during these years, however, and favoring

content over abstraction. JoAnn Callis's 1970s color photographs have an uncomfortable psychological edge, which, upon close inspection, one finds is not due to their explicit content, but rather is brought to them by the viewer. In her work from this period Callis was contriving carefully composed, ambiguous scenes that seemed to have been excerpted from a narrative context; the clear but abbreviated narrative quality of the images necessitated participation by the viewer, who had to provide an interpretation, for the photographer supplied none. Callis was not interested in making portraits—she used her subjects as props. She used color not to satisfy formal requirements, but to emotionally charge and unbalance her images through color's power to heighten the mood of a scene and to trigger a personal response in the viewer. Ideas of structure or of abstraction were far less important to Callis, though she has a keen sense of design. The forgotten moments and quiet, ordinary interstices of daily life are the settings of these photographs, but their compositions are pared down to the most minimal elements, so that the slightest oddity gives a nearly prosaic scene a psychological torque.

Callis was moving away from the mode of the formal study, nearly ubiquitous at the time, but she still used the photograph in the classic form of the straight single image, wholly unmanipulated, often composed through a balanced frontal view. Yet it is not the visual data of these photographs that compel us, but their connotative thrust. In this regard the work is not far afield from Surrealism, with its juxtapositions of insignificant objects to create unexpected drama and psychological enigma, and its emphasis on the viewer's active, interpretative role. The very notion of the Surrealist object hinged on the reconciliation between representation and perception, a nexus particularly well articulated by photography because of its customary basis in pictorial fact. (This is one reason why surrealistic transpositions of reality were a continuing issue in photography long after they had been abandoned in painting.) In 1980 Callis shifted from the use of models, in images characterized by a suppressed sexuality and a slight morbidity, to settings of more neutral and impersonal objects; she had become more interested in the subtler kind of tension generated by illogical associations among banal, everyday things. These images are somewhat more formally organized than her earlier work, and their sense of narrative is less certain, but they still suggest a sort of Rorschach test incorporating common objects instead of inkblots. Both here and in her 1970s work Callis demonstrates that the seemingly straightforward photograph need not be based primarily on formal terms, but on implication. Callis's images demanded a different kind of aesthetic criteria. In the cinematic overtones of her earlier images, with their sense of artifice and suggestion of narrative, she anticipates an approach that would become explicit in Cindy Sherman's photographs of the 1980s.

In her "Expedition Series," begun in 1976, Ruth Thorne-Thomsen alludes to landmark nineteenth-century photographs from the era when the medium was first explored, but transforms these stylistic references into intimate visions of unlikely imaginary scenes. Her sepia prints, made with a pin-

hole camera, seem to record fantastic lands and remnants of vanished civilizations. The artifice of her images is tempered by their mimicry and evocation of a revered tradition in the photography of an important historical period. With the pinhole camera's great depth of field, Thorne-Thomsen can cleverly juxtapose scale—objects in the near foreground and in the far distance appear equally in forms, with consequent distortions of the viewer's perception of their size. The presence of such elements as men in suits, or late-twentieth-century buildings, grounds the photographs in the real, creating unsettling rifts with the equal evidence of their representational impossibility. The pared-down settings, often set along the shore, recall Giorgio de Chirico's haunting views. The soft focus and warm tonality reinforce the dreamlike mood of the passages Thorne-Thomsen has constructed; once again, these are enormously private visions that use bits of reality suggestively to fabricate a false world.

The heritage of the early Surrealists is unmistakably evident in the complex tableaux of Joel-Peter Witkin. His disturbing photographs are easily dismissed for their repellent subject matter and sexual explicitness, but they actually capture the same perversity and chamber-of-horrors quality of the Surrealism of half a century ago, although they render it more convincingly disturbing. Eroticism was a central theme for the Surrealists—"We will reduce art to its simplest expression which is love," one manifesto claimed[40]—and Witkin combines the erotic and the morbid in his photographs, which continually evoke the taboo, the forbidden. They describe a world like that of Federico Fellini's film *Satyricon* (1969),[41] at once satanic and horrifying. It is a latter-day Boschian purgatory of corpses, fetuses, corpulent women, animals, hermaphrodites, and sexual paraphernalia, all proffering a contemporary rather than a mythological damnation.

Witkin himself has provided a clear statement of his sincerity in addressing such subject matter. For him it is not simply gratuitous grotesquerie:

> I guess I've come to realize that there's a form of beauty in everything. In every form there's a certain gracefulness. I've been thinking about the last trial of St. Francis of Assisi. He had this terrible fear of lepers, and one morning he was walking down the road and saw the most grotesque leper. And he knew, to get beyond the leper's stench, to get beyond the knowledge of the certain, eventual, sickening demise of his own flesh, he knew that he had to kiss that leper on his spongy, pus-filled lips. And at the instant St. Francis kissed him the leper turned into Christ.[42]

Witkin admits the difficulty of the assignment he has taken on, but he confronts his own fears and doubts and continues his examination of a sordid sphere of life. His photographs have emerged over a fifteen-year period, steadily becoming more complex, challenging, and intellectually engaging. Religious themes recur in his imagery; indeed, his work shows a strong allegorical trend,[43] with a frequent inclusion of Judeo-Christian iconography. These symbolically rich pictures are also informed by painting; *Expulsion from Paradise of Adam and Eve* (1984), for example, recalls Masaccio's *Ex-*

pulsion of Adam and Eve (1427) in the Brancacci Chapel in Florence.[44] Not surprisingly, one also finds the nineteenth-century Belgian artist Félicien Rops among Witkin's influences.

Witkin's photographs suggest rather definite narratives, permutations of ancient stories through the workings of a dark imagination. The brutality of his compositions is matched by his rough manipulation of his negatives, almost as if they were to be punished for the vision they carried; the obliterated backgrounds, deliberately vignetted edges, chemical spills, and scratch marks that characterize his carefully staged images, contribute to their sense of the fantastic. A warm tonality and softened focus partially mitigate the contemporaneity of the scenes, adding a patina of age that paradoxically increases their authority. Even the most innocent of Witkin's tableaux suggest a highly charged sexuality and latent violence, if only through their association with and similarity to his more explicit images. To dismiss them because of their controversial nature, however, is to underestimate their weight, and the challenge they offer in their provocative blend of artifice and reality. Witkin looks within himself and humanity to present a realm of memory, fantasy, and nightmare.

Mystery, but of a wholly different kind, is the essence of Susan Rankaitis's monumental photographic monoprints. With their dark, brooding planes of black and brown, her seven- to ten-foot-long sheets have a shimmering luminescence, which derives from the manipulations through which she achieves richly metallic colors out of black-and-white materials. Admittedly influenced by Surrealism, Rankaitis uses the photogram technique, contact images, positive and negative elements, and solarization to create her abstractions. The dense black backgrounds further support the timeless, changing, dreamlike atmosphere of her work, its shifting of imagery from register to register. Rankaitis's dense montages are actually a hybrid of painting and photography; they conjoin painterly abstraction with technological and microfiche images to form a curious mixture of specific content and formalist design. These dichotomies further reflect the dichotomy between modern life and existential enigma, a fundamental concern of the artist's. The shifting scale, the absence of a literal reality, and the painterly use of tone and light in her work make these enormous pieces quite evocative.

The various works discussed above recode visual information in a way that draws less upon the American photographic heritage of formalism and humanism than upon the traditions of art forms—literature, film—that have not felt obligated simply to represent fact. In these works, imagination and fantasy have given rise to artifice, freeing the photograph from its functional role as a documentary record and allowing it to investigate conceptual, abstract, or metaphoric possibilities. This change from explicit to implicit description has enabled the photographer to operate more suggestively, and even to exploit viewers' expectations of empirical accuracy. The attention to nature and the social landscape has been expunged in favor of an interior personal vision. — K.M.G.

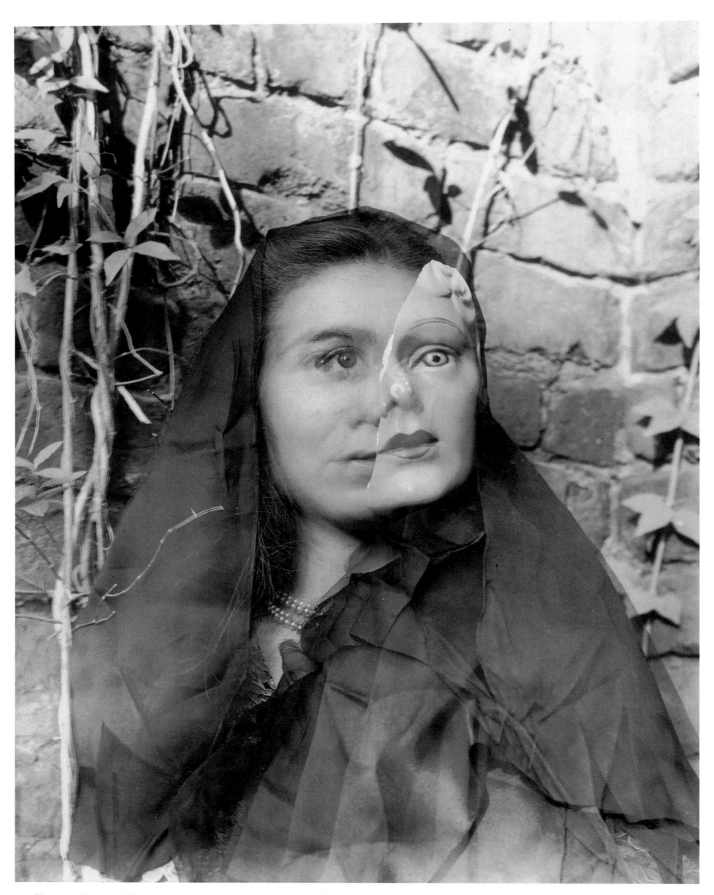

Clarence John Laughlin
The Masks Grow to Us. 1947
Gelatin-silver print, 13½ x 10¼ in.
Los Angeles County Museum of Art, Ralph M. Parsons Fund

66

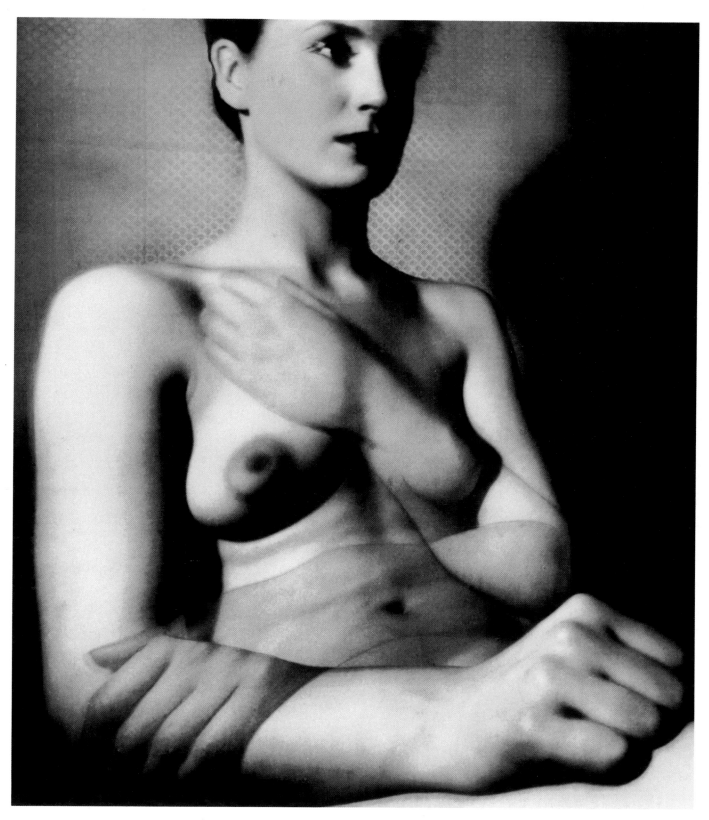

Bill Brandt
Nude, London. 1956
Gelatin-silver print
8¼ x 10¼ in.
Edwynn Houk Gallery, Chicago

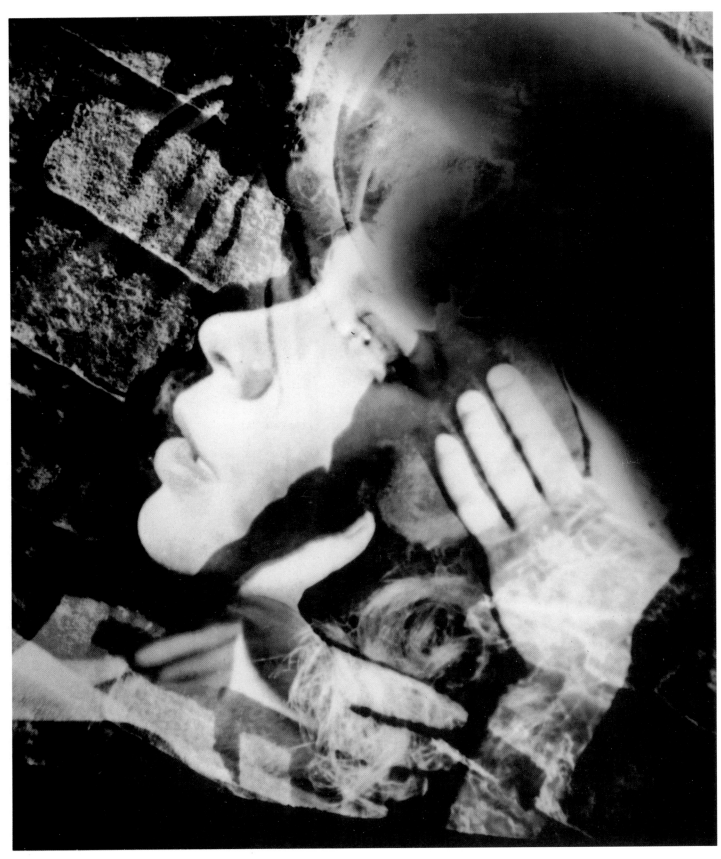

Val Telberg
Portrait of a Friend. ca. 1947
Unique gelatin-silver print
10⅞ x 9⅛
Los Angeles County Museum of Art

Frederick Sommer
Moon Culmination, 1951
Gelatin-silver print, 9⅝ x 7½ in.
Collection of Leland Rice

Nathan Lyons
Untitled. ca. 1959
Gelatin-silver print
7½ x 9⁷/₁₆ in.
Courtesy of Brent Sikkema, Vision Gallery, Boston

Walter Chappell
Burned Mirror, Denver, Colorado, 1956. 1956
Gelatin-silver print
10 x 8 in.
Collection of the artist

Carl Chiarenza
Untitled. 1964
Gelatin-silver print
9 x 13½ in.
Courtesy of Brent Sikkema, Vision Gallery, Boston

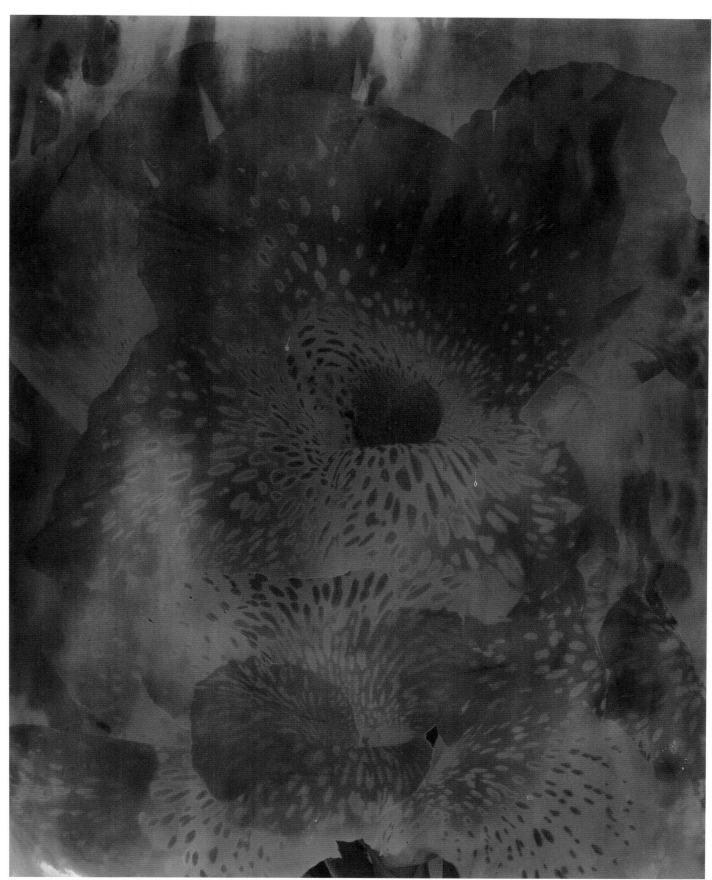

Edmund Teske
Untitled. 1962
Gelatin-silver print with duotone solarization, 13⅝ x 10¾ in.
Los Angeles County Museum of Art
Ralph M. Parsons Fund

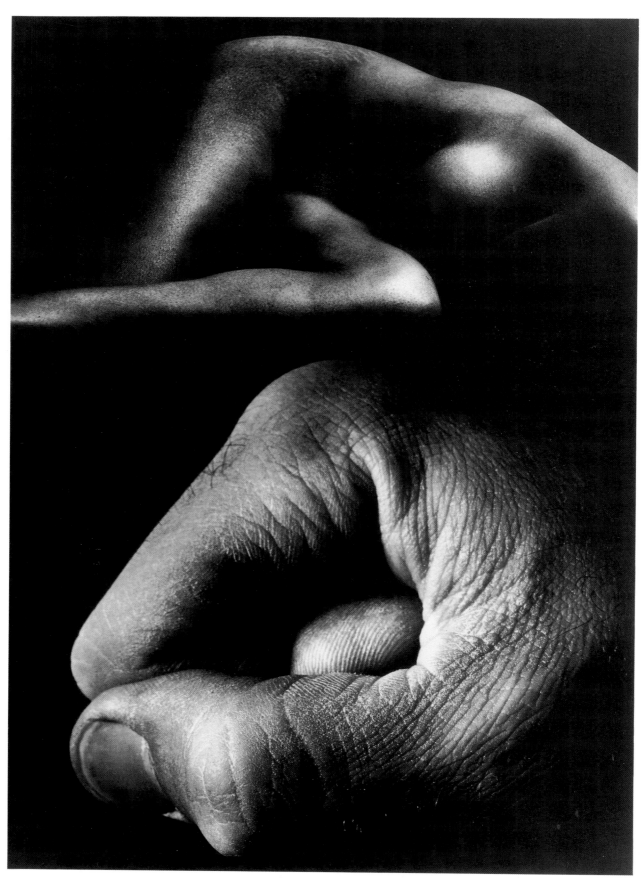

Jerry Uelsmann
Equivalent. 1964
Gelatin-silver print
11 x 14 in.
Courtesy of the Witkin Gallery, New York

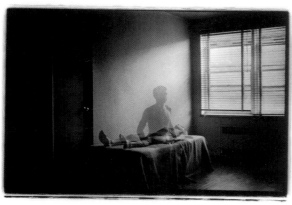

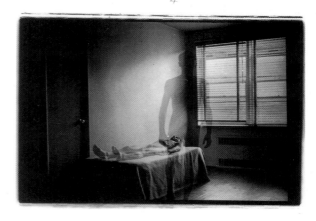

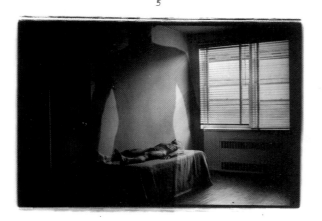

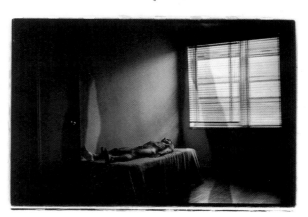

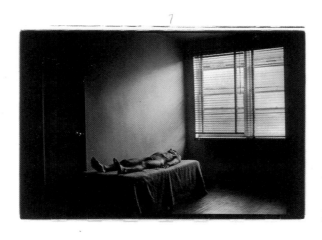

Duane Michals
The Spirit Leaves the Body. 1968
Seven gelatin-silver prints in sequence
3¼ x 5 in. each
Courtesy of the Sidney Janis Gallery, New York

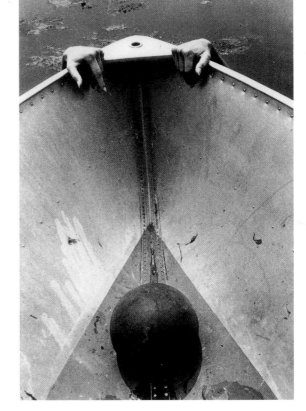

Ralph Gibson
Four untitled prints from "The Somnambulist." 1969
Gelatin-silver prints
Approx. 8 x 5 in. each
Collection of the artist

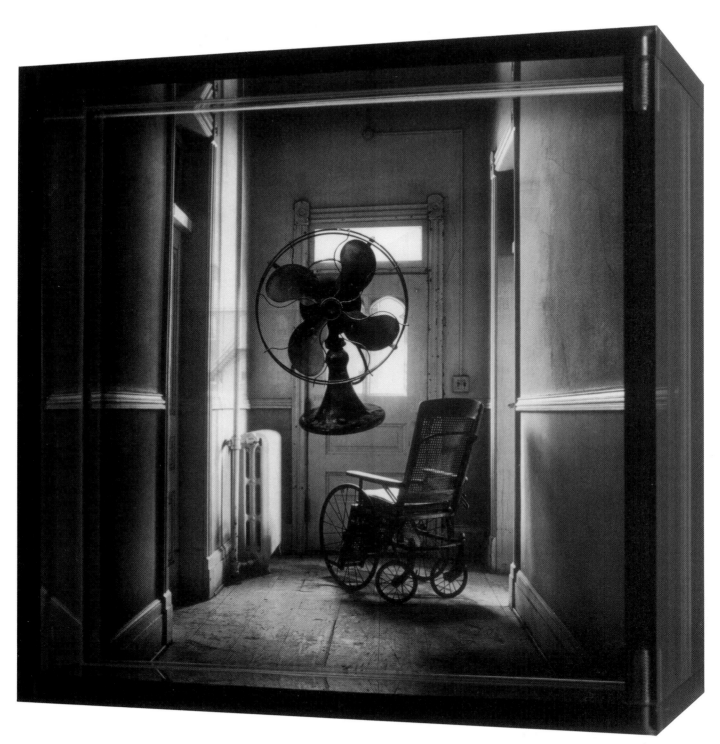

Doug Prince
Floating Fan. 1972
Acrylic plastic and gelatin-silver print on graphic arts film
8 x 8 x 3½ in.
Collection of the artist

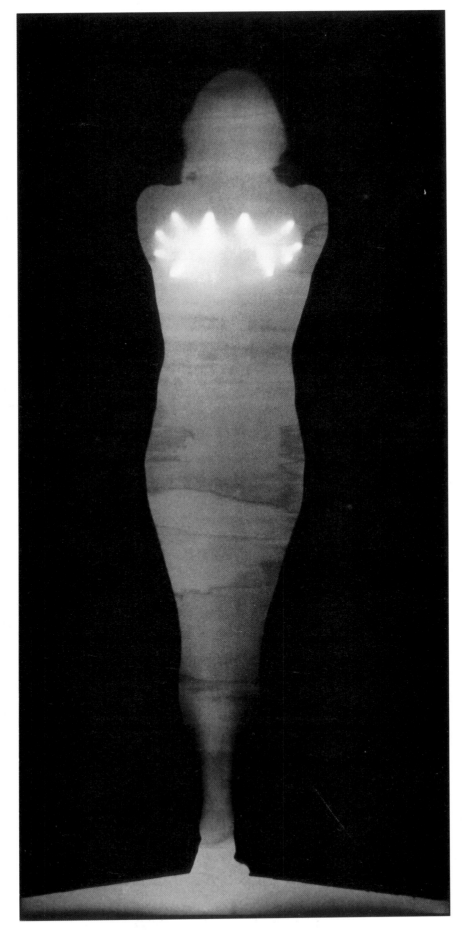

Bruce Conner
Starfinger Angel. 1975
Gelatin-silver photogram
85 x 39 in.
Courtesy of Fraenkel Gallery,
San Francisco

3.

Popular Culture, Pop Art

In writing about Kurt Schwitters from the perspective of the 1960s, John Coplans and Walter Hopps remarked:

> Two innovations are central to advanced art in the twentieth century: first, the introduction of nonobjective or purely abstract imagery; and second, a revolutionary approach to the use of artistic materials and media.[1]

Photography is implicated in both these developments. Painting's turn away from representation coincided with the camera's increasing presence on the scene. In the mid-nineteenth century photography relieved art of its narrative, expository function, and in doing so allowed painting, under the influence of other historical pressures, to abandon (if only briefly) representation.

With the Impressionists, painting began to divorce itself from the material reality of what it represented; the effects of light, then of paint itself, became the painter's subject. The Cubist, Futurist, and Constructivist painters of this century began to actively fracture observable reality, to try to discover an underlying geometry within everyday appearances. At the same time, however, photography's increasing presence in the world, primarily in the form of photomechanical reproduction, made it progressively more difficult for the realm of "advanced art" to ignore it. As Walter Benjamin foresaw in his 1936 essay "The Work of Art in the Age of Mechanical Reproduction," photography already was changing the very basis on which objects were judged to be art:

> Works of art are received and valued on different planes. Two polar types stand out: with one, the accent is on cult value; with the other, on the exhibition value of the work. . . . With the different methods of technical reproduction of a work of art, its fitness for exhibition increased to such an extent that the quantitative shift between its two poles turned into a qualitative transformation of its nature. This is comparable to the situation of the work of art in prehistoric times when, by the absolute emphasis on its

cult value, it was, first and foremost, an instrument of magic. Only later did it come to be recognized as a work of art. In the same way today, by the absolute emphasis on its exhibition value the work of art becomes a creation with entirely new functions, among which the one we are conscious of, the artistic function, later may be recognized as incidental. This much is certain: today photography and the film are the most serviceable exemplifications of this new function.[2]

One consequence of photomechanical reproduction, Benjamin notes, is that originality and authenticity become problematic: "that which withers in the age of mechanical reproduction is the aura of the work of art."

The twentieth-century artist's impulse to expand beyond the prevailing nineteenth-century fine-art mediums—painting on canvas, sculpture in stone and metals—can be seen as an accommodation to the growing dominion of the photographic image in Western culture. What Coplans and Hopps refer to as "the crisis in media" of twentieth-century art—the demolition of the traditional hierarchy of artistic materials—began with the *papiers collés* of Cubists Pablo Picasso and Georges Braque and was continued by artists allied with Dada, Constructivism, de Stijl, and Surrealism. Kurt Schwitters, Max Ernst, Marcel Duchamp, Hannah Höch, John Heartfield, László Moholy-Nagy, Man Ray—these artists and many others incorporated the photographic image into collages, assemblages, and montages.[3] Although critics focused at the time on the insignificance of the materials employed, this kind of art is equally important for introducing "given" visual information—information provided automatically by photography and photomechanical reproduction—into the vocabulary of twentieth-century art.

In the years following World War II, however, the role of photography in the avant-garde art of the 1920s and 1930s was largely ignored, purged by the tenets of a modernist criticism that stressed purity and independence of mediums, by an aesthetic urge to reassert the spiritual values of abstraction, and by a culture now bent on reasserting the primacy of the individual following wartime depersonalization. The psychological trauma of the war experience, together with the strict regimentation military organization required, no doubt fueled the desire for an aesthetic in which the individual, in the form of the artist, could communicate matters of the spirit directly, purely, and without the mediation of culture. The critical and cultural environment that allowed Abstract Expressionism to flourish in the 1940s and 1950s repressed the already pervasive visual presence of photography, at least as far as fine art was concerned. And it repressed the photograph because it sought to eliminate any reference to the world itself, to the textures and imperfections of everyday life.

It was more than a minor interruption, then, when in 1955 Robert Rauschenberg first exhibited works that he called "combines." These hybrids of painting and sculpture incorporated such disparate items as furniture, tires, a stuffed goat, and both actual photographs and photographic reproductions. By adopting the Surrealists' interest in collage and assemblage, and using ob-

jects and images far removed from the refined tastes of the art world, Rauschenberg opened the gates for a new, inclusive aesthetic that would embrace the manifestations and contradictions of everyday, commonplace culture—including the omnipresent photograph. Critic Lawrence Alloway has called it "an aesthetic of heterogeneity."[4]

Photography makes an even more marked appearance in the silkscreen paintings Rauschenberg began to make in 1962. Using "found" images or his own photographs (he had been taking pictures since his days at Black Mountain College in North Carolina, another Bauhaus-émigré outpost), transferring them to photosensitized silkscreens, and then inking them onto canvas, he created overlapping layers of visual information, some of it strongly symbolic and some simply suggestive. In Rauschenberg's 1963 painting *Junction,* for example, images as diverse and enigmatic as a weather gauge and a football share the picture plane, and he makes no attempt to disguise the montaged nature of its construction. Each element is, as Alloway points out, "an instantly delivered image, speedily made as whole and full as an object in a collage, but susceptible to nuances of painterly pressure."

During the 1960s, Rauschenberg also extended his embrace of the "ready-made" photographic image to include direct transfers, in which he rubbed published images onto paper using a pencil, and lithographic prints. *Booster* (1967) shows Rauschenberg's virtuosity as a printmaker—it incorporates silkscreen and a two-stone color lithograph—as well as his penchant for combining and recombining images. Other than the dominant image, a full-length X-ray of the artist himself, the imagery in the print can be found in his *Test Stone* lithographs, which served as preliminary studies for *Booster.* While *Booster* shows Rauschenberg at his most personal (he is, after all, transparent in the image), a print like *Landmark* (1968) suggests that he also was interested in photographs as conveyers of charged, political information—as indices of contemporary culture.

Rauschenberg's reliance on the photographic image marked a significant shift in postwar art—one that would prove to have far-reaching and unforeseen consequences. As Douglas Crimp has written, looking back from the perspective of the 1980s:

> While it was only with slight discomfort that Rauschenberg was called a painter throughout the first decade of his career, when he systematically embraced photographic images in the early 60s it became less and less possible to think of his work as *painting.* It was instead a hybrid form of *printing.* Rauschenberg had moved definitively from techniques of *production* (combines, assemblages) to techniques of *reproduction* (silkscreens, transfer drawings). And it is this move that requires us to think of Rauschenberg's art as postmodernist. Through reproductive technology postmodernist art dispenses with the aura. The fantasy of the created subject gives way to the frank confiscation, quotation, excerptation, accumulation, and repetition of already existing images. Notions of originality, authenticity, and presence, essential to the ordered discourse of the museum, are undermined.[5]

At almost the same time, the Pop artist Andy Warhol began to use the silkscreen technique to reproduce borrowed or "appropriated" images in his paintings. Beginning in 1960 Warhol had begun to paint pictures closely based on images from advertising and cartoons. His famous "Campbell's Soup Cans" series, which in the public eye came to symbolize Pop Art, were painted by hand, despite their assembly-line look.[6] But in late 1962 he adopted the photo-silkscreen technique, which led him more directly into the realm of the photograph. Among the earliest and most impressive pictures made by this method are the "Disaster Paintings" of 1963. To make them, Warhol culled from newspapers pictures that combined tabloid sensationalism and a distanced, almost distracted sense of loss, enlarged them, and repeated them on large canvases. This serial technique, which would become a hallmark of Warhol's painting throughout the 1960s, manages both to magnify the disaster and to disperse it: through repetition it loses some of its horror. At the same time his use of repetition comments on the photographic image's proliferation as well as its inadequacies. It is as if Warhol set out to demonstrate what Walter Benjamin had said about the loss of aura in the age of mechanical reproduction.

Rauschenberg and Warhol were not alone in trying to incorporate into their art the photographic manifestations of American culture. On the West Coast, in 1957, the assemblage artist Wallace Berman exhibited a series of furniture-like pieces that incorporated photographic images at the influential Ferus Gallery. (These pieces were destroyed shortly after being exhibited.)[7] After a hiatus in his career, Berman returned to photographic images in a series of collages made from Verifax materials.

Throughout the 1960s, Los Angeles artist Ed Ruscha was engaged in publishing a series of artists' books that make use of the photograph's deadpan, documentary appearance. In *Twenty-Six Gasoline Stations* (1962), *Various Small Fires and Milk* (1964), *Some Los Angeles Apartments* (1965), and *Every Building on the Sunset Strip* (1966), Ruscha catalogued the undistinguished landscape of southern California with an ironical Conceptualist wit. In part structuralist, systematic exercises that seem allied to the work of Sol LeWitt, Bernhard and Hilla Becher, and Hanne Darboven, and in part celebrations of the mundane in the spirit of Rauschenberg and Warhol, Ruscha's books depend on the apparent neutrality of the photograph, that is, on its seemingly uninflected, nonjudgmental transcription of visible reality. The pictures of gas stations in *Twenty-Six Gasoline Stations* are not meant to express the artist's interior life, or even to show evidence of an artistic eye; rather, they are simply to be read as elements in a conceptual game orchestrated by their maker.

Ruscha's bookworks anticipate the Conceptualist-based photography of the 1970s, and his treatment of the photograph—as a sign, like language, instead of as a picture, like a painting—marks a crucial and fundamental shift in the way photographs were perceived. Whereas a modernist like Minor White could remain committed to the idea that the art of photography lay in

its capacity to convey individual vision, to permit idiosyncratic expression, for an artist like Ruscha, with no commitment to the medium per se and with the example of Rauschenberg and Warhol in front of him, photographs became art only when they were used in the process of making art. Photographs attracted them not because of their expressiveness, but because of their mute, ineluctable objectivity. They were tokens of a world outside the narrow confines of the art world, and in the quest to break down the boundaries separating art and life—a quest that characterized the cultural life of the 1960s—photographs seemed to be radical instruments.

The art world of the 1960s was a much more complicated organism than a subsequent reading of the painting and sculpture of the period may suggest primarily because so much of the art of the decade lay outside the boundaries of those two mediums. Rauschenberg was more than just a painter/printmaker; he also designed sets for Merce Cunningham, produced and performed in experimental dances, and worked with engineers on combining art with new technology. Warhol was more than a Pop artist; he directed films such as *Blow Job* and *Empire* (both 1964), and ran The Factory, his own artists' space. Independent filmmakers, spearheaded by Jonas Mekas, tried to raise the artistic level of American film. With the arrival of portable video equipment in 1965, artists such as Nam June Paik began to refashion perceptions about the aesthetic potentials of the television set.

It was also a decade when art activity began to move out of the studio. Performance art required a performance space: Earth Art required the great outdoors. Even when working in their studios, some artists preferred to forsake traditional materials in favor of using their own physical presence, giving rise to body art. To document far-off or ephemeral activities, artists such as Michael Heizer, Dennis Oppenheim, and Robert Smithson employed photography as evidence, relying on its documentary quality to convey the appearance and intentions of their work to a large audience, as well as to document its very existence. For most of the art audience, the work's existence *depended* on photography: without photographs, much of it would have remained inaccessible or, like Yves Klein's famous leap out the window, invisible.

Heizer, Oppenheim, and Smithson all produced influential Earth Works in the late 1960s, and they all used photographs as adjuncts to their art. Heizer's 1970 photocollage *Circular Surface Planar Displacement Drawing, 90° Vertical Planar Rotary* is a two-dimensional analogue of his geometrically organized and rationally engineered incisions into the earth, the most well-known of which is *Double Negative,* executed in Nevada in 1969. It does not document an Earth Work, but serves as a working drawing or blueprint of one. Oppenheim's *Annual Rings* and *Transference of Weather Data onto Frozen River* (both 1968) are documents of the artist's hybrid Earth/Performance art pieces. Done with mowed grain, snow, and ice, the pieces themselves were quite temporary, but the records of them—which include site maps and text in addition to photographs—are permanent. In

Smithson's case, some photographs were meant to immortalize temporary, staged transformations of the environment; others were meant simply as records of major, and supposedly permanent, excavations. (Ironically, one of the latter, *Spiral Jetty* of 1970, has been inundated by the Great Salt Lake; the photographs of it now constitute the only means by which we can know it.) But even as records, some of the photographs of Smithson's Earth Art have an independent existence, since they show us the work from vantage points (e.g., aerial views) that were otherwise reserved for a privileged few.

All this activity, and the critical attention to photography that it provoked,[8] had a profound influence on what was still a largely insular photography world. More important, it created new ways in which photographs could function as art. Instead of being restricted to the realm of the so-called photographic, with its reliance on form as a means of expression, they could interact with the ideas of the art world as a whole—from Duchampian gesture to Minimalist structure.

Rauschenberg's influence extended far beyond his technique of collaging images through printing; it was his *attitude* toward the photograph that made him such a liberating force for photographers. For him the photograph was simply an image—one loaded with personal, political, and aesthetic significance, to be sure—but an image all the same. Thus he felt no compunction about cropping it, enlarging it, reusing it, reversing it, converting it into grist for his own mill. It did not even matter to him that the image came from his own camera; a certain democracy of the image prevails in his work.

Rauschenberg's example, together with that of Warhol, helped usher in a great period of photographic experimentation, one in which the concerns of collage and the techniques of printmaking became vital to the photography community. In Los Angeles Robert Heinecken, Robert Fichter, and Todd Walker extended photography into the arena of printmaking and, as teachers, introduced these new possibilities to their students. On the East Coast the photographers Syl Labrot, Naomi Savage, and John Wood, among others, became committed to printmaking technologies, and to the notion of their art as a process of image manipulation and transformation. Coupled to the simultaneous growth of photography programs within academia, this conception of the medium was to become integral to the experimental art photography of the late 1960s and early 1970s.

Rauschenberg's influence was felt in less obvious ways as well. At the time he began incorporating photographs into his work, there was no commercially viable gallery devoted to photography in the United States, nor did there exist the marketplace of dealers, collectors, and promoters that has now been established. Thus, outside the precincts of some pioneering museums, photographs were not often viewed in the same terms as paintings and sculpture. Most photographs were hand-held, intimate objects. But Rauschen-

berg's combine paintings and prints, in which photographic reproductions are embedded, were large, gallery-sized works, made to "hold" the wall.

One can see in such photographic works as Ray K. Metzker's "Composites" of the mid-1960s a response to the challenge of "holding" the wall in a gallery environment. While distinct from Rauschenberg in his commitment to formalist photography, Metzker shares with him an educational background rooted in Bauhaus precedent (Metzker at the Institute of Design, Rauschenberg at Black Mountain College), and a commitment to experimentation and intuition. His large-scale "Composites," like Rauschenberg's silkscreen paintings, combine multiple images on a single field, often blurring their content by overlapping them. Metzker, however, was scrupulous in using only images he himself had made, and he has restricted his palette to black and white.

Today large-scale pictures are an increasing presence wherever photographs are displayed as art. The new attitude does not apply to size alone, however, as Marvin Heiferman pointed out in an essay accompanying his 1986 exhibition "The Real Big Picture":

> To simply inscribe visual information, a small photographic print does the job elegantly. One learns to read a photograph—to identify subject matter, to discern formal structure, to value craft, to appreciate the art of photography. One becomes a connoisseur of the image. But the more intriguing aspect of photography is not the fetishized print but the latitude of usage and taste that the medium encourages and allows.

Finally, and perhaps most important in light of subsequent trends, Rauschenberg's appropriation of images dealing with popular-culture icons, like that of the Pop artists, helped photographers to view the entire image universe as part of their inheritance and domain. Where before, under the dictates of Stieglitzian modernism, one could claim an image as one's own only if it had never been seen before, it now became possible to make pictures by using pictures. Robert Heinecken's 1964–68 portfolio of twenty-five offset prints called "Are You Rea" is an inventive and early example of this new procedure. Each plate was made directly from a magazine page; the resulting print shows the reproductions and texts from both sides of the page, the overlapping information providing irony and humor.

The 1960s penchant for images of popular culture, and the "borrowing" of them for the purposes of art, corresponds to a surprising degree with the preoccupations of postmodernist art in the 1980s. This art rejects, and to an extent criticizes, modernism's faith in originality, in the independence and self-sufficiency of form, and in the artist as a heroic figure outside the boundaries of his or her society. Moreover, postmodernist art rejects the modernist distinction between "high culture" and popular culture, and between "high art" mediums such as painting and sculpture and less exalted visual materials such as photographs. Thus Rauschenberg's early work is viewed today by critics such as Crimp as a precursor of current attitudes toward images and their

role in the social fabric. But we need to remember that Rauschenberg's reliance on the photographic image was unique for only a short time. What is remarkable is how quickly the influence of photographs became acknowledged, after years of repression, once the ice was broken. The new forms and practices that had developed at the decade's end and carried over into the 1970s—labeled, with pluralistic zest, with such names as Earth Art, body art, narrative art, performance art, systems art, Conceptual Art—all relied, to greater or lesser degree, on photography, and all employed it without prejudice.

At the same time, ironically, photography was entering the art marketplace on its own, fueled by the modernist momentum provided by Stieglitz and Moholy-Nagy. Thus many artists were exposed for the first time to "fine art" photography, and discovered the tantalizing conundrums of photographic representation for themselves. This interest in the medium, which like independent film and video was a newcomer to the art world, contributed to its use within the various practices that grew up in opposition to painting.

Nevertheless, throughout the 1960s and early 1970s a clear distinction between what was art and what was "merely" photography remained in force, much to the detriment of photography. Rauschenberg and Warhol, whose medium by this time was essentially a kind of photo-derived printmaking, continued to be known as painters. This was not due to any motive on their part but is simply evidence that the art world remained entrenched in the traditional notion of painting's superiority. In terms of the popular and critical mainstream of the 1960s, painting remained in the central position—whether the overriding presence of photography in the visual universe was excluded, as it was in geometric abstraction and Minimalism, or acknowledged, as it was in Pop Art and in Photorealist painting.

The appearance of the style known as Photorealism in the late 1960s was the most problematic and irony-laden manifestation of the valuation of painting over the photographic image in the art world. Photorealist painters such as Chuck Close, Richard Estes, and Audrey Flack were enchanted by the lenticular and specular effects of photographs, and their spotless, intricately rendered works were based on photographs—in Close's case, the photograph served as a miniature template for the paintings. But despite such a total dependency on photographic appearances, the Photorealists insisted on the primacy of paint, rejecting the unmediated photograph as somehow beneath art. The only Photorealist willing to embrace photography in its primary state has been Chuck Close, who has used the large-format Polaroid studio camera as a means for producing larger-than-life multi-image portraits.

Photorealist painting managed to grate the nerves of both nonrealist painters and photographers. The painters felt this work was too compromised by the photographic image: it was insufficiently inflected despite the presence of abstract passages in store-window reflections and automobile hubcaps. Photographers felt Photorealist work was yet another way to retain the hierarchy of painting first and photography last. Minimalists such as Donald Judd and

Dan Flavin favored a neater solution: they rejected not only photography but also images as a class, preferring sculpture to painting, spatial manipulation and "object-ness" to two-dimensional representation. For a while the Minimalists, with their puritanical style and critical theorizing, were able to suppress the liberating effects of art that acknowledged photographic representation. But their own reductiveness, and a mounting antagonism toward the art marketplace, created the impetus for a new kind of art—an art of ideas, one in which photographs would finally be allowed entrance to the art world in their innocent, unaltered state. — A.G.

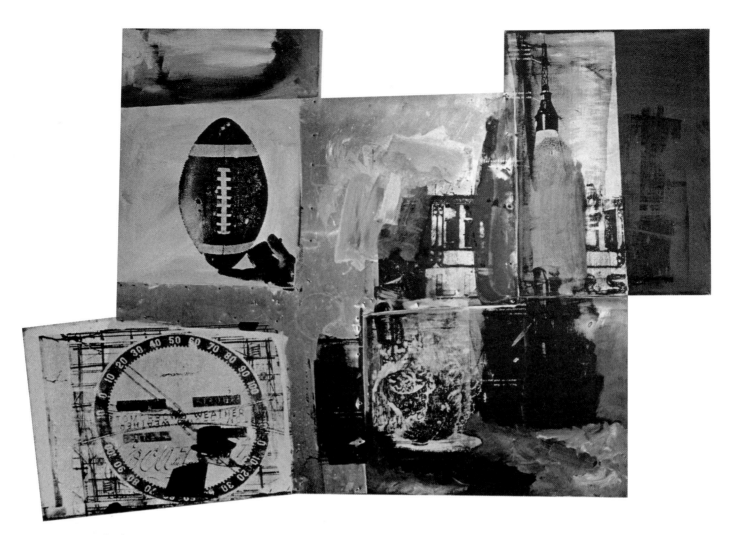

Robert Rauschenberg
Junction. 1963
Oil and silkscreen ink on metal and canvas
45½ x 61½ in.
Collection of Christopher Rauschenberg

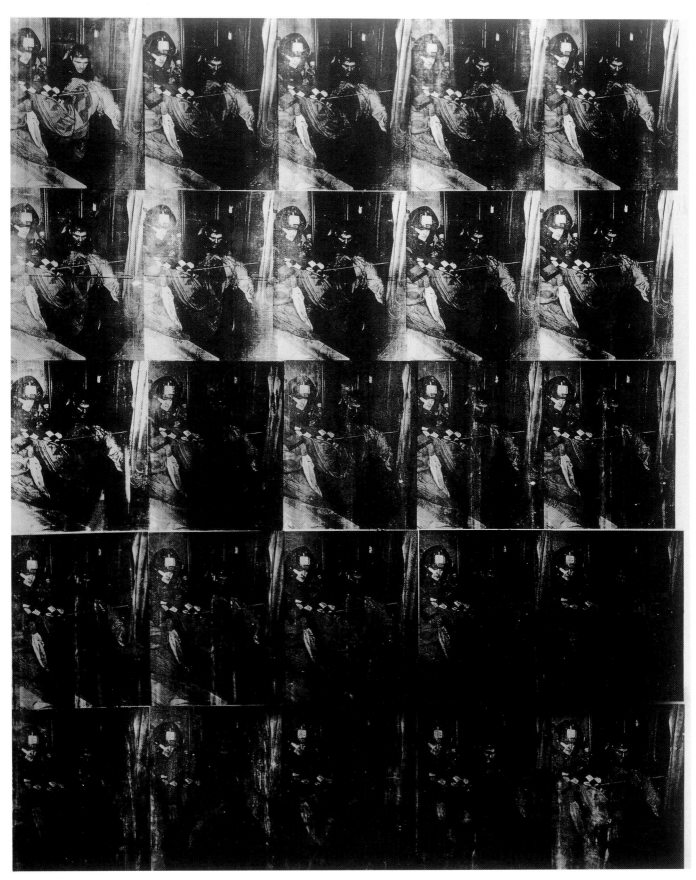

Andy Warhol
Black and White Disaster. 1962
Acrylic and silkscreen enamel on canvas
96 x 72 in.
Los Angeles County Museum of Art

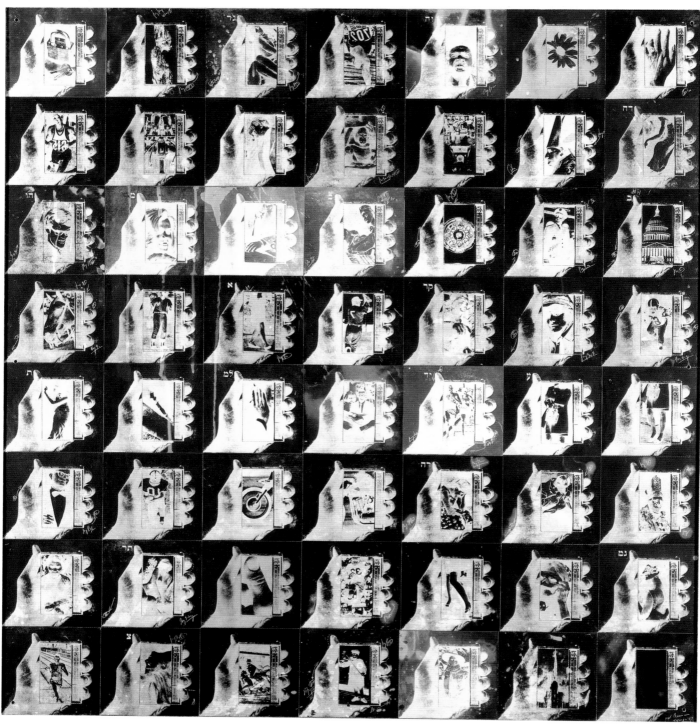

Wallace Berman
Untitled. 1957
Verifax collage mounted on plywood
48 x 45 in.
Los Angeles County Museum of Art
Gift of the Kleiner Foundation

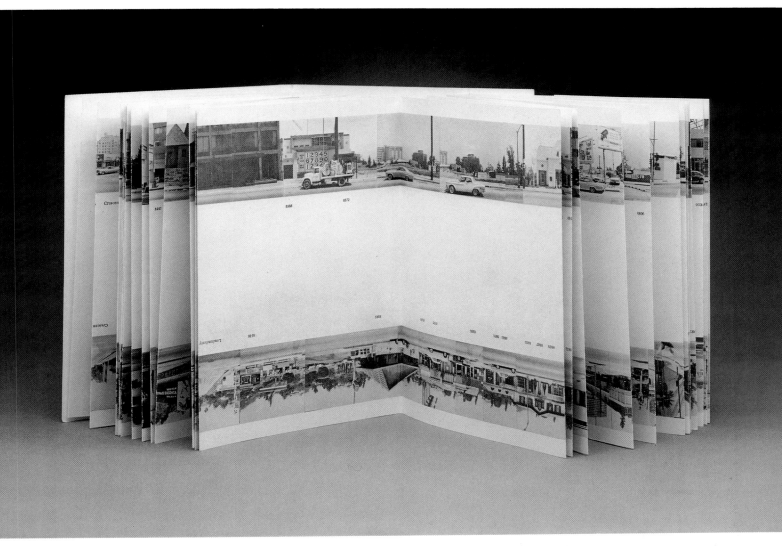

Ed Ruscha
Every Building on the Sunset Strip. 1966
Accordion-folded sheet, two strips of lithographs, softcover
7⅛ x 460⅝ in.
Los Angeles County Museum of Art

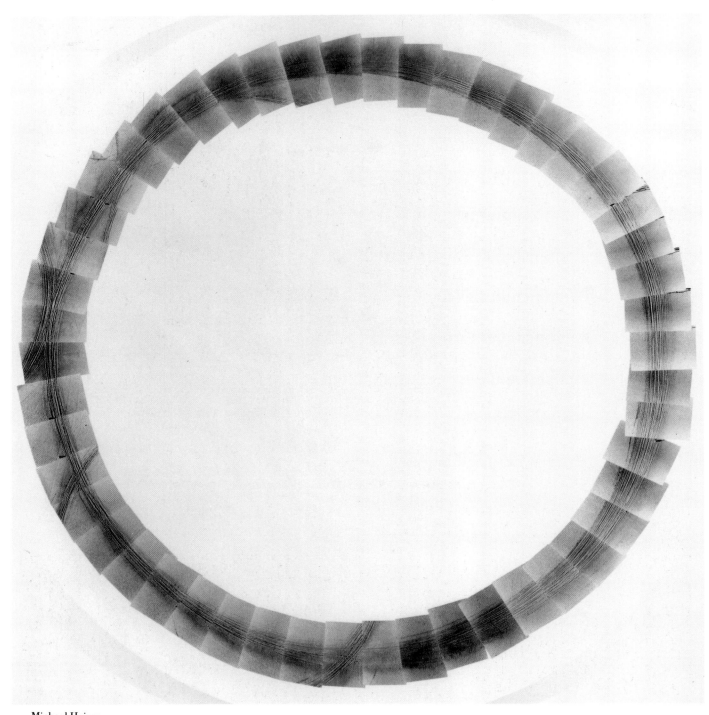

Michael Heizer
*Circular Surface Planar Displacement Drawing 90°/Vertical Planar
 Rotary.* 1970
Gelatin-silver print mounted on board
80½ in. diameter
Collection of the artist
Photograph in collaboration with Gianfranco Gorgoni

Dennis Oppenheim
Annual Rings. 1973
Gelatin-silver prints, electrostatic prints, maps, text on board, 40 x 30 in.
John Gibson, New York

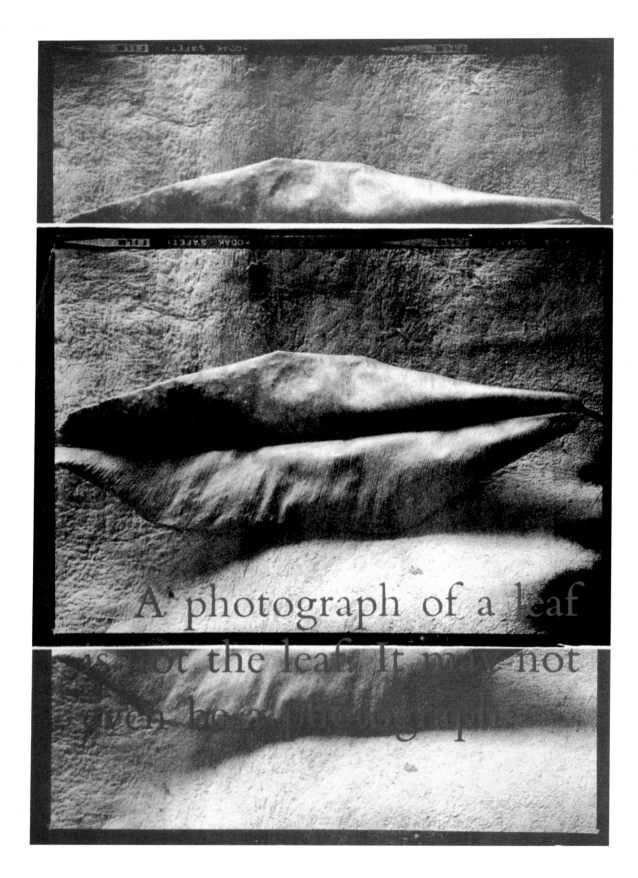

Todd Walker
A photograph of a leaf is not the leaf. It may not even be a photograph. 1971
Photo-silkscreen, 22⅜ x 15½ in.
Collection of the artist

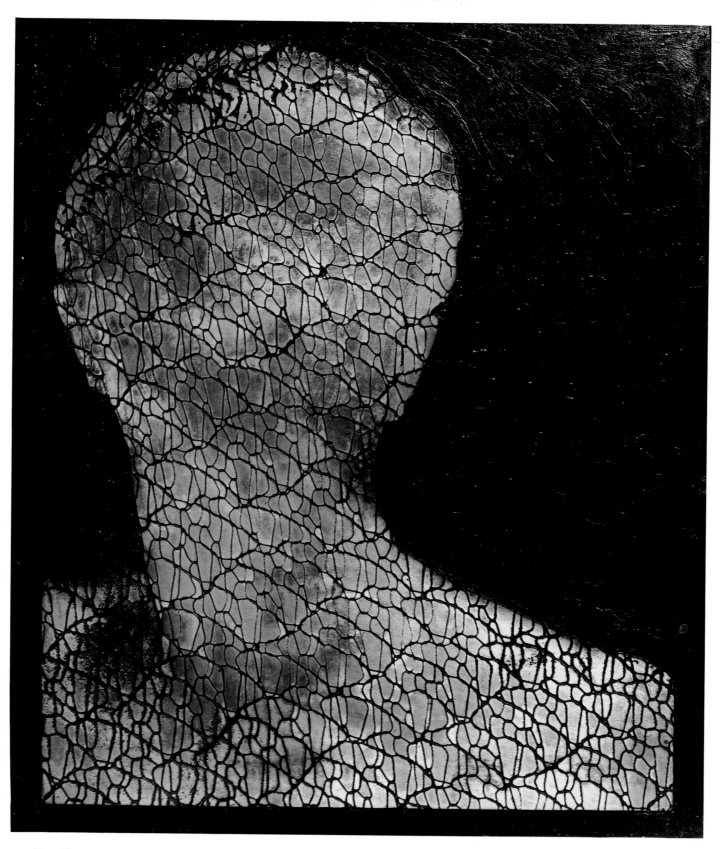

Naomi Savage
Enmeshed Man. 1972
Paint and tempera on copper-plated magnesium
70 x 55½ in. (framed)
Collection of the artist

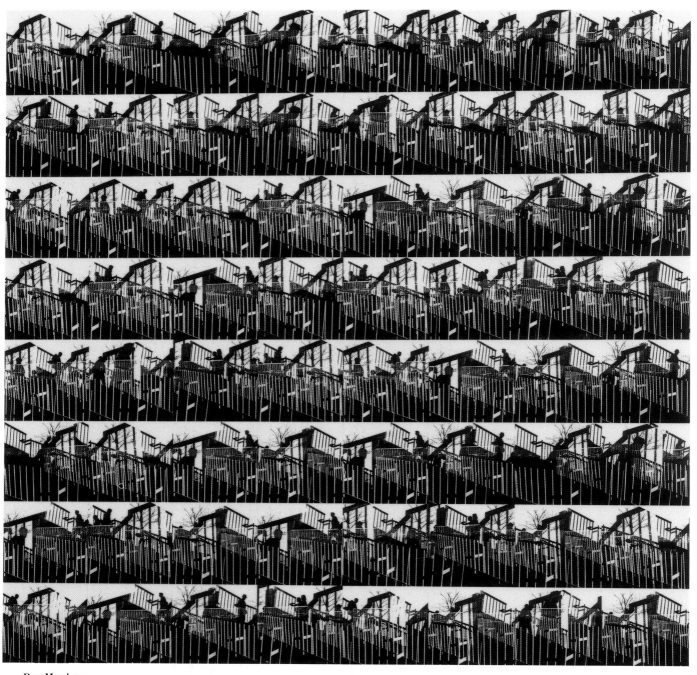

Ray Metzker
Penn Center. 1966
Gelatin-silver print
50 x 50 in. framed
Courtesy of the Laurence Miller Gallery, New York

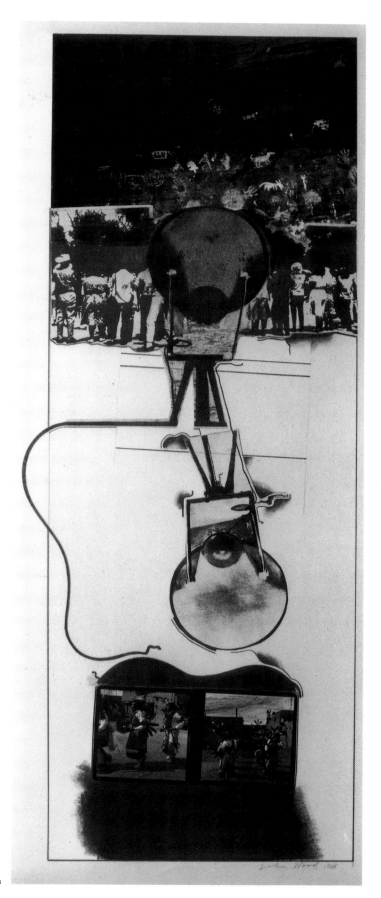

John Wood
A Summer Transmission. 1968
Mixed-media, gelatin-silver print, collage,
and marking pen and pencil
21 x 7½ in.
Grunwald Center for the Graphic Arts
Frederick S. Wight Art Gallery, UCLA, Los Angeles

Kenneth Josephson
Postcard Visit, Buffalo. 1970
Gelatin-silver print and postcard
4¹/₁₈ x 6¼ in.
Courtesy of the artist and Rhona Hoffman Gallery, Chicago

4.

Breaking the Mold:
Experiments in Technique and Process

The photographic tradition of lyrical, poetic images based on evocative abstractions, printed in deep, rich blacks and fine grays, was of diminishing interest to many of the artists emerging in the 1960s. Their pictures were less concerned with the purely "photographic" than those of their predecessors, and they had shockingly less allegiance to the gelatin-silver print, with its attendant demand for fastidious precision. Such prints had until then been considered *the* medium of the photograph; in the 1960s photographers began to seek new means, new technologies. At the same time, formal abstraction was subordinated to a search for new visual vocabularies. This shift was not motivated by a desire for social comment, but grew in large measure from these artists' training in art. They represented a break with previous generations of photographers whose background was more technical than artistic. In parallel with the search for new means in art beyond the flat canvas and other traditional mediums, a search that led to video, Earth Works, Performance Art, and so on, photographers also looked to radical new processes and materials to express themselves. Thus the change that photography underwent during the 1960s and early 1970s concerned the nature of the medium itself.

This change was equally aesthetic, however. Increasingly supported by photographers in leadership roles,[1] men and women entering the field in the 1960s subverted the tradition of allegiance to a single, even exclusionist, stylistic approach and heritage. If new visual languages had already been introduced to photography during the preceding years, the medium was to be subjected to even more radical visual developments during the 1960s, developments that offered entirely fresh and far-reaching modes of visual syntax and structure. The investigations of both formal abstraction and of a spiritual basis for imagery in earlier decades had run parallel to similar searches in painting, but now the paths of photography and art began to converge.

Through its inclusion in the Pop Art lexicon, photography assumed a novel and prominent position in art. This inclusion not only granted it an unprecedented status as a medium for artistic exploration, but, more important,

involved a recognition of the photograph as a seminal source of visual imagery for our times. The camera image came to be perceived as a cultural bell-wether, as a visual encapsulation of the zeitgeist. Photography curricula began to appear in art schools and university art departments.[2] Once the medium was situated in an art context, its traditional record-making mode no longer seemed sufficient, and it was subjected to an intellectual scrutiny that required it to progress beyond the accomplishments of the past. The aesthetic formulas that had gained currency during the 1950s underwent an abrupt expansion. In contrast to that decade's heroic, personal, inner visions, or to its schematized formal abstractions, the photography of the 1960s introduced a pedestrian, even genre imagery, utterly profane in comparison to the preceding styles, and set in motion a controversy as intense as the one that Pop Art had engendered in painting. Just as Pop Art undermined the acceptance painting had achieved through seriousness and decorum, the new, casual, somewhat rough photographic processes and images threatened to make a mockery of all that the preceding refined, sublime work had attained.

Black and white, as Robert Frank said in the 1950s, were the colors of photography. They had become dogmatically defined as the only appropriate means of photographic representation, and indeed they were well suited to the reserved yet stark existential inquiries of photographers like Frank or Minor White. Up through the 1950s, the use of color in photography was chiefly confined to limited experiments and to commercial applications. Moreover, color processes were somewhat suspect as vehicles for serious work, in part because of their technical difficulty, which limited the individual photographer's control over the developing process. There was also an aesthetic objection. Black and white had a certain power to abstract the subject, minimizing its ordinary identity and liberating the composition for a more general and poetic reading; through their directness in replicating the subject, most attempts at color compromised this possibility.

In part, the process of silver-based, black-and-white photography had prevailed so completely simply because of the standardization and availability of mass-produced materials. Other photographic methods such as carbon, platinum, bromoil, bromide, and gum processes had long been abandoned in favor of the commercially successful gelatin-silver print. But in addition to their unavailability, virtually all of these earlier processes had been soundly proscribed by modernists. They had been dismissed as pictorial misadventures of the antique age before photography found its true form in the crisp, precise, gelatin-silver print. In consequence, through the 1950s serious photographs were virtually always black, white, and gray. It is also worthwhile to recall that until as late as the 1970s they were generally small—commonly printed on eight-by-ten-inch or eleven-by-fourteen-inch paper, with occasional enlargements to sixteen-by-twenty inches. Small prints were practical in that there was no real market for photography, and their low price, assuming they were sold at all, precluded the production of more costly prints. But these pragmatic considerations had aesthetic analogues. Scale was intimate, and

was expected to be so. The desire for maximum detail and high resolution—in short, issues of craft and technique—virtually demanded contact printing, or only small enlargements.

The writings of modernist photographers had clearly articulated these aesthetic issues, and their dictates had largely become photographic dogma by mid-century. Charles Sheeler observed in 1939, "The difference in the manner of arrival at their destination—the painting being the result of a composite image and the photograph being the result of a single image—prevents these media from being competitive." For him, photography held the "possibility of accounting for the visual world with an exactitude not equaled by any other medium."[3] And in 1930 Edward Weston wrote, "Photography is too honest a medium, direct and uncompromising, to allow of subterfuge."[4] He spoke of the respect of painters for "photography *when it is photography* both in technique and viewpoint, when it does something they cannot do," and he went on to emphasize that there is only "contempt, and rightly so, when [a photograph] is an imitation painting." He opposed any kind of manipulation of the print: "no manual interference is allowed, nor desired in my way of working." Weston believed that "the camera . . . must have inherent qualities either different or greater than those of any other medium." Moreover, he had firm opinions on how the camera was to be used. "So the camera for me is best in close up . . . recording with its one searching eye the very quintessence of the thing itself rather than a mood of that thing." (He strongly opposed the pictorialist photographers, with their allegorical costume pieces and dizzy, out-of-focus blurs.) The most egregious offense was the pursuit of "painter-like results" because they were "so at variance with the real nature of the medium."[5] Weston has been considered the foremost photographer of the century, and his views on the aesthetic role of photography became extremely influential as the medium gained adherents and as his own position became established.

Ansel Adams also played a part in the codifying of the photograph, emphatically believing that straight photography, simple and unsullied, was the appropriate solution for the medium:

> I believe any "fussiness" only distracts from and weakens the
> print. I do not retouch or manipulate my prints because I believe
> in the importance of the direct optical and chemical image. . . . I
> use the legitimate controls of the medium only to augment the
> *photographic* effect.

The notion of a crossover of processes or aesthetics from other media was proscribed: "When a photograph has the 'feel' of an etching or a lithograph, or any other graphic medium, it is questionable—just as questionable as a painting that is photographic in character." Expression was acceptable, provided it was truthful to the aesthetic: "A great photograph is a full expression of what one feels about what is being photographed in the deepest sense, and is thereby a true expression of what one feels about life in its entirety," but "the expression of what one feels should be set forth in terms of simple

devotion to the medium."[6] For Adams, technical precision was key to the well-planned photograph. Certainly the spontaneous snapshot, or any techniques of post-exposure composition through darkroom procedures, were unacceptable, and the notion of any Dada humor, playfulness, or banality was abhorrent. "Precision and patience, and devotion to the capacities of the craft, are of supreme importance." Faithful factual representation of the real world was something of an issue of artistic honor with Adams, who stated, "I photograph truthfully."[7] In short, the medium was reserved and serious, maintaining a decorum appropriate to *art*.

The authority of these ideas was reinforced by an insufficiency of public debate over the medium. Books and magazines on photography have multiplied exponentially during the past decade, but through the 1960s they were still relatively rare. Principally because of the absence of other histories, Beaumont Newhall's *History of Photography* (first published in 1937 and revised in 1938, 1949, 1964, and recently in 1982) firmly established a preferred set of aesthetics and a canon of practitioners. *Aperture* magazine may have broadened the imagery of photography, but it favored a traditional approach in terms of means, emphasizing high-quality reproductions of straight, unmanipulated exposures. Yet in the early 1960s young photographers, and certain teachers such as Henry Holmes Smith, had become uncomfortable with these doctrinaire limitations in photography, and sought to break free from the rigidity and standardization of the medium by investigating alternatives to the domination of the black-and-white print. They believed that photography held a greater potential, but it had to be used more innovatively, going beyond both representation and the strange descriptions of the Surrealist's work. The obvious limitations of the black-and-white palette, and of the size of the print, were a concern: decisions and options of scale and color available to artists in other fields were closed to those working in photography. Photographers began to examine visual solutions from printmaking and painting with an eye to applying them in their own medium. There was increasing dissatisfaction with the gelatin-silver print as the sole ground for the photograph; the surface of the print was another preset component that might be varied, as was the very format of the square or rectangular image, which was determined by the perimeters and proportions of the negative. (The Purist tradition had demanded that one print the full negative, and extreme cropping was seen as a sign of inexpertise.)

In 1963 Art Sinsabaugh wrote, "Today can and should be the time for those interested in the visual images possible through photography to advance the quality of this imagery by turning back to the techniques of the past." More to the point, he suggested, "I appeal for a critical reevaluation of the discarded techniques of photography to enhance the images of the future."[8] This kind of curiosity about the unexplored possibilities of the medium, and about exchanges between it and other visual media such as painting and printmaking, was perceived by many as reflecting a disregard for the true traditions of photography. Yet more and more artists began to travel the ave-

nues it opened. Andy Warhol's and Robert Rauschenberg's explorations of the application of photo-emulsion to linen demonstrated the inventive potential of the photograph, and provided perhaps the most significant impetus to the medium's expansion in recent decades. The customary separation of different art forms was eroded as the photograph appeared in paintings, lithographs, and etchings. Influences moved in every direction, both from photography to art and the reverse. Photographers were quickly recognizing that exciting possibilities lay beyond black-and-white and gelatin-silver. A pivotal change in attitude was the focus on *photography* rather than on the *photograph,* for the photograph was fettered by tradition, while photography as a medium covered any kind of photographic imagery, and could accommodate great latitude.

As photographers moved away from the metaphoric abstract image and toward images more emblematic of contemporary American culture, a concomitant shift in presentation was required. The restrained, pristine aestheticism of the black-and-white print lacked the spontaneity and casualness necessary for contemporary, culturally oriented subject matter. Part of the solution came from experiments with the manipulation of negative and print, and from the line of development opened up by Warhol and Rauschenberg; another part came, as Sinsabaugh had suggested, from photography's own past and processes that had long been repudiated. In the nineteenth century, numerous methods of making photographic images had been explored, with varying degrees of commercial success. But beginning in the later part of the century the overwhelming effectiveness of the gelatin-silver print had gradually subordinated the other processes, including the albumen, platinum, and gum-bichromate prints. To modernists such as Weston, this latter came to be considered one of the chief offenders in permuting the photographic qualities of precision and truth. Its use in the production of saccharine, "impressionistic" scenes was repugnant to the modernist aesthetic sensibility; its soft, synthetic colors obviated the reality of a subject. Various other processes were similarly offensive, but it was to antique methods like these that certain artists of the 1960s turned.

In doing so, they compromised the clear boundaries that photography had carved out to show its distinctness from painting or printmaking. The adoption of alternative processes, along with the interest in the manipulation of negatives and prints, repudiated the standards of modernism, decamping to the very practices that it had struggled to eradicate from photography as corrupting and derivative. These developments were seen as a threat to the integrity of the photograph as the product of a refined process and craft. More significantly, they were perceived as weakening the well-defined aesthetics of photography by an unwholesome alliance with other media that could only produce bastard results. Supposedly, this was a sort of visual miscegenation that attacked photography's heritage, destroyed its purity, and produced works that were neither truly photographs nor proper to any other medium. And indeed, many of the intermedia works that appeared during these years

were the results of processes too mechanical to fit easily into printmaking aesthetics, on the one hand, but conversely too painterly to fit into photography, leaving the artist unacceptable to either canon. The values and criteria traditionally used to judge a photograph were useless in assessing these works, and some of the artists in question found themselves dismissed as extremists who took untoward liberties with the medium of photography. In general, this work received scant economic support at the time. It was not through the galleries or even the museums that it gained its momentum, but through the universities.

In some of the developments of the 1950s we can see a preparation for the more pronounced changes of the 1960s, for example in Henry Holmes Smith's experiments with making images from thick syrup on glass, in a process that essentially combined the photogram with cliché-verre.[9] This latter is a form of picture-making that is photographic in materials and process, but cameraless, using drawing and painting techniques to form the image. The method offered Smith a means of "automatic" picture-making paradoxically akin to both gestural Abstract Expressionist painting and the mechanical apparatus of camera and lens. Another experimenter was Edmund Teske, who, as noted earlier, worked out a complex process that he called "duotone solarization." Through this unique method of making prints Teske created evocative montages that would attain greater compositional sophistication and power over the years. He played an important role in the Los Angeles community of photographers looking to innovative means.

The need to transcend the limitations of the monochromatic palette and explore color compelled Syl Labrot to investigate the complex dye transfer process in the late 1950s. Abstraction that was confined to black and white denied the most dramatic element—the power of sheer color to evoke feeling. Labrot's prints showed his interest in abstraction and color field painting. Much like Siskind in his earlier work, Labrot focused on excerpted details, reducing his images to simplified compositions of color and texture. From striking graphic arrays to sinuous layers of material, his use of color is restrained. Labrot illustrates that the photograph was indeed capable of covering the same ground as painting, though on a smaller scale.

Removed from the fertile regional loci of photography such as George Eastman House in Rochester, New York, and the Institute of Design, in Chicago, was Robert Heinecken, who had come to photography in the course of studying art at the University of California, Los Angeles, during the 1950s. He began teaching there in 1960, and in the next two years established a photography program within the art department. Although the curriculum covered the technical means of photography, a cerebral, challenging approach, interdisciplinary in its basis, was the hallmark. The progressive atmosphere of the Los Angeles art community, and Heinecken's training in printmaking and other media, led him to stress an innovative, expansive approach to photography, and to incorporate nontraditional techniques and means.[10]

By 1965 Heinecken had already used projections and superimposed

imagery in his own work and had investigated collage and manipulation of found photographs. The mass media—newspapers, magazines, television—were a significant source of material for him; his *Child Guidance Toys* of 1963, among other works, indicates his predilection for innocuous visual data culled from the public realm. Contrary to the traditions of serious photography as represented by, say, the abstractionists of the 1950s, Heinecken was looking to "low," common sources for his pictures. He admits that the inappropriateness of this attracted him, and there was also a sociopolitical aspect to his concerns. The media and the cultural issues they raise would continue to fascinate him long after Pop Art ran its course in painting.

Heinecken has experimented a great deal with photographic form. Since the early 1960s his works have often juxtaposed images and text. At one point he was rephotographing advertisements from the media, printing them not on paper but as black-and-white transparencies, and mounting them in free-hanging settings. Another technique was the "print through" process, a cameraless, photogram method in which the subject, a printed page, was used in lieu of a negative; when light passed through it its image was recorded on photographic paper. The result superimposed the data from both the front and the back of the page. This direct process, with its unpredictable visual and literary effects, eliminated the formality and precision of composition of Weston's "previsualization," introducing instead a Dada-like element of chance and randomness. Its mixture of realism and irreverence was of course a dramatic rupture with the decorum maintained by earlier photographers. And similarly, the other forms of assemblage emanating from the West Coast at that time were perceived as a vulgar affront to hard-won introspective abstraction.

Heinecken's "Are You Rea" series of offset prints, published in 1968, was the product of nearly five years of print-through photographs.[11] He purposefully kept these works to the scale of their originals;[12] some of them were never made into intermediate photographs but went directly to the offset plate. They clearly assert Heinecken's interest in content, and in the use of language to influence imagery. The free association of detail that they offer produces remarkable insights and ironies. Various social themes recur—cosmetics, marriage, women and children.[13] The new combinations of negative and positive images form another context, and the original meanings are conflated in the revised image. The pairing of language and image here, with the text guiding the interpretation of the image, often in ironic or humorous ways, is an excellent example in art of the semiological analyses of photographs that were coming forth in the criticism of the 1960s, for example in Roland Barthes's 1961 essay "The Photographic Message."[14]

Explicit eroticism, again taken directly from imagery circulating in the media, dominated Heinecken's work for several years around 1970. In one significant group of works he excerpted and rephotographed entire pages from different magazines and then montaged them together through overprinting, creating sardonic and sometimes shocking juxtapositions of images,

or of text and images. The power of these sometimes tasteless combinations stemmed from the fact that they were assemblages, direct quotations, of our culture and times. Violence was also a concern: in one work, a Vietnamese soldier holds up two heads, while a caption reads, "Try a little tenderness."[15]

Heinecken has investigated numerous processes and formats. An exploration of the 3M Company's Color-in-Color photocopy machine finally resulted in a series of lithographs. Works on photosensitized linen joined the photographic with the conventional materials of painting; Heinecken conceived of these pieces as objects rather than images, as with his three-dimensional works of the mid-1960s. His emphasis on experimental photography, and his willingness to accent and encourage wide-ranging solutions, have influenced many younger artists, and he has certainly contributed to the growth of Los Angeles as a center of art photography with its own style and interest in innovation. That interest can in part be traced to the absence of an established photographic tradition in the city. With no history of regional concerns (such as New York's, with photojournalism and street photography), with no institution to impose a style, and with no revered masters or senior practitioners such as Minor White, Walker Evans, Garry Winogrand, or, in northern California, Ansel Adams, present on the scene, photography in Los Angeles in the 1960s and early 1970s was of a renegade sort.

Darryl Curran, for example, an artist who had studied with Heinecken, was making collages and dimensional pieces, including works with emulsions on glass during these years. Along with Robert Fichter, who moved to Los Angeles in 1968, Curran was one of the principal artists working extensively with the cyanotype, or blueprint medium. He also produced a number of dimensional foot-square photographic pieces based on found commercial images, including toilet-paper packaging; Curran revised the image, printing it positively and negatively, collaging it and pairing it with contact prints in varying registers. These works are not flat: like canvases, they stand on stretchers, and they are backed with Masonite, giving them depth. In that they require no frame or glazing, they are removed from the traditional presentation of the photograph as a picture, giving it more of the quality of an object.

This interest in the third dimension, and in the disruption of the flat image, is visible in a variety of work from the 1960s, when large photographs modeled into sculptured forms, and small works such as Heinecken's *Figure Blocks* (1966), which fragmented the torso into cubes, began to appear. Douglas Prince's Plexiglas constructions incorporating multiple layers of transparencies were also part of this trend, as were the sculpturally oriented pieces of Los Angeles artist Jerry McMillan, known for his various works combining photographs and paper bags to reveal hidden vistas, to play on the idea of "content" by putting it on the outside.[16] Other artists involved in this investigation of such sculptural properties as volume, scale, and space looked to stuffed photographs, stitched images, images on vacuum-formed plastic, metal reliefs, film images on plastic, quilted images, and so on. For the most

part, this research was overly attentive to process and materials, and lacked compelling visual or intellectual underpinning. Perhaps only in the area of offset imagery—in which a sculptural volume could easily be attained as a direct and logical result of a piled-up multiple—was the search for a three-dimensional object truly successful. Nonetheless, the mass of three-dimensional work does reflect how attitudes toward scale, color, imagery, and indeed the fundamental ways of reading a photograph were changing in the 1960s.

Naomi Savage's innovative spirit and urge for visual experimentation perhaps grew out of not so much her undergraduate studies in art, as well as photography and music, as from her work with Man Ray. Savage's combinations of photography and etching are unlike the usual photo-etching; in her work of the late 1960s and early 1970, she freely combined different media, employing collage along with other graphic techniques such as engraving and intaglio. She has continually shown a predilection for combining old photographic techniques with more experimental ones such as the use of negative images, multiple exposures, photograms, solarization, and toning. Savage has even printed on metallic foils, and she is perhaps best known for her photo-etchings on metal sheets, in which the etching plate is itself the artwork rather than merely a part of the process. Clearly, these works orient themselves more to the status of the object than to that of the image. Savage is an early example of the contemporary artist exploiting the vast possibilities of the photographic process to make art, and feeling no need to abide within traditional formats. Because her pictures transform their subjects so completely her work has an exotic, unreal appearance.

John Wood, eschewing the canonical single, straight image, made dynamic use of multiple exposures and composite images in his work of the mid-1960s. Wood, who trained at the Institute of Design, is easily at home with experiment. For him, the photographic image is but a component of the final work, and he feels no compunction about abandoning standard horizontal and rectangular placement, say, or about leaving the realm of photography for other means and mediums. A group of his collage works shown in the landmark exhibition "The Persistence of Vision," which Nathan Lyons organized in 1967 for the George Eastman House in Rochester, New York, illustrates the license he took in constructing his compositions during the 1960s.[17] His works from 1965–66 are neither social documents nor single-image formal abstractions, but favor a more contradictory usage of the photographic process.

Wood transformed his images of this period through various means. Screened photographs, transfer drawings on glass, photo-engravings, and the use of a process camera, along with lithography, collage, and montage, were among his techniques. He also explored painterly manipulations of the negative, occluding parts of it, as well as alterations of the surface of the print. His collages of the mid- to late-1960s pursue an abstraction of their visual data that attains a balance between the painterly and the photographic; by using fragments of images rather than complete ones, Wood dismembered the pic-

torial continuity of the photograph. His free use of the photograph and his wholesale incorporation of it into those collages, which also included other art forms such as drawing, provided a new set of visual criteria quite different from that appropriate to the abstract single image. Wood also investigated scale, working on sometimes extremely large sheets of drawing paper rather than with the standardized sizes of photographic papers. And he ran his compositions over modular formats of diptychs and triptychs, giving them a structure of multiple yet interactive units. This too was uncommon, and it helped to suspend the specificity of the photography, abstracting it further.

Wood achieved sophisticated gestural passages with graphite and inks in these collage works; in some ways he was closer to painting and the print, with their line and the massing of tones, than to photography. Yet works such as *A Summer Transmission* (1968) show the clear influence of László Moholy-Nagy, and particularly of his "Photo-Plastik" collages. The empty planes of Wood's images, their lack of a specific ground, their floating elements and linearity, all recall Moholy's earlier works. In the 1970s Wood moved on to explore the composite print and the multiple-framed sequential image, applying the latter effectively to portraits.

A student of Henry Holmes Smith, Robert Fichter played a significant role in cross-fertilizing the interest in photographic manipulation that had appeared on both the West and the East coasts, having worked in both Los Angeles and Rochester by 1969. Fichter reinforced the vigor of the experimental program that Heinecken had established in Los Angeles, and he was pivotal to the group of artists working in the late 1960s in Rochester. His training and interests in fields beyond photography, and his commitment to synthesis between art forms, led him to a visual vocabulary quite new to photography. His work—one hesitates to call his prints from the 1960s photographs, as they were so stridently antithetical to the norm—has a William Wiley–esque funk quality, a playful, "laid-back" attitude, yet below its apparent humor it makes sharp social criticism. Though much more apparent in recent years, Fichter's social commentary and iconography were evident in the late 1960s. (Dogs and military figures, for example, make recurrent and pointed appearances.[18]) Fichter has a background in painting and printmaking that has left him as open to these mediums as to photography, and a good number of his prints from the 1960s are of a sort of hybrid form that sets drawing and printmaking techniques alongside photographic materials and processes. Their brash, sometimes strident colors and compositions clearly were not at all consonant with the aesthetics that still prevailed at the time, and he has long been considered a renegade photographer who has taken extreme liberties with the medium.

Fichter's gelatin-silver prints of the 1960s were often solarized, dismantling their literalness through the abstracted unreality of the reversed tones. Assemblage was and continues to be important to his work; his prints combine numerous prosaic flotsam, building dense compositions whose details may rise to the viewer's consciousness only long after seeing them. To realize

his unique vision Fichter made use of a plethora of materials and processes between 1966 and 1968, in an abrupt revolution from the sedate black-and-white, single-image photograph: lithographic prints with offset, transparent tape, solarized gelatin-silver prints, oil crayon, graphite, watercolor, cyanotypes, rubber stamps, decals, and prints that combine the Verifax copy-machine and gum-bichromate processes all coalesce in a fabricated, highly artificial-looking realm incorporating found images from the mass media as well as the artist's own drawings.[19] The combination of cyanotypes with gum printing was of particular interest to him in the late 1960s and on into the 1970s. Long before toys surfaced as subjects for postmodern artists, Fichter had used them, representing the astronaut, soldier, and cowboy as contemporary mythical figures.

Smith's interest in experimentation with process was also passed on to another of his students, Betty Hahn, who was among the first photographic artists to embrace methods closer to printmaking than to traditional photography, reflecting her art training. In her early work she made broad use of color, arranging fields of it to establish the structure of an image, and her explorations in this area, like Fichter's, led her to experiment with the gum-bichromate prints. Since the photographic emulsion used in the process can be applied by hand to any paper, the resulting print can be given a painterly irregularity. The gum-bichromate and cyanotype alternatives provided interactive possibilities for artists like Hahn. Their process implies an aesthetic quite removed from that of the black-and-white gelatin-silver print, with its opportunities for technical craft and detailed representation; the gum print reinforces the sense of the photograph as an object. It can use rough rather than slick paper to contribute to a painterly feel, and it violates modernist tradition in its lack of sharpness and, of course, in its color. Though Robert Demachy and others had used gum prints around the turn of the century, they had done so in order to approximate the hazy, atmospheric, impressionistic manner of painting that was then popular, and their work was romantic and pictorial in orientation. Hahn and others were not interested in the aura of the romantic—they liked the freewheeling chromatic possibilities of the gum print, and the release it offered from the omnipresent gelatin-silver print. Moreover, the process was ideally suited to the composite print, which many artists were then exploring. Hahn's work of this type shows a fresh looseness of composition and a proliferation of denser detail. She has also used drypoint, etching, photoetching, collage, and film positives in her work.

The prints and books of Keith Smith from this period have an autobiographical theme, and his images are often based on casual snapshots. He has been interested in the book medium since 1967; to date, he has produced some 115 small-edition or unique volumes. Smith has worked with a wide variety of processes, from photoetchings, for which he is well known, to cyanotypes, screen prints, offset lithographs, and prints made on the Color-on-Color and Verifax copy machines. Before he began working with books he was producing elongated prints of sequential images, or composite images drawn

from several frames, to make enigmatic portraits, and this form recurs in his work. Smith studied at the Institute of Design, and his basic sense of exploration is consistent with the school's concern with a wide range of photographic solutions, and its emphasis on adapting existing techniques to achieve innovative results. Thus any one of his books may utilize a variety of processes. He is not interested in the photograph per se, however—to Smith, photography is a functional tool, a means rather than an end. His pictorial solutions have never been intended to serve the old aesthetics of the medium. Drawing has played an important role in his art, and a good deal of handwork is visible in his prints; his diverse works share an interest in the art work as a physical object and in an interactive use of materials. In fact Smith's attitudes typify those of the photographic artists who emerged in the 1960s, many of them with art-school training, and conversant with issues and media beyond the factual realm of black-and-white photography.

These kinds of permutations of the traditional photograph are also seen in the work of Alice Wells, an artist living in Rochester in the 1960s whose work in the early part of the decade consisted of relatively straightforward photographic studies of nature. Around the middle of the decade, with the encouragement of other artists, Wells began to shift away from nature as a subject and to explore alterations of process and format. From 1966 on she focused on multiple-image composite prints, often solarized, their bold negative renditions energetic and possessing a strong emotional impact. The juxtapositions and interactions of overlapping exposures in these works drastically alter the photograph's conventional factualness, transforming the snapshot, quotidian character of Wells's images to connect them with a wider consciousness and intellectual awareness. In another technique, she would run exposed film back through the camera and shoot it again, producing a "many-momented image."[20] She was also one of the first to use the diptych format, which she began to explore as early as 1965, and which others, including Thomas Barrow and Eve Sonneman, would use more extensively later. In 1968 she acquired a number of antique glass-plate negatives at an auction, and the following year she began her "Found Moments Transformed" series, in which she used solarizing, staining, and other manipulations to alter the compositions of these old photographs, and even the faces of their subjects. Changed so profoundly, these thirty works take on a timeless quality, removed as they are from their original context and historical roots. Wells's contribution to photography's rupture from the single, straight image is often overlooked, yet she was an early experimenter with the form and vocabulary of the medium.

Another woman contributing to the broadening of photography's possibilities during the 1960s was Barbara Blondeau. She studied painting at the Art Institute of Chicago in the early 1960s, returning to school several years later to study photography with Aaron Siskind and Joseph Jachna at the Institute of Design. Unfortunately, her oeuvre is rather small, for she died relatively young, in 1974. Blondeau's background in painting naturally led her to

the cliché-verre process, and to other means and formats involving photographic manipulation. Whatever the method she used, repetition, narrative, and pattern are evident in all her work.[21] Like many Institute of Design artists, she considered innovation paramount—she was always searching for new expressive means. One avenue was the composite print, involving both the montage or juxtaposition of negatives and overlay techniques. Another was the incorporation of text in the work, as in her untitled solarized image of a woman's head of 1967. The radical toning that produced gold and purple-brown tones on some of her prints was achieved through experimental processes, and she also experimented with halftone screens, in an assault on the traditional refinement of the black-and-white print. She began to work with strip prints—continuous rolls of prints made from unsegmented film exposures—in 1968; intrigued with the potential of this relatively untested format, she continued with it until 1970. (Keith Smith had made use of the method, and William Larson and Ray Metzker, also Institute of Design graduates, have explored it as well.) Blondeau's prints in this form have a strong sense of design, enhanced by their dark backgrounds and attenuated proportions. They vary tremendously in content. Patterns on nudes, and the appearance of rapidly moving figures reminiscent of Etienne Jules Marey's, are typical.

As we have repeatedly seen, the idea of the purely photographic image as an art object failed to satisfy many artists in the 1960s. Increasingly, the photograph was merely the starting point or source material, not the finished product. Nor did these artists require that the surface of the print remain unblemished; many of them had backgrounds in drawing and painting, and they saw no reason why the photograph couldn't be similarly marked. In the mid-1960s, for example, Jack Fulton was pairing his epigrammatic black-and-white prints with casually handwritten words. The results were a punning kind of haiku, simple graphic images combined with brief twists of language. Fulton was influenced by the poets of his local Bay Area, and by his friendship with the San Francisco funk artist William Wiley. His irreverence and humor were evident even before the "Funk" exhibition of 1967 that brought work like Wiley's recognition, and the same attention to ironic, clever, dumb fragments of daily life that characterized the art of that exhibition is clearly seen in his photographs. These indecorous works are antithetical to the aura of seriousness and refinement that surrounded much of the photography of the 1950s. Indeed, Fulton's images are somewhat like graffitied snapshots; the texts in his works are rude markings of the once-pristine photographic print. Yet the works depend for their success more on the connections Fulton makes between visual language and humorous written and spoken language than on their imagery. He has long had a fascination with words,[22] and he uses them to inject sly variations and ricocheting meaning to his images. Joycean plays and a stream-of-consciousness kind of narration are apparent; the texts have a lyrical, poetic quality—they seem more verbal than written, as if they needed to be read aloud. Additional doodlings and colored markings make it impossi-

ble for the photographs to function as formal objects, for these marginalia capsize the imagery, carrying it off to new territory. Fulton has never enjoyed widespread attention in photographic circles—his humorousness transgresses the boundaries of propriety. Yet despite his appearance of naiveté and his enjoyment of increasingly complex puns, his ideas are serious. In the past decade he has become a kind of diarist, chronicling his ramblings in the West, and always connecting them to themes of transcendence.

Until the late 1960s Todd Walker was a commercial photographer, but he had studied in Los Angeles under Edward Kaminski, and eventually he abandoned commercial work in favor of teaching and a greater concentration on the medium. He is perhaps best known for his prints using the Sabattier process, a method of achieving a partial reversal of tones, similar to solarization, by reexposing the film or paper to light during the development.[23] Walker's prints are chiefly concerned with formal aspects of shape, tone, texture, color, and line. He has also produced small books using the offset-lithographic process, a method in which he is highly skilled. In their even repetitions of images, his collotype monoprints, such as *Pearl Dancing* (1969), are reminiscent of the work of Eadweard Muybridge, but they use a variety of inks from section to section, and fragments overlap, some being printed with more clarity than others. The emphatic color makes little attempt at realism; at one point, in fact, Walker built a cavelike environment as a set for his work, eliminating not only the real world from his photographs but even the world of the studio. The feeling of casualness suggested by the inexactitude and roughness of the perimeters of Walker's prints captures a sense of spontaneity. The artist played an important role in encouraging younger Los Angeles artists to manipulate photographic processes and to experiment across art forms, for example, by adapting traditional printmaking processes to the medium of photography.

In the 1960s investigation of unconventional technology in art, some turned to the copy machine. Inasmuch as the technology was so integral to contemporary culture, they considered such machines appropriate means of modern-day picture-making. Copy-machine reproductions were not photographs per se but essentially they still made use of the photographic process, although they updated it from a basically nineteenth-century technology to a twentieth-century one. Furthermore, this was a paradoxical use of a copying mechanism—to make original works. And it seemed an appropriately pedestrian means for images drawn from banal sources in contemporary culture. Much of the material that artists used for reproduction was drawn from magazines, newspapers, and other popular, mass-media sources of found images. A new preference for collage over the single image, combined with an interest in high-density compositions using numerous elements, contributed to the fascination with machine images; collage, or more accurately montage, seemed apt for the times, since it mirrored the high-volume materialism of 1960s affluence. Also, the notion of abandoning the camera in favor of composing an image directly on the copy-machine glass was appealing in that it allowed for

extemporaneous, improvisatory solutions with immediately visible results. The first wave of artists using copy machines in the 1960s led the way for much wider usage in the late 1970s.

Los Angeles artist Wallace Berman was perhaps the first to gain recognition for his photocopied works, collages made with the Verifax machine in the mid-1960s.[24] Originally a sculptor and a maker of assemblages, Berman found the move to photocopied collages a natural step. A frequent motif in these works is a hand holding a transistor radio, its speaker replaced by a picture; often the works also refer to signs and symbols from Hebrew. (The artist was becoming increasingly drawn to mysticism and the Cabala.) By repeating certain elements like a refrain, Berman formed new visual structures out of conventional images, creating an aura of the cinematic.[25] His work exemplifies the interest that artists from outside the field of photography were developing in the medium during this period. Logically enough, these men and women had but little concern for the classic photograph or its formal aesthetics; they were more interested in the process itself. A patent disregard for photographic convention, and a lack of interest in traditional means, was common in their work, and this helped to expand the boundaries that had previously defined photography, and to sever the medium's links with the past.

In Rochester, artists associated with the George Eastman House who had already been examining alternative forms also took up the Verifax machine. Fichter, for example, began producing Verifax prints around 1968, as did his colleague Thomas Barrow. Barrow continued using the machine through 1975, focusing for subject matter on commercial products, mass-media material, and other contemporary flotsam. In 1973 he produced two artists' books made with the Verifax machine, *Trivia* and *Trivia 2*. Utilizing themes such as transportation and fashion, the books consist chiefly of photocopied images paired with bits of text. Each book, of twenty or twenty-one sheets, is unique, for Barrow produced variations on the pages while he was working at the machine, or simply made different imagery altogether. The works illustrate the cultural inventorying typical of the artist's work; their blend of formal concerns with an attention to content gives them a peculiar documentary value. The Verifax prints have a graininess and imprecision, as if occluding tissue had been laid over the original data. Random technical defects are left in as chance occurrences. The machine-made images of Barrow's books presage his later, more sophisticated sprayed photograms, which make use of some sort of direct imaging of products and advertising from mass-media sources. Images of cans, cosmetics, beauty treatments, lingerie, shoes, and technical gadgets are typical. Through their murkiness, their informality, and their utterly common subject matter, these rude, oblong prints desecrate the craft tradition of the straight photograph. Nor do they reveal any conventional sense of pictorial hierarchy or structure. The influence of assemblage is evident in Barrow's work. The avalanche of contemporary stuff that it describes perhaps shows just what makes today's homes so banal—or perhaps constitutes a paean to capitalism in our time.

The notion of cameraless image generation has been most extensively explored by Sonia Sheridan, an early enthusiast of the copy machine, and an exemplar of a characteristic often seen in women who work with photography—a readiness to use the medium radically and innovatively, in ways unfettered by homage to traditional methods and subjects. Sheridan is attracted by the copy machine's immediacy, and its interactive process. Her works also depict another type of interaction, a literal one between artist and machine: her VQC telecopier prints are images of her hands, face, and other body details. Unlike many artists whose interest in the copy machine is a passing one, Sheridan, the founder of the Generative Systems Department at the School of the Art Institute of Chicago, has investigated many technological means. She has had a close association with the 3M Company,[26] working extensively with its Color-in-Color machine, and she has explored computer-generated prints, the Thermo-Fax and Halide Xerox photocopiers, video, and the recopying of prints produced through different processes. Perhaps her most unusual efforts are prints generated from microfilm images transmitted by sound over telecommunications transmission systems, producing peculiar abstract compositions. Her "VQC Moving Face Set" (1974) is reminiscent of Anton Giulio Bragaglia's futurist portraits in its repetitious sequence of facial fragments. Sheridan's work is more than just an exploration of alternative processes, for in its interaction with contemporary technology it is representative of our time, in which reproductive machinery, visual and audio, is omnipresent.

California artist Ellen Land-Weber has also used the 3M Color-in-Color machine in large works that exploit the sumptuous chromatic tonalities the machine can produce while at the same time portraying the three-dimensional objects that constitute the artist's subject matter with an atmospheric softness verging on the romantic. These works from the mid-1970s on, printed as they are on Arches paper, give no evidence of their copy-machine origin, appearing rather as traditional lithographs. The ability of the machine to render a lithographlike reproduction that circumvents the usual exactitude of the camera lens, along with the extremely short time needed to create the print and its low cost relative to the traditional graphic media, make these works especially appealing. Their nonphotographic appearance and scale, and their broad, atmospheric use of color, give them presence. The reproduction has been transformed into an exotic rendition belying its mechanical genesis. Like other copy-machine artists, Land-Weber has acquired her own machine and materials, giving her the unimpeded access to her medium necessary to produce a body of prints.[27]

William Larson's involvement with machine-made images reflects the spirit of experimentation inculcated by the Institute of Design. To him as to Barrow, an earlier Institute of Design graduate, the copy machine affords a perfect synthesis of late-twentieth-century vernacular technology and vernacular art-making as well as a means of using the photographic image but not the photograph. Larson's background in painting and printmaking has encouraged him to consider image-making in wider terms than purely photo-

graphic ones. His "Electro-Carbon Drawings"—known also as "Fireflies" because of the image of a firefly that recurs in this series, in a visual pun on the flight of information and light—were generated between 1971 and 1978 with a Graphic Sciences teleprinter, which converts the visual material into audio signals that can be transmitted over a telephone line, then recomposed as an image, reproducing the original as a facsimile.[28] The transmissions per image in Larson's series varied from three or four to as much as ten.[29] Like his earlier work, the teleprinted pictures are voluminous aggregations of data. In both form and content they have the quality of collage, juxtaposing found images in loose structures, arrays of discrete elements. Field and cloud imagery gives these humble prints a sense of recollection; they have a delicate nature. Brief textual phrases, syllables, or arrangement of letters offer little real information, but suggest cryptic meanings. The horizontal scan lines also evoke a shift in space and time.

All these artists reveal an interest in fashioning an *object* as much as an image; in gaining command over format, process, color, ground, and scale; and in creating an interactive process of art-making that transcends the previous limits of photography. The radically new aesthetic of their work from the 1960s and early 1970s reflects the expansive mood of the period, with its interest in experimentation and its search for new forms. The achievements of these years unquestionably helped set the stage for the changes that followed, for they firmly established the notion that photography need not confine itself to viewing the external world, and could interact with other media. — K.M.G.

THE FORTUNATE, FASHIONABLE RESCUE

Robert Heinecken
From "Are You Rea." 1964–68
A portfolio of 25 offset lithographs, 10 x 12½ in. (sheet)
Los Angeles County Museum of Art, Gift of the artist

Darryl Curran
L.A. Series #12, L.A. Series #18, L.A. Series #8, L.A. Series #7. 1970
Gelatin-silver prints on masonite board with wooden frame
12 x 12 x 1 in. each
Collection of Darryl and Doris Curran

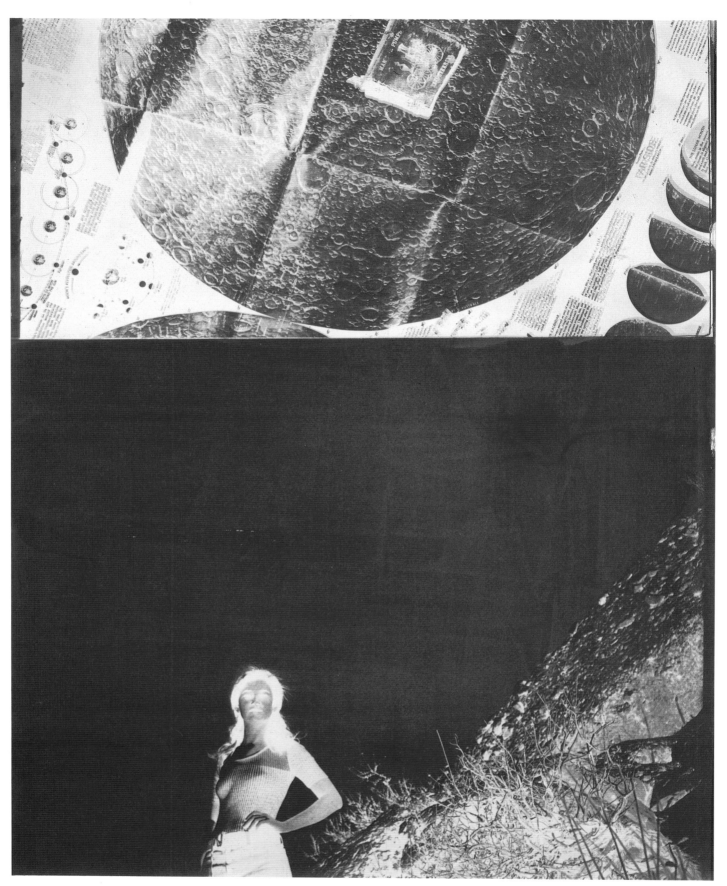

Robert Fichter
Negative Figure and Moonscape. 1969
Cyanotype and gum bichromate, 25³⁄₁₆ x 19⁷⁄₈ in.
Collection of the artist

Betty Hahn
Ultra Red and Infra Violet. 1967
Gum bichromate
22⅛ x 14¾ in.
Courtesy of the Andrew Smith Gallery, Santa Fe, New Mexico

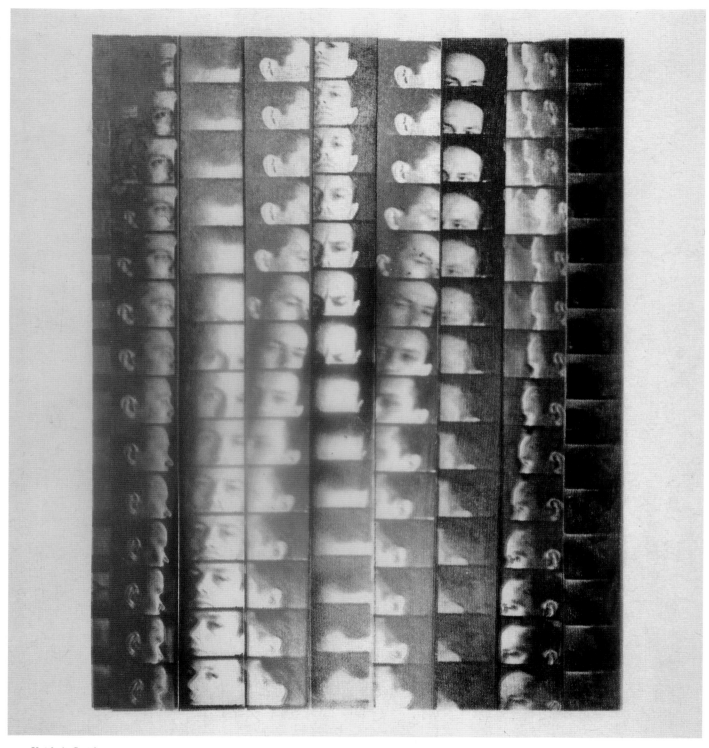

Keith A. Smith
Head Movements. 1966
Photo-etching, print emulsion, and colored inks on etching paper
14⅞ x 13⅞ in.
Collection of the artist

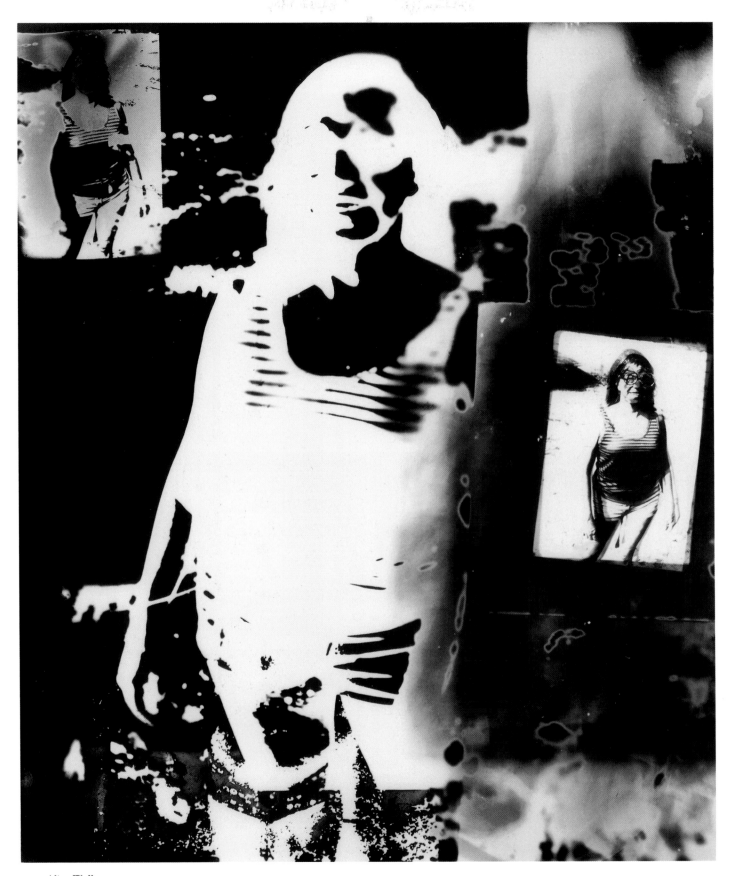

Alice Wells
Untitled. 1966
Solarized gelatin-silver print
13½ x 10⅝ in.
Courtesy of the Visual Studies Workshop, Rochester

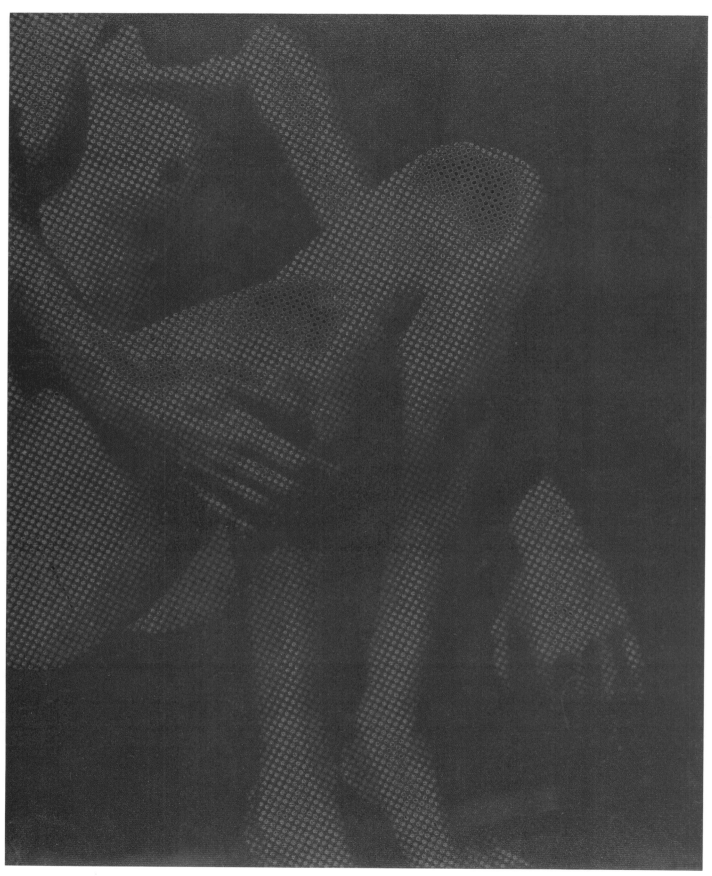

Barbara Blondeau
Untitled. 1967
Process unknown, 13⅞ x 10⅝ in.
Courtesy of the Visual Studies Workshop, Rochester

the old house being torn down in the background belonged to a very elderly lady who lived with a chinese couple that were her companions for decades. She recently passed away. They left. Down comes the house. The lot is vacant. San Rafael.

seems out of the past

I wonder, just how many <u>motels</u> were there <u>built</u> in the 30's?

This is the El Camino motel. The King's highway. a place to stop from the sojourn. Oasis from traffic. Clandestine dates. Camel butts all over the place. It is remarkable however of the apparent lack of travelers.

Jack Fulton
Seams of the Passed. 1976
Chromogenic-development print with text
10⅞ x 13⅞ in.
Collection of the artist

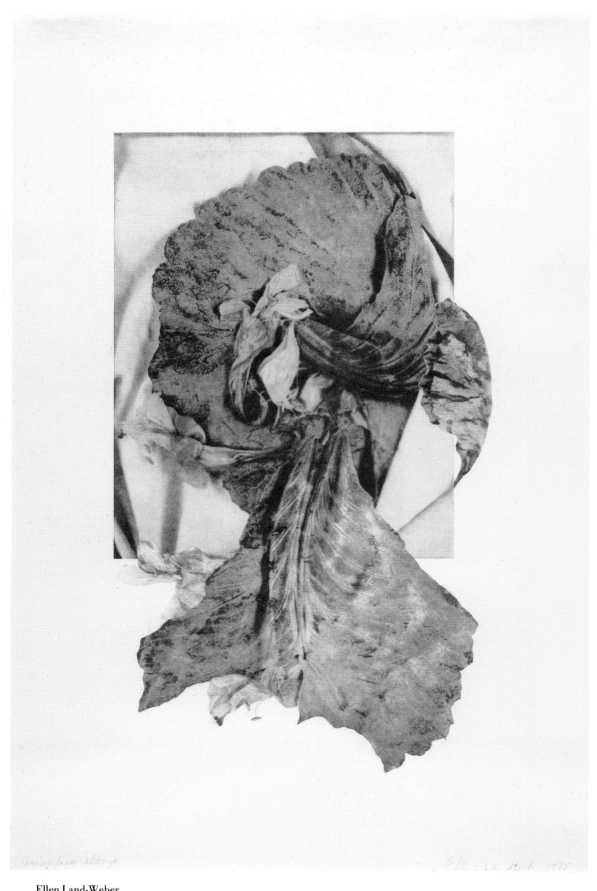

Ellen Land-Weber
Amaryllis and Cabbage. 1975
3M Color-in-Color print, 22 x 14½ in. (sheet)
Collection of the artist

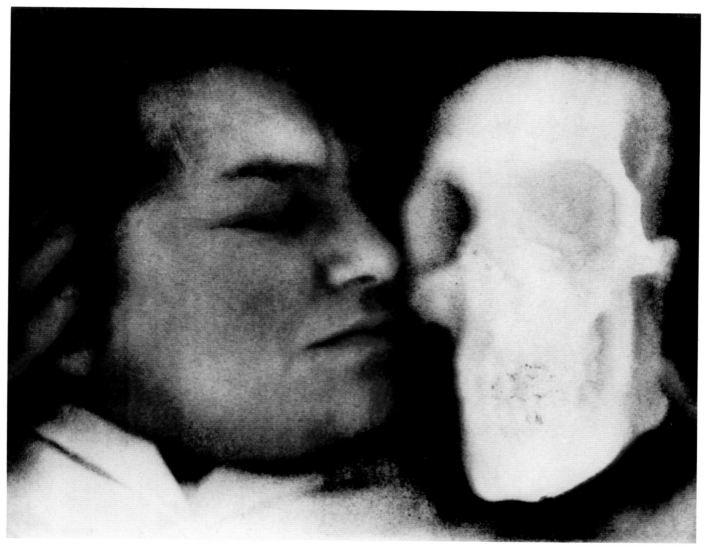

Sonia Landy Sheridan
Sonia with Skull. 1971
3M Color-in-Color print
8⁷/₁₆ x 11 in.
Courtesy of the Visual Studies Workshop, Rochester

Thomas Barrow
Four untitled prints from the series
"Trivia 2." 1973
Verifax matrix prints, 13⅞ x 8½ in. each
Collection of Joe Deal

William Larson
Transmission 0035. 1974
Electro-carbon print
11 x 8½ in.
Collection of the artist

Lucas Samaras
Photo-Transformation, 11/1/73. 1973
Internal dye diffusion-transfer (Polaroid SX-70) print
3⅛ x 3¹/₁₆ in.
Los Angeles County Museum of Art
Ralph M. Parsons Fund

5.

Conceptual Art
and the Photography of Ideas

In 1975 John Szarkowski, director of the Department of Photography of the Museum of Modern Art and since 1962 a dominant figure in shaping the critical climate for photography, wrote an article for the *New York Times Sunday Magazine* in which he attempted to account for photography's new-found cachet as an art medium. The article's title betrays its modernist underpinnings: "A Different Kind of Art." Szarkowski argued, as he did in *The Photographer's Eye,* that the art of photography resides in its differences *as a medium* from the other visual arts. Among the distinctions he makes is that it is "a perfect tool for visual exploration and discovery, but a rather clumsy one for realizing the inventions of pure imagination."

The assertion is not without a historical irony, coming as it did in the middle of the 1970s, for it coincided precisely with the moment that a significant number of artists outside the tradition of this medium were adopting photography as a tool of "pure imagination." Some chose to create fictional narratives, some to invent a theater of the self, some to stretch photographic meaning with words, some to expose flaws in the medium's documentary capabilities. This interest in photography as a carrier of ideas was not confined to the United States; artists in Europe also were exploiting the medium in ways totally unforeseen within its modernist practice. If there was a precedent for the new attitude toward photography, it was to be found in Man Ray, for whom photography was a means of capturing the random, improvisational aspects of life, which he felt underpinned the superficial stability of appearances.

As Szarkowski explained it in "A Different Kind of Art":

> Some contemporary artists who began (at least nominally) as painters, and who have in recent years worked their way through a succession of nonpictorial art forms (happenings, conceptual art, earth works, systems art, etc.) have demonstrated a quick appreciation of the idea of photography as a technique particularly well-suited to record the infinite variegation of human experience.

Such artists, having been taught by Duchamp, Tinguely and others that the act of art need not be married to the crafting of fine manufactures, have been quick to realize that a photograph can be a work of art without being a flagrantly beautiful object.[1]

While there is a suggestion of peevishness in Szarkowski's repetition of the word "quick" in this passage, his description of the situation of 1975 is accurate. As much as he was able to perceive the fundamental change being wrought in the medium he had loved for a lifetime, however, he was not able to embrace it. For to do so would have meant discarding the very essentials of his aesthetic: that the art of photography consists of exploiting the medium's unique qualities, that its functions and purposes are different than those of painting or any other visual art, that it has its own tradition, history, and criticism. As a work of criticism, "A Different Kind of Art" is an attempt to shore up these beliefs in the face of a widespread collapse of modernist ideals. The real "different kind of art" in the 1970s was not photography per se, but its use within the precincts of the art world—primarily by adherents of Conceptual Art and its many branches.

Conceptual Art as a term came into widespread currency in the late 1960s, but the first manifestation of its aesthetic were visible much earlier in the decade. The most well-known precursor of Conceptual Art's use of photography is Yves Klein's *The Leap* of 1960, a photograph of the French artist diving streetward from a second-story ledge, also titled *The Painter of Space Throws Himself into the Void*. The picture is a fake—Klein did jump, but he used nets to catch his fall, and a different background was added in the darkroom[2]—and yet it captures the artist's Duchampian gesture *as if* it were real. The photograph is at once the enduring document of an ephemeral artistic event and a collusive element in its execution.

Like Marcel Duchamp, the Conceptualists believed in ideas more than objects, and their chosen mission was to investigate systems of information

and theories of knowledge and perception. Many had political beliefs, forged in the counterculture ethos of the day, that led them to seek ways to avoid producing more "art objects" for consumption; they wanted to "dematerialize" art, to take it away from its traditional dependence on the physical object—or, as Duchamp put it, to free art from the tyranny of the retinal. Among the alternatives used in their attempt to free art from its dependence on the nonstop production of paintings and sculpture was, needless to say, photography.

While Conceptual Art encompassed a diversity of artistic intentions and appearances, it has certain characteristic aspects. As Andrea Miller-Keller, curator of the Sol LeWitt Collection at the Hartford Atheneum, has observed:

> There is a prevailing "look" to much of the work: both photography (which was just being accepted into the realm of fine art during this period) and language play a predominant role; there is a relative lack of color; most presentations are physically unpretentious and require close scrutiny in order to be read. These characteristics are quite unlike those which might be used to describe the immediately preceding movements of abstract expressionism, pop art and even minimalism.[3]

Among the characteristics uniting such Conceptual artists as Joseph Kosuth, Robert Barry, Jan Dibbets, Eleanor Antin, and Lawrence Weiner, according to Miller-Keller, are their interests in repetition, real time and real space, scale, process, the nature of perception, self-portrayal, incompleteness or omission, and the very act of looking at art. As they were to discover, photography lent itself to the artistic investigation of many of these themes.

In most Conceptual Art the photograph functions as a sign or indicator of an organizing idea, not as a precious object to be savored for its formal organization, surface appearance, or expressive capacity. Conceptual artists sought to rescue art from the dominion of the precious object, and photographs were considered ideal because they were so little valued—until, of course, Conceptual Art helped make them valuable. Conceptual artists viewed photography in the same way that they viewed language: as a carrier of cultural messages.

Besides Ed Ruscha, whose innovative picture books such as *Twenty-Six Gasoline Stations* were early examples of the new, idea-based art, the pioneers of Conceptual artworks involving photography include Bruce Nauman, John Baldessari, Bernhard and Hilla Becher, Hans Haacke, and Douglas Huebler. Along with Conceptualists who occasionally employed the photographic image, such as Kosuth in his *One and Three Umbrellas* (1965), these artists brought Conceptual Art and photography into prominence in the New York gallery scene of the early 1970s.

Nauman's suite of eleven color photographs, made during 1967–70, shows how radical the Conceptual artists' conception of photography was when compared to that of the art photographers of the time. For Nauman,

who used photographs primarily to document what was then called body art, photography was an alternative to traditional image-making systems, and it had the advantage of being quick, technically simple, and outside the prevailing value system of the art world. But it also possessed its own quirks, a certain deaf-and-dumbness that rendered it susceptible to the inflections of language—thus the punning titles of the pictures. Rather than capture images from the world that exists, Nauman chose to enlist photography's documentary "look" in the service of patently fabricated situations. The result is a witty overthrow and cancellation of photography's conventional functions.

John Baldessari is probably the most important influence on contemporary, Conceptualist-based photography, both as an artist whose use of photography has maintained its originality for more than fifteen years and as an influential teacher on the West Coast. His first exhibited "paintings," done in the late 1960s, consisted of words and photographs applied to canvas. By the 1970s, however, he had rejected any reference to painting and begun to focus on the photograph itself. In works like *A Different Kind of Order* (*The Thelonius Monk Story*) (1973) and *Throwing 4 Balls in the Air to Get a Straight Line* (*Best of 36 Tries*) (1973), photographs are used in the service of Conceptual notions about the process of perception. Increasingly, the photograph itself became the location of Baldessari's perceptual inquiries, whether manipulated to contain a "hidden" message or simply spliced together with other images to create a kind of automatic dialogue between them. In refining his grasp of photography's capacity for creating meanings both intentional and unintended, Baldessari has achieved a masterful blend of humor, perceptiveness, and inventiveness.

Bernhard and Hilla Becher, a German couple trained in painting, began their documentation of domestic and industrial structures in the late 1950s. Interested in the similarities of construction as well as in the less obvious individual characteristics of water towers, blast furnaces, and half-timbered houses, they have pursued their quarry throughout Europe and in the United States for more than twenty-five years. Their grid-format "typologies" focus our attention on the uniformity of certain functional motifs at the same time they display the diversity possible within a given set form. When their work was first shown in New York in the 1960s it immediately caught the imagination of the Conceptualists; in 1972 Carl Andre—whose own sculptural grids thread the gap between Minimalism and Conceptualism—wrote an appreciative article on the Bechers' work for *Artforum* in which he noted the advantage that photographs have, compared to paintings, as "objective records."[4] But as much as their work is allied with Conceptual Art's interest in the line between order and disorder, the Bechers function more like cultural anthropologists, sifting the visual shards of a vestigialized industrial culture.

Hans Haacke has used photography's "objective record" status in a series of artworks that seek to upset or undermine the separation of the art world from political realities. His *Manhattan Gallery Goers' Residence Pro-*

file (1969–70), *Manhattan Real Estate Holdings: A Real Time Social System* (1971), which caused his exhibition at the Guggenheim Museum to be cancelled, and *Les Poseuses* (1975) all direct the viewer's attention to economics rather than to aesthetics, and to the connections between wealth, the art world, and social inequities. Photographs play a major role in the appearance of these works, although the meaning of the work becomes clear only after reading the accompanying texts. More recently Haacke's works have become less verbally didactic and more iconic, assuming, as in *The Safety Net* (1982), the status of sculpture while retaining the photograph as an evidentiary device.

Douglas Huebler began to use photographs as elements in his Conceptual process pieces in the late 1960s, and since 1971 they have played an integral role in his *chef d'oeuvre*, called *Variable Piece #70 (In Process)*. In it Huebler uses photos, words, and (lately) paintings to tell what are essentially tall tales, and to chart the artist's ongoing ambition of photographing every human being in the world. Seemingly ordinary and uninformative, the pictures are given life by their captions, or by Huebler's mystery-novel-style narratives.

Even those whose ties were to Minimalist sculpture, with all its reductive, geometric, and systematic rigor, were not immune to the objectivist, notational charms of photography. Both Mel Bochner and Sol LeWitt have incorporated photographs into their investigations of structures and systems, taking advantage of their reproducibility and multiplicity by assembling them into grids (the grid being characteristic of Minimalism's quest for order). This rigid type of multiple-print organization, which rejects the notion of the sanctity of the individual image without succumbing to collage's dependency on chance and process, became a major motif of the art photography of the 1970s. Its influence can be seen in the work of artists as diverse as Marcel Broodthaers, Jan Dibbets, Gilbert and George, and MANUAL.

The interest in serial forms and structural issues in the Conceptual photography of the period is allied with, and to an extent an outgrowth of, a parallel momentum in independent filmmaking. Beginning in the late 1960s, artists such as Vito Acconci, Robert Morris, Richard Serra, Robert Smithson, and Lawrence Weiner directed films that closely examined the nature of time/space representation while dispensing completely with the narrative conventions of the cinema. Acconci's *Openings* (1970) is a typical example: for fourteen minutes the camera remains stationary as the artist pulls the hairs from his belly one by one, out to the edges of the frame. Artists who were part of this structuralist film movement, such as Michael Snow and Hollis Frampton, were naturally interested in the analogous issues of representation in still photography. Working in Canada, Snow produced both films and photographic works that dramatized the processes of perception and observation with an almost puritanical spareness.

In terms of photography's place in the art world, the legacy of Conceptual Art has been inestimably fruitful. It also has been richly diverse. For

from each of Conceptual Art's implicit concerns—real time, process, information and knowledge theory, systems and structure—has come a body of work involving photographs. The urge to reveal underlying structure, so important to artists like LeWitt and the Bechers, extended to artists such as Dibbets, Dan Graham, Jan Groover, and on the West Coast, Lew Thomas. Eve Sonneman's diptychs, consisting of adjacent 35mm frames, explore the notion of real-time activity, as does the 1975 series "Vegetable Locomotion," an enormously funny homage to Eadweard Muybridge by Hollis Frampton and Marion Faller, and Roger Cutforth's views of Western scenes, which show the effects of the passage of time on the land. Richard Long and Hamish Fulton, English artists with close ties to the environment, recorded their wilderness walks with photographs—in Fulton's case, the photographs become independent visual experiences that amplify or explicate his perfunctory textual descriptions.

The Conceptualist influence can also be felt in photographs that seem in other ways to be allied with the traditional documentary practice of photography. John Pfahl, for example, with allegiances both to modernist landscape photography and to contemporary art issues, managed in his extended series of "Altered Landscapes," beginning in 1974, to combine elements of both. Using traditionally sublime views as his sites, he intervened in the scenes by duplicating or violating their "natural" features. By wrapping aluminum foil around tree trunks, or arranging lengths of string across the ground, he confounded both conventional perspective and the expectations of an audience more attuned to Ansel Adams.

Lewis Baltz's series of pictures "The New Industrial Parks near Irvine, California," taken in 1974 and exhibited at the Leo Castelli Gallery in New York in 1975, combine a documentary intention (showing, in this case, the anonymity and mediocrity of the inhabited California landscape) with a Conceptual presentational strategy (the buildings were taken head-on, without embellishment, and the photographs were presented in a series to achieve a sense of repetitiveness). Seen in sequence, they recall the obsessive inventorying of Ed Ruscha's book *Every Building on the Sunset Strip*. Pfahl, Baltz, and Paul Berger are among a number of photographers whose work of the mid-1970s reflects Conceptualist concerns without abandoning a commitment to the unmanipulated, descriptive photographic print.

Conceptual Art also spawned a number of subspecies, including what came to be known as narrative or story art. As practiced by the likes of Mac Adams, Bill Beckeley, Peter Hutchinson, Jean LeGac, and Roger Welch—most of whom exhibited at the John Gibson Gallery in New York starting in the mid-1970s—narrative art combined the spirit of systematic inquiry and perceptual curiosity of Conceptual Art with a poetic sense of storytelling, often with the artist/narrator as protagonist. LeGac's series of works featuring "the painter" is typical: the artist speaks through an alter ego, text and photographs are combined as in a child's picturebook, and the tone is a mix of sincerity, irony, and humor.

Roger Welch's narrative art is about memory and its dislocations, suppressions, and inventions. His *Family Photo Pieces* (1972) probe his own family's recollections of occasions depicted in family snapshots. *The Roger Woodward Niagara Falls Project* (1975) records the memories of a boy who survived being swept over the falls. These works combine photographs and the written word in the service of the artist's attempt to locate the past within an imaginative present. Welch's other work includes a series of imaginary children, each drawn from family snapshots provided by a couple, and air-brushed photographs in which individual viewers' recollections determine which parts of the image are revealed and which are obscured. Like most Conceptual artists, he has no allegiance to photography, and uses video, drawing, and even painting as he deems appropriate.

Mac Adams's and Bill Beckeley's photographic works bring to mind the *nouveaux romans* of Alain Robbe-Grillet, novels that strive for narrative force solely through objective description. Like Robbe-Grillet's stories, Adams's and Beckeley's works resemble mysteries; the mute presence of physical objects makes them read like clues to a crime. In Adams's case, the overt association is with a kind of Hitchcockian melodrama. Another artist who sought to create a similarly charged atmosphere is Ger van Elk, who has painted and airbrushed formally posed tableaux photographs to give them an unnerving, otherworldly effect. Peter Hutchinson, on the other hand, is more concerned with the intersections of the natural world and language. In his *Alphabet Scenes* (1974) he combined pictures, anecdotal texts, and sculptural letter-forms in a way that stressed their elemental properties. Hutchinson's earlier work was more purely Conceptualist, documenting his performances on and in the landscape and using photographs as a means to order and reorganize his experiences.

The interest in photographs as tools in the investigation of perception was shared by William Wegman and Robert Cumming, two of the wittiest artists to use photography during the 1970s. Wegman, who began his career using video, found in photographs the perfect foil for his rich and irrepressible imagination. For a time he altered them with paint and scissors, but he learned that he could use them unembellished in groups. *Family Combinations* (1972), a piece done the same year as Roger Welch's *Family Photo Pieces,* uses double printing to combine images of the artist, his father, and his mother, in what is at once an act of genetic speculation and an Oedipal nightmare.

Cumming's photography, which began as a means of documenting his Conceptual, process-oriented sculpture, evolved during the decade into a sustained analysis of the quirks and foibles of the physical world. At first he arranged the photographs, tableau-fashion, using sculptural props made ahead of time, and presented them serially, so that they appeared to record a physical event over time. *Barrier Explosion* (1973) is a classic example of his photographic deceptions: while the piece appears to show a row of boards being pierced by one continuous projectile, the "debris" of the first barrier hangs in

the air in exactly the same position throughout the subsequent prints. Despite the promise of utter honesty suggested by the large-format contact prints, Cumming nearly pulls the wool over our eyes. But he is never interested in true deception, only the appearance of it, and he gives away his sleight of hand in every piece. His is a world that seems to be going hilariously haywire, even in his later "found" images of broken mailboxes, melting snowballs, and *trompe l'oeil* movie sets.

In part because it was enjoyable, and in part because its premises were understandable outside the cave of art-world theory, the work of Cumming and Wegman was among the first Conceptualist-influenced, "extra-photographic" imagery to find a wide audience within the prevailing modernist realm of the photography world. Its acceptance was fueled by an already apparent dissatisfaction with traditional photography. New York's Light Gallery had opened in 1971 to represent the "new" photography not represented at Witkin Gallery, also in New York; however, Light's first director, Harold Jones, chose to show mostly Institute of Design–influenced experimental photography, mixed with established figures like Garry Winogrand. At the George Eastman House in Rochester, the curator of contemporary photography, William Jenkins, saw beyond the medium's formalist constraints. He became so interested in the fact that artists such as Baldessari and Wegman were using photography conceptually that in 1975 he used them as centerpieces of a group show called "The Extended Document." This was one of the photography community's first introductions to Conceptual artists' interest in, and use of, the photographic image.

Another artist using photography who came to the attention of the photography world early in the decade was Lucas Samaras, a sculptor and erstwhile performance artist of a decidedly expressionistic bent. All of Samaras's work proceeds from a primal need to act out psychologically loaded issues, but his manipulated self-portraits, taken with a Polaroid SX-70 camera designed for the amateur market, were his most explicit venture into self-revelation. Exhibiting the same sense of freehand abandon, garish color, and rococo patterning as his work in sculpture and painting, these bizarre, unnerving "Photo-Transformations" brought Samaras's work to a new and broader public, including the audience interested primarily in photography.

Samaras was not alone in probing the psychological territory that lies between the subject and the observer. Peter Campus, a video artist known for his interactive installations, turned to projected slide images in his installations of the late 1970s. Each installation showed a human face, at several times magnification, projecting a specific yet ambiguous emotional charge to which the viewer was compelled to react. The painter Chuck Close, in his forays into photography, produced similar psychologically charged spaces by building larger-than-life portraits from a number of closely detailed fragments. And with their "photo-pieces," the former performance artists Gilbert and George devised a system of personal description and confrontational address based on a grid of prints, some parts of which are colored by

hand. Within this format, the two English artists seek to upset conventionality with content that involves homosexuality, British social attitudes, and what the artists call, in one such piece, "modern fears."

The photograph, as a result of the evidentiary, you-are-there look of its transcription, also proved an able instrument for critiquing the social system and the art marketplace. Besides Haacke, artists such as Les Levine and Victor Burgin have adopted photography as a means of expressing their political messages. For example, Levine's "The Troubles: An Artist's Document of Ulster," a 1979 suite of photo-etchings derived from the artist's own photographs, deals directly with the polarized social fabric of Northern Ireland, while his later series "Art Studio Fashions" depicts college art students holding one-word signs that say, ambiguously but imperatively, "Move," "Heat," "Race," and so on. (Levine, a "media artist" who also paints, writes, and produces videotapes, once coined the term "camera art" to describe his work with photography—and, presumably, to distinguish himself from photographers at large.) Burgin is more overtly political in his work, which in the 1970s focused on the rhetoric of advertising and in the mid-1980s addresses sexual politics from the perspective of Freudian revisionism and poststructuralist theory.

For artists like Haacke, Levine, and Burgin, photography remains important because it functions beyond the boundaries of the art world and is less a part of the established art-world value system than painting and sculpture. However, during the 1970s, as photography came to prominence as a favored medium of vanguard art, its efficacy as a gesture of refusal to participate in the art marketplace proportionally diminished. As photography galleries came into being, as photographs began to be shown along with the more traditional (and valuable) visual arts in galleries and museums, and as auction houses began to feature seasonal photography sales, the medium seemed to have hurdled the last barrier to being accepted as an art.

Indeed, photographs began to appear from unexpected sources and in unexpected places, and anyone on the trail of contemporary art would have trouble avoiding them. Painters, not just Conceptual artists, began to perceive their charms. One of the first to meld paint and photography in a painting context was Lynton Wells, who imported photo-sensitive linen in large rolls, enlarged scenes of lightbulbs onto it, and added paint as a final embellishment. David Hockney became enchanted with the camera's perspectival system, producing a portfolio of snapshots and later fashioning large-scale photomontages that were exhibited with the same fanfare as his paintings. Anselm Kiefer, the German painter whose reputation became international in the 1980s, has used photographs in his work for more than a decade; today even his most thickly painted canvases often have a mural-sized photograph embedded underneath the paint. He has also used photographs as the primary page elements in a series of unique, hand-painted books, for example *Brünhilde Schläft* (1980).

Despite a lingering nervousness among artists about being called "photographers"—Hamish Fulton, for one, still hesitates to participate in shows that contain only photographs, lest his work be mistaken for landscape photography—the 1970s were a decade in which photography flourished within the art world as never before. It happened because of a historical coincidence: photography's claims to being a fully modern art, as most eloquently advanced by John Szarkowski, were beginning to be recognized; and at the same time artists, in reaction to what was perceived as a dead end in painting, began to use photography for reasons of their own. As Judith Tannenbaum remarks in the catalogue *Concept, Narrative, Document*:

> In part, the pervasiveness of photography in the art of the 1970s is related to the greatly increased critical recognition of photography itself. . . . Perhaps both the current widespread popularity of photography and the dependence of much recent art on photographic images can be understood in part as a reaction to Abstract Expressionism and Minimalism. [5]

The attention paid photography's newfound popularity conceals a fundamental shift in the medium's direction, however—a shift that makes speaking of photography *as a medium* problematic. For just as photography had reached its goal of becoming accepted as a modernist art, primarily on its own formalist momentum, the ground had shifted underneath its feet. Modernist purity of means and uniqueness of mediums were no longer the highest values in the art world of the 1970s; instead, the advanced artists of the day were comingling photography, language, performance, painting, video, and other mediums, and collapsing the distance between art and life, high and low culture, the fine and popular arts. There were, in other words, not one but two currents propelling photography to prominence, and to a large extent they were at cross purposes.

Photography's role did not go unchallenged. At the same time that it captured the critical attention and artistic imagination once devoted to painting, painting was staging a comeback. As a result, today the 1970s are remembered chiefly as a decade of pluralism, one in which a variety of styles, movements, and mediums coexisted and were appreciated without prejudice or privilege. This summary and somewhat myopic assessment masks a significant turnaround: at the start of the 1970s it was fashionable to work with any material except paint; by the decade's end painting had come back into its own again. It came back, ironically enough, not in the form of Minimalism or geometric abstraction or anything else redolent of where it had left off, but as a new form of Expressionism—the one arena in which photography could not claim an inherent proficiency. Still, in the years that painting virtually disappeared, photography flourished, and its traditional practice was nourished and transformed by its appearance in the art world. — A.G.

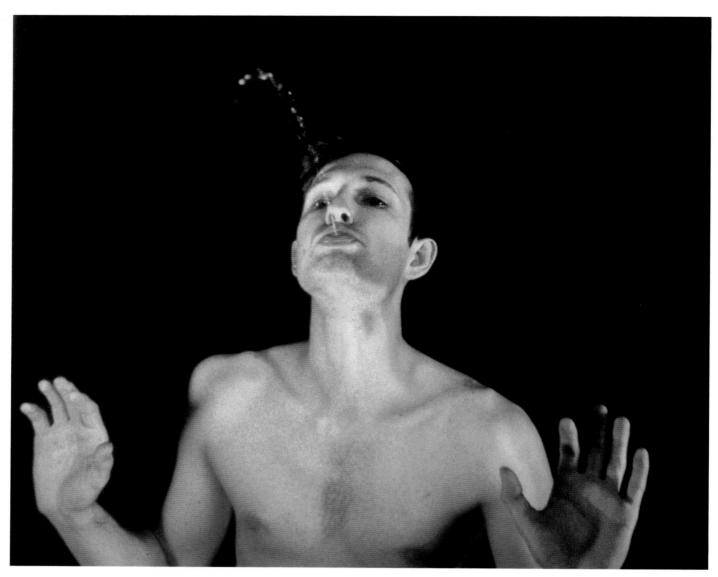

Bruce Nauman
Portrait of the Artist as a Fountain,
from a portfolio of eleven pictures. 1966
Chromogenic-development print
19¾ x 23¾ in.
Courtesy of the Holly Solomon Gallery, New York

WRONG

John Baldessari
Wrong. 1967
Photo emulsion, acrylic on canvas
59 x 45 in.
Los Angeles County Museum of Art
Contemporary Art Council Funds, New Talent Purchase Award

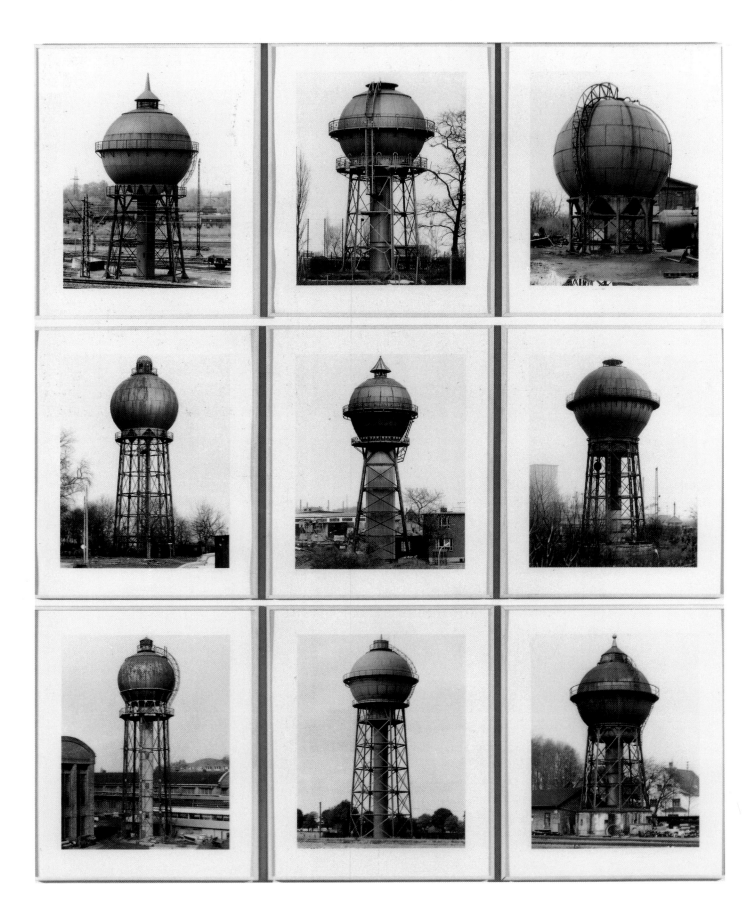

Bernhard and Hilla Becher
Water Towers. 1980
Nine gelatin-silver prints, 20 x 16 in. each
Museum of Fine Arts, Houston

Hans Haacke
The Safety Net (*Proposal for
 Grand Central Station*). 1982
Color transparency and light box
42 x 74 x 6½ in.
Collection of the artist
Courtesy of the John Weber Gallery, New York

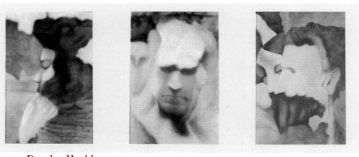

Douglas Huebler
Variable Piece #506/Tower of London. March/May 1975. 1975
Text, gelatin-silver prints, color print, and acrylic on paper
Four panels, 20 x 24 in. each
Collection of Stuart and Judy Spence

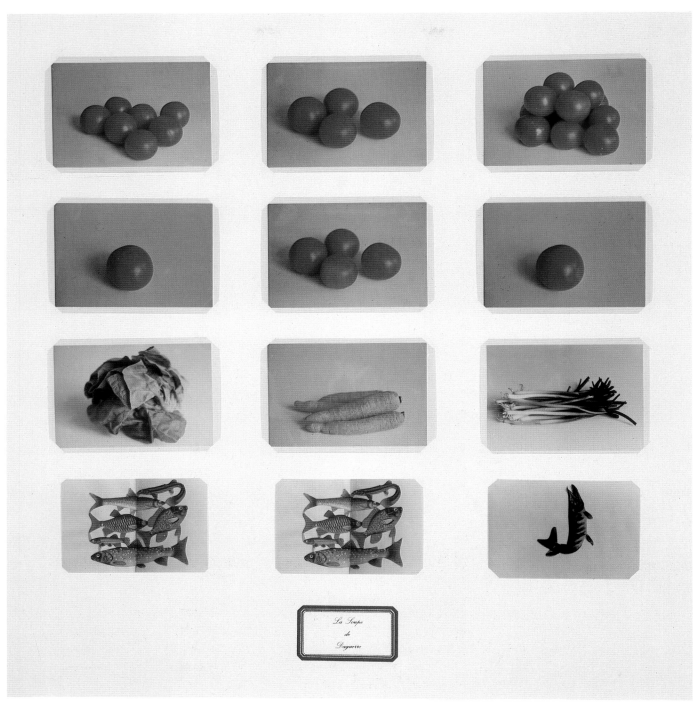

Marcel Broodthaers
La Soupe de Daguerre, 1976
Twelve color-coupler prints on paper
21 x 20½ in.
Courtesy of Multiples/Marian Goodman Gallery, New York

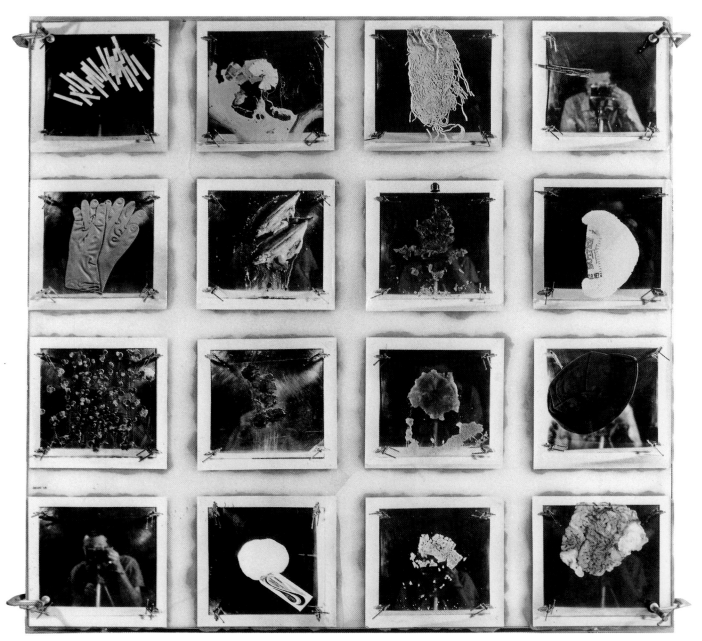

Michael Snow
Press. 1969
Photographs, plastic, and metal clamps
72 x 72 x 10 in.
Collection of Dr. and Mrs. Sidney L. Wax

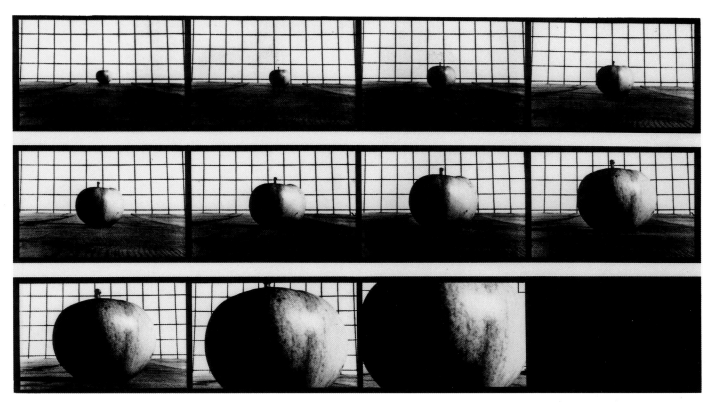

Hollis Frampton and Marion Faller
Apple Advancing (var. *Northern Spy*),
from the series "Sixteen Studies from Vegetable Locomotion." 1975
Gelatin-silver print
11 x 14 in.
Albright-Knox Art Gallery, Buffalo, and Evelyn Rumsey Cary Fund

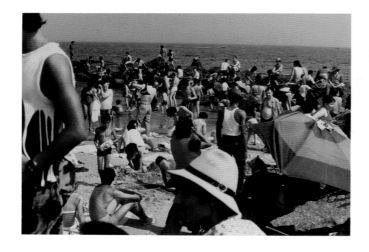
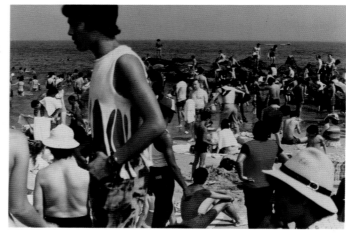
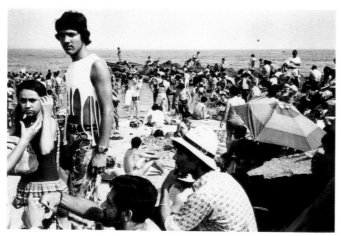
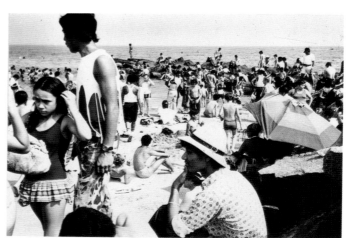

Eve Sonneman
Coney Island. 1974
Two gelatin-silver prints, two chromogenic-development (Ektacolor) prints
23 x 25⁷⁄₁₆ in.
Collection of the artist
Courtesy of Castelli Uptown, New York, and Cirrus Gallery, Los Angeles

Jan Groover
Untitled. 1977
Three chromogenic-development (Ektacolor) prints
11½ x 52 in. overall
Museum of Fine Arts, Houston

John Pfahl
Slanting Forest, Lewiston, New York,
from the portfolio "Altered Landscapes," edition 22/100. 1975
Dye-imbibition print
7⅜ x 10⅛ in.
Los Angeles County Museum of Art
Gift of Barry Lowen

Lewis Baltz
South Wall, Resources Recovery Systems, 1882 McGaw, Irvine,
from the series "The New Industrial Parks near Irvine, CA." 1974
Gelatin-silver print
6 x 9 in.
Newport Harbor Art Museum, Newport
Gift of Dr. and Mrs. Richard Squire Jonas

Mac Adams
Smoke and Condensation. 1978
Two gelatin-silver prints
33 x 58 in. overall
Collection of Andrew Schwartz

One way to end a story is to give it a sad ending. I was riding in a carriage down fifth avenue with a woman, but we had nothing to say. Central park was on the right. Townhouses and museums were on the left. The horse wore blinders; he could not look to the left or to the right and become distracted, losing the way. I was using a portable typewriter. Its carriage clunked from right to left as the sound of the keys synchronized with the clicking of the horse's hoofs. Then one blinder fell loose. He became distracted by the buildings on the right, ignoring the scenery on the left. His steps became irregular and I used some short words—and some long—writing about the parklights that flickered between the trees.

Bill Beckley
Sad Story. 1976
Two silver dye-bleach, one gelatin-silver print, text panel
40 x 30 in. each
John Gibson, New York

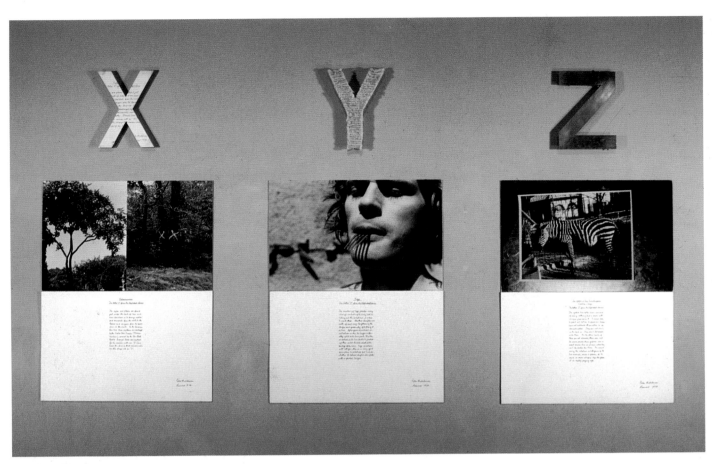

Peter Hutchinson
X, Y, Z, from the "Alphabet Series." 1974
Color prints, texts, and mixed-media letters
Each 60 x 30 in. overall
John Gibson Gallery, New York

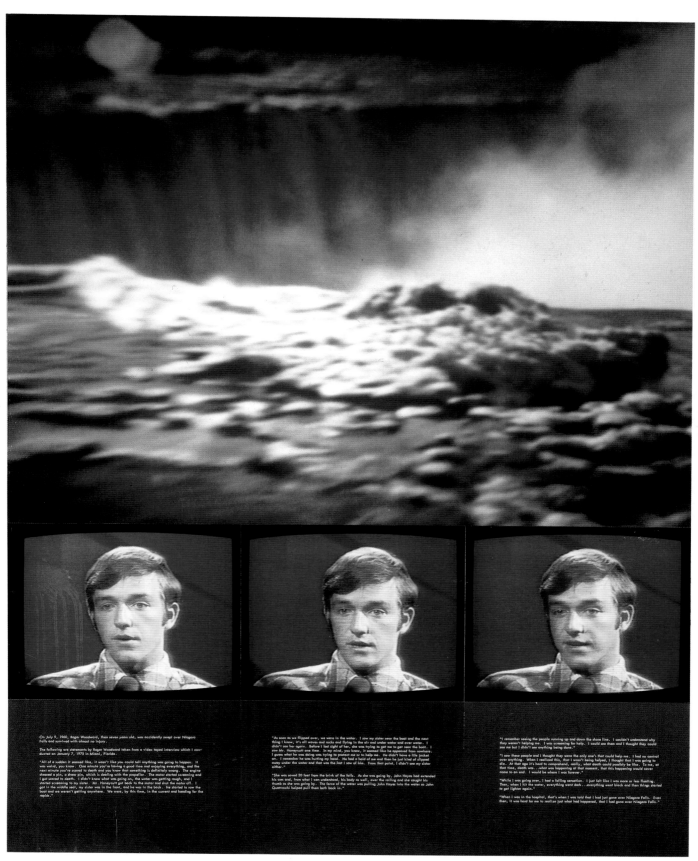

Roger Welch
The Roger Woodward Niagara Falls Project. 1975
Gelatin-silver and color prints and text on board
24½ x 20 in. each
Collection of Tad Crawford, New York

Ger Van Elk
Russian Diplomats,
from the series "Missing People." 1976
Chromogenic-development print
42⅜ x 49⅝ in.
Collection of the Morton G. Neumann Family, New York

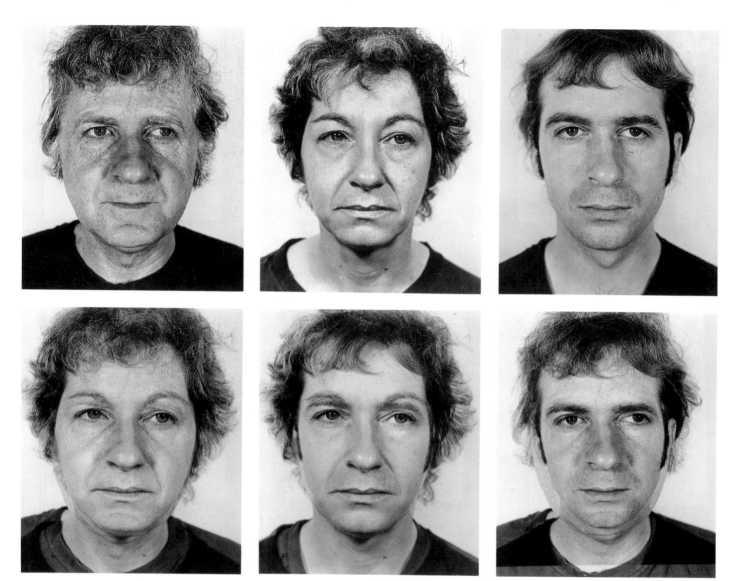

William Wegman
Family Combinations. 1972
Six gelatin-silver prints
11¹³/₁₆ x 14¼ in. each
Collection of Ed Ruscha

Jan Dibbets
Sea, Land. 1975
Five dye-coupler prints
29 x 39 in. framed
Collection of Barbara Kasten

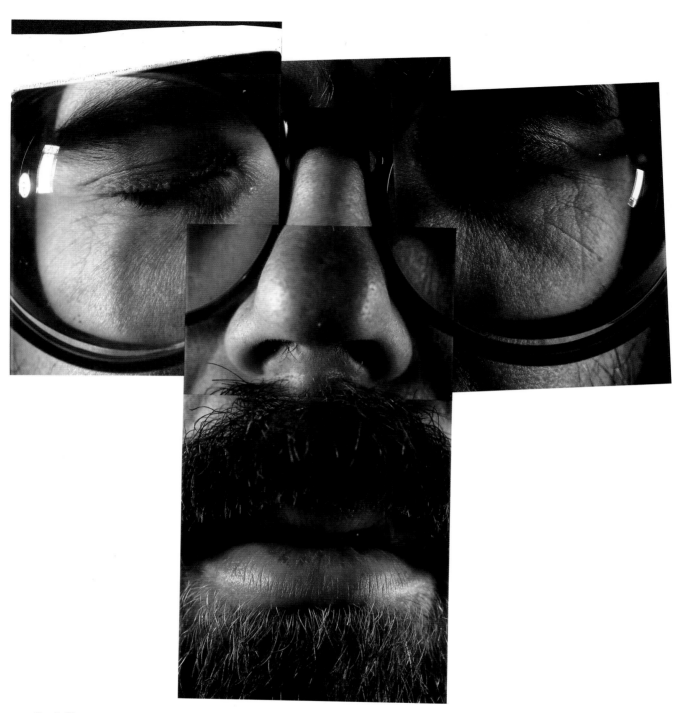

Chuck Close
Self Portrait. 1979
Internal dye diffusion-transfer (Polacolor ER Land film) prints
20 x 24 in. each; 84 x 60 in. framed
Courtesy of the Polaroid Collection, Cambridge

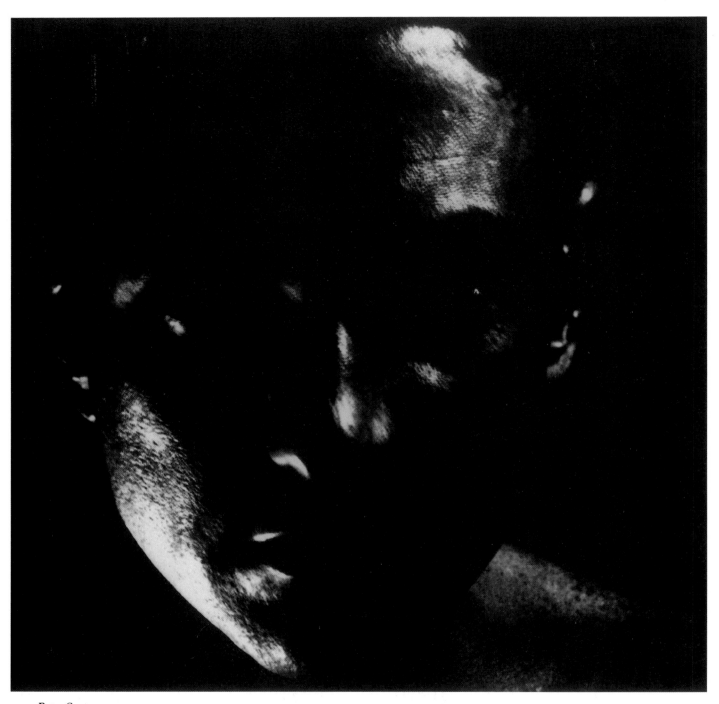

Peter Campus
Man's Head. 1978
Photo-projection
120 x 120 in.
Courtesy of Paula Cooper Gallery, New York

I.R.A. FUNERAL

GENERAL FORD, CHIEF OF STAFF OF BRITISH ARMY, AT BOMB SITE

SISTERS OF A BOMB VICTIM REMOVING SYMPATHY NOTES FROM FLOWERS SENT BY FRIENDS

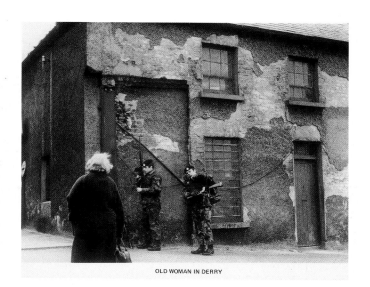

OLD WOMAN IN DERRY

FAMILY LAY DAUGHTER, A BOMB VICTIM, TO REST IN BELFAST

MRS. YOUNG (CATHOLIC) IS CONSOLED BY NEIGHBORS AFTER HEARING HER SON, JOHN, WAS SHOT ON 'BLOODY SUNDAY.'

Les Levine
Selected images from the series "The Troubles: An Artist's
 Document of Ulster." 1979
Gelatin-silver prints, 22 x 30 in. sheet each
Courtesy of Ted Greenwald Gallery, New York

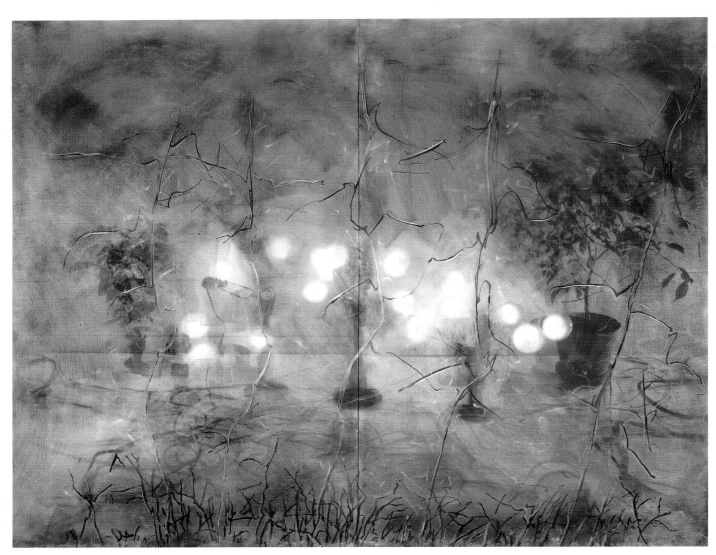

Lynton Wells
December Wizard. 1977
Acrylic on photo-sensitized linen
66 x 84 in.
Collection of the artist

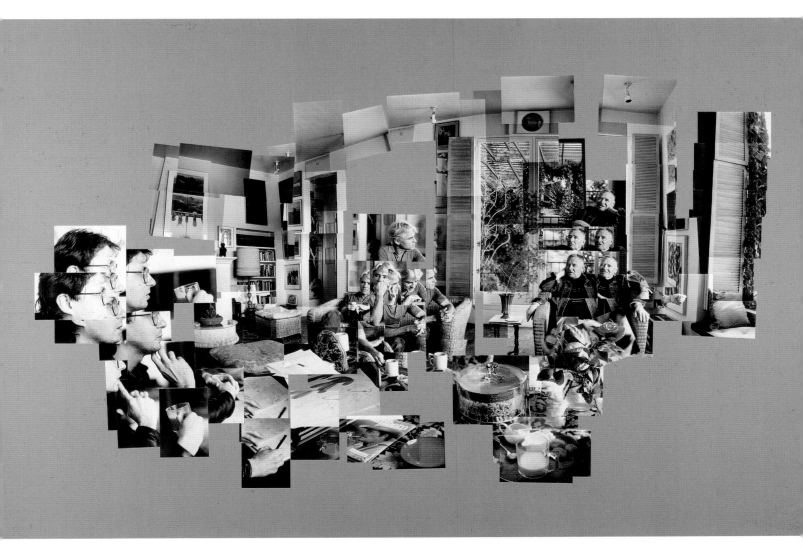

David Hockney
Christopher Isherwood Talking to Bob Holman, Santa Monica,
 14 March 1983. 1983
Collage of chromogenic-development prints
43½ x 64½ in.
Collection of David and Jeanine Smith

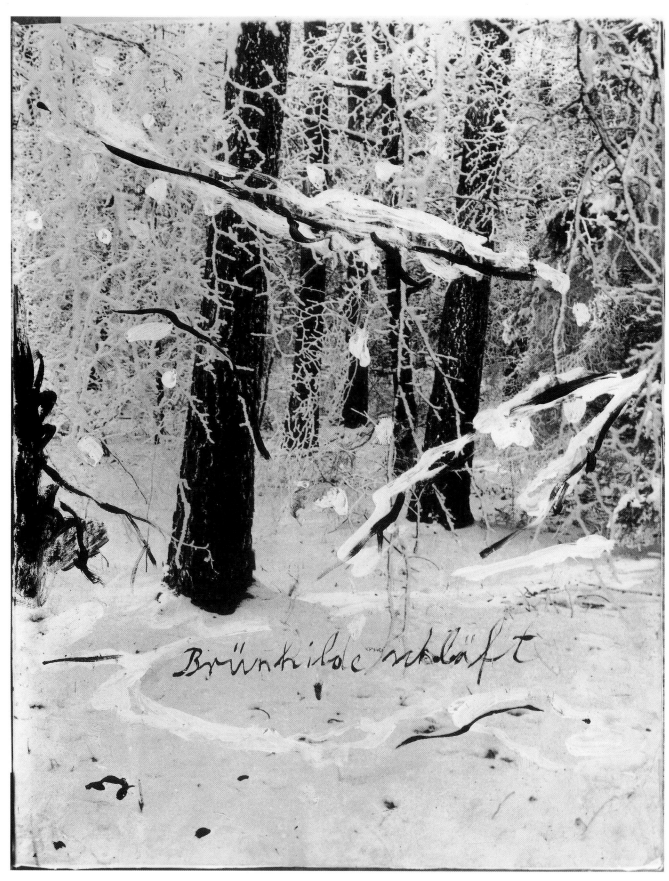

Anselm Kiefer
Cover from *Brünhilde Schläft*. 1980
Gelatin-silver print highlighted with oil; bound book, 23 x 16¾ in.
Toledo Museum of Art, Toledo, Ohio

6.

In the Studio:
Construction and Invention

A major shift in the photography of the 1960s came from artists outside the traditional photographic community, artists concerned not with visual terms alone but with a more intellectual approach, a cerebral loading of the image. For them the reductive tendencies of late modernist photography, with its obsessive allegiance to formalist aesthetics, were effete—or, as Ed Ruscha remarked in the early 1960s, in an unintentional turn on Paul Delaroche's pronouncement on painting a century before, "photography is dead as a fine art." The Conceptual works these artists produced required a new critical approach and vocabulary; the old modernist criteria were not applicable. To some, this type of photograph was suspect, for it abandoned the aesthetic that had finally gained photography wide acceptance. Customary analytical gauges—design, color, texture, form, line, metaphoric nuance, and so on—were irrelevant to conceptual images, which were produced primarily as illustrations of intellectual ideas. Furthermore, the artists in question had no interest in the fine print, the quality of the work as a physical object, or in questions of technique, material, and process—the craft concerns that had been so important in photography. Instead they offered bland descriptive records: snapshot photographs, images intentionally without visual interest. These photographs were not precious objects but mere facts.

In some ways, the Conceptual photograph resembles the traditionally defined documentary photograph, with its function of factual record. The Conceptual photograph may describe time and place, and it may have a narrative element, for the objects and occurrences within it are generally related to each other by a contextual framework. Often that framework is defined by text, whether through a title or through some kind of writing within the image. However, although many Conceptual photographs do act as records, they differ crucially from the documentary image in that the event is often set up or arranged by the artist. Furthermore, these works avoid any aestheticism; they have a stark neutrality and "dumbness," in part informed by the prevailing Minimalist standards in art, which urged the elimination of all un-

necessary visual detail. (These were also, of course, the years of Conceptual Art.) In a sense these artists were anti-photographers, eschewing the tradition of their medium while coopting its process. Their images are akin to "industrial photography";[1] these casual ready-made works, like Marcel Duchamp's ready-made art pieces, are "antiaesthetic." Again in a nod to Duchamp, they describe trivial rather than heroic subjects, and they are also Duchampian in the humor, which is apparent in works such as Bruce Nauman's *Portrait of the Artist as a Fountain* (1966) and Eleanor Antin's series "100 Boots" (1971–73). The banal subjects and meanings of these images from the 1960s and early 1970s have little to do with high art. At the time, though, they offered a welcome avenue of development to the medium of photography.

Conceptual work replaced the hallowed single-image photograph with multiple-frame works, some of them involving a series of comparisons, as in pieces by Bernhard and Hilla Becher and Ruscha, some of them sequences proceeding in time and space like the progressions of Jan Dibbets, John Baldessari, and William Wegman. Whether these photographs record prosaic facts, like Ruscha's *Various Small Fires and Milk* (1964), or more complex issues or sequences of events, they have an underpinning of Conceptualist context or stratagem. The objects they depict are considered not as purely visual subjects, of interest strictly for their sensorial properties, but rather as the exponents of intellectual constructs or statements. Ultimately, the Conceptual movement was yet another manifestation of the kind of modernist reduction that had pared representation down to abstraction; now the object was even relieved of its physical orientation, reduced to an essential idea.

Ruscha, a Los Angeles artist, is known for the language paintings and artist's books that he has produced from the 1960s on. He works in a variety of mediums, although today, by and large, he has left photography behind. He has been influential within photography, however, for as early as 1962 he clearly articulated alternatives for the field besides the formalist fine print. Ruscha's work in the Pop vein of the early 1960s, based on his interest in

common objects and in the vernacular landscape of southern California, increasingly brought him in contact with photography, but the medium remained a tool for him rather than an end in itself. His images are basic, forthright snapshots of phlegmatic contemporary subject matter. *Every Building on the Sunset Strip,* an accordion-fold book from 1966, literally chronicles both sides of the Hollywood street, folding out to several yards long. The visual interest of any one frame is limited—we sense that this volume of banal subjects, like other Ruscha books, is in part a joke at the expense of the documentary tradition in photography—but the collection as an aggregate, and in fact the idea of compiling such a group of images, is more compelling than any single part.

Another Los Angeles artist, John Baldessari, challenged the severe theoretical orientation of Conceptual Art in the 1960s. His paintings, videos, and photographs are concerned principally with language, but, as with Ruscha, they have a definite low-key humor, relieving the seriousness of other artists' approach to the idea as a kind of philosophical grail. This contributes to their accessibility, and ties Baldessari to the Duchampian tradition of questioning the nature of art itself. Common objects and simple ideas drawn from everyday subjects typify his photographs. His works often comprise sequential images, illustrating a changing condition, and incorporating a wider range of data than a single picture could.

Baldessari is almost wholly Conceptual in his use of the photograph; he has scant concern with formal issues. The prominent use of text is seen in his work as early as 1966. *Wrong,* a painting from 1967 based on a snapshot of the artist, with the word "Wrong" written below the image, illustrates his gradually increasing interest in the photographic record, and also shows the importance of language to him: his work often involves this kind of cooperation between writing and image, whether the text is located within the frame or outside it, in the form of a title. In both cases the text is used as a sign system. In some of his photographs Baldessari has set himself tasks, such as blowing cigar smoke to match the shapes of clouds, or throwing four balls in the air to get a straight line. The camera has allowed him to measure his success with these ephemeral activities, and thus it has become his primary spectator. This is true of the Conceptual projects of many artists. The Duchampian notion of art as the product of a process of selection, which also appears in the work of a variety of artists, is another of Baldessari's themes, explicitly in his "Choosing" series of 1975, in which he is seen pointing to an item—a chocolate, a green bean—that he has selected from a trio. Here Baldessari parodies the idea of decision-making while acknowledging the importance of decision in both life and art.

Baldessari's use of the photograph has little to do with its qualities as an art object. To him it is a convenient mechanical tool. In addition, he values its concordance with the mass media, much as he also uses video for its commonality with the ubiquitous medium of mainstream television. Yet despite his detachment from the field, Baldessari has been enormously influential in

photography over the past fifteen years, helping to emphasize a concern with content over a concern with pictorial issues. His role as teacher and mentor in southern California, and his commitment to dismantling the conventions of the medium, have especially contributed to the sense of latitude in the photography of the region.

The Conceptual mode of photography gained considerable momentum in the Bay Area in the late 1960s and early 1970s, for example, in the work of Lew Thomas. His *Black & White* (1971) is a stark, simple work: the leftward of two eleven-by-fourteen-inch sheets of photographic paper is black, with white type spelling out the word "black" while the right sheet is white, with black type spelling out "white." On one level these two brief descriptive "captions" may seem superfluous, but on another they raise questions of the role of text in defining the interpretation of an image. Although *Black & White* makes use of Minimalism, Thomas's concern is not with formal issues but rather with Conceptual photography and the ideas it can address—structuralism, language, coding. By definition the piece is photographic, yet it lacks any of the usual attributes of the photograph. Its visual elements have been pared down to written language. By reducing photography to its essentials—the use of photographic materials and reproduction techniques, and of the classic photographic tones of black and white—Thomas enforces basic Conceptual ideas about the medium, as he does in a number of works from this period.

Several of Thomas's works from the early1970s focus on time and repetition. One of his techniques was to shoot all thirty-six exposures of the standard film roll on basically the same subject, with subtle changes, and then to arrange the results in large grids. The formal, abstract quality of *Light-On-Floor* (1973)[2] initially overrides Thomas's concentration on the essence of the photographic—black, white, and light. Utterly reductive, their subject matter completely submerged in the overall image, Thomas's multiunit works use the frames of the camera film to illustrate perspectives of both time and space.

The various challenges to the reportorial mode of photography that had been mounted in the years preceding 1970 were slight compared to the significant departures achieved during the ensuing decade. Nevertheless, a tandem hegemony of humanism and formalism still dominated the aesthetics of the medium throughout the 1970s. Artists concerned principally with information and content, at the expense of the pictorial, were at odds with much critical and curatorial opinion. These artists had no interest in lenticular observation of the external world, or even of their own private lives; instead, they were interested in making pictures, with a camera, of subjects of their own creation. They were moving away from the traditional view of photography as a process of editing, of selecting from the subjects available—away from a view of the artist as essentially a spectator—and toward a more active role, one of considerably more latitude and responsibility. Much like the early photogram experiments of Man Ray and László Moholy-Nagy in the 1920s,

their works were made indoors, in darkrooms or studios. Such photographs, based on tableaux and other subjects created or organized expressly to be photographed, were fundamentally Constructivist in their conception: the compositions were attained through a process first of conscious thought and reason, then of assemblage in accordance with the previously determined idea. To the extent that the work had precedents, they lay in the photographed assemblages of Frederick Sommer, the formal abstractions of Francis Bruguière, Man Ray's posed shots, John Heartfield's collages, and the studio compositions of Florence Henri, among other examples.[3] These works, all highly innovative for their period, are early examples of the artificial subject in photography.

The Conceptual photographers of the 1970s saw themselves as auteurs, not editors. And once they gained the authority to actually compose and craft images as artists did in other media, such as painting, photography entered an expansive new dimension. Photographers no longer had to work with extant subjects and forms, available light, and the other trappings of reality; no longer had to play the role of witness. The fabrication introduced into the photography of the 1970s was diametrically opposed to the notion of photographic evidence as certifiable truth. Of course, the sort of tweaking of reality in which much of this art indulged had appeared before, for example in the 1960s work of Duane Michals. The issues in most of the earlier sleight of hand, however, were the revelation of a hidden reality and a self-reflective intrigue with the medium of photography. In the 1970s the issue was the right of the photographer to *create* his or her own subject.

Such artifice had long and assiduously been proscribed in the mainstream modernist tradition. The mid-nineteenth-century composite prints of Henry Peach Robinson, for example—posed, operatically scaled narrative tableaux—had stood for decades as an example of sacrilegious abuse of the medium. And the theatricality of William Mortensen's 1930s work was harshly criticized by Purist photographers like Ansel Adams, who insisted on the primacy of the straight, "fine art" photograph over the manipulated or staged image. Modernist photographers took their subjects as they found them. Furthermore, staged images trod uncomfortably close to commercial photography, to advertising or fashion work, domains considered utterly inappropriate for photography that aspired to be taken as an art form. The Conceptualist-influenced photographers of the 1970s, then, were innovative not so much in their use of processes and materials as in their rediscovery of a photographic language that had been excluded by modernist canons. Clearly their works required new aesthetic criteria, a new critical vocabulary.

Paul Berger's "Mathematics" series come not from his personal laboratory but from the scientific setting. Here he recycles fragments of complex mathematical equations and diagrams, using the hastily jotted chalklines as abstractions in a basic way. But more significant, these are also fragments of language, like syllables and phrases reiterated and recombined. The meaning is dense, private, open to the few. The sequence of several score of prints es-

tablishes an ebb and flow of black-and-white, two-dimensional images. They were described by Leroy Searle as being "self-reflexive," that is, about photography itself.

One of the first artists to make extensive use of constructed subject matter for his photographs was Robert Cumming, who had studied painting and had also worked in sculpture of different kinds before turning to the camera.[4] Cumming's works of the early 1970s have a Conceptual orientation, and reveal the influence of his earlier concerns with construction, yet they are emphatically photographic in nature.[5] Cumming did not radicalize the photograph by means of a new process or materials. In technique they are undramatic—they use the traditional materials and format of the eight-by-ten-inch gelatin-silver print and they have none of the aura of preciousness or polish often associated with works of art—but they have nonetheless proved highly seminal in their notions of photographic content and subject matter. These cerebral images are more intellectually engaging than visually arresting: in part, their subject is the photograph's inherent potential for persuasive *trompe l'oeil*, in part it is the notion of the self-created environment or tableaux to replace the external world. The informative titles of the works are paired closely with the images, guiding the viewer's interpretation of them and adding a level of irony.

The staged situations in Cumming's photographs mimic reality, but in a humorous, controlled fashion. These are sets for which the artist has supplied all the props. He creates events similar to elementary science experiments, showing, for example, that "of eight balls dropped from the peak of the roof, two fell to the north, six fell to the south" (in the work of this title from 1974). Here and elsewhere Cumming plays with and distorts the idea of the validity of photographic evidence. His works combine wit, information, an idiosyncratic sense of pictorial composition, and Conceptual ideas, and they also offer a sophisticated integration of sculptural objects, performance, and artifice. These carefully constructed tableaux reflect an interest in cinema, a fascination with the fraudulent reality of the movies. (Cumming has in fact taken photographs of Hollywood sound stages that show all the off-screen machinery used to produce film's illusion of reality.) Tongue-in-cheek references to Eadweard Muybridge's sequential images of a century ago also touch on issues of cinema, artifice, and the photograph as a documentary record.

Like John Pfahl, John Divola employed the picturesque in his photographs. An abandoned apartment on the edge of the Pacific is the subject of his "Zuma" series, a sequel to his earlier series on vandalized interiors. Here Divola records the decline of the space, initially through simple neglect, then through vandalism and fire. His images are not straight documents, however, for he has altered and embellished the site, painting on walls and ceilings. Influenced by Gordon Matta Clark, these photographs are setups for the camera and records of private performances.

Characteristic of Bart Parker's work is the tension between knowable reality and that presented in his images. Parker has effectively used this

disjunction between image and reality in various bodies of work since the late 1960s. However, it is in his pairings of photographs and text that date from the early 1970s that the strength of the photographic image as language and sign is clearest. Parker shrewdly suggests the primacy of the photograph as reality for contemporary society in his *Tomatoe Picture* (1975): a tomato and a photograph of a tomato look virtually identical except for the captions that identify one as the original object and the other as a mere two-dimensional representation. The work offers an example of the postmodernist attitude whereby a representation becomes indistinguishable from the original. And also, by equating sign and object he provides a lucid example of semiological theory.

Les Krims began taking photographs involving constructions and contrived setups as early as 1969. Among his early works of this kind are two series, "The Only Photographs in the World to Ever Cause a Kidnapping" (1972), and, more clearly, "The Incredible Stack O' Wheat Murders" (1972). The latter body of work masquerades as a group of police photographs of murder scenes, each body accompanied by a ludicrously unexpected stack of pancakes as a recurring visual motif and a calling card of the perpetrator. Poking fun at traditional documentary shots and injecting a wry humor into his style, Krims recognized the potential for fakery of the supposedly reportorial photograph, anticipating an approach that would become much more widespread by the end of the 1970s as more camera artists began staging the contents of their images. With its interest in underlying ideas, his work also reflects a Conceptual orientation. Some of his contrived scenes have a mock-instructional purpose, as when they explain how to make chicken soup. By the mid-1970s Krims had begun fashioning elaborate setups involving innumerable proofs, so that the image is crowded with minute details. He has been a controversial figure because of his use of female nudes in a manner considered derogatory or exploitative, and this has obscured the contribution of his tableaux. Yet his small offset portfolios of images have been widely disseminated. He was also an early explorer of the manipulated Polaroid SX-70 photograph, in which the emulsion is rubbed as it sets, producing strange and unusual effects.[6]

One of the earliest examples of full-scale, studio-based tableaux was the collaboration between David Levinthal and Garry Trudeau that resulted in the volume *Hitler Moves East: A Graphic Chronicle, 1941–43*, published in 1977. Based on a project that Levinthal had begun in 1973, the images of battle scenes from the Eastern front have a convincing authenticity. They are completely fraudulent, however, as they are setups using toy soldiers and small models; the mass-produced toys are surrogate actors in the invented and staged drama. These photographs resemble narrative paintings, wherein the artist reconstructs historical events and makes them accessible to the audience. Yet the apparent honesty of the photographs imparts a reality to this endeavor; and their close correlation to actual war photographs adds to their disturbing believability. Levinthal builds on known visual models that have

been disseminated through the mass media: war films, documentary footage, and still images that appeared in magazines. The hazy images invoke the noted Robert Capa photograph *Omaha Beach, near Colleville-sur-Mer, Normandy coast, June 6, 1944. American troops landing on D-Day*. Although Levinthal capitalizes on the blurred, imperfect quality of photographs taken under adverse conditions, these are fictions based on a true event. The act of re-presenting history—and not just a personalized composition—strikes deep at the apparent honesty of the medium. Levinthal forces the viewer to recall his own recollections and images, and to compare them with his artificial narratives.

Los Angeles was an especially fertile ground in the 1970s for artists more concerned with the concept or content of photographic imagery than with its function as a record. The acceptance granted there to works produced in the manipulable space of the studio, instead of as a sampling of subject matter available in the world, may have been due in part to the city's proximity to the film industry, with its extensive use of artifice. Additionally, Los Angeles had little tradition of street photography, and no resident noted practitioners of the mode, such as Joel Meyerowitz or Garry Winogrand in New York. There was no local photography magazine and there was a dearth of photojournalism; no institutional tastemaker like New York's International Center of Photography encouraged humanist documentary work, and no established museum program helped mold taste. All these factors contributed to the city's openness to innovation in photography; but also of importance were the medium's strong connections with the local art milieu and the orientation of the region's photographers toward experiment. Robert Heinecken, for example, played a significant role in encouraging younger artists to develop new approaches, as did Baldessari and Robert Fichter, Cumming, Ruscha, William Wegman, and Douglas Huebler. Edmund Teske, Darryl Curran, and Todd Walker also contributed to the alternative mood of work in Los Angeles.

After training and working as a sculptor, Los Angeles artist Stanley Mock began to investigate photography in the early 1970s, when he was involved in a three-dimensional project incorporating large screens. Discarding the flexible panels he had been using, he produced a number of mural-sized works on photosensitized linen; the big format of these pieces proved to Mock a natural scale to work in after sculpture, and he continued with it in a long-running series of portraits. The nearly life-sized figures in these images were derived from found photographs—discarded portrait-studio takes—that Mock rephotographed and printed on large sheets of cloth or paper, transforming them into anonymity by covering them with a thick waxy layer of colored resin. Their details obscured, the figures have character but no true identity. They are stereotypes, remembrances, modern Romano–Egyptian Fayoum portraits. Mock often reused certain figures, recombining the subjects into pairs or groups. The original photographs served as no more than raw data.

Women photographers have played a key role in the expansion of the

medium in the last ten years, and their contribution has been especially visible in the work of a number of Los Angeles artists. For over a decade Judith Golden has focused on the transformation of a subject, even of the artist herself, into various imaginary roles and personas. Her humorous, irreverently playful approach to the medium may be traced to her studies at the University of California, Davis, home to the funk artist William Wiley and others of similar approach. Golden's work grapples with feminist issues, and with concepts of beauty and illusion. She blatantly manipulates her photographs and then vigorously hand-colors the final print, revealing a license and will to fabricate a contrived public image. During the 1970s Golden repeatedly used herself as a subject in portraits of different types, as in her "Chameleon" and "Magazine" series of the mid-1970s; indecorous and humorous, her self-portraits suggest transitory personas, seemingly adopted for convenience, or for dissimulation. She has frequently used magazine covers or fragments of mass-media images of women to serve as masks, yet has always revealed a more vulnerable self behind the facade. A number of untitled works of hers from 1975 illustrate how people can easily accept a false front to conceal themselves. Seen serially, the images reveal Golden in numerous fraudulent roles gleaned from the media, anticipating the appropriation, role-playing, and narrative elements seen recently in work by younger artists. In the late 1970s Golden began a group of large-scale works using posters from epics and adventure films in which she substituted herself in the place of the leading actress, realizing the housewife's fantasy of seeing herself on screen with a hero.

Suzanne Bloom and Ed Hill began collaborating together in 1974, under the name "MANUAL," a word carrying allusions to the handbook or guide and to touch, reflecting the artists' interest in the phenomenological aspects of art.[7] Trained in painting, they came to photography through its ancillary role in other media; video, for instance, has played a part in their work nearly from the beginning.[8] *Identifying with Mona Lisa* (*The Problematic of Identity Theory I and II*) (1977), a two-panel collage of Polaroid SX-70 prints, electronically merges images of the Leonardo painting with pictures of a modern woman, Stephanie Kaldis, raising the issue of the art object so layered by comment, so often reproduced, so vulnerable to technologies that were unimaginable when it was made, that it is transformed, no longer existing as it was first conceived.[9] MANUAL is interested in the use of reproductions, acknowledging Walter Benjamin's discussion of the original work of art in our age of mechanical reproduction.

Larry Sultan and Michael Mandel, who are also concerned with issues of the social reception of photographs, began working collaboratively in the mid-1970s, producing large-scale pieces such as the monumental billboards *Oranges on Fire* (1975) and *Ties* (1978). Along with these publicly oriented works—they are too big to be seen in anything but a public arena—Mandel and Sultan have made similar pieces, including a series of cards, much like the bubble gum sport cards collected by children, that treat photographers as if they were baseball players. In 1977 the artists published *Evidence,* a book of

vernacular, found photographs taken from the files of different public and corporate institutions.[10] These images reveal amusing relationships to formal photographic concerns and to certain familiar photographic styles, but they also have an anonymity, a deadpan look, which stems from their origin as simple records of information, pictures devoid of aesthetic intention. While these are documentary images, the purpose of *Evidence* is not to describe facts or empirical conditions. The absence of any guiding captions, essays, or other language to establish a context for the images suspends them in the imagination of the viewer, who remains uncertain of their actual meaning. Thus Sultan and Mandel illustrate the key role that language plays in decoding or defining the interpretation of photographs, elaborating on a notion that Benjamin discussed as early as the 1930s, and Roland Barthes, among others, since then.

The media and their portrayal of women have been the focus of Jack Butler's work for over a decade. In 1978 Butler began the series "Excitable Pages," in which he painted over found images taken from magazine illustrations and advertising, then rephotographed them and once again painted on the resulting Cibachrome prints. The works' juxtapositions of media and of different kinds of visual information, and the removal of the images from their contexts, transform the original photography, bringing out meanings that otherwise would remain subliminal. An image of a couple, for example, worked over in paint and presented without the romantic copy that would accompany it in the perfume advertisement from which Butler excerpted it, suggests an ambiguous yet clearly violent encounter. Elsewhere, black tape is used to cross out the eyes of the figures, charging previously neutral poses with an unwholesome aura of the illicit. The visual messages that Butler unveils in these pictures are quite different from those they seem to carry in their original contexts. In both cases, however, the viewer's reading of them is dependent on a form of visual literacy, a familiarity with the cultural conventions that bear on the presentation of the image.

The photographs that Harry Bowers was taking in the late 1970s are large—some of them forty by thirty inches, later works sixty by fifty—but his interest was not in scale for its own sake, but in presenting objects in their actual size. These color prints describe old shirts (often floral Hawaiian ones) and other assorted secondhand clothes, arranged in compositions that suggest characters, perhaps friends of the artist's, more than mere objects. The garments are flattened out, two-dimensional, their representation schematized and planar. Their bright patterns and varied textures bring to the pictures a decorative liveliness that overshadows the formalism of the compositions. Bowers's works are significant not only for their size but also for their use of color, which is broad and painterly, and is integral to the structures of the images. The photographer is in complete control over his palette. His desire and ability to arrange a tableau, to construct a subject for his camera, become more and more evident as his work progresses.

Susan Rankaitis requires studio space for her towering three-yard

panels, which she works on over a period of months. She places the mammoth sheets of paper on the floor, working as a painter might on canvas. Large sheets of metal and airplane parts are used to form the photograms preparatory to the airbrushing, painting, projecting, and contact printing that are all involved in constructing her pieces. Inventing subjects for photographs succeeded the use of Conceptual images and took the form of diverse imaginative tableaux. Small figures and toys, constructions, and elaborate setups have all been devised for the camera. Eileen Cowin moved from still lifes to full theatrical tableaux vivants using family members as subjects. Sandy Skoglund, and others such as Patrick Nagatani, created enormously complex arrangements for the camera. Skoglund combines a sense of humor and of color with her craftsmanship.

In 1978 the Polaroid Corporation began making its twenty-by-twenty-four-inch Polaroid camera available to selected artists. Although photographers had already begun to investigate tableaulike arrangements and constructions, this manner of working received a tremendous stimulus from the Polaroid program. The enormous Polaroid camera is bound to the studio it is housed in, and therefore the artists who use it must bring to it whatever material they wish to photograph, rather than finding their subjects spontaneously in the world. In other words, the camera legitimizes, even actually imposes, the role of auteur. The results have varied; some photographers have suffered from the camera's restrictions. This particular machine requires previsualization, an inventiveness in advance followed by a brief period of high activity. Some of the most successful works executed through the technique are those of Robert Fichter, and the key to his remarkable images is his basic attention to the art of assemblage, which by 1979, when he gained access to the Polacolor camera, had been part of his work for over a decade. A dense subject matter of found imagery and objects was already a natural element in his prints. In addition, they already had a narrative quality, an emphasis on content, and an established iconography. Fichter's Polaroids are far more polished than his other work, but this is only a superficial difference. The Polaroids incorporate his earlier interests—printmaking, drawing, the use of toy soldiers or cowboys; they are not a departure but a summation. They present a riot of visual information—nineteenth-century lithographs and engravings, toys, models, fish, wallpaper, the artist's drawings. And works such as *Veteran Recruit #3* (1980) and *Mr. Mule Presents a Trout* (1980) are clear social comment, criticisms of government and war.

The Polaroids and Cibachromes of Barbara Kasten, who had worked in fiber long before she began making photographs, are based on details from room-sized constructions or installations of paper, mirrors, wire, and various industrial materials. They have their origin in the work of the Constructivist artists, as well as in such earlier images as Florence Henri's 1930s photographs. Before working with these color prints Kasten had made extensive use of the photogram, chiefly in large cyanotypes. These pieces from the early 1970s are minimal and wholly abstract; they show the artist's longstanding

attention to formal concerns, and to the use of everyday materials as subject matter. Around 1976 Kasten's work grew more ambitious, for example when she produced a large-scale screen of gelatin-silver photograms mounted on stretched canvas. Some of the patterns were supplemented by paint, adding a subtle color and texture to the panels. These and subsequent cyanotypes reveal Kasten's increasing interest in Constructivism as a basis for her compositions, and finally in 1980 the Polaroids and then the Cibachromes began to appear. De Stijl colors—blue, red, white, black—contribute to the angular modernist tone and underlying reductivism; the mirror reflections and cutouts amplify the complexity of the compositions. Increasingly, Kasten has varied the palette of her work and has incorporated more diverse objects in her constructions. The installations dominate the photographs and are carefully planned in advance. In some cases Kasten has been interested enough in the physical installation she has created that she has exhibited it along with her photographs of it.

Artists' studios provided subject matter for Leland Rice. In his series of interiors, formal issues of color, light, space, and texture are utilized for his Minimalist compositions. He deftly uses the painted surfaces to form his own intriguing images, which in their simplicity are strangely captivating. Rice never uses color in a heavy-handed manner, and this intelligent use of it separated him from the many practitioners of the later 1970s who employed color superficially, without meaning. His hues are sparing and painterly, in service to the composition and the issues he engages. Rice also expanded the scale of photographs, eventually making thirty-by-forty-inch prints his standard. The scale reflects his subjects, with their expansive, painterly space.

By the end of the 1970s photographic collages were hardly a new genre, but the most common application of the multiple frame was in sequences and progressions. In 1980 Joyce Neimanas began to explore the construction of large panels of numerous frames that together create a rough impressionistic portrait. (David Hockney has done similar work.) Beginning with *Untitled #4* (her numbering sequence is not precisely chronological), Neimanas, whose photographic work extends back into the 1960s, used the small prints of the Polaroid SX-70 camera to assemble dense collages describing interiors and people. These compositions appear to replicate reality, but close scrutiny reveals that they are masterful dissemblers of truth. Her exterior landscapes are fakes—they may be based on an aerial map, for instance, or the same view may be reproduced three times to give the appearance of a continuous scene. Elements appear again and again, often shifting in scale as well as in placement. Neimanas assembles her photographs to suit her own pictorial strategy, which is not to reproduce the scene before the lens: a sitting figure may end up lying on a couch, while a table top is incorporated into the picture not according to the rules of perspective, but as it was shot, from directly above. Neimanas shows how readily the eye conforms to convention, interpreting what it sees according to its habit rather than to what is actually before it. Artifice and fabrication are the hallmarks of these

collages. Neimanas has worked with rectilinear grids, but only briefly—she quickly abandoned this inflexible format for a looser crowd of overlapping Polaroids. She toys with photographic truth, cleverly suggesting that her arrangements have existed in the world. In fact, they are all of her own making.

JoAnn Callis used set-up arrangements of her own design to mimic fragments of memory. The content, lighting, and color are all contrived to heighten the effect she desires and to create the palpable tension of these images. Callis was among the first to capitalize on our familiarity with images produced by the media, including film. These fragments, images without syntax, carry a portentousness far beyond the literal data contained within the picture. It is the viewer who injects the sense of discomfort or uneasiness based on his or her own preconceptions—which in turn are often based on film or print images. Callis's tableaux were radical for their transcendent color sensibility, disinterest in formal aesthetics, and emphasis on constructed scenes. Again they reveal the artist as *auteur,* directing the scene. As with other artists, the studio was essential to the planning and construction of the composition.

Sandy Skoglund, like many artists on the West Coast, created intricately complex arrangements for the camera that looked to the tradition of the still life but are now expanded to full environments. By fashioning whole installations, artists fully constructed a new reality for the camera. Skoglund adroitly used highly saturated, contrasting colors and a plethora of sculptural objects, such as cats or fish, which populate her pictures to skew the otherwise believable image. The unusual colors suggest a realism not ordinarily visible but nonetheless there. These works illustrate the need that was felt by many artists to make physical objects, even if those objects themselves were not the final product. The need for direct, interactive artmaking, seen repeatedly in earlier works, reasserts itself in these installations wherever there is a true interaction between sculpture, painting, and photography. Once again, the demand and the right of the artist to exercise absolute control over his subject is demonstrated.

As has been noted earlier, the photographs of Joel-Peter Witkin disclose a strong link to the Surrealist lineage in photography. Witkin's images indicate the interest of photographers in creating their own subjects and environments, and accordingly his works are planned and then composed in the studio. The various accoutrements and the setting are key components, once again illustrating the shift from the photographer's role as editor or voyeur to that of *auteur.* The controlled studio space allows Witkin to achieve the desired mood of the work, clearly something essential to his photographs. The alleged truthfulness of the photograph combined with the horrific imagery produce powerful, disturbing works far removed from ordinary daily life.

The manipulated image— one altered in the negative or the print— has steadily gained currency since the early seventies. Artists trained in other mediums, and even those with photography backgrounds, found that the combination of the precise photographic image with paint or drawing produced

challenging images. Holly Roberts has all but obliterated the photographic image in her works. Quite distinct from the tedious hand-coloring work that has come and gone in photography, Roberts's pieces use the photograph only as a foundation or springboard. Indeed, the photograph seems more like a palimpsest. The success of her work stems from its simplicity and the honesty of the painting. These pieces also have an eerie quality produced by the effect of rough painterly color subordinating the mechanistic image beneath the surface.

Jeff Weiss has produced environmental works incorporating photographs, steadily moving away from the common form of the medium. His recent monumental multipart Cibachrome works are apocalyptic, examining, in some, politics and environmental issues. Weiss uses the negative image rather effectively in his untitled piece of 1985–86, in which the contorted images of a man and a woman flank a mushroom-shaped cloud, making them insubstantial and transfigured. A video monitor was used in the production of the work, giving the images a screen pattern across the sheet.

The importance of the media-generated image has not been limited to those identified as postmodernists, but has been utilized by numerous artists. One such artist is Dede Bazyk, who studied with John Baldessari. Bazyk has repeatedly used reproductions for her work, often manipulating the print and painting over the large-scale pieces, even puncturing the sheet. Many of her recent works are large, free-standing pieces somewhat allied to her sculptures. Enlarged in scale and brightly colored, these pictures, taken from old biology books, often do not appear to be photographs. The casual pirating of banal imagery and the simple addition of strident hues in these works attest to the distance between traditional aesthetics and the use contemporary artists make of the photograph. — K.M.G.

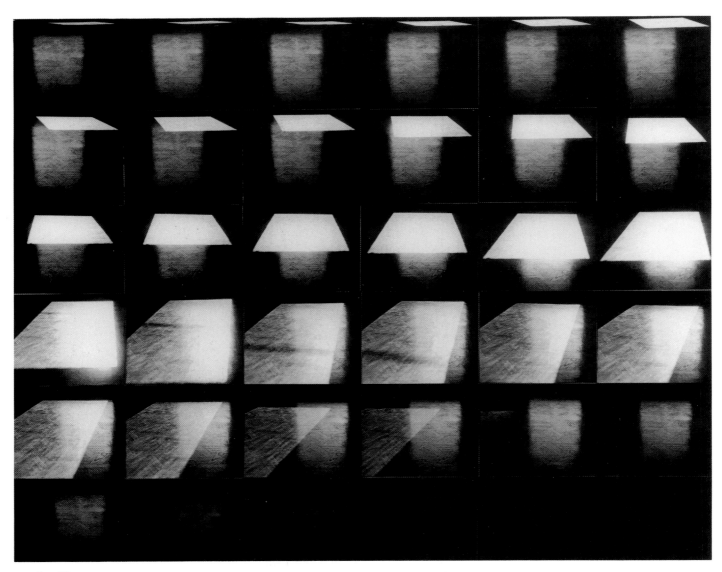

Lew Thomas
Light on Floor. 1973
Thirty-six gelatin-silver prints
48 x 60 in.
Collection of Neil Morse and Jane Kenner

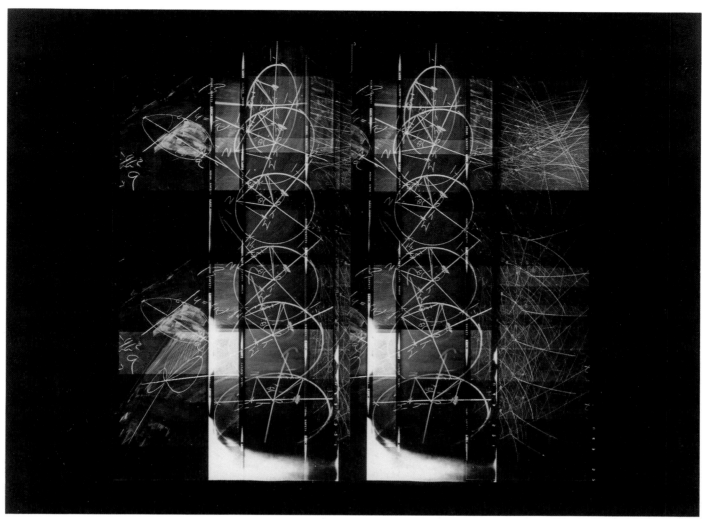

Paul Berger
Mathematics #57,
from the series ''Mathematics.'' 1977
Gelatin-silver print
16 x 20 in.
Collection of the artist

Robert Cumming
Barrier Explosion. 1973
Four gelatin-silver prints
8 x 10 in. each
Collection of John Upton, San Clemente

John Divola
Zuma Number 29,
from the series "Zuma One." 1978
Dye-imbibition print
14⁷/₁₆ x 17⁷/₈ in.
Los Angeles County Museum of Art
Ralph M. Parsons Fund

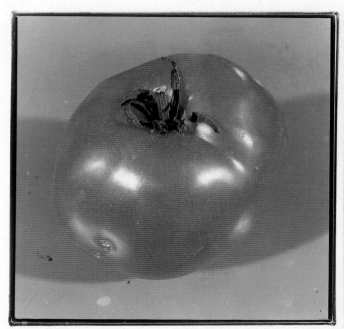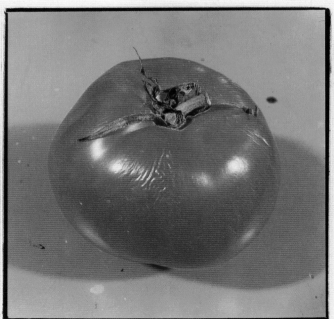

TOMATOE PICTURE

Bart Parker
Tomatoe Picture. 1977
Chromogenic-development (Ektacolor) print
10 x 13 in.
Collection of the artist
Courtesy of the artist and Visual Studies Workshop, Rochester

Stan Mock
Montebello. 1975–76
Photographic emulsion on paper mounted on muslin with aniline dye
 and polyester resin
96 x 82 in.
Collection of the artist

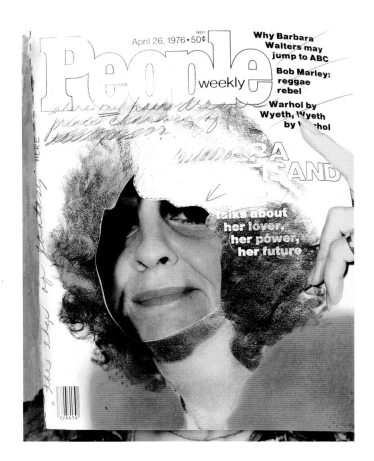

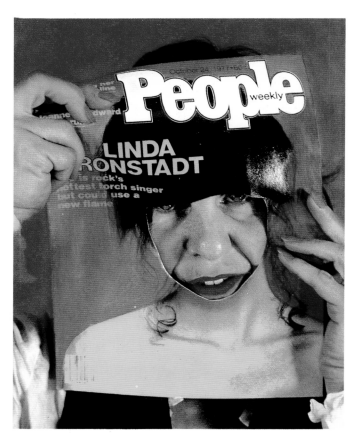

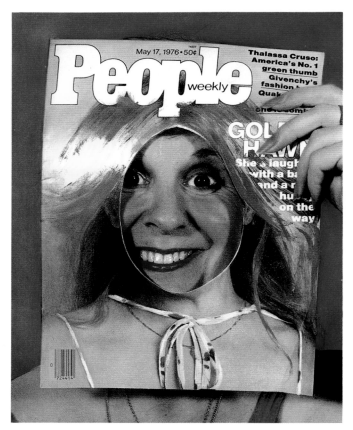

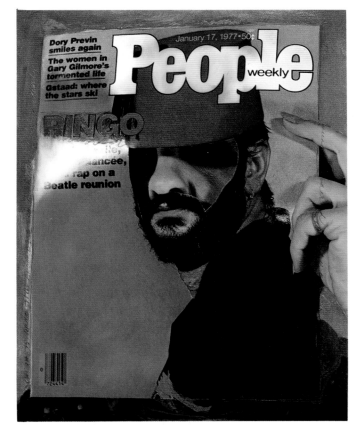

Judith Golden
Barbra Streisand; Linda Ronstadt; Goldie Hawn; Ringo Starr,
from the "Self-Portrait Fantasy Series #4, *People Magazine.*" 1976–78
Four gelatin-silver prints with oil paint, 14 x 11 in. each (approximate)
Goldie Hawn: Collection of Richard Fraioli; others courtesy of the Etherton Gallery, Tucson

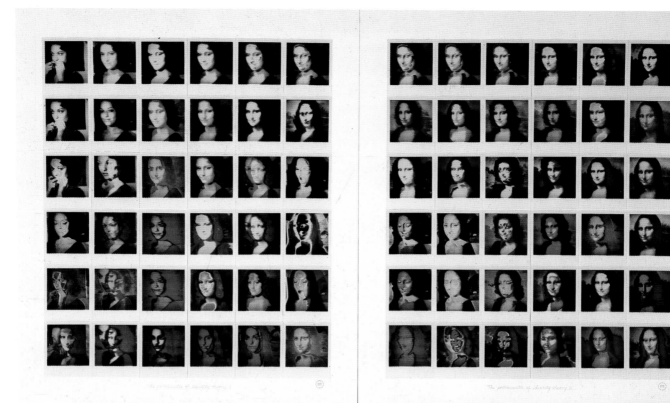

MANUAL (Suzanne Bloom and Ed Hill)
Identifying with Mona Lisa (*The Problematic of Identity Theory I and II*). 1977
Two panels of internal dye diffusion-transfer (SX-70) prints,
30½ x 25 in. each
Museum of Fine Arts, Houston

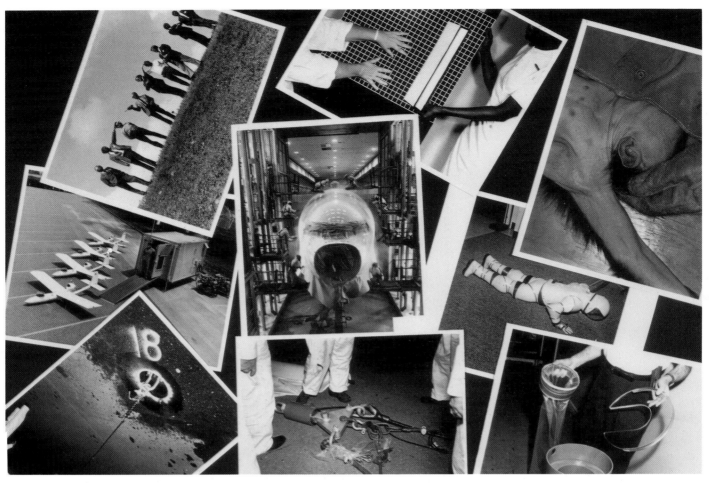

Larry Sultan and Mike Mandel
Selection from *Evidence.* 1977
8 x 10 in. (approx.) each
Courtesy of the artists

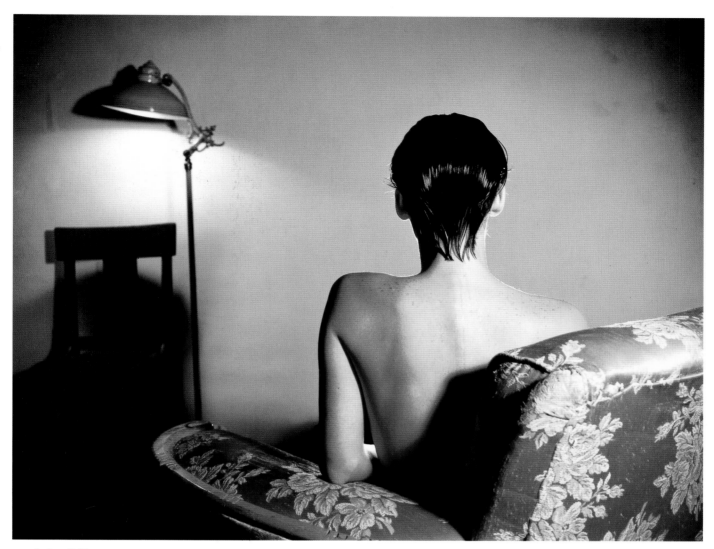

JoAnn Callis
Woman with Wet Hair. 1978
Dye-imbibition print
19⅞ x 23⅞ in.
Los Angeles County Museum of Art
Ralph M. Parsons Fund

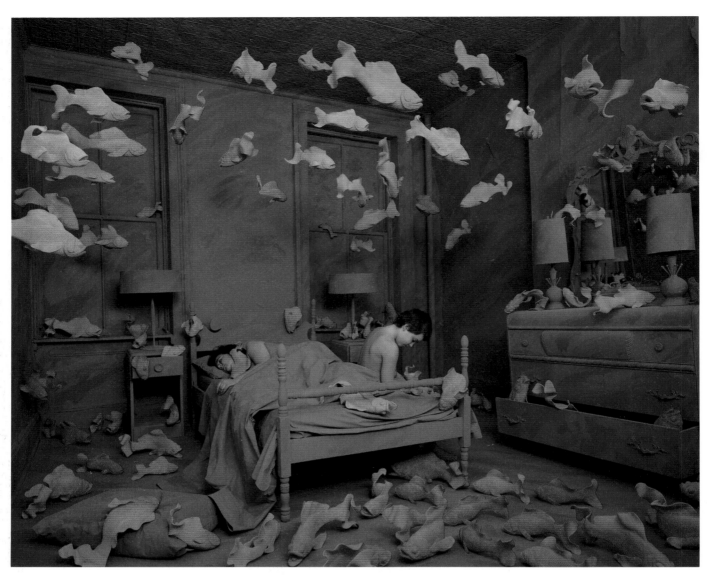

Sandy Skoglund
Revenge of the Goldfish. 1981
Silver dye-bleach (Cibachrome) print
30 x 40 in.
Courtesy of Castelli Uptown, New York

Jack Butler
#26, from the series "Excitable Pages." 1978
Silver dye-bleach (Cibachrome) print with applied color
16 x 20 in.
Los Angeles County Museum of Art

Harry Bowers
Jane, Far and Few,
from the series "Skirts I've Known." 1978
Chromogenic-development (Ektacolor) print, 30 x 40 in.
Courtesy of the artist

Leland Rice
Wall Sites (P.S. 1 Papered Wall). 1978
Chromogenic-development (Ektacolor) print
29½ x 37¼ in.
Collection of Rose Tarlow

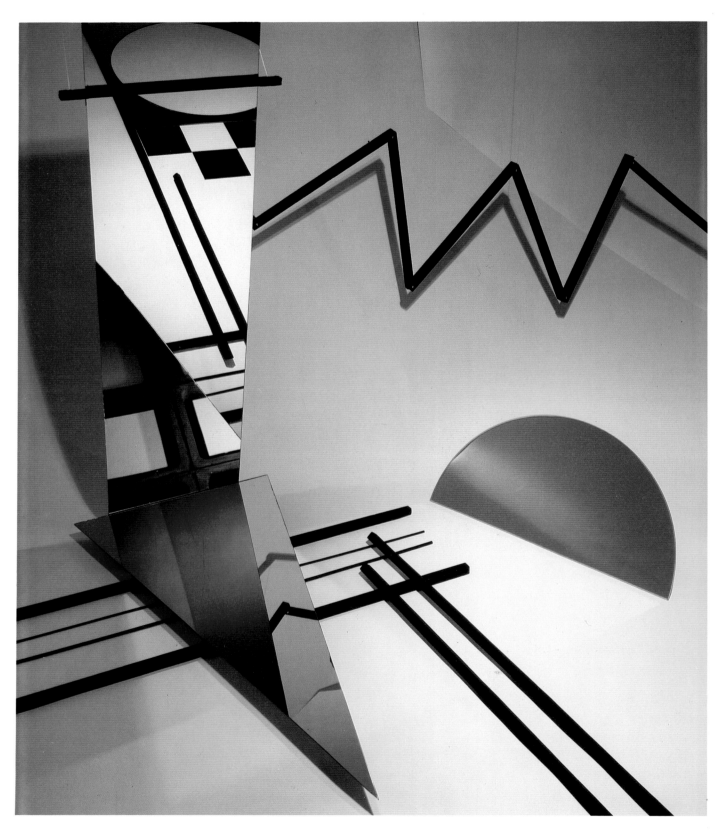

Barbara Kasten
Construct PC/III-A. 1981
Internal dye diffusion-transfer (Polacolor ER Land film) print
20 x 24 in.
Courtesy of the Polaroid International Collection, Cambridge

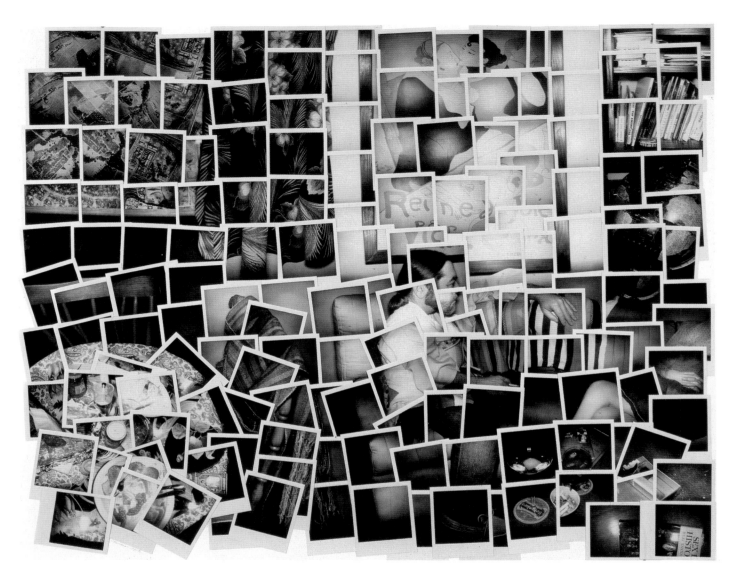

Joyce Neimanas
Untitled #2 (*R.H. with Lautrec Poster*). 1981
Collage of internal dye diffusion-transfer (Polaroid SX-70) prints
31⅝ x 39⅞ in. (sheet)
Collection of the artist

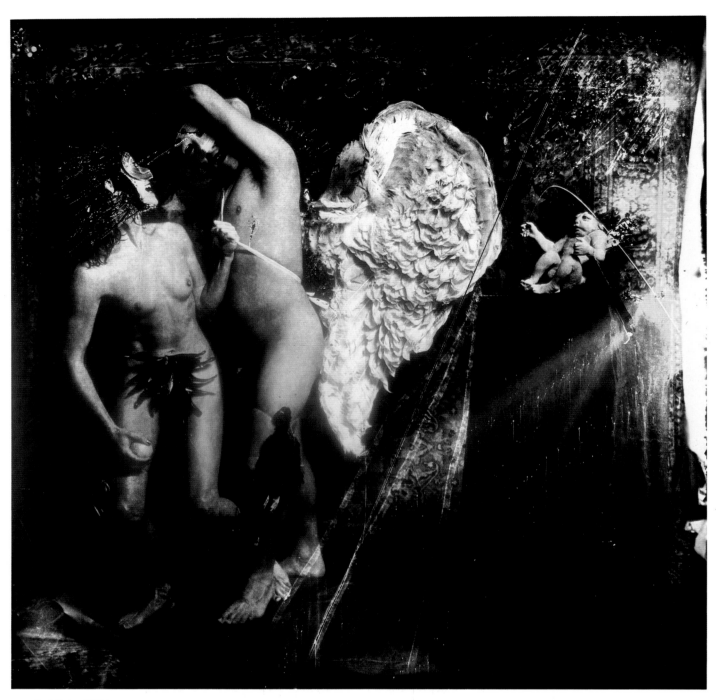

Joel-Peter Witkin
Expulsion from Paradise of Adam and Eve. 1980
Gelatin-silver print
28 x 28 in.
Courtesy of the G. H. Dalsheimer Gallery, Baltimore

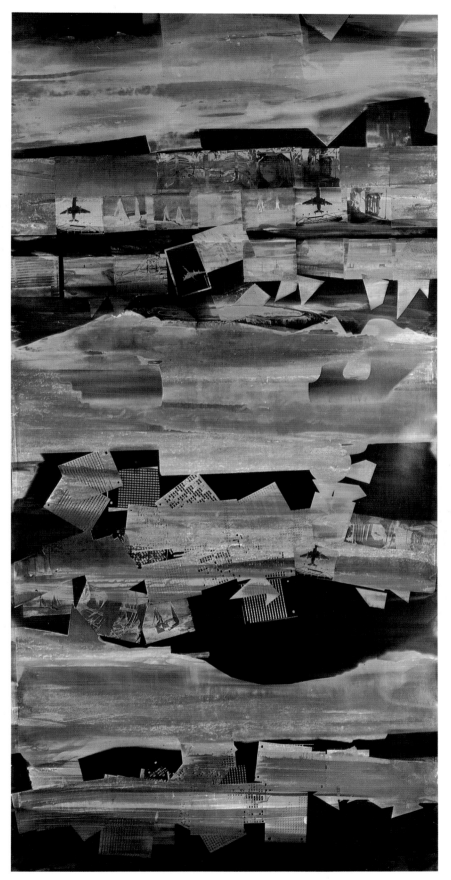

Susan Rankaitis
Lake. 1980
Combined-media photographic monoprint, 82 x 40 in.
Collection of Robbert Flick and Susan Rankaitis

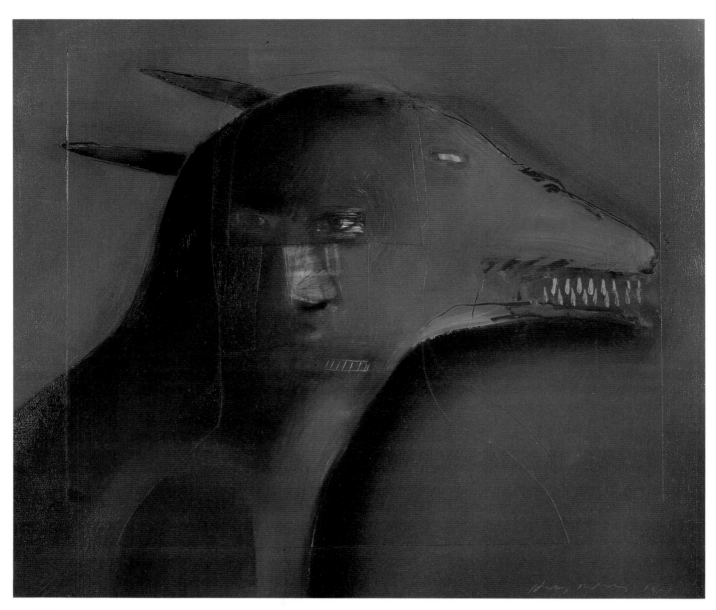

Holly Roberts
Dog with Man Inside. 1986
Oil on gelatin-silver print mounted on canvas
25 x 28 in.
Collection of Ms. Judy Mannes and Mr. David Dantzler

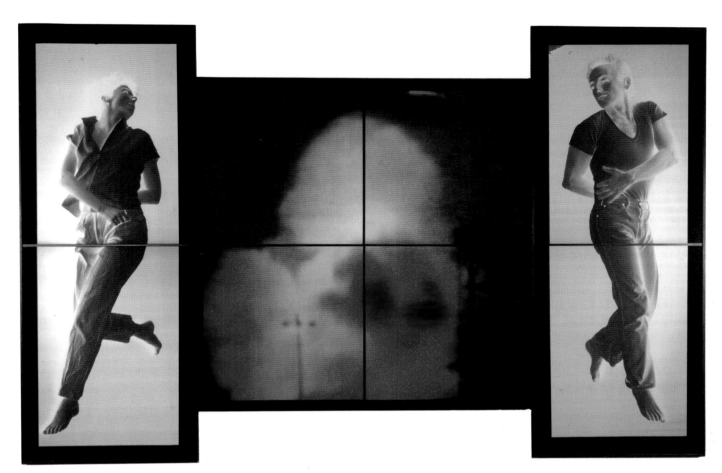

Jeff Weiss
Cross Fire. 1985–86
Silver dye-bleach (Cibachrome) prints
120 x 80 in.
Courtesy of the Burnett Miller Gallery, Los Angeles

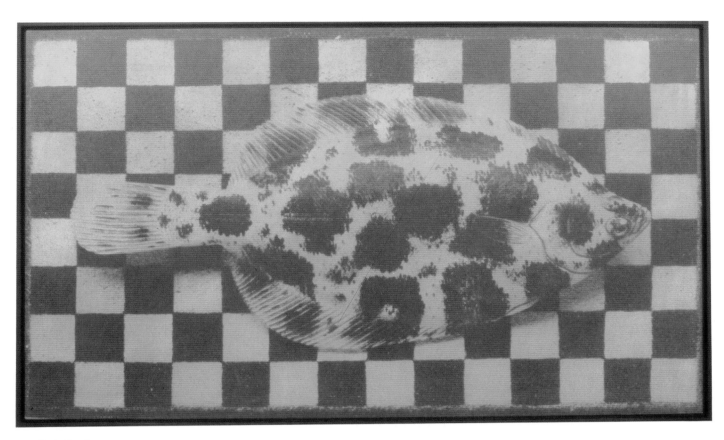

Dede Bazyk
The Grand Facade Soon Shall Burn. 1986
Oil paint on gelatin-silver print
40 x 67½ in.
Collection of Jon Brees Thogmartin

7.

Camera Culture in a Postmodern Age

It has been said that our behavior derives more from what we watch than from our own lived experience. At the very least, camera images now account for a substantial percentage of our visual encounters with the world, and they help teach us about the world to the extent that they are able to convey it. As the Conceptual artist Lawrence Weiner has said in discussing John Baldessari's use of media imagery, "We think of any unknown situation in terms of something we've seen at the movies."[1] Movies, however, are only a part of the story.

The self-conscious awareness that we live in a camera-based and camera-bound culture is an essential feature of the photography that came to prominence in the art world of the early 1980s and has come to be called postmodernist. Generally speaking, postmodernist art accepts the world as an endless hall of mirrors, as a place where all we *are* is images and where all we *know* are images. There is little room in the postmodern world for a belief in the originality of one's experience, in the sanctity of the individual artist's vision. What postmodernist art implies is that things have been used up, that we are at the end of the line in terms of the creation of images, and that we are all prisoners of what we see. Clearly these are disconcerting and radical ideas, and it takes no great imagination to see that photography, as a nearly indiscriminate producer of images, is in large part responsible for them.

In Cindy Sherman's series of black-and-white "Untitled Film Stills" (1978–79), for example, the eight-by-ten glossy publicity print is the model on which the artist manufactures a series of masks for herself. In doing so Sherman unmasks the conventions not only of *film noir* but also of woman-as-depicted-object. The stilted submissiveness of her subjects refers to stereotypes in the depiction of women and, in a larger way, questions the whole idea of personal identity, male or female. Since she has used herself as her subject in all her photographs to date, there is the temptation to call these self-portraits, but in essence they deny the self.

A number of observers have pointed out that Sherman's imagery borrows heavily from the almost subliminal image universe of film, television, fashion photography, and advertising. One can see, for instance, certain correspondences between her photographs and actual film publicity stills of the 1950s. But her pictures are not so much specific borrowings from the past as they are distillations of cultural types. The masks that Sherman creates are neither mere parodies of cultural roles nor are they layers, like the skin of an onion, which, peeled back, might reveal some inner essence. Rather, they admit to the ultimate unknowableness of the "I." By implication they challenge the essential assumption of a discrete, identifiable, recognizable "author" in art—an effect that allies them with poststructuralist, or deconstructive, literary theory, which rejects the notion of authorial intention in favor of interpretive freedom.

There is, of course, a certain self-consciousness in photographs like these, but it is not one that encourages us to identify with the artist in any traditional sense, as in Velázquez's *Las Meninas.* Rather, it is a self-consciousness that promotes an awareness of photographic representation, of the camera's role in creating and disseminating the "commodities" of visual culture.

The same awareness can be seen in Eileen Cowin's tableaux images taken since 1980, which she once called "Family Docudramas." Modeled loosely on soap-opera vignettes, film stills, or the sort of scenes one finds in a photographic romance comic, these elegant photographs depict arranged family situations in which a sense of discord and anxiety prevails. Like Sherman, Cowin uses herself as the foil of the piece, and she goes further, including her own family and, at times, her identical twin sister. In the pictures that show us both twins at once, we read the two women as one: as participant and as observer, as reality and fantasy, as anxious ego and critical superego. Cowin's tableaux violate many of the conventions of familial self-depiction, but even more importantly, they unmask conventional notions of interpersonal behavior, opening onto a chilling awareness of the disparity between how we think we behave and how others see us behave.

Laurie Simmons's photographs are as carefully staged—as fabricated, as directed—as those of Cindy Sherman and Eileen Cowin, but she usually makes use of miniaturized representations of human beings in equally miniaturized environments. In her dollhouse images of the late 1970s, female figures grapple somewhat uncertainly with the accoutrements of everyday middle-class life—cleaning bathrooms, confronting dirty kitchen tables, bending over large lipstick containers. Simmons clearly uses the doll figures as stand-ins—for her parents, for herself, for cultural models as she remembers them from the 1960s, when she was a child growing up in the suburbs. She is simultaneously interested in examining the conventions of behavior she acquired in her childhood and in exposing the conventions of representations that were the means by which these behavior patterns were transmitted. As is

true also of the work of Ellen Brooks, the dollhouse functions as a reminder of lost innocence. But Brooks's melodramatic tableaux have an acidic edge, and an atmosphere of sexual tension that makes them more disturbing than nostalgic.

In their work, Sherman, Cowin, Simmons, and Brooks all create surrogates, emphasizing the masked or masking quality of postmodernist photographic practice. Other photographers, however, concentrate our attention on the simultaneous process of unmasking. One of these is Richard Prince, the leading practitioner of the art of "rephotography." Prince photographs pictures that he finds in magazines, cropping them as he sees fit, with the aim of unmasking the syntax of the language of editorial and advertising photography. Like the others, he implies through his art the exhaustion of the image universe: it suggests that a photographer can find more than enough images already existing in the world without the bother of making new ones. Pressed on this point, Prince will admit that he has no desire to create images from the raw material of the physical world; he is perfectly content to glean his material from photographic reproductions.

Prince is also a writer of considerable talent. In his book *Why I Go to the Movies Alone,* we learn something of his attitudes toward the world—attitudes that are shared by many artists of the postmodernist persuasion. The characters he creates are called "he" or "they," but we might just as well see them as stand-ins for the artist, as his own verbal masks:

> Magazines, movies, T.V., and records. It wasn't everybody's condition but to him it sometimes seemed like it was, and if it really wasn't, that was alright, but it was going to be hard for him to connect with someone who passed themselves off as an example or a version of a life put together from reasonable matter. . . . His own desires had very little to do with what came from himself because what he put out (at least in part) had already been out. His way to make it new was *make it again,* and making it again was enough for him and certainly, personally speaking, *almost* him.

And:

> They were always impressed by the photographs of Jackson Pollack [sic], but didn't particularly think much about his paintings, since painting was something they associated with a way to put things together that seemed to them pretty much taken care of.
>
> They hung the photographs of Pollack right next to these new "personality" posters they just bought. These posters had just come out. They were black and white blow-ups . . . at least thirty by forty inches. And picking one out felt like doing something any new artist should do.
>
> The photographs of Pollack were what they thought Pollack was about. And this kind of take wasn't as much a position as an attitude, a feeling that an abstract expressionist, a TV star, a Hol-

lywood celebrity, a president of a country, a baseball great, could easily mix and associate together . . . and what measurements or speculations that used to separate their value could now be done away with. . . .[2]

Prince's use of existing images is one version of a postmodernist practice that has come to be called "appropriation." In certain quarters appropriation has gained considerable notoriety, largely as a result of works like Sherrie Levine's 1979 *Untitled (After Edward Weston)*, for which the artist simply made a copy print from a reproduction of a famous 1926 Edward Weston image (*Torso of Neil*) and claimed it as her own. It seems important to stress that appropriation as a tactic is not designed *per se* to tweak the noses of the Weston heirs, to *épater les bourgeois*, or to test the limits of the First Amendment. Nor is it necessarily the *sine qua non* of postmodernism. It is, rather, a direct, if somewhat crude, assertion of the finiteness of the visual universe.

Because a copy photograph can have much the same surface texture, if not quite the same tones, as an original photograph, Levine's *tabula rasa* appropriations from art photography frequently depend on: first, their captions; and second, a theoretical explanation that one must find elsewhere. But her subsequent copies of paintings—made from reproductions found in art books—made her intentions explicit: they are clearly stand-ins for the originals, lacking the physicality of the brushstrokes and, to anyone acquainted with the originals, a true rendition of their colors. The imperfections of the reproductions from which Levine copies are magnified and made obvious.

Those artists using others' images believe, like Prince, that it is dishonest to pretend that untapped visual resources still exist in some hypothetical, Edenic woods, waiting to be found by artists who can then claim to be original. For them, imagery is now overdetermined—that is, the world already has been glutted with pictures taken in the woods. Even if this weren't the case, however, no one ever comes upon the woods culture-free. In fact, these artists believe, we enter the woods as prisoners of our preconceived image of the woods, and what we bring back on film merely confirms our preconceptions.

Another artist to emphasize the unmasking aspect of postmodernist practice is Louise Lawler, who examines with great resourcefulness the structures and contexts in which images are seen. Her art-making activities fall into several groups: photographs of arrangements of pictures made by others, photographs of arrangements of pictures arranged by the artist herself, and installations of arrangements of pictures. Why the emphasis on arrangement? Because for Lawler—and for all postmodernist artists, for that matter—the meaning of images is always contingent on their contexts, especially their relations with other images. One often has the feeling in looking at her work that one is trying to decode a rebus: the choice, sequence, and position of the pictures she shows us imply a rudimentary grammar or syntax. In *Slides by*

Night (*Now That We Have Your Attention What Are We Going to Say?*), her installation piece of 1985, Lawler presents a slot-machine-like sequence of images that then "paid off" with pictures of classical sculpture stored in a museum basement. Significantly, the original installation at Metro Pictures gallery in New York could only be seen at night, through the windows of the darkened, locked gallery.

Barbara Kruger's pictures integrate appropriated photographs with imperative text, using the rhetoric of political sloganeering and hard-sell advertising to address the disparity between the viewer and the viewed in terms of feminist theory. "Your manias become science," we read in one such collage—and the "you" seems clearly male. "We are your circumstantial evidence," we read in another—and the "we" seems clearly female. But the work has a strange reversal embedded within it: the voice, conventionally an instrument of authority, power, and control, is given over to the victim, the dispossessed. In this way Kruger's *prima facie* vitriol reveals that the "innocent" discourse of billboards, commercials, and advertisements is politically charged.

A similar sort of sly unmasking of the discourse of the status quo appears in the work of Victor Burgin, an English artist who makes political issues primary in his work. Since the middle 1970s he has used photographs in combination with words to highlight social inequities and, of late, sexual codes, as in *The Bridge* (1984). Equally well versed in Marx, Freud, Barthes, and Lacan, he transposes intellectual conceits into a form that approximates that of billboards, creating enigmatic and powerful tableaux. In *The Bridge*, notions about sexual difference are paired with scenes from a Hitchcock film.

In James Welling's pictures yet another strategy is at work, one that might be called appropriation by inference. Instead of re-presenting someone else's image, they present the archetype of a certain kind of image. Unlike Prince, Levine, Lawler, and Kruger, Welling molds raw material to create his pictures, but the raw material he uses is likely to be as mundane as crumpled aluminum foil, Jell-O, or flakes of dough spilled on a velvet drape. These pictures look like pictures we have seen—abstractionist photographs from the Equivalent school of modernism, for instance, with their aspiration to embody some essence of human emotion. In Welling's work, however, the promise of emotional expressionism is always unfulfilled. His pictures present a state of contradiction. In expressive terms they seem to be "about" something specific, yet they are "about" everything and nothing. To the artist they embody tensions between seeing and blindness; they offer the viewer the promise of insight but at the same time reveal nothing but the inconsequence of the materials with which they were made. They are in one sense landscapes, in another abstractions; in still another sense they are dramatizations of the postmodern condition of representation.

The "Perpetual Photos" of Alan McCollum are in much the same vein, locating themselves at the outer limit where representation approaches

abstraction, and where the specific and individual degenerates into the generic. McCollum has enlarged sections of still images of television shows, concentrating on the framed artworks that hang on the walls of the sets. When blown up beyond the limits of their definition, the alleged art appears as pure shapes of black and white.

Similarly, Sarah Charlesworth, in her posterlike presentations of totemic figures, and James Casebere, in his patently artificial constructions of houses and street scenes, remove photography from the domain of the particular and edge it toward the generic. In the process they alert us to the fact that photographs not only contain signs, they *are* signs. By stylizing them, they create an equivalence between a photograph's content and its physical presence. Welling, McCollum, Charlesworth, and Casebere all treat photographic images as ambiguous signs, as carriers of meanings quite apart from their apparent intentions.

This kind of postmodernist art is on the whole not responsive to the canon of art photography. These artists use photography because it is an explicitly reproducible medium, because it is the common coin of cultural image interchange, and because it avoids the aura of authorship that the poststructuralist thought of Jacques Derrida and others calls into question—or at least avoids that aura to a greater extent than do painting and sculpture. Photography is, for these artists, the medium of choice; it is not necessarily their aim to be photographers, or, for most of them, to be allied with the traditions of art photography. They come, by and large, from the tradition of Conceptual Art, which influenced many of them when they were in art school. But at least as large an influence on these artists is the experience of present-day life itself, as perceived through popular culture: TV, films, advertising, corporate logoism, public relations, *People* magazine, and the entire industry of mass-media image-making.

Postmodernism in art also comes equipped with a theory about how we perceive the world, one that is rooted in the early twentieth-century structuralism of Swiss linguist Ferdinand de Saussure and the semiotics of the American philosopher C. S. Peirce. What structuralist linguistic theory and semiotic sign theory have in common is the belief that things in the world—literary texts, images, whatever—do not wear their meanings on their sleeves. They must be deciphered, or decoded, to be fathomed. But today, as a consequence of the "deconstruction" theory of Derrida, all meanings are understood to be provisional—that, as Terry Eagleton suggests in *Literary Theory: An Introduction:*

> Nothing is ever fully present in signs: it is an illusion for me to believe that I can ever be fully present to you in what I say or write, because to use signs at all entails that my meaning is always somehow dispersed, divided and never quite at one with itself. Not only my meaning, indeed, but *me:* since language is something I am made out of, rather than merely a convenient tool I use, the whole

idea that I am a stable unified entity must also be a fiction. . . . It is not that I can have a pure, unblemished meaning, intention or experience which then gets distorted and refracted by the flawed medium of language: because language is the very air I breathe, I can never have a pure, unblemished meaning or experience at all.[3]

This inability to have "a pure, unblemished meaning or experience at all" is the central premise of the art we call postmodernist. And it is, quite naturally, a theme that characterizes much of the photography of the 1980s, explicitly or implicitly. Ruth Thorne-Thomsen's miniature landscapes, for example, which evoke the glories of nineteenth-century exploratory photography, are made from tiny arrangements set up by the artist on the Chicago lakefront. Joel-Peter Witkin's morbid grotesqueries, while clearly allied to Surrealist precedents, frequently are based on the compositions and subject matter of classic paintings.

Many artists today are trying to find ways to compensate for the depletion of the single image's efficacy. Nan Goldin's *tour-de-force* slide-and-sound show, *The Ballad of Sexual Dependency*, relies on the cumulative impact of several hundred images and a score of pop songs to communicate its message about contemporary mores; the individual photograph is subordinated because no one picture alone can tell the whole story. The same is true of Neil Winokur's "totems," portraits that, in their attempt to describe their subjects, rely not just on the image of a face but also on personal objects. By working in multiples, photographers like Goldin and Winokur acknowledge the inadequacy of the single image and imply that photographic meaning is more complicated, fragmentary, and elusive than Stieglitz's notion of the Equivalent suggests.

To dramatize the secondhand condition of experience, artists such as Robert Mapplethorpe, Sherman, Thorne-Thomsen, and Witkin rely on pastiche, what Frederic Jameson has called "speech in a dead language . . . blank parody, parody that has lost its sense of humor."[4] Pastiche can take many forms; it doesn't necessarily mean, for example, that one must collage one's sources together, as Rauschenberg did in his combine paintings and photo-collaged silkscreens. This calling up of historical precedent resembles the postmodernism of architecture, in which ornamentation is "borrowed" from past styles without regard for its original meanings. But much of what is "borrowed" in photographs is outside the medium's artistic traditions; in Sherman's color work the antecedent is popular visual culture, and in Winokur's portraiture it is commercial photography.

It is worth noting, however, that within the art photography of the last forty years there are antecedents for the postmodernist involvement with pastiche, appropriation, and mass-media representation. Robert Heinecken, for example, rephotographed magazine imagery in his "Are You Rea" series (1964–68). One can even see the seeds of a postmodernist attitude in the

work of Walker Evans and Robert Frank. Besides paying attention to the presence of signs in the landscape, they saw photography as a sign-making or semiotic medium, as is clear from the structure and sequencing of Evans's *American Photographs* and Frank's *The Americans*. The inheritors of this legacy adopted both their recognition of the photograph as a social sign and their apparently skeptical view of American culture. Lee Friedlander's work, for example, despite having earned a reputation as formalist in some quarters, consists largely of a critique of our conditioned ways of seeing.

We might also look again at the work of younger photographers we are accustomed to thinking of as formalists. Consider John Pfahl's series of "Altered Landscapes." Pfahl uses his irrepressible humor to mask a more serious intention, which is to call attention to our absence of innocence with regard to the landscape. By intervening in the land with his partly Conceptual, party madcap bag of tricks, and by referencing us not to the scene itself but to its postcard simulation, he supplies evidence of the postmodern condition. In short, it does not seem possible in this day and age to claim that one can have a direct, unmediated experience of the world. All we see is seen through the kaleidoscope of all that we have seen before.

The overlap between modernist and postmodernist practice seems to appear not only in photography but in the painting and sculpture tradition as well, where, as mentioned earlier, Rauschenberg's work of the 1950s and 1960s appears, in retrospect, to be proto-postmodern, as do Andy Warhol's silkscreen paintings based on photographs. Not only did Rauschenberg, Warhol, and others break with Abstract Expressionism, they also brought into play the photographic image as raw material, and the idea of pastiche as artistic practice.

It seems unreasonable to claim, then, that postmodernism in the visual arts necessarily represents a clean break with modernism—that, as Douglas Crimp has written, "Postmodernism can only be understood as a specific breach with Modernism, with those institutions which are the preconditions for and which shape the discourse of Modernism."[5] Indeed, there is even an argument that postmodernism is inextricably linked with modernism—an argument advanced most radically by the French philosopher Jean François Lyotard in the book *The Postmodern Condition: A Report on Knowledge*:

> What, then, is the Postmodern? . . . It is undoubtedly a part of the modern. All that has been received, if only yesterday . . . must be suspected. What space does Cézanne challenge? The Impressionists. What object do Picasso and Braque attack? Cézanne's. What presupposition does Duchamp break with in 1912? That which says one must make a painting. . . . *A work can become modern only if it is first postmodern.* Postmodernism thus understood is not modernism at its end but in the nascent state, and this state is constant.[6]

It is clear, in short, that postmodernism as a critical enterprise—not postmodernism conceived as pluralism, but the postmodernism that seeks to

make problematic the relations of art and culture—is itself problematic. Postmodernism swims in the same seas as the art marketplace, yet claims to have an oppositional stance toward that marketplace. It attempts to critique our culture from inside that culture, believing that no "outside" position is possible. It rejects the notion of the avant-garde as one of the myths of modernism, yet in practice it functions as an avant-garde. And its linkage to linguistic and literary theory means that its critical rationale tends to value verbal analysis more than visual. But for all this, it has captured the imagination of a young generation of artists.

Today the future direction of photography may be less clear than at times in the past, but never before has the medium been so fully integrated with the other, more established visual arts. To use photography today no longer requires artists to isolate themselves from the mainstream of contemporary art. Indeed, an awareness of the broader issues of the art world now seems essential for anyone involved with photography as an art. The oft-asked, hoary question "Is photography an art?" has been answered in the most convincing possible way: not by any claim to uniqueness or self-sufficiency, but by the widespread, vital presence of photographs within the art world. Whether we choose to call a work photography or painting is less important than if it addresses the conditions of our times. And one of the conditions of our times is the omnipresence of photographs and photographic images. — A.G.

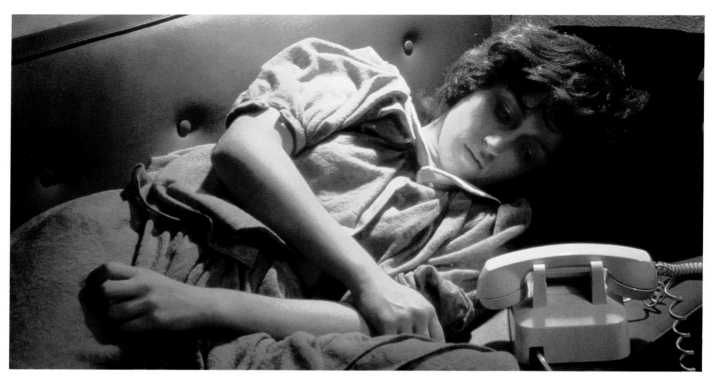

Cindy Sherman
Untitled #90. 1981
Chromogenic-development (Ektacolor) print
24 x 48 in.
Collection of Joan Simon, New York

Eileen Cowin
Untitled. 1980
Chromogenic-development (Ektacolor) print
19⅛ x 24 in.
Collection of the artist

Laurie Simmons
Splash. 1980
Silver dye-bleach (Cibachrome) print
20 x 24 in.
Private collection

Ellen Brooks
Doctor and Nurse. 1979
Chromogenic-development (Ektacolor) print
20 x 24 in.
Collection of the artist

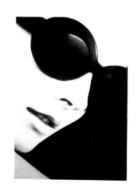
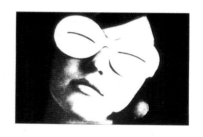
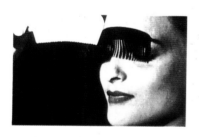
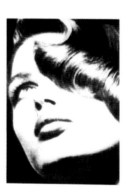

Richard Prince
Untitled Gang. 1982–84
Chromogenic-development (Ektacolor) print, 58½ x 48 in.
Collection of George Waterman, New York

Sherrie Levine
After Ludwig Kirchner. 1982
Chromogenic-development (Ektacolor) print
16 x 20 in.
Courtesy of the Mary Boone Gallery, New York

Louise Lawler
Untitled images from "Slides by Night (Now That We Have Your Attention
 What Are We Going to Say)." 1985
Photo-projection, image size variable
Courtesy of the artist and Metro Pictures, New York

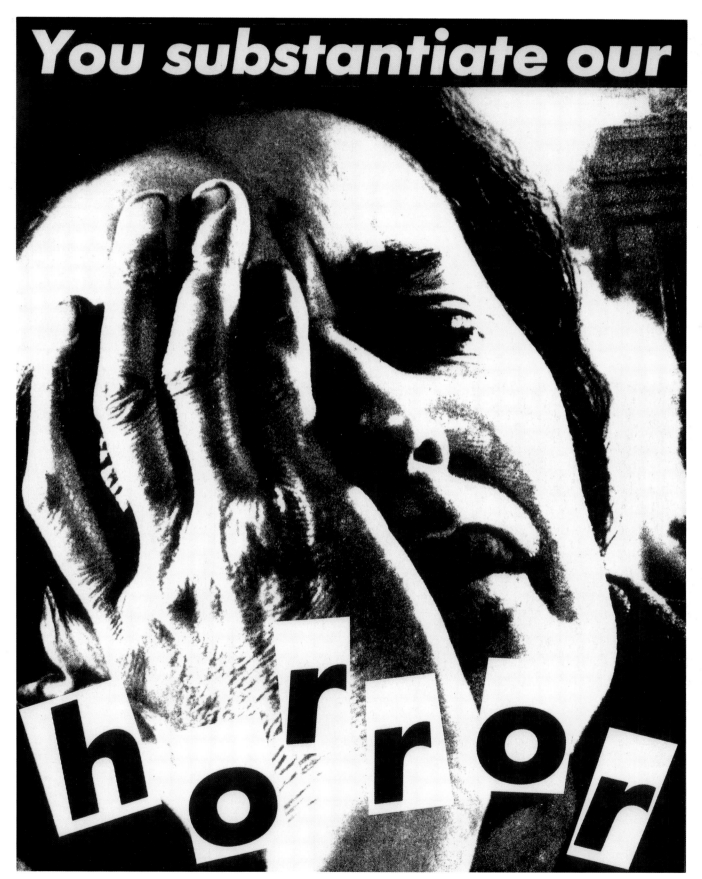

Barbara Kruger
You substantiate our horror. 1983
Gelatin-silver print
120 x 96 in.
Courtesy of the Mary Boone Gallery, New York

Victor Burgin
The Bridge—Dora in S.F. 1984
Gelatin-silver print
36 x 60 in.
John Weber Gallery, New York

James Welling
April 16b. 1980
Gelatin-silver print
4⅛ x 3¼ in.
Collection of Joel Wachs, Los Angeles

Allan McCollum
#73A and *#73B*, from the series "Perpetual Photo." 1985
Two gelatin-silver prints
9¾ x 11½ in. each
Diane Brown Gallery, New York

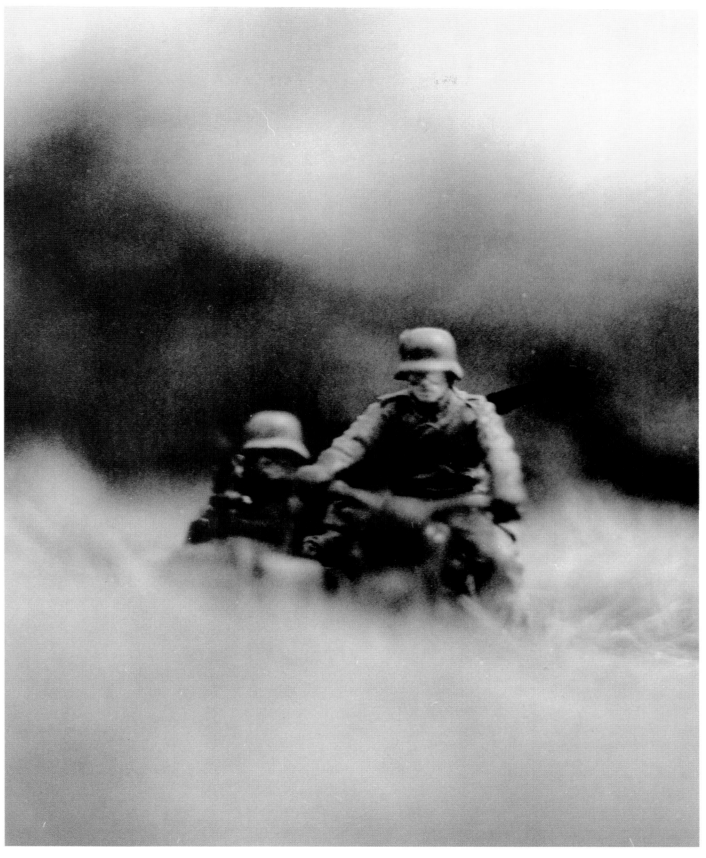

David Levinthal
Spring offensive begins, June 1942, from the series "Hitler Moves East." 1974
Gelatin-silver print
10 x 8 in.
Collection of the artist
Courtesy of the Area X Gallery, New York

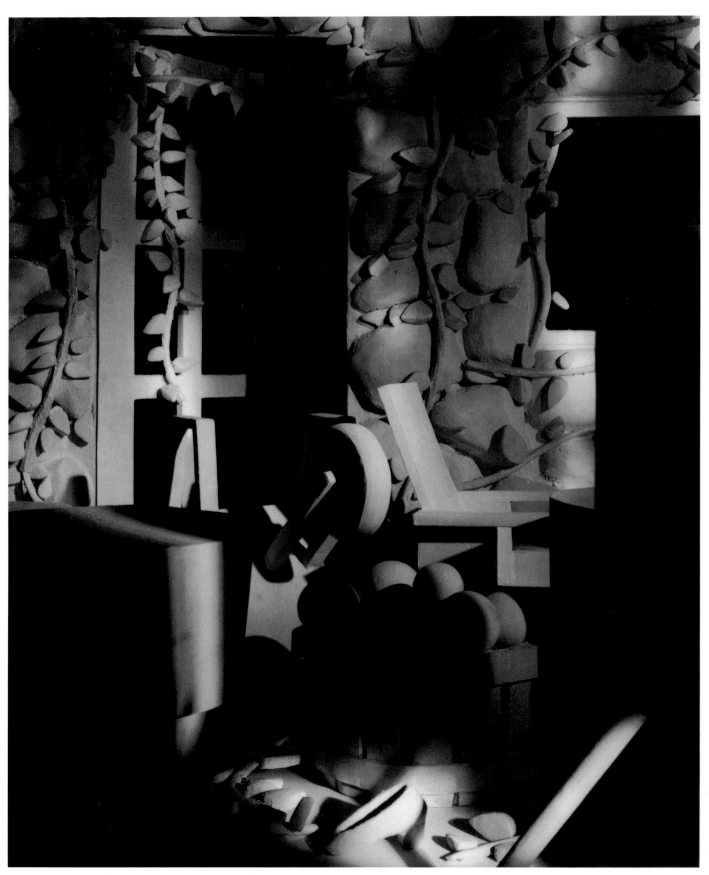

James Casebere
Stonehouse. 1983
Gelatin-silver print, 30 x 24 in.
Courtesy of Kuhlenschmidt/Simon, Los Angeles

Nan Goldin
Brian on Our Bed with Bars, from the series "The Ballad of Sexual
 Dependency." 1983
Color transparency, single-screen projection, image size variable
Collection of the artist
Courtesy of Marvin Heiferman

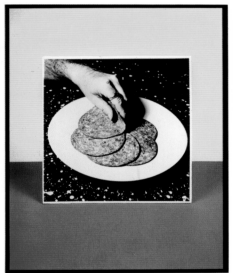
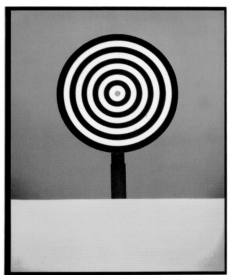

Neil Winokur
William Wegman: Totem. 1985
Five silver dye-bleach (Cibachrome) panels
20 x 16 in. each
Collection of the artist, Courtesy of Janet Borden

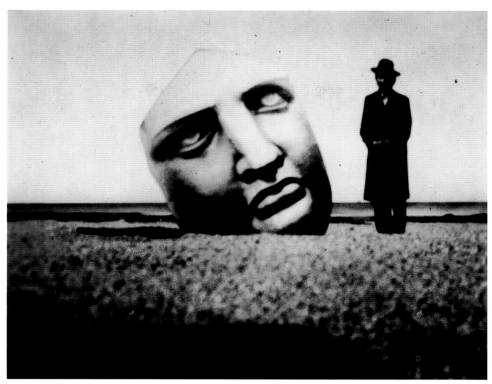

Ruth Thorne-Thomsen
Untitled, Chicago (Liberty Head),
from the series "Expeditions." 1978
Toned gelatin-silver print
4 x 5 in.
Courtesy of the Allan Frumkin Gallery—Photographs, Chicago

Notes to the Text

INTRODUCTION

1. See, for example, John Szarkowski, *Mirrors and Windows: American Photography since 1960* (New York: Museum of Modern Art, 1978); Jonathan Green, *American Photography: A Critical History 1945 to the Present* (New York: Harry N. Abrams, 1984); and Peter Turner, ed., *American Images: Photography 1945–1980* (New York: Viking Press, 1985).

2. Ansel Adams, "A Personal Credo," *American Annual of Photography, 1944*, vol. 58. Reprinted in Nathan Lyons, ed., *Photographers on Photography: A Critical Anthology* (Englewood Cliffs, NJ: Prentice-Hall, and Rochester, NY: George Eastman House, 1966).

ONE: The Enduring Modernist Impulse

1. Edward Weston, "Photographic Art," *Encyclopedia Britannica*, 14th ed., vol. 17 (New York and Chicago: Encyclopedia Britannica, Inc., 1940), pp. 796–99. Reprinted in Peter C. Bunnell, *Edward Weston on Photography* (Salt Lake City: Peregrine Smith Books, 1983), p. 126.

2. A. D. Coleman, "Because It Feels So Good When I Stop," *Camera 35*, October 1975. Reprinted in A. D. Coleman, *Light Readings: A Photography Critic's Writings 1968–1978* (New York: Oxford University Press, 1979), p. 213.

3. Quoted by Charles H. Caffin, *Photography as a Fine Art*, 1901, reprint edition by Morgan & Morgan, 1971, p. 36. Cited in Sarah Greenough, *Alfred Stieglitz: Photographs and Writing* (Washington, DC: National Gallery of Art, 1983), p. 12.

4. "Alfred Stieglitz and 'The Idea of Photography,' " Greenough, *Alfred Stieglitz*, p. 23.

5. Nancy Newhall, ed., *The Daybooks of Edward Weston*, 2 vols. (Millerton, NY: Aperture, 1973), vol. 2, p. 154.

6. John Pultz and Catherine B. Scallen, *Cubism and American Photography*, catalogue of exhibition, Oct.–Dec. 1981 (Williamstown, MA: Sterling and Francine Clark Art Institute, 1981).

7. Hans M. Wingler, *The Bauhaus* (Cambridge, MA: MIT Press, 1976), p. 8.

8. Margaretta K. Mitchell, *Recollections: Ten Women of Photography* (New York: Viking Press, 1979), p. 141.

TWO: Surrealism, Symbolism, and the Fictional Photograph

1. See Barbara Rose, *American Art Since 1890: A Critical History* (New York: Frederick A. Praeger Publishers, 1967), p. 209.

2. André Breton, "Deuxième Manifeste du surréalisme," in *Manifestes du Surréalisme* (Paris: Jean-Jacques Pauvert, 1946), p. 154.

3. For example, in the work of Arthur Dove, Georgia O'Keeffe, and John Marin, in the prewar years, and certainly in the work of Mark Rothko and Adolph Gottlieb at the time.

4. Willard Huntington Wright, "The Forum Exhibition of Modern Painters . . . on View at the Anderson Gallery, Kennerly, 1916," in Sam Hunter and John Jacobus, *American Art of the 20th Century* (New York: Harry N. Abrams, 1973), p. 108.

5. Here one considers the acrimonious clash early in the century between American realist painters, such as The Eight, and the new abstractionists who felt that social propaganda had no place in art, or at best was unnecessary.

6. Clarence John Laughlin, *Clarence John Laughlin: The Personal Eye*, introduction by Jonathan Williams (Millerton, NY: Aperture, 1973), p. 14.

7. Jonathan Williams, "Clarence John Laughlin," in George Walsh, Colin Naylor, Michael Held, eds., *Contemporary Photographers* (New York: St. Martin's Press, 1982), p. 438, and Laughlin, p. 14.

8. Or, if not theoretically, cinematic mise-en-scène: Laughlin was interested in experimental film, and considered his group of images "Poems of the Inner World" as a series of notes for unrealized films.

9. In fact, Telberg was refused admission to the Photo League because of his use of multiple imagery. See *Val Telberg* (San Francisco: Museum of Modern Art, 1983), p. 5.

10. Ibid., p. 9.

11. Ibid., p. 8.

12. Ibid., p. 5.

13. In an announcement for an exhibition at the Hacker Gallery, New York, January 3–29, 1955.

14. See Jan-Gunnar Sjolin, "Notes on a Photograph by Frederick Sommer," *Kalejdoskop*, vol. 6 (1976). Reprinted in trans. by Ada M. Fung, in Constance W. Glenn and Jane K. Bledsoe, eds., *Frederick Sommer at Seventy-Five: A Retrospective* (Long Beach, CA: California State University, 1980), p. 32.

15. Minor White, ed., *Frederick Sommer* (Rochester, NY: Aperture, 1962), unpaginated.

16. See, for example, Naomi Rosenblum, *A World History of Photography* (New York: Abbeville Press, 1984), p. 563.

17. See Henry Holmes Smith et al., "Frederick Sommer: Collage of Found Objects," *Aperture*, vol. 4, no. 3 (1956), unpaginated.

18. See Jonathan Green, *American Photography: A Critical History 1945 to the Present* (New York: Harry N. Abrams, 1984), p. 72.

19. Interestingly, John Szarkowski, in his catalogue for the "Mirrors and Windows" exhibition at the Museum of Modern Art, New York, in 1978, identifies three significant events in the 1950s for photography, two of them documentary endeavors—Robert Frank's book *The Americans*, published in the United States in 1959, and Edward Steichen's "Family of Man" exhibition at the Museum of Modern Art in 1955—and the third the inception of *Aperture*.

20. See Wassily Kandinsky, *Concerning the Spiritual in Art*, translated with an introduction by M. T. H. Sadler (New York: Dover Publications, 1977). Reprint of English translation *The Art of Spiritual Harmony* (London: Constable and Company, Ltd., 1914).

21. See Breton, "Deuxième Manifeste du surréalisme," p. 42.

22. Bullock achieved some success as a singer, both in the United States and in Europe, where he spent several years as a musician in the 1920s. See David Fuess, *Wynn Bullock* (Millerton, NY: Aperture, History of Photography Series, 1976), pp. 5–6.

23. Kaminski is credited with a progressive interest in the experimental uses of photography—its logical connection with Surrealism for example—in the early 1940s. He was the instructor not only of Bullock but of Todd Walker, Lee Friedlander, Ralph Gibson, and others.

24. See Wynn Bullock, "Space and Time," *Photography*, vol. 17, no. 9 (1962), pp. 42–49. Reprinted in Lyons, *Photographers on Photography*, pp. 37–40.

25. Quoted in Barbara Bullock-Wilson, *Wynn Bullock, Photography: A Way of Life*, edited by Liliane DeCock (Dobbs Ferry, NY: Morgan & Morgan, 1973), pp. 23–24.

26. See Nathan Lyons, Syl Labrot, and Walter Chappell, *Under the Sun: The Abstract Art of Camera Vision* (Millerton, NY: Aperture, 1972), unpaginated.

27. Walter Chappell, "Intuitions of Reality," *Under the Sun*, n.p.

28. Teske's presentation of his work is deliberate and careful: he has consistently used a stylized mounting format in which the image is set on a piece of brown paper or board floated in the center of a much larger sheet.

29. James Enyeart, "Jerry Uelsmann," in *Contemporary Photographers*, pp. 772–73.

30. Marco Livingstone, "A Meeting with Duane Michals," *Duane Michals: Photographs/Sequences/Texts 1958–1984* (Oxford: Museum of Modern Art, 1984), unpaginated.

31. "Duane Michals," an interview with Professor Gassan and his students, in Peninah R. Petruck, ed., *The Camera Viewed: Writings on Twentieth-Century Photography*, 2 vols. (New York: E.P. Dutton, 1979), vol. 2, pp. 76–80. Reprinted from *Image* (January 1971).

32. Livingstone, "A Meeting with Duane Michals," unpaginated.

33. Ibid.

34. Vicki Goldberg, "Duane Michals," in *Contemporary Photographers*, p. 514.

35. See Ralph Gibson, *The Somnambulist* (New York: Lustrum Press, 1970), unpaginated.

36. Samaras was the first artist to undertake a body of work involving a manipulation of the Polaroid emulsion as it was developing. By rubbing the surface while the print was emerging, when it was visible but not yet set, he was able to shift the dyes beyond their initial perimeters, to obliterate details, to melt parts of the image together, or to expand them to fantastic proportions. In addition, Samaras had learned to circumvent the mechanical apparatus of the Polaroid camera—beyond the distortions he wished on the film itself, he was able to make use of multiple exposures.

37. See *Lucas Samaras: Photo-Transformations* (Long Beach, CA: The Art Galleries, California State University, 1975), p. 8.

38. The technique of the large-format automatic portrait was utilized by Robert Rauschenberg in the late 1940s. It was in the 1951 exhibition "Abstraction in Photography" at the Museum of Modern Art, New York. See *Robert Rauschenberg* (Washington, D.C.: National Collection of Fine Art, Smithsonian Institution, 1976), p. 63.

39. See Terri Cohen and Anthony Reveau, *Bruce Conner: Photograms* (San Francisco: Art Museum Association of America, 1985).

40. See André Breton, "Poisson Soluble," 1924, in *Manifeste du Surréalisme*. Also see Robert Short, *Dada and Surrealism* (London: John Calmann & Cooper Limited, 1980).

41. See Van Deren Coke, introduction, *Joel-Peter Witkin, Forty Photographs* (San Francisco: Museum of Modern Art, 1985), p. 6.

42. From a 1981 interview published in the exhibition announcement *Joel-Peter Witkin: Photographs 1979–1982* (San Francisco: Fraenkel Gallery, 1982), unpaginated.

43. As Coke points out, this strain appears in Witkin's work as far back as 1970. Coke, *Joel-Peter Witkin, Forty Photographs*, p. 7.

44. Other works by Witkin that are clear references to paintings include his *Harvest*, 1984, which mimics Arcimboldo's paintings, and *Manuel Osorio*, a reworking of Goya's *Don Manuel Osoria de Zuñiga*.

THREE: Popular Culture, Pop Art

1. John Coplans and Walter Hopps, introduction, *Kurt Schwitters: A Portrait from Life* by Kate Trauman Steinitz (Berkeley: University of California Press, 1968), p. xi.

2. Walter Benjamin, "The Work of Art in the Age of Mechanical Reproduction," reprinted in *Photography in Print* (New York: Touchstone/Simon & Schuster, 1981), p. 328.

3. William C. Seitz, "The Art of Assemblage," fall 1961, Museum of Modern Art, New York.

4. Lawrence Alloway, introduction, *Robert Rauschenberg* (Washington, DC: Smithsonian Institution, 1976), p. 5.

5. Douglas Crimp, "Appropriating Appropriation," *Image Scavengers* (Philadelphia: Institute of Contemporary Art, 1983), p. 33.

6. Barbara Haskell, *Blam! The Explosion of Pop, Minimalism, and Performance, 1958–1964* (New York: Whitney Museum of American Art and W. W. Norton, 1984), p. 79.

7. John Coplans, *Assemblage in California*, catalogue (Irvine, CA: University of California, 1968), p. 8.

8. To cite but one example, see Carl Andre's appreciation of Bernhard and Hilla Becher's photo works, "A Note on Bernhard and Hilla Becher," *Artforum*, vol. 11, no. 4 (December 1972), p. 59. Reprinted in Amy Baker Sandback, ed., *Looking Critically: 21 Years of Artforum Magazine* (New York: Artforum, and Ann Arbor: UMI Research Press, 1984), pp. 122–23.

FOUR: Breaking the Mold: Experiments in Technique and Process

1. Among the principal individuals who encouraged experimentation were Nathan Lyons, Institute of Design instructors Aaron Siskind and Harry Callahan (Callahan left the institute in 1961), Henry Holmes Smith, and Robert Heinecken.

2. The Society for Photographic Education, founded in 1963, promoted the integration of photography into art training and was instrumental in advancing changing trends.

3. Charles Sheeler, "A Brief Note on the Exhibition," *Charles Sheeler, Paintings, Drawings, Photographs* (New York: Museum of Modern Art, 1939), p. 11.

4. Edward Weston, "Photography—Not Pictorial," *Camera Craft*, vol. 37, no. 7 (1930), pp. 313–20. Reprinted in Lyons, *Photographers on Photography*, p. 156ff.

5. Ibid., pp. 155–57.

6. Ansel Adams, "A Personal Credo," *American Annual of Photography*, vol. 58, pp. 7–16. Reprinted in Lyons, *Photographers on Photography*, pp. 29–30.

7. Ibid., p. 31.

8. Art Sinsabaugh, *Six Photographers*, (Urbana: University of Illinois, 1963), unpaginated.

9. See Rosenblum, *A World History of Photography*, p. 563, and Howard Bossen, *Henry Holmes Smith: Man of Light* (Ann Arbor: University of Michigan Research Press, 1983), pp. 37–63.

10. For an overview of the program see Louise Katzman, *Photography in California, 1945–1980* (New York: Hudson Hills Press and the San Francisco Museum of Modern Art, 1981), pp. 50–52.

11. A set of twenty-five reproductions, in an edition of 500, with a statement by Heinecken and selections of text by André Breton.

12. See James Enyeart, ed., "Robert Heinecken," *Heinecken* (Carmel, CA: Friends of Photography, in association with Light Gallery, New York, 1980), p. 101.

13. Heinecken intentionally limited his selection of themes in order to reduce the overall volume and focus of the portfolio. See Charles Hagen, adaptation of interview with R. Heinecken, *Afterimage*, April 1976.

14. Reprinted in Petruck, *The Camera Viewed*, vol. 2, pp. 188–201. Originally published in Roland Barthes, *Image—Music—Text* (New York: Farrar, Straus & Giroux, 1977).

15. See *Heinecken*, p. 47.

16. See Peter Bunnell, "Photographs as Sculpture and Prints," *Art in America*, vol. 57, no. 5 (September/October 1969), pp. 56–61.

17. See Nathan Lyons, ed., *The Persistence of Vision* (New York: Horizon Press, and Rochester, NY: George Eastman House, 1967).

18. Fichter's social iconography and comment would become more pronounced in his better-known tableaux of the late 1970s, yet the dominant themes that he is currently working with have longstanding precedents in his work.

19. See *Robert Fichter: Photography and Other Questions*, edited and with text by Robert A. Sobieszek (Albuquerque: University of New Mexico Press, and Rochester, NY: International Museum of Photography at George Eastman House, 1983).

20. *The Woman's Eye*, edited and with an introduction by Anne Tucker (New York: Alfred A. Knopf, 1973), p. 127.

21. See Charles Hagen, introduction, *Barbara Blondeau, 1938–1974*, ed. David Lebe et al. (Rochester, NY: Visual Studies Workshop, and Philadelphia: Philadelphia College of Art, 1976), p. 3.

22. See Van Deren Coke, *Jack Fulton's Puns & Anagrammatic Photographs* (San Francisco: San Francisco Museum of Modern Art, 1979), unpaginated.

23. Many prints that appear to be solarized have in fact been achieved by the Sabattier process, not by the actual solarization method of massive overexposure at the moment of the original photograph.

24. The Verifax is a wet-print process, the result of research done in the 1940s at Kodak. It involves a disposable paper negative, the matrix, from which a print is made on treated paper. See Marilyn McCray, *Electroworks* (Rochester: International Museum of Photography at George Eastman House, 1979), for a discussion of various machine processes.

25. See "Wallace Berman's Verifax Collages," *Artforum*, vol. 4, no. 5 (January 1966), pp. 39–41; Jack Hirshman and Gail R. Scott, *Wallace Berman* (Los Angeles: Los Angeles County Museum of Art, 1968); and *Wallace Berman: Verifax Collages* (New York: Jewish Museum, 1968).

26. See McCray, *Electroworks*, p. 11.

27. Unfortunately, the Color-in-Color dyes migrate over time, and the prints must be interleaved with glassine to minimize their interaction with the support sheets.

28. See William Larson, *Fireflies* (Philadelphia: Gravity Press, 1976), unpaginated.

29. Paula Marincola, "William Larson Ex Machina," *William Larson: Photographs 1969–85* (Philadelphia: Institute of Contemporary Art, University of Pennsylvania, 1985), p. 2.

FIVE: Conceptual Art and the Photography of Ideas

1. *The New York Times Sunday Magazine*, April 13, 1975, p. 66.

2. See Marjorie Welish, "The Specter of Art Hype and the Ghost of Yves Klein," *Sulphur*, vol. 12 (1982), UCLA, pp. 22–28.

3. Andrea Miller-Keller, "From the Collection of Sol LeWitt," Independent Curators Incorporated in association with the Wadsworth Atheneum, New York, and Hartford, CT, 1984.

4. Carl Andre, "A Note on Bernhard and Hilla Becher," p. 59.

5. Judith Tannenbaum, *Concept, Narrative, Document* (Chicago: Museum of Contemporary Art, 1979).

SIX: In the Studio: Construction and Invention

1. Edward Ruscha quoted in John Coplans, "Concerning Various Small Fires: Edward Ruscha Discusses His Perplexing Publications," *Artforum*, vol. 3, no. 5 (February 1965), p. 25.

2. Thomas has acknowledged that these images were shot by Natalie Thomas, "while he was at the dentist." See Lew Thomas, *Structural(ism) and Photography* (San Francisco: NFS Press, 1978), p. 38.

3. See Van Deren Coke, *Fabricated to Be Photographed* (San Francisco: San Francisco Museum of Modern Art, 1979).

4. See James Alinder, "An Interview with Robert Cumming," *Robert Cumming Photographs* (Carmel: Friends of Photography, 1979), pp. 47–55.

5. In his recent work Cumming has moved away from photography and is making drawings.

6. See Les Krims, *Fictcryptokrimsographs* (Buffalo: Humpy Press, 1975).

7. See Anne Tucker, "Interview with Ed Hill and Suzanne Bloom (MANUAL) at their home, Thursday, December 20, 1979, beginning at 3:30 P.M." in Anne Tucker, *Suzanne Bloom and Ed Hill (MANUAL): Research and Collaboration* (Houston: Seashore Press, 1980), p. 10.

8. See ibid., p. 7.

9. See ibid., p. 16.

10. Among these were the Bechtel Corporation, the Burbank Fire Department, Jet Propulsion Laboratories, the Los Angeles Department of Public Works, the National Coal Association, the Pacific Telephone Company, the United States Department of Justice, the Veterans Administration, and TRW, Inc.

SEVEN: Camera Culture in a Postmodern Age

1. Quoted by Hunter Drohojowska in "No More Boring Art," *Artnews*, vol. 85, no. 1 (January 1986), p. 64.

2. Richard Prince, *Why I Go to the Movies Alone* (New York: Tantam Press, 1983), pp. 63, 69–70.

3. Terry Eagleton, *Literary Theory: An Introduction* (Minneapolis: University of Minnesota Press, 1983), p. 96.

4. Frederic Jameson, "Postmodernism and Consumer Society," in Hal Foster, ed., *The Anti-Aesthetic: Essays on Postmodern Culture* (Port Townsend, WA: Bay Press, 1983), p. 114.

5. Douglas Crimp, "The Photographic Activity of Postmodernism," *October*, no. 15 (winter 1980), p. 91.

6. Jean François Lyotard, *The Postmodern Condition: A Report on Knowledge* (Minneapolis: University of Minnesota Press, 1984), p. 79. The emphasis is mine.

Artists' Biographies
Bibliography
Index

Artists' Biographies

Dates given in parentheses following an entry indicate subsequent exhibitions in that gallery or museum.

ANSEL ADAMS

Born: San Francisco, CA, 1902

Died: Carmel, CA, 1984

Education: Studied concert piano, San Francisco, 1914–27
Studied photography with the photofinisher Frank Dittman, San Francisco, 1916–17

Awards: John Simon Guggenheim Memorial Fellowship, 1946 (renewed 1948), 1958
DFA, University of California, Berkeley, 1961
Yale University, New Haven, CT, 1973
University of Massachusetts, Amherst, 1974
University of Arizona, Tucson, 1975
Fellow, American Academy of Arts and Sciences, 1966
DH, Occidental College, Los Angeles, 1967
United States Presidential Medal of Freedom, 1980

Selected Individual Exhibitions:
1951 Art Institute of Chicago
1952 George Eastman House, Rochester, NY
1967 Boston Museum of Art
1970 Witkin Gallery, New York (1972)
1974 Metropolitan Museum of Art, New York
1976 Center for Creative Photography, University of Arizona, Tucson
Victoria and Albert Museum, London
1977 Fotografiska Museet, Stockholm
1979 Museum of Modern Art, New York
1982 San Francisco Museum of Modern Art

Selected Group Exhibitions:
1951 "Contemporary Photography," Contemporary Arts Museum, Houston
1959 "Photography at Mid-Century," George Eastman House, Rochester, NY
1963 "The Photographer and the American Landscape," Museum of Modern Art, New York
1974 "Photography in America," Whitney Museum of American Art, New York
1978 "Mirrors and Windows: American Photography since 1960," Museum of Modern Art, New York (traveled)

MAC ADAMS

Born: South Wales, Great Britain, 1943

Resides: New York, NY

Education: NDD, Cardiff College of Art, 1966
ATD, Cardiff College of Art, 1967
MFA, Rutgers University, 1969

Awards: National Endowment for the Arts, New Genres, 1976, 1980
National Endowment for the Arts, Sculpture, 1982

Selected Individual Exhibitions:
1969 Douglass College, Rutgers University, New Brunswick, NJ
1974 112 Greene Street, New York
1975 Arnolfini Gallery, Bristol, England
1976 John Gibson Gallery, New York (1978)
1977 Museum of Art, University of Iowa
1978 Francoise Lambert, Milan, Italy
1979 Hal Bromm Gallery, New York
1980 Welsh Arts Council of Great Britain (travelled)
1981 A. Space, Toronto, Canada
1982 D.A.A.D. Galerie, Berlin, West Germany
1983 Freidus/Ordover Gallery, New York (1984)
1984 "Dead End," a collaborative installation with architect Henry Smith Miller and performer Peter Gordon for Creative Time, Inc., New York
1985 Sable/Castelli Gallery, Toronto, Canada

Selected Group Exhibitions:
1967 "Contemporary Painting/Sculpture in Wales," National Museum, Wales
1969 "Soft Art," New Jersey State Museum, Trenton
1975 "Not Photography," Fine Arts Building, New York
1976 "The Artist and the Photograph," Israel Museum, Jerusalem
"Narrative in Contemporary Art," University of Guelph, Canada
1977 "American Narrative/Story Art 1967–1977," Museum of Fine Art, Houston (traveled)
Documenta 6, Kassel, West Germany
1978 "Personal Visions: Places, Spaces," Bronx Museum, New York
1979 "The Altered Photograph," Institute for Art and Urban Resources, P.S. 1, New York
1980 "Painting and Sculpture Today, 1980," Indianapolis Museum of Art

1981 "Erweiterete Fotografie," 5th Vienna International Biennale, Austria
1982 "Tableaux," Contemporary Arts Center, Cincinnati
1983 "Photo as Art," Neue National Galerie, Berlin, West Germany
1984 "International Survey of Recent Painting and Sculpture," Museum of Modern Art, New York
1985 "Body and Soul, Recent Aspects of Figurative Sculpture," Contemporary Arts Center, Cincinnati (traveling throughout 1987)
1986 "The Real Big Picture," Queens Museum, Flushing, New York

JOHN BALDESSARI

Born: National City, CA, 1931

Resides: Santa Monica, CA

Education: BA, San Diego State College, CA, 1953
MA, San Diego State College, CA, 1957

Awards: National Endowment for the Arts, New Genres, 1974
National Endowment for the Arts, Photography, 1982

Selected Individual Exhibitions:
1960 La Jolla Museum of Contemporary Art, CA (1966)
1968 Molly Barnes Gallery, Los Angeles
1971 Galerie Konrad Fischer, Düsseldorf (1973)
Art & Project, Amsterdam (1972)
1973 Sonnabend Gallery, New York (1975, 1978, 1979, 1980, 1984, 1986)
Galerie Sonnabend, Paris (1975)
1975 Stedelijk Museum, Amsterdam
1978 Whitney Museum of American Art, New York (films)
Institute of Contemporary Art, Boston
1981 Stedelijk Van Abbemuseum, Eindhoven, The Netherlands (traveled)
The New Museum, New York (traveled)
Museum Folkwang, Essen, West Germany
1982 Contemporary Arts Museum, Houston
1984 Margo Leavin Gallery, Los Angeles (1986)

Selected Group Exhibitions:
1968 "New Work: Southern California," University of California, San Diego
1969 "Konzeption—Conception," Stadtische Museum, Leverkusen, West Germany
 Biennial, Whitney Museum of American Art, New York (1972, 1977, 1979, 1983)
1970 "Information," Museum of Modern Art, New York
1971 "Prospect '71: Projection," Kunsthalle, Düsseldorf
 "Koncept-Kunst," Kunstmuseum, Basel
1975 "The Extended Document," International Museum of Photography at George Eastman House, Rochester, NY
1977 "Contemporary American Photographic Works," Museum of Fine Arts, Houston
1979 "American Photography in the '70's," Art Institute of Chicago
1980 "Visual Articulation of Idea," Visual Studies Workshop, Rochester, NY (traveled)
1981 "The Museum as Site: Sixteen Artists," Los Angeles County Museum of Art
 "Erweiterte Fotografie," International Biennale, Vienna
1982 Documenta 7, Kassel, West Germany
1983 "Photography Used in Contemporary Art, In and Around the '70's," National Museum of Modern Art, Tokyo
1985 "Carnegie International," Museum of Art, Carnegie Institute, Pittsburgh
1986 "Television's Impact on Contemporary Art," Queens Museum, Flushing, NY

LEWIS BALTZ

Born: Newport Beach, CA, 1945

Resides: Sausalito, CA

Education: BFA, San Francisco Art Institute, 1969
MFA, Claremont Graduate School, CA, 1971

Awards: National Endowment for the Arts, Photography, 1973, 1976
John Simon Guggenheim Memorial Fellowship, 1977
US/UK Bicentennial Exchange Fellowship, 1980

Selected Individual Exhibitions:
1970 Pomona College, Claremont, CA
1971 Castelli Graphics, New York (1981)
1972 International Museum of Photography at George Eastman House, Rochester, NY
1974 Corcoran Gallery of Art, Washington, DC
1975 University of New Mexico, Albuquerque
 Leo Castelli Gallery, New York
1976 Corcoran Gallery of Art, Washington, DC
 Museum of Fine Arts, Houston
1981 San Francisco Museum of Modern Art

1983 Rhode Island School of Design, Providence
1984 University Art Museum, University of California, Berkeley
1985 Victoria and Albert Museum, London
 University of New Mexico, Albuquerque
1986 Newport Harbor Art Museum, Newport Beach, CA

Selected Group Exhibitions:
1975 "14 American Photographers," Baltimore Museum of Art (traveled)
 "New Topographics," International Museum of Photography at George Eastman House, Rochester, NY (traveled)
1977 Biennial, Whitney Museum of American Art, New York
1978 "Mirrors and Windows: American Photography since 1960," Museum of Modern Art, New York (traveled)
 "Court House: A Photographic Document," Art Institute of Chicago (traveled)
1979 "American Images," Corcoran Gallery of Art, Washington, DC (traveled)
 "Photographie als Kunst 1879–1979/Kunst als Photographie 1949–1979," Tiroler Landesmuseum Ferdinandeum, Innsbruck, Austria
1981 "Photography: A Sense of Order," Institute of Contemporary Art, Philadelphia
1984 "Photography in California: 1945–1980," San Francisco Museum of Modern Art
1985 "American Images: Photography 1945–1980," Barbican Art Gallery, London (traveled)
1986 "The Real Big Picture," Queens Museum, Flushing, NY

THOMAS BARROW

Resides: Albuquerque, NM

Born: Kansas City, MO, 1938

Education: BFA, Kansas City Art Institute, 1963 (graphic design)
Northwestern University, Evanston, IL, 1964 (filmmaking)
MS, Institute of Design, Illinois Institute of Technology, Chicago, 1965–67

Awards: National Endowment for the Arts, Photography, 1973, 1978

Selected Individual Exhibitions:
1969 University of California, Davis
1972 Light Gallery, New York (1974, 1976, 1982)
1975 Deja Vu Gallery, Toronto, Canada
1982 Friends of Photography, Carmel, CA
1987 Los Angeles County Museum of Art (traveled)

Selected Group Exhibitions:
1969 "Vision and Expression," George Eastman House, Rochester, NY
1970 "The Photograph as Object," National Gallery of Canada, Ottawa
1972 "Photography into Art," Camden Arts Centre, London
1973 "Seen and Unseen," Fogg Art Museum, Harvard University, Cambridge

"Light and Lens: Methods of Photography," Hudson River Museum, Yonkers, NY
1975 "The Extended Document," International Museum of Photography at George Eastman House, Rochester, NY
 "Texture: A Photographic Vision," Whitney Museum of American Art, New York
1977 "Contemporary American Photographic Works," Museum of Fine Arts, Houston
1979 "Attitudes: Photography in the Seventies," Santa Barbara Museum of Art, CA
 "Electroworks," International Museum of Photography at George Eastman House, Rochester, NY
1980 "The New Vision: Forty Years of Photography at the Institute of Design," Light Gallery, New York
1981 "Erweiterte Fotografie," International Biennale, Vienna
1984 "Rochester: An American Center for Photography," International Museum of Photography at George Eastman House, Rochester, NY
 "Cover to Cover: Experimental Bookworks," Museum of Fine Arts, Museum of New Mexico, Santa Fe
1986 "Television's Impact on Contemporary Art," Queens Museum, Flushing, NY

DEDE BAZYK

Born: Santa Monica, CA, 1951

Resides: Los Angeles, CA

Education: BFA, California Institute of the Arts, Valencia, 1973
MFA, California Institute of the Arts, Valencia, 1975

Selected Individual Exhibitions:
1976 Otis-Parsons School of Art and Design, Los Angeles
1978 Video installation, The Kitchen, New York
1980 Video installation, Architectural Association, London
1983 Nova Scotia College of Art and Design, Halifax, Nova Scotia

Selected Group Exhibitions:
1976 "Southland Video Anthology," Long Beach Museum of Art, CA (traveled to San Francisco Museum of Art)
1986 "T.V. Generations," Los Angeles Contemporary Exhibitions, CA

BERNHARD AND HILLA BECHER

Reside: Düsseldorf, West Germany

Bernhard Becher:

Born: Siegen, West Germany, 1931

Education: Staatlichen Kunstakademie, Stuttgart, 1953–56 (painting and lithography)
Staatlichen Kunstakademie, Düsseldorf, 1957–61 (typography)

Hilla (Wobeser) Becher:

Born: Potsdam, West Germany, 1934

Education: Studied photography in Potsdam, n.d.

Staatlichen Kunstakademie, Düsseldorf, n.d.
Married and began working together in photography, 1961
Awards: British Council Photo Study Grant, 1966
Fritz-Thyssen-Stiftung Grant, West Germany, 1967–68

Selected Individual Exhibitions:
1963 Galerie Ruth Nohl, Siegen, West Germany (1968)
1967 Staatliche Museum, Munich
Bergbau-Museum, Bochum, West Germany
1968 Goethe Center, San Francisco
Stedelijk Van Abbemuseum, Eindhoven, The Netherlands
1969 Stadtische Kunsthalle, Düsseldorf
1970 Stadtische Museum, Ulm, West Germany
Moderna Museet, Stockholm
1971 Kabinett fur Aktuelle Kunst, Bremerhaven, West Germany (1974)
1973 Galerie Sonnabend, Paris (1975, 1979)
1974 National Gallery of Canada, Ottawa
Wadsworth Atheneum, Hartford, CT
1975 Museum of Modern Art, New York
1977 Sonnabend Gallery, New York (1978, 1981, 1983, 1985)
1980 Westfalisches Landesmuseum, Munich
1981 Stedelijk Van Abbemuseum, Eindhoven, The Netherlands (retrospective)
1985 Museum Folkwang, Essen, West Germany
ARC/Musée d'Art Moderne, Paris

Selected Group Exhibitions:
1970 "Information," Museum of Modern Art, New York
1972 "Paris-Amsterdam-Düsseldorf," Solomon R. Guggenheim Museum, New York
1974 "Idea and Image," Art Institute of Chicago
"Image and Idea," Photokina, Cologne
1975 "New Topographics: Photographs of a Man-Altered Landscape," International Museum of Photography at George Eastman House, Rochester, NY
1977 Documenta 6, Kassel, West Germany
Biennale, São Paulo, Brazil
"Europe in the Seventies: Aspects of Recent Art," Hirshhorn Museum and Sculpture Garden, Washington (traveled)
1979 "Photographie als Kunst 1879–1979/Kunst als Photographie 1949–1979," Tiroler Landesmuseum Ferdinandeum, Innsbruck, Austria
"Concept, Narrative, Document," Museum of Contemporary Art, Chicago
1982 "Counterparts: Form and Emotion in Photography," Metropolitan Museum of Art, New York (traveled)
1983 "Big Pictures by Contemporary Photographers," Museum of Modern Art, New York

1984 "Artistic Collaboration in the Twentieth Century," Hirshhorn Museum and Sculpture Garden, Washington, DC

BILL BECKLEY

Born: Hamburg, PA, 1946

Resides: New York, NY

Education: BFA, Kutztown State University, PA
MFA, Tyler School of Art, Temple University

Awards: National Endowment for the Arts, New Genres, 1978

Selected Individual Exhibitions:
1972 Holly Solomon Gallery, New York
Rudolf Zwirner, Cologne
Françoise Lambert, Milan (1974, 1975)
1973 John Gibson Gallery, New York (1974, 1976, 1983, 1986)
1974 Gallery 20, Amsterdam (1975)
1977 Nigel Greenwood, London (1979, 1980)
1978 Museum of Modern Art, New York
1981 International Center of Photography, New York
1984 Stadtisches Museum, Mönchengladbach, West Germany (retrospective)

Selected Group Exhibitions:
1969 "Art in the Mind," Allen Memorial Art Museum, Oberlin, OH
1971 "Projects: Pier 18," Museum of Modern Art, New York
1974 "Art and Architecture," Royal College of Art, London
1975 Biennale, Paris
1976 "Narrational Imagery: Beckley, Ruscha, Warhol," University of Massachusetts, Amherst
Biennale, Venice
1978 "American Narrative/Story Art: 1967–77," Contemporary Arts Museum, Houston (traveled)
1979 "Image and Text," Art Institute of Chicago
Biennial, Whitney Museum of American Art, New York
1980 "Photographic Art," Musée d'Art Moderne, Paris
1981 "Alternatives in Retrospect," The New Museum, New York

PAUL BERGER

Resides: Seattle, WA

Born: The Dalles, OR, 1948

Education: BA, University of California, Los Angeles, 1970
MFA, The Visual Studies Workshop, Rochester, NY, 1973 (Program in Photographic Studies of the State University of New York, Buffalo)

Awards: Young Photographer's Award, 6th International Meeting of Photography, Festival d'Arles, France, 1975
National Endowment for the Arts, Photography, 1979, 1986

Selected Individual Exhibitions:
1975 Art Institute of Chicago
1977 Light Gallery, New York (1980, 1982)

1980 Seattle Art Museum, WA
1984 California Museum of Photography, University of California, Riverside
1985 University Art Museum, University of California, Santa Barbara

Selected Group Exhibitions:
1970 "California Photographers 1970," Memorial Union Art Gallery, University of California, Davis; The Oakland Museum; The Pasadena Art Museum, CA
1978 "The Criticism of Photography," University Gallery, University of Massachusetts, Amherst
"Aesthetics of Graffiti," San Francisco Museum of Modern Art
1979 "American Photography in the '70's," Art Institute of Chicago
"Attitudes: Photography in the Seventies," Santa Barbara Museum of Art
1981 "Erweiterte Fotografie," International Biennale, Vienna
1982 "20 x 24," National Gallery of Fine Arts, Washington, DC
"Photographs in Sequence," Museum of Fine Arts, Houston
1983 "Outside New York: Seattle," The New Museum, New York
1985 "Images of Excellence," International Museum of Photography at George Eastman House, Rochester, NY (traveled)
"Between Science and Fiction," Biennale, São Paulo, Brazil

WALLACE BERMAN

Born: Staten Island, NY, 1926

Died: Los Angeles, CA, 1976

Education: Chouinard Art Institute, Los Angeles, 1944
Jepson Art School, Los Angeles, 1944

Awards: William & Norma Copley Foundation Award, 1965
National Council of Arts and Humanities Grant, 1966
National Endowment for the Arts, Painting, 1967

Selected Individual Exhibitions:
1957 Ferus Gallery, Los Angeles
1968 Los Angeles County Museum of Art, California (traveled)
1977 Timothea Stewart Gallery, Los Angeles
1978 Whitney Museum of American Art, New York
Otis Institute, Los Angeles (retrospective)
1979 L. A. Louver, Venice, CA
1982 Charles Cowles Gallery, New York

Selected Group Exhibitions:
1966 "Los Angeles Now," Robert Fraser Gallery, London
1968 "Assemblage in California," University of California, Irvine
1969 "West Coast 1945–1969," Pasadena Art Museum, California (traveled)
"Pop Art Redefined," Hayward Gallery, London
1975 "Collage and Assemblage," Los Angeles Institute of Contemporary Art

1976 "The Last Time I Saw Ferus,"
Newport Harbor Art Museum,
Newport Beach, CA
1977 "Painting and Sculpture in
California: The Modern Era," San
Francisco Museum of Modern Art
(traveled)
1979 "Electroworks," International
Museum of Photography at George
Eastman House, Rochester, NY
1981 "Art in Los Angeles: 17 Artists in
the Sixties," Los Angeles County
Museum of Art

BARBARA BLONDEAU

Born: Detroit, MI, 1938

Died: Philadelphia, PA, 1974

Education: BFA, School of the Art Institute
of Chicago, 1961 (painting)
MS, Institute of Design, Illinois Institute
of Technology, 1968 (photography)

Selected Individual Exhibitions:
1967 St. Mary's College, Notre Dame, IN
1975 Philadelphia College of Art
1976 Visual Studies Workshop,
Rochester, NY (retrospective;
traveled)

Selected Group Exhibitions:
1969 "Vision and Expression," George
Eastman House, Rochester, NY
1970 "Into the '70's: Photographic
Images by 16
Artists/Photographers," Akron Art
Institute, OH
1972 "The Multiple Image," Hayden
Gallery, Massachusetts Institute of
Technology, Cambridge
1974 "Visual Interface," Tyler School of
Art Gallery, Philadelphia
1976 "Three Centuries of American Art,"
Philadelphia Museum of Art
1978 "Spaces," Museum of Art, Rhode
Island School of Design, Providence
1981 "Cliché-Verre: Hand-Drawn,
Light-Printed—A Survey of the
Medium from 1839 to the Present,"
Detroit Institute of Arts

HARRY BOWERS

Born: Los Angeles, CA, 1938

Resides: Berkeley, CA

Education: BS, University of California,
Berkeley, 1964 (engineering physics)
MFA, San Francisco Institute, San
Francisco, 1974 (photography)

Awards: National Science Fellowship, 1965
National Endowment for the Arts,
Photography, 1978, 1980
Ruttenberg Foundation Grant, 1984

Selected Individual Exhibitions:
1973 Extension Gallery, University of
California, San Francisco
1976 Hansen Fuller Gallery, San
Francisco (1978)
1980 Thomas Segal Gallery, Boston
G. Ray Hawkins, Los Angeles
1981 The Photographer's Gallery, London
1983 Delahunty Gallery, Dallas
1985 Fuller-Goldeen Gallery, San
Francisco

Selected Group Exhibitions:
1977 "Bent Photography, California,
U.S.A." Australian Center for

Photography, Paddington (traveled)
1979 "Object/Illusion/Reality,"
California State University,
Fullerton (traveled)
1980 "Beyond Color," San Francisco
Museum of Modern Art
1981 "California Color," The
Photographer's Gallery, London
1982 "Color as Form: A History of Color
Photography," International
Museum of Photography at George
Eastman House, Rochester, NY
1985 "Signs of the Times: Some
Recurring Motifs in
Twentieth-Century Photography,"
San Francisco Museum of Modern
Art
1986 "Photography: A Facet of
Modernism," San Francisco
Museum of Modern Art

BILL BRANDT

Born: South London, England, 1904

Died: London, 1983

Education: Educated in Germany and
Switzerland
Studied under Man Ray in Paris,
1929–30

Awards: Doctor honoris causa, Royal
College of Art, London, England, 1977

Selected Individual Exhibitions:
1948 Museum of Modern Art, New York
(1969)
1963 George Eastman House, Rochester,
NY
1972 British Arts Council (traveled)
1973 Witkin Gallery, New York
1975 Hayward Gallery, London
Victoria and Albert Museum,
London
1976 Marborough Fine Art, London
1978 Moderna Museet, Stockholm
1979 Zeit-Foto Salon, Tokyo
1981 Royal Photographic Society, Bath,
England
1982 Art Gallery of Ontario, Toronto
1985 "Behind the Camera," Philadelphia
Museum of Art (retrospective)

Selected Group Exhibitions:
1955 "The Family of Man," Museum of
Modern Art, New York
1977 "Concerning Photography," London

MARCEL BROODTHAERS

Born: Belgium, 1924

Died: Cologne, West Germany, 1976

Selected Individual Exhibitions:
1964 Galerie Saint Laurent, Brussels
1965 Galerie Aujourd'hui, Palais des
Beaux-Arts, Brussels
1973 Art & Project, Amsterdam
(retrospective)
1975 Institute of Contemporary Arts, New
Gallery, London

Selected Group Exhibitions:
1964 "Distinction Jeune Sculpture Belge
1963," Palais des Beaux-Arts,
Brussels
1965 "Pop Art, Nouveau Realisme,
etc. . . ." Palais des Beaux-Arts,
Brussels
1968 "Three Blind Mice," Stedelijk Van
Abbemuseum, Eindhoven, The
Netherlands

1969 "Konzeption—Conception,"
Stadtische Museum, Leverkusen,
West Germany
1970 "Information," Museum of Modern
Art, New York
1971 "Prospect '71: Projection,"
Stadtische Kunsthalle, Düsseldorf,
West Germany
1972 "Amsterdam–Paris–Düsseldorf,"
Solomon R. Guggenheim Museum,
New York
1973 "Bilder—Objekt—Filme—Konzept,"
Stadtische Galerie im Lenbachhaus,
Munich; Palais de Beaux-Arts,
Brussels

ELLEN BROOKS

Born: Los Angeles, CA, 1946

Resides: New York, NY

Education: BA, University of California,
Los Angeles, 1968
MA, University of California, Los
Angeles, 1970
MFA, University of California, Los
Angeles, 1971

Awards: National Endowment for the Arts,
Photography, 1976, 1980

Selected Individual Exhibitions:
1977 San Francisco Art Institute
1978 N.A.M.E. Gallery, Chicago
1981 Barbara Gladstone Gallery, New
York (1983)

Selected Group Exhibitions:
1970 "Photography into Sculpture,"
Museum of Modern Art, New York
1974 "Bay Area Photography: New
Directions," M. H. de Young
Memorial Museum, San Francisco
1979 "Fabricated to be Photographed,"
San Francisco Museum of Modern
Art (traveled)
"Attitudes: Photography in the
Seventies," Santa Barbara Museum
of Art
1983 "Images Fabriques," Centre
Georges Pompidou, Paris
1984 "Photography in California:
1945–1980," San Francisco
Museum of Modern Art
1986 "The Real Big Picture," Queens
Museum, Flushing, NY

WYNN BULLOCK

Born: Chicago, IL, 1902

Died: Pacific Grove, CA, 1975

Education: Columbia College, New York,
1925–27 (music)
University of West Virginia,
Morgantown, 1931–32
Art Center School, Los Angeles,
1938–40 (photography)

Selected Individual Exhibitions:
1947 Santa Barbara Museum of Art
(1970)
1954 University of California, Los
Angeles
1956 M. H. de Young Memorial Museum,
San Francisco
1957 George Eastman House, Rochester,
NY (1966)
1969 San Francisco Museum of Art
(1970, 1976)
1970 Amon Carter Museum, Fort Worth

1976 Metropolitan Museum of Art, New York
Art Institute of Chicago
Selected Group Exhibitions:
1955 "The Family of Man," Museum of Modern Art, New York (traveled)
1959 "Photography at Mid-Century," George Eastman House, Rochester, NY
1960 "The Sense of Abstraction in Contemporary Photography," Museum of Modern Art, New York
1974 "Photography in America," Whitney Museum of American Art, New York
1975 "The Land: 20th Century Landscape Photographs Selected by Bill Brandt," Victoria and Albert Museum, London (traveled)
1980 "Photography of the '50's," International Center of Photography, New York (traveled)
1981 "American Landscape," Museum of Modern Art, New York
1982 "Color as Form: A History of Color Photography," International Museum of Photography at George Eastman House, Rochester, NY

VICTOR BURGIN

Born: Sheffield, Yorkshire, England, 1941

Resides: London

Education: ARCA, Royal College of Art, London, 1965
MFA, Yale University, New Haven, CT 1967

Awards: US/UK Bicentennial Arts Exchange Fellowship, 1976–77
Deutscher Akademischer Austauschdienst Fellowship, Berlin, 1978–79

Selected Individual Exhibitions:
1976 Institute of Contemporary Arts, London
Robert Self Gallery, London
1977 Stedelijk Van Abbemuseum, Eindhoven, The Netherlands
1978 Museum of Modern Art, Oxford, England
1979 Deutscher Akademischer Austauschdienst, Berlin
1980 Picker Art Gallery, Colgate University, Hamilton, NY
Selected Group Exhibitions:
1969 "When Attitudes Become Form," Kunsthalle, Bern (traveled)
1970 "Information," Museum of Modern Art, New York
1971 "6th Guggenheim International," Solomon R. Guggenheim Museum, New York
1972 Documenta 5, Kassel, West Germany
"The New Art," Hayward Gallery, London
1977 "Europe in the '70's," Art Institute of Chicago
1979 "3 Perspectives on Photography," Hayward Gallery, London

JACK BUTLER

Born: Oswego, NY, 1947

Resides: South Pasadena, CA

Education: BA, California State College, Los Angeles, 1972
MA, California State University, Los Angeles, 1972
MFA, University of California, Los Angeles, 1979

Awards: National Endowment for the Arts, Photography, 1981

Selected Individual Exhibitions:
1976 Orlando Gallery, Encino, CA (1977)
1981 BC Space Gallery, Laguna Beach, CA
1984 University of Connecticut, Storrs
1985 Lightsong Gallery, University of Arizona, Tucson
Selected Group Exhibitions:
1976 "Photography and Language," LaMamell Camerawork Gallery, San Francisco
1977 "Eros and Photography," Camerawork Gallery, San Francisco
1981 "Californian Colour," The Photographers' Gallery, London
1982 "Color as Form: A History of Color Photography," International Museum of Photography at George Eastman House, Rochester, NY (traveled)
"Studio Work: Photographs by Ten Los Angeles Artists," Los Angeles County Museum of Art
1985 "Signs of the Times: Some Recurring Motifs in Twentieth-Century Photography," San Francisco Museum of Modern Art
"Extending the Perimeters of Twentieth-Century Photography," San Francisco Museum of Modern Art

HARRY CALLAHAN

Born: Detroit, MI, 1912

Resides: Atlanta, GA

Education: Michigan State College, East Lansing, 1931–33 (engineering)

Awards: Graham Foundation Grant, 1956
Rhode Island Governor's Award for Excellence in the Arts, 1969
Distinguished Contribution Award, National Association of Schools, 1972
John Simon Guggenheim Memorial Fellowship, 1972
National Endowment for the Arts, Photography, 1976
Photographer and Educator Award, Society for Photographic Education, 1976
DFA, Rhode Island School of Design, 1978
Distinguished Career in Photography Award, The Friends of Photography, 1980

Selected Individual Exhibitions:
1946 750 Studio Gallery, Chicago
1951 Art Institute of Chicago
Museum of Modern Art, New York
1958 George Eastman House, Rochester, NY (retrospective) (1969, 1971)
1964 Hallmark Gallery, New York
El Mochuelo Gallery, Santa Barbara
1968 Museum of Modern Art, New York (1976)
1972 Light Gallery, New York (1974, 1976, 1978, 1980)
1978 Biennial, Venice

1984 Art Institute of Chicago
Selected Group Exhibitions:
1948 "In and Out of Focus," Museum of Modern Art, New York
1950 "Photography at Mid-Century," Los Angeles County Museum of Art
1955 "The Family of Man," Museum of Modern Art, New York (traveled)
1959 "Photography in the Fine Arts," Metropolitan Museum of Art, New York
1963 "The Photographer and the American Landscape," Museum of Modern Art, New York
1977 "The Photographer and the City," Museum of Contemporary Art, Chicago
1981 "The New Color: A Decade of Color Photography," International Center of Photography, New York
"American Landscape," Museum of Modern Art, New York
1982 "Color as Form: A History of Color Photography," International Museum of Photography at George Eastman House, Rochester, NY

JO ANN CALLIS

Born: Cincinnati, OH, 1940

Resides: Los Angeles, CA

Education: BA, University of California, Los Angeles, 1974
MFA, University of California, Los Angeles, 1977

Awards: Ferguson Award, Friends of Photography, Carmel, CA, 1978
National Endowment for the Arts, Photography, 1980, 1984

Selected Individual Exhibitions:
1975 Orange Coast College, Costa Mesa, CA (1978)
1980 G. Ray Hawkins Gallery, Los Angeles
1986 Min Gallery, Tokyo
Selected Group Exhibitions:
1977 "Callis, Kasten, Zimmerman," University of Southern California, Los Angeles
1978 "The Photograph as Artifice," California State University, Long Beach
1979 "Attitudes: Photography in the Seventies," Santa Barbara Museum of Art
Witkin Gallery, New York
1985 Biennial, Whitney Museum of American Art, New York

PETER CAMPUS

Born: New York, NY, 1937

Resides: New York, NY

Education: Ohio State University, 1960

Awards: John Simon Guggenheim Memorial Fellowship, 1975
National Endowment for the Arts, Video, 1976

Selected Individual Exhibitions:
1972 Bykert Gallery, New York (1973, 1975)
1974 Everson Museum of Art, Syracuse, NY
1976 Museum of Modern Art, New York

1978 Whitney Museum of American Art, New York (film and video)
1979 Paula Cooper Gallery, New York (1981, 1982, 1983, 1985, 1986)
Kolnischer Kunstverein, Cologne, West Germany
1980 Centre Georges Pompidou, Paris

Selected Group Exhibitions:
1971 Corcoran Gallery of Art, Washington, DC
1973 Biennial, Whitney Museum of American Art, New York
"Revision," Contemporary Arts Museum, Houston
1974 "Projected Images," Walker Art Center, Minneapolis
1976 "Autogeography," Whitney Museum of American Art, New York
"Changing Channels," Museum of Fine Arts, Boston .
1978 Biennale, Venice
1979 "The Elusive Image," Walker Art Center, Minneapolis
"Videotapes aus Museumbesitz," Kaiser Wilhelm Museum, Krefeld, West Germany
1980 "Extensions of Photography," University Art Museum, University of California, Santa Barbara
1983 "Photography in America 1910–Present," Tampa Museum, FL
1984 "Content: A Contemporary Focus, 1974–1984," Hirshhorn Museum and Sculpture Garden, Washington, DC

PAUL CAPONIGRO

Born: Boston, MA, 1932

Resides: Santa Fe, NM

Education: Boston University, College of Music, 1950–51 (piano)
California School of Fine Arts, San Francisco, 1956
Rochester Institute of Technology, NY, 1957–58

Awards: John Simon Guggenheim Memorial Fellowship, 1966
National Endowment for the Arts, Photography, 1971, 1975, 1982

Selected Individual Exhibitions:
1958 "In the Presence Of," George Eastman House, Rochester, NY
1968 Museum of Modern Art, New York (traveled)
1969 Friends of Photography, Carmel, CA (1975)
1973 Art Institute of Chicago
1975 Victoria and Albert Museum, London
1976 Albright-Knox Art Gallery, Buffalo, NY
Museum of Fine Arts, Santa Fe, NM
1979 High Museum of Art, Atlanta
1981 Marlborough Gallery, New York

Selected Group Exhibitions:
1960 "The Sense of Abstraction in Contemporary Photography," Museum of Modern Art, New York
1963 "The Photographer and the American Landscape," Museum of Modern Art, New York
1964 "The Photographer's Eye," Museum of Modern Art, New York

1967 "Photography in the Twentieth Century," George Eastman House, Rochester, NY, with the National Gallery of Canada, Ottawa (traveled)
1974 "American Masters," Smithsonian Institution, Washington, DC
"Photography in America," Whitney Museum of American Art, New York
1975 "14 American Photographers," Baltimore Museum of Art (traveled)
1978 "Mirrors and Windows: American Photography since 1960," Museum of Modern Art, New York (traveled)
1979 "Attitudes: Photography in the Seventies," Santa Barbara Museum of Art
1981 "American Landscape," Museum of Modern Art, New York
1982 "Color as Form: A History of Color Photography," International Museum of Photography at George Eastman House, Rochester, NY

JAMES CASEBERE

Born: Lansing, MI, 1953

Resides: New York, NY

Education: BFA, Minneapolis College of Art and Design, 1976
MFA, California Institute of Arts, Valencia, 1979

Awards: National Endowment for the Arts, Photography, 1982, 1986
New York State Council on the Arts, Visual Artists, 1982
New York Foundation for the Arts Fellowship, 1985

Selected Individual Exhibitions:
1979 Artists Space, New York
1981 Franklin Furnace, New York
1982 Sonnabend Gallery, New York (1984)
CEPA Gallery, Buffalo, NY
1984 Diane Brown Gallery, New York
1985 Richard Kuhlenschmidt Gallery, Los Angeles

Selected Group Exhibitions:
1979 "Fabricated to be Photographed," San Francisco Museum of Modern Art (traveled)
1981 "Erweiterte Fotografie," International Biennale, Vienna
1982 "Tableaux: Nine Contemporary Sculptors," The Contemporary Art Center, Cincinnati
1983 "Images Fabriques," Centre Georges Pompidou, Paris (traveled)
"In Plato's Cave," Marlborough Gallery, New York
1985 Biennial, Whitney Museum of American Art, New York
1986 "The Real Big Picture," Queens Museum, Flushing, NY

WALTER CHAPPELL

Born: Portland, OR, 1925

Resides: Near Taos, NM

Education: Ellison-White Conservatory of Music, Portland, 1932–43 (music)
Benson Polytechnical School, Portland, 1939–43 (architectural drawing)
Taliesin West, Paradise Valley, AZ, 1953–54 (architecture)

Photographic printmaking with Minor White, Rochester, NY, 1957–58

Awards: National Endowment for the Arts, Photography, 1977, 1980, 1984

Selected Individual Exhibitions:
1957 George Eastman House, Rochester, NY
1959 Smithsonian Institution, Washington, DC
1964 El Mochuelo Gallery, Santa Barbara
1967 Museum of New Mexico, Santa Fe
1973 Visual Studies Workshop, Rochester, NY (1976)
Musée d'Art Moderne, Paris
1978 Philadelphia Museum of Art

Selected Group Exhibitions:
1959 "Photography at Mid-Century," George Eastman House, Rochester, NY
1960 "The Sense of Abstraction in Contemporary Photography," Museum of Modern Art, New York
1967 "Photography in the Twentieth Century," George Eastman House, Rochester, NY, with the National Gallery of Canada, Ottawa (traveled)
1968 "Light 7," Hayden Gallery, Massachusetts Institute of Technology, Cambridge
1974 "Photography in America," Whitney Museum of American Art, New York
1978 "Mirrors and Windows: American Photography since 1960," Museum of Modern Art, New York (traveled)

CARL CHIARENZA

Born: Rochester, NY, 1935

Resides: Rochester, NY

Education: BFA, Rochester Institute of Technology, 1957
MS, Boston University, 1959
AM, Boston University, 1964
PhD, Harvard University, 1973

Awards: Howard Thurman Educational Trust Fund Fellowship, 1962
Kress Foundation Research Grant, 1970–71
Artist's Fellowship, Massachusetts Arts and Humanities Foundation, 1975–76
National Endowment for the Arts, Photography, 1977

Selected Individual Exhibitions:
1960 Image Gallery, Boston
1962 Carl Siembab Gallery, Boston (1968, 1976, 1978, 1980, 1982)
1963 Harvard University, Cambridge
1968 Focus Gallery, San Francisco
1979 Minneapolis Institute of Arts

Selected Group Exhibitions:
1957 Albright-Knox Art Gallery, Buffalo, NY
1959 "Photography at Mid-Century," George Eastman House, Rochester, NY
1960 "The Sense of Abstraction in Contemporary Photography," Museum of Modern Art, New York
1963 "Photography in the Fine Arts IV," Metropolitan Museum of Art, New York (traveled)
1967 "Photography in the Twentieth Century," George Eastman House,

Rochester, NY, with the National Gallery of Canada, Ottawa (traveled)
1969 "Eight Photographers," Harvard University, Cambridge
1972 "Contemporary American Photographers," Fogg Art Museum, Harvard University, Cambridge
1977 "Contemporary American Photography," Target Collection, Museum of Fine Arts, Houston (traveled)
1979 "Attitudes: Photography in the Seventies," Santa Barbara Museum of Art

CHUCK CLOSE

Born: Monroe, WA, 1940

Resides: New York, NY

Education: BA, University of Washington, Seattle, 1962
BFA, Yale University, School of Art and Architecture, 1963
MFA, Yale University, School of Art and Architecture, 1964

Awards: Fulbright Grant to Vienna 1964–65
National Endowment for the Arts, Painting, 1973

Selected Individual Exhibitions:
1970 Bykert Gallery, New York (1971, 1973, 1975)
1971 Los Angeles County Museum of Art
1972 Museum of Contemporary Art, Chicago
1973 Akron Art Institute, OH
Museum of Modern Art, New York
1975 Minneapolis Institute of Art
Phoenix Art Museum, AZ
San Francisco Museum of Modern Art
1976 Baltimore Museum of Art
1977 Pace Gallery, New York (1979, 1983, 1986)
Wadsworth Atheneum, Hartford, CT
1979 Centre Georges Pompidou, Paris
1980 Walker Art Center, Minneapolis (traveled)
1985 "Chuck Close: Works on Paper," Contemporary Arts Museum, Houston

Selected Group Exhibitions:
1969 Biennial, Whitney Museum of American Art, New York (1977, 1979)
1970 "22 Realists," Whitney Museum of American Art, New York
1971 "Prospect '71: Projection," Kunsthalle, Düsseldorf
1972 "Amerikanischer Fotorealismus," Wurtembergischer Kunstverein, Stuttgart (traveled)
Documenta 5, Kassel, West Germany
1977 Documenta 6, Kassel, West Germany
"Paris–New York," Centre Georges Pompidou, Paris
1979 "The Altered Photograph," P.S. 1, Institute for Art and Urban Resources, Long Island City, NY
"The Decade in Review: Selections from the 1970s," Whitney Museum of American Art, New York
1980 "Printed Art: A View of Two Decades," Museum of Modern Art, New York

1981 "Photographer as Printmaker" (organized by Arts Council of Great Britain; traveled)
1982 "Great Big Drawings," Hayden Gallery, Massachusetts Institute of Technology, Cambridge
1984 "Drawing 1974–1984," Hirshhorn Museum and Sculpture Garden, Washington, DC
1986 "The Real Big Picture," Queens Museum, Flushing, NY
"An American Renaissance: Painting and Sculpture since 1940," Museum of Art, Fort Lauderdale, FL

BRUCE CONNER

Born: McPherson, KN, 1933

Resides: San Francisco, CA

Awards: Ford Foundation Fellowship Grant, 1964
Copley Foundation Award, 1965
National Endowment for the Arts, 1973 (painting), 1984 (film)
American Film Institute Grant, 1974
John Simon Guggenheim Memorial Fellowship, 1975
Honorary Doctorate of Fine Arts, San Francisco Art Institute, 1986

Selected Individual Exhibitions:
1956 Rienzi Gallery, New York
1960 Alan Gallery, New York (1961, 1963, 1964, 1965)
1964 Robert Fraser Gallery, London
George Lester Gallery, Rome
1965 Rose Art Museum, Brandeis University, Waltham, MA
University of British Columbia Art Gallery, Vancouver
1967 Institute of Contemporary Art, University of Pennsylvania
1974 M. H. de Young Memorial Museum, San Francisco
1977 Denver Art Museum
1983 Fraenkel Gallery, San Francisco (1986)
1984 Los Angeles Museum of Contemporary Art

Selected Group Exhibitions:
1961 "The Art of Assemblage," Museum of Modern Art, New York
1962 "50 California Artists," Whitney Museum of American Art, New York
1964 The Hague, The Netherlands
1967 "Sculpture of the '60s," Los Angeles County Museum of Art
1977 "Paris–New York," Centre Georges Pompidou, Paris
1978 "Aspekte der Jahre," Nationalgalerie, Berlin
1982 Biennial, Whitney Museum of American Art, New York
"Form, Freud & Feeling," San Francisco Museum of Modern Art
"100 Years of California Sculpture," Oakland Museum, CA

CARLOTTA CORPRON

Born: Blue Earth, MN, 1901

Resides: Denton, TX

Education: BS, Michigan State Normal College (now Eastern Michigan University), Ypsilanti, 1925 (art)
MA, Teachers College, Columbia University, New York, 1926

Art Center School, Los Angeles, 1936 (photographic technique)
Private photographic studies under Gyorgy Kepes

Selected Individual Exhibitions:
1948 Dallas Museum of Fine Arts
1953 Art Institute of Chicago
University of Georgia, Athens
1954 Women's University of North Carolina, Greensboro
1955 Ohio University, Athens
1977 Marcuse Pfeifer Gallery, New York
1980 Amon Carter Museum, Fort Worth
Texas Woman's University, Denton

Selected Group Exhibitions:
1944 "Captured Light," Norlyst Gallery, New York
1945 "Design with Light," Art Alliance, Philadelphia
1951 "Contemporary Photography," Contemporary Arts Association, Houston
1951 "Abstraction in Photography," Museum of Modern Art, New York
1975 "Women of Photography: An Historical Survey," San Francisco Museum of Modern Art
1979 "Recollections: 10 Women of Photography," International Center of Photography, New York (traveled)
1980 "Photography's Response to Constructivism," San Francisco Museum of Modern Art
"Light Abstractions," University of Missouri, St. Louis, MO

EILEEN COWIN

Born: Brooklyn, NY, 1947

Resides: Santa Monica, CA

Education: BS, State University College of New York at New Paltz, 1968
MS, Illinois Institute of Technology, Chicago, 1970

Awards: National Endowment for the Arts, Photography, 1979, 1982

Selected Individual Exhibitions:
1980 Orange Coast College, Costa Mesa, CA (1983)
1984 University of Arizona, Tucson
H. F. Manes Gallery, New York
1985 Viviane Esders, Paris
Los Angeles County Museum of Art

Selected Group Exhibitions:
1975 "14 American Photographers," Baltimore Museum of Art (traveled)
"Picture Puzzles," Museum of Modern Art, New York
1977 Biennale, Paris
Biennial, Whitney Museum of American Art, New York
1978 "Mirrors and Windows: American Photography since 1960," Museum of Modern Art, New York (traveled)
1979 "Fabricated to be Photographed," San Francisco Museum of Modern Art
1980 "The New Vision: Forty Years of Photography at the Institute of Design," Light Gallery, New York (traveled)
1981 "The Photographer as Printmaker" (organized by the Arts Council of Great Britain; traveled)

"New Voices Two: Six Photographers Concept/Theatre/Fiction," Allen Memorial Art Museum, Oberlin, OH
1986 "Monumental Drawing," Brooklyn Museum, New York

ROBERT CUMMING

Born: Worcester, MA, 1943

Resides: West Suffield, CT

Education: BFA, Massachusetts College of Art, Boston, 1965 (painting)
MFA, University of Illinois, Champaign, 1967 (painting)

Awards: National Endowment for the Arts, Photography, 1973
National Endowment for the Arts, New Genres, 1974
National Endowment for the Arts, Printmaking, 1983
John Simon Guggenheim Memorial Fellowship, 1980–81
Artist-in-Residence Exchange Program, Japan–U.S. Friendship Commission, 1981

Selected Individual Exhibitions:
1973 John Gibson Gallery, New York (1975, 1977)
1976 Los Angeles Institute of Contemporary Art
1979 Friends of Photography, Carmel, CA (retrospective)
1982 Werkstatt fur Photographie, Berlin Castelli Uptown, New York (1984, 1985, 1986)
1986 Whitney Museum of American Art, New York (retrospective) San Francisco Museum of Modern Art

Selected Group Exhibitions:
1971 "24 Young Los Angeles Artists," Los Angeles County Museum of Art
1972 "Books by Artists," Newport Harbor Art Museum, CA

DARRYL CURRAN

Born: Santa Barbara, CA, 1935

Resides: Los Angeles, CA

Education: BA, University of California, Los Angeles, 1960
MA, University of California, Los Angeles, 1964

Awards: National Endowment for the Arts, Photography, 1980

Selected Individual Exhibitions:
1972 The Center of the Eye, Aspen
1974 Focus Gallery, San Francisco
1981 G. Ray Hawkins Gallery, Los Angeles

Selected Group Exhibitions:
1968 "Young Photographers '68," Purdue University, Lafayette, IN
1969 "Vision and Expression," George Eastman House, Rochester, NY
1970 "The Arrested Image," Oakland Museum, California
"Photography into Sculpture," Museum of Modern Art, New York
1974 "Light and Substance," University of New Mexico, Albuquerque
1977 "New Blues," Arizona Commission for Arts and Humanities (traveled)

1978 "Mirror and Windows: American Photography since 1960," Museum of Modern Art, New York (traveled)
1979 "Translations: Photographic Images with New Forms," Herbert F. Johnson Museum of Art, Cornell University, Ithaca, NY
1981 "Altered Image," Center for Creative Photography, University of Arizona, Tucson
1982 "Altered States," School of Art & Design, University of Illinois, Urbana-Champaign
1984 "Photography in California: 1945–1980," San Francisco Museum of Modern Art (traveled)

JAN DIBBETS

Born: Weert, The Netherlands, 1941

Resides: Amsterdam, The Netherlands

Education: Bischoppelijk College, Weert, 1953–59
Academie voor Beeldende an Bouwedde Kunsten, Tilburg, 1959–63
Studies painting with Jan Gregor, Eindhoven, 1961–63
St. Martin's School of Art, London, 1967
Self-taught in photography

Awards: British Council Scholarship, London, 1967
Heineken Prize, The Hague, 1969
Cassandra Foundation, New York, 1971

Selected Individual Exhibitions:
1965 Galerie Swart, Amsterdam (1966, 1967)
1968 Galerie Konrad Fischer, Düsseldorf (1971, 1973)
1969 Museum Haus Lange, Krefeld, West Germany
1970 Zentrum fur Aktuelle Kunst, Aachen, West Germany
1971 Stedelijk van Abbemuseum, Eindhoven, The Netherlands
1972 Israel Museum, Jerusalem
1973 Leo Castelli Gallery, New York (1975)
1975 "Jan Dibbets: Autumn Melody," Kunstmuseum, Lucerne
1980 Kunsthalle, Berne
1982 "Saenredam-Senaque," Renault Recherches Art et Industrie Centre International de Creation Artistique, France

Selected Group Exhibitions:
1970 "Information," Museum of Modern Art, New York
1971 "Guggenheim International," Guggenheim Museum, New York
1972 "Konzept/Kunst," Kunstmuseum, Basel Biennale, Venice
1974 "Photokina '74," Cologne
"Contemporanea," Parcheggio Villa Borghese, Rome
"Projekt '74," Kunsthalle, Cologne
1978 "23 Photographers/23 Directions," Walker Art Gallery, Liverpool
1979 "Photographie als Kunst 1879–1979/ Kunst als Photographie 1949–1979," Tiroler Landesmuseum Ferdinandeum, Innsbruck, Austria (traveled)

1981 "Murs," Centre Georges Pompidou, Paris
1982 "1960–80, Attitudes, Concepts, Images," Stedelijk Museum, Amsterdam
Documenta 7, Kassel, West Germany
"Postminimalist," Aldridge Museum, Richfield, CT

JOHN DIVOLA

Born: Santa Monica, CA, 1949

Resides: Venice, CA

Education: BA, California State University, Northridge, 1971
MA, University of California, Los Angeles, 1973
MFA, University of California, Los Angeles, 1974

Awards: National Endowment for the Arts, Photography, 1973, 1976, 1979
John Simon Guggenheim Memorial Fellowship, 1986

Selected Individual Exhibitions:
1976 Center for Creative Photography, University of Arizona, Tucson (1983)
1980 Catskill Center for Photography, Woodstock, NY
1982 University of New Mexico, Albuquerque
1985 La Jolla Museum of Contemporary Art, CA

Selected Group Exhibitions:
1973 "24 From L.A.," San Francisco Museum of Modern Art
1978 "Photograph as Artifice," California State University, Long Beach (traveled)
"Mirrors and Windows: American Photography since 1960," Museum of Modern Art, New York (traveled)
1979 "Divola, Henkel, Parker, Pfahl," Visual Studies Workshop, Rochester, NY (traveled)
"Attitudes: Photography in the Seventies," Santa Barbara Museum of Art
1981 Biennial, Whitney Museum of American Art, New York
1982 "Color as Form: A History of Color Photography," International Museum of Photography at George Eastman House, Rochester, NY (traveled)
1984 "Photography in California: 1945–1980," San Francisco Museum of Modern Art
"Anxious Interiors," Laguna Beach Art Museum, CA

ROBERT FICHTER

Born: Fort Meyers, FL, 1939

Resides: Tallahassee, FL

Education: BFA, University of Florida, Gainesville, 1963 (printmaking and painting)
MFA, Indiana University, Bloomington, 1966 (photography and printmaking)

Awards: National Endowment for the Arts, Photography, 1980, 1984

Selected Individual Exhibitions:
1968 George Eastman House, Rochester, NY
1972 Center of the Eye, Aspen, CO
 Visual Studies Workshop, Rochester, NY (traveled)
1974 Light Gallery, New York (1976)
1978 Camerawork Gallery, San Francisco
1980 Robert Freidus Gallery, New York (1981)
1984 Frederick S. Wight Gallery, University of California, Los Angeles (traveled)
Selected Group Exhibitions:
1968 "Contemporary Photographers," University of California, Los Angeles
1969 "Serial/Modular Imagery," Purdue University, Lafayette, IN (traveled)
1970 "The Photograph as Object 1843–1969," National Gallery of Canada, Ottawa (traveled)
1972 "'60s Continuum," International Museum of Photography at George Eastman House, Rochester, NY
1973 "Photography into Art," Scottish Arts Council Gallery, Edinburgh
1977 "Painting in the Age of Photography," Kunsthaus, Zurich
1981 Biennial, Whitney Museum of American Art, New York
1984 "Photography in California: 1945–1980," San Francisco Museum of Modern Art
1985 "Extending the Perimeters of Twentieth-Century Photography," San Francisco Museum of Modern Art

HOLLIS FRAMPTON

Born: Wooster, OH, 1936

Died: Buffalo, NY, 1984

Education: Western Reserve University, Cleveland, 1954–57

Awards: National Endowment for the Arts Grant, 1975
American Film Institute Grant, 1977

Selected Individual Exhibitions:
1965 Goddard College, Plainfield, VT
 Peninsula Gallery, Palo Alto, CA
1970 Konrad Fischer Gallery, Düsseldorf, West Germany
1975 Visual Studies Workshop, Rochester, NY (with Marion Faller) (1982)
1982 Light Work/Community Darkrooms Gallery, Syracuse, NY
1983 CEPA Gallery, Buffalo, NY
Selected Group Exhibitions:
1973 "Options and Alternatives: Some Directions in Recent Art," Yale University Art Gallery, New Haven, CT
1976 "The Photographer and the Artist," Sidney Janis Gallery, New York
1977 "Locations in Time," International Museum of Photography at George Eastman House, Rochester, NY
1982 "Target III: In Sequence," Museum of Fine Arts, Houston
1983 "Radical Rational, Space Time: Idea Networks in Photography," Henry Art Gallery, University of Washington, Seattle

JACK FULTON

Born: San Francisco, CA, 1939

Resides: San Rafael, CA

Education: College of Marin, Kentfield, CA, 1957–58, 1960–61
San Francisco State College, 1962–63

Awards: National Endowment for the Arts, Photography, 1981

Selected Individual Exhibitions:
1967 Sacramento State College, CA
1969 M. H. de Young Memorial Museum, San Francisco
1973 The Floating Photography Foundation, New York
1975 E. B. Crocker Art Gallery, Sacramento, CA
1979 San Francisco Museum of Modern Art
1980 Silver Image Gallery, Seattle
Selected Group Exhibitions:
1969 "Repair Show," Berkeley Gallery, San Francisco
1970 "The Pollution Show," Oakland Museum, CA
1978 University of Colorado, Boulder, 1978
1979 "Altered Photographs," P.S. 1, Institute for Art and Urban Resources, Long Island City, NY
 "Sequences," Santa Barbara Museum of Art
1982 "Altered States," University of Illinois, Champaign-Urbana
1983 "Self as Subject," University of New Mexico, Albuquerque
1984 "Photography in California: 1945–1980," San Francisco Museum of Modern Art (traveled)

RALPH GIBSON

Born: Los Angeles, CA, 1939

Resides: New York, NY

Education: Studied photography in US Navy, 1956–1960
San Francisco Art Institute, 1960–61

Awards: National Endowment for the Arts, Photography, 1973, 1976, 1986
Creative Artists Program Service (CAPS), 1977
John Simon Guggenheim Memorial Fellowship, 1985

Selected Individual Exhibitions:
1970 San Francisco Art Institute
1971 Focus Gallery, San Francisco (1976)
1972 Pasadena Museum of Art, CA
1973 International Museum of Photography at George Eastman House, Rochester, NY
1974 Palais des Beaux-Arts, Brussels
1976 Castelli Graphics, New York (1978, 1980, 1982)
1977 Fotografiska Museet, Stockholm
 Museum of Modern Art, Oxford, England
1978 Center for Creative Photography, University of Arizona, Tucson
 Museum of Modern Art, Brisbane, Australia
1980 Kunstmuseum, Düsseldorf
1982 Centre Georges Pompidou, Paris
 Shadai Gallery, Tokyo

1985 Leo Castelli Gallery, New York
Selected Group Exhibitions:
1974 "New Images in Photography," Lowe Art Museum, Miami, FL
1977 "Rooms," Museum of Modern Art, New York
 "Contemporary American Photographic Works," Museum of Fine Arts, Houston
1978 "Mirrors and Windows: American Photography since 1960," Museum of Modern Art, New York (traveled)
1979 "Photographie als Kunst 1879–1979/Kunst als Photographie 1949–1979," Tiroler Landesmuseum Ferdinandeum, Innsbruck, Austria
 "Attitudes: Photography in the Seventies," Santa Barbara Museum of Art
1980 "Old and Modern Masters of Photography," Victoria and Albert Museum, London
 "Instantenes," Centre Georges Pompidou, Paris
1982 "Counterparts: Form and Emotion in Photography," Metropolitan Museum of Art, New York
 "Form, Freud & Feeling," San Francisco Museum of Modern Art
1983 "Particulars," Museum of Art, Philadelphia
 "Phototypes," Whitney Museum of American Art, New York
1985 "Anxious Interiors," Bronx Museum, New York

JUDITH GOLDEN

Born: Chicago, IL, 1934

Resides: Oracle, AZ

Education: BFA, School of the Art Institute of Chicago, 1973
MFA, University of California, Davis, 1975

Awards: National Endowment for the Arts, Photography, 1979
Arizona Commission on the Arts, Artist's Fellowship, 1984

Selected Individual Exhibitions:
1977 University of Colorado, Boulder
 University of California, San Francisco
 School of the Art Institute of Chicago
1978 Orange Coast College, Costa Mesa, CA
 Portland School of Art, ME
1983 Center for Creative Photography, University of Arizona, Tucson
1986 Museum of Photographic Arts, San Diego
Selected Group Exhibitions:
1977 "Contemporary Photography," Fogg Art Museum, Harvard University, Cambridge
1978 "Silver and Ink," Oakland Museum, California
1979 "Translations: Photographic Images with New Forms," Cornell University, Ithaca, NY
 "Attitudes: Photography in the Seventies," Santa Barbara Museum of Art

1981 "Erweiterte Fotografie,"
International Biennale, Vienna
"Autoportraits Photographiques
1898–1981," Centre Georges
Pompidou, Paris
1982 "Collage and Assemblage," San
Francisco Museum of Modern Art
1983 "The Self as Subject: Visual Diaries
of 14 Photographers," University of
New Mexico, Albuquerque
1984 "Photography in California:
1945–1980," San Francisco
Museum of Modern Art (traveled)
1985 "Extending the Perimeters of
Twentieth-Century Photography,"
San Francisco Museum of Modern
Art

NAN GOLDIN

Born: Washington, DC, 1953

Resides: New York, NY

Education: BA, Tufts University, Medford,
MA, 1977
MFA, School of the Museum of Fine
Arts, Boston, 1978

Awards: Englehard Foundation,
Cambridge, MA, 1986

Selected Individual Exhibitions:
1979 Mudd Club, New York
1981 Artists Space, New York
The Kitchen, New York (1983)
Whitney Museum of American Art,
Downtown Branch, New York
1982 Club 57, New York
1983 Rotterdam Arts Foundation, The
Netherlands
1984 Babylon Theater, West Berlin
Moderna Museet, Stockholm
1985 Institute of Contemporary Art,
Boston
1986 Burden Gallery, New York

Selected Group Exhibitions:
1980 "Times Square Show,"
Collaborative Projects, Inc., New
York
1981 "New York, New Wave," P.S. 1,
Institute for Art and Urban
Resources, Long Island City, NY
"Lichtbildnisse: Das Porträt in der
Fotografie," Rheinisches
Landesmuseum, Bonn, West
Germany
1982 "Faces Photographed," Grey Art
Gallery and Study Center, New York
University, New York
1983 "Presentation: Recent Portrait
Photography," Tuft Museum,
Cincinnati
1985 Biennial, Whitney Museum of
American Art, New York
"Self-Portrait," Museum of Modern
Art, New York
1986 Berlin Film Festival
"The Real Big Picture," Queens
Museum, Flushing, NY

JAN GROOVER

Born: Plainfield, NJ, 1943

Resides: New York, NY

Education: BFA, Pratt Institute, Brooklyn,
1965 (painting)
MA, Ohio State University, Columbus
(art education)

Awards: Creative Artists Program Service
(CAPS), New York State Council on the
Arts, 1975, 1978
National Endowment for the Arts,
Photography, 1978
John Simon Guggenheim Memorial
Fellowship, 1979

Selected Individual Exhibitions:
1974 Light Gallery, New York
1976 Corcoran Gallery of Art,
Washington, DC
International Museum of
Photography at George
Eastman House, Rochester, NY
1977 Baltimore Museum of Art
Sonnabend Gallery, New York
(1978, 1980, 1981)
1978 Galerie Sonnabend, Paris
1981 Camera Obscura, Stockholm
1983 Neuberger Museum, State
University of New York at Purchase;
Laguna Gloria Art Museum and the
Baltimore Museum of Art
1985 Robert Miller Gallery, New York
1986 Cleveland Museum of Art

Selected Group Exhibitions:
1977 "Locations in Time," International
Museum of Photography at George
Eastman House, Rochester, NY
"Contemporary American
Photographic Works," Museum of
Fine Arts, Houston (traveled)
1978 "Mirrors and Windows: American
Photography since 1960," Museum
of Modern Art, New York (traveled)
1979 "Auto-Icons," Whitney Museum of
American Art, New York
"Photographie als Kunst
1879–1979/Kunst als
Photographie 1949–1979," Tiroler
Landesmuseum Ferdinandeum,
Innsbruck, Austria
1980 "American Images: New Work by
Twenty Contemporary
Photographers," International
Center of Photography, New York
(traveled)
1981 "The New Color Photography,"
Everson Museum of Art, Syracuse,
NY (traveled)
1982 "Color as Form: A History of Color
Photography," International
Museum of Photography at George
Eastman House, Rochester, NY
(traveled)
"Counterparts: Form and Emotion
in Photographs," Metropolitan
Museum of Art, New York (traveled)
1983 "Big Pictures by Contemporary
Photographers," Museum of
Modern Art, New York
1985 "American Images: Photography
1945–1980," Barbican Art Gallery,
London

HANS HAACKE

Born: Cologne, West Germany, 1936

Resides: New York, NY

Education: MFA, State Academy of Fine
Art, Kassel, West Germany, 1960

Awards: Fulbright Fellowship, 1961
John Simon Guggenheim Memorial
Fellowship, 1973

National Endowment for the Arts,
Conceptual/Performance/New Genres,
1978

Selected Individual Exhibitions:
1967 Hayden Gallery, Massachusetts
Institute of Technology, Cambridge
1972 Museum Haus Lange, Krefeld, West
Germany
1975 John Weber Gallery, New York
(1977, 1979, 1981, 1983)
1976 Kunstverein, Frankfurt, West
Germany
1977 Wadsworth Atheneum, Hartford, CT
1978 Museum of Modern Art, Oxford,
England
1979 Stedelijk Van Abbemuseum,
Eindhoven, The Netherlands
1984 Tate Gallery, London
1985 Kunsthalle, Bern
1986 The New Museum, New York
(traveled)

Selected Group Exhibitions:
1962 "Nul," Stedelijk Museum,
Amsterdam
1968 "The Machine as Seen at the End of
the Mechanical Age," Museum of
Modern Art, New York
1969 "When Attitude Becomes Form,"
Kunsthalle, Bern
1970 "Information," Museum of Modern
Art, New York
"Software," Jewish Museum, New
York, and Smithsonian Institution,
Washington, DC
1972 Documenta 5, Kassel, West
Germany
1976 Biennale, Venice (1978)
1978 "Das serielle Prinzip in der
zeitgenossischen Kunst: Pop Art,
Minimal Art, Konzept Kunst,"
Kunstmuseum, Lucerne
1982 Documenta 7, Kassel, West
Germany
1983 "Photography in Contemporary
Art," National Museum of Modern
Art, Tokyo, and National Museum of
Modern Art, Kyoto
1984 "On Sexuality and Differences," The
New Museum, New York
"Content: A Contemporary Focus,
1974–1984" Hirshhorn Museum
and Sculpture Garden, Washington,
DC

BETTY HAHN

Born: Chicago, IL, 1940

Resides: Albuquerque, NM

Education: AB, Indiana University, 1963
MFA, Indiana University, 1966

Awards: Pratt Graphics Center Award, New
York, 1971
National Endowment for the Arts,
Photography, 1979, 1982
Honored Educator, Society for
Photographic Education 1984

Selected Individual Exhibitions:
1971 Center for Photographic Studies,
Louisville
1973 Witkin Gallery, New York (1979)
1974 Focus Gallery, San Francisco
1981 Center for Creative Photography,
University of Arizona, Tucson
1984 University of New Mexico,
Albuquerque

1986 Museum of Fine Arts, Santa Fe
Selected Group Exhibitions:
1967 "Photography in the Twentieth Century," George Eastman House, Rochester, NY, with the National Gallery of Canada, Ottawa (traveled)
1969 "Vision and Expression," George Eastman House, Rochester, NY (traveled)
1972 "Photography into Art," Camden Arts Centre, London
1973 "New Images 1939–1973," Smithsonian Institution, Washington, DC
1977 "The Great West: Real/Ideal," University of Colorado, Boulder (traveled)
1978 "Contemporary Photography," Walker Art Gallery, Liverpool, England
1981 "Erweiterte Fotografie," International Biennale, Vienna
1986 "Artists in Mid-Career," San Francisco Museum of Modern Art

ROBERT HEINECKEN

Born: Denver, CO, 1931
Resides: Los Angeles, CA, and Chicago, IL
Education: BA, University of California, Los Angeles, 1959
MA, University of California, Los Angeles, 1960
Awards: John Simon Guggenheim Memorial Fellowship, 1976
National Endowment for the Arts, Photography, 1977, 1981, 1986
Friends of Photography Peer Award, 1985
Selected Individual Exhibitions:
1965 Long Beach Museum of Art, California
1968 Focus Gallery, San Francisco
1970 Witkin Gallery, New York
1972 Pasadena Art Museum, California
1973 Light Gallery, New York (1976, 1979, 1981)
1976 International Museum of Photography at George Eastman House, Rochester, NY
1978 Chicago Center for Contemporary Photography
San Francisco Museum of Modern Art
1983 Foto Forum, Kassel, West Germany
1986 Min Gallery, Tokyo
Center for Creative Photography, University of Arizona, Tucson
Selected Group Exhibitions:
1967 "The Persistence of Vision," George Eastman House, Rochester, NY (traveled)
"Photography in the Twentieth Century," George Eastman House, Rochester, NY, with the National Gallery of Canada, Ottawa (traveled)
1969 "Vision and Expression," George Eastman House, Rochester, NY (traveled)
1970 "Photography into Sculpture," Museum of Modern Art, New York
1974 "Photography in America," Whitney Museum of American Art, New York
1978 "Mirrors and Windows: American Photography since 1960," Museum

of Modern Art, New York (traveled)
1981 "Altered Image," Center for Creative Photography, University of Arizona, Tucson
"Color and Color Photographs," San Francisco Museum of Modern Art
1982 "Target III: In Sequence," Museum of Fine Arts, Houston
1983 "Big Pictures by Contemporary Photographers," Museum of Modern Art, New York
1985 "Extending the Perimeters of Twentieth-Century Photography," San Francisco Museum of Modern Art
1986 "Stills: Cinema and Video Transformed," Seattle Art Museum

MICHAEL HEIZER

Born: Berkeley, CA, 1944
Resides: New York, NY
Education: San Francisco Art Institute, 1963–64
Awards: John Simon Guggenheim Memorial Fellowship, 1983
Selected Individual Exhibitions:
1969 Galerie Heiner Friedrich, Munich (1977)
1970 Dwan Gallery, New York
1971 Detroit Institute of Arts
1974 Ace Gallery, Los Angeles (1977)
Fourcade, Droll Inc., New York
1976 Xavier Fourcade Inc., New York (1977, 1979, 1980, 1983)
1979 Museum Folkwang, Essen, West Germany
1984 Museum of Contemporary Art, Los Angeles
Selected Group Exhibitions:
1968 "Earthworks," Dwan Gallery, New York
"Sculpture Annual," Whitney Museum of American Art, New York
1969 "When Attitudes Become Form," Kunsthalle, Bern
1970 Biennale, Venice
1971 "Guggenheim International Exhibition," Solomon R. Guggenheim Museum, New York
1973 "American Drawings 1963–1973," Whitney Museum of American Art, New York
1975 "Drawing Now," Museum of Modern Art, New York (traveled)
1976 "200 Years of American Sculpture," Whitney Museum of American Art, New York
"Probing the Earth: Contemporary Land Projects," Hirshhorn Museum and Sculpture Garden, Washington, DC (traveled)
1977 Documenta 6, Kassel, West Germany
1980 "Hidden Desires," Neuberger Museum, Purchase, NY
1981 "The Americans: The Landscapes," Contemporary Arts Museum, Houston
"Artists in the American Desert," Sierra Nevada Museum of Art, Reno (traveled)
"Nature-Sculpture," Kunstverein, Stuttgart, West Germany

DAVID HOCKNEY

Born: Bradford, England, 1937
Resides: Los Angeles, CA, and London
Education: Bradford College of Art, 1953–57
Royal College of Art, 1959–62
Awards: Paris Biennale, Graphics Prize, 1963
Honorary Degree, University of Bradford, England, 1983
Kodak Photography Book Award for *Cameraworks*, 1984
Honorary Degree, San Francisco Art Institute, 1985
Honorary Doctorate in Fine Art, Otis Parsons Institute, Los Angeles, 1985
Selected Individual Exhibitions:
1963 "Painting with People In," Kasmin Gallery, London (1965, 1966, 1968, 1969, 1970, 1972, 1980)
1964 Museum of Modern Art, New York (1968, 1979)
1966 Stedelijk Museum, Amsterdam
1970 Whitechapel Art Gallery, London (traveled)
1972 Victoria and Albert Museum, London
1974 Musée des Arts Decoratifs, Palais du Louvre, Paris
1978 Yale Center for British Art, New Haven (traveled)
L.A. Louver, Venice, CA (1982, 1983, 1985)
1979 M.H. de Young Memorial Museum, San Francisco
1982 Centre Georges Pompidou, Paris
1984 Jeffrey Fraenkel Gallery, San Francisco
1986 "Photographs by David Hockney," International Exhibitions Foundation, Washington, DC (traveled)
Selected Group Exhibitions:
1963 "British Paintings in the Sixties," Whitechapel Art Gallery, London (traveled)
1964 "Contemporary Painters and Sculptors as Print Makers," Museum of Modern Art, New York
1971 "British Sculpture and Painting, 1960–1970," National Gallery of Art, Washington, DC
1981 "Art in Los Angeles: 17 Artists in the Sixties," Los Angeles County Museum of Art
1982 "1960–80: Attitudes/Concepts/Images," Stedelijk Museum, Amsterdam
1983 "Photography in Contemporary Art: The 1960s to the 1980s," National Museum of Modern Art, Tokyo (traveled)
1984 "Gemini G.E.L.: Art and Collaboration," National Gallery of Art, Washington, DC (traveled)

DOUGLAS HUEBLER

Born: Ann Arbor, MI, 1924
Resides: Los Angeles, CA
Education: MFA, University of Michigan, 1955
Selected Individual Exhibitions:
1970 Art and Project, Amsterdam

1972 California Institute of the Arts, Valencia, CA
Museum of Fine Arts, Boston
1973 Westfalischer Kunstverein, Munster
Israel Museum, Jerusalem
Museum of Modern Art, Oxford, England
1975 MTL, Brussels, Belgium
1979 Stedelijk Van Abbemuseum, Eindhoven, The Netherlands
Los Angeles County Museum of Art
1980 Dittmar Memorial Gallery, Northwestern University, Evanston, IL
1984 Museum of Contemporary Art, Los Angeles
Los Angeles Center for Photographic Studies
1986 Leo Castelli Gallery, New York

Selected Group Exhibitions:
1967 "Cool Art," Aldrich Museum, Ridgefield, CT
1969 "When Attitude Becomes Form," Kunsthalle, Bern
"Op Losse Schroven," Stedelijk Museum, Amsterdam
1970 "Information," Museum of Modern Art, New York
1971 "Earth, Air, Fire and Water: Elements of Art," Museum of Fine Arts, Boston
"Books and Multiples," Philadelphia Museum of Art, Philadelphia
1972 "Konzept/Kunst," Kunstmuseum, Basel
1973 "Kunst als Boel," Stedelijk Museum, Amsterdam
1974 "Idea and Image in Recent Art," Chicago Art Institute
"The Artist and the Photograph," Israel Museum, Jerusalem
1977 "American Narrative/Story Art: 1967–1977," Contemporary Arts Museum, Houston (traveled)
1978 "Narration," Institute of Contemporary Art, Boston
1979 "Words Words," Museum Bochum, Bochum, West Germany
1980 "Contemporary Art in Southern California," High Museum of Art, Atlanta, GA
1982 "Target III: In Sequence," Museum of Fine Arts, Houston
"Comment," Long Beach Museum of Art, Long Beach, CA
1984 "Verbally Charged Images," Independent Curators Inc., New York (traveled)

PETER HUTCHINSON

Born: London, 1930

Resides: New York, NY, and Provincetown, MA

Awards: National Endowment for the Arts, Conceptual/Performance/New Genres, 1975

Selected Individual Exhibitions:
1969 John Gibson Gallery, New York (1970, 1973, 1974, 1983, 1984, 1985)
Museum of Modern Art, New York
1972 Museum Haus Lange, Krefeld, West Germany
1974 Stedelijk Museum, Amsterdam
1976 Art in Progress, Düsseldorf

1982 Gallery "A," Amsterdam
1983 Ohio Arts Gallery, Columbus
1985 "Mountain Grammar II," Yaki Kornblit Gallery, Amsterdam

Selected Group Exhibitions:
1968 "Scale Models and Drawings," Dwan Gallery, New York
1969 "The Artists' Viewpoint," Jewish Museum, New York
1970 "Information," Museum of Modern Art, New York
1971 "Earth, Air, Fire and Water: Elements of Art," Museum of Fine Arts, Boston
1972 "Chance Art," Centraal Museum, Utrecht
1977 "American Narrative/Story Art: 1967–1977," Contemporary Arts Museum, Houston (traveled)
1979 "Concept, Narrative, Document," Museum of Contemporary Art, Chicago
1981 "Alternatives in Retrospect," films and tapes, The New Museum, New York
1984 "Photography, New Directions," Provincetown Art Association Museum
1985 "A New Beginning, 1968–78," Hudson River Museum, New York

JOSEPH JACHNA

Born: Chicago, IL, 1935

Resides: Oak Lawn, IL

Education: BS, Institute of Design, Illinois Institute of Technology, 1958 (art education)
MS, Institute of Design, Illinois Institute of Technology, 1961 (photography)

Awards: Ferguson Foundation Grant, Friends of Photography, Carmel, CA, 1973
National Endowment for the Arts, Photography, 1976
Illinois Arts Council Grant, 1979
John Simon Guggenheim Memorial Fellowship, 1980

Selected Individual Exhibitions:
1961 Art Institute of Chicago
1963 St. Mary's College, Notre Dame, IN
1965 University of Illinois, Chicago (1977)
1974 Center for Photographic Studies, Louisville, KY
Nikon Photo Salon, Tokyo
1980 Chicago Center for Contemporary Photography, Columbia College, IL
1985 Southern Illinois University, Carbondale
1986 Tweed Museum of Art, University of Minnesota

Selected Group Exhibitions:
1963 "Contemporary Photographers," Art Institute of Chicago
1966 "American Photography: The Sixties," University of Nebraska, Lincoln
1967 "Photography USA," DeCordova Museum, Lincoln, MA
1968 "Light 7," Massachusetts Institute of Technology, Cambridge
1975 "For You, Aaron," Renaissance Society Gallery, University of Chicago

1977 "The Photographer and the City," Museum of Contemporary Art, Chicago
1978 "Spaces," Museum of Art, Rhode Island School of Design, Providence
1981 "Second Sight," Carpenter Center for the Visual Arts, Harvard University, Cambridge
1983 "Harry Callahan and His Students: A Study in Influence," Georgia State University Art Gallery, Atlanta
1985 "Signs of the Times," San Francisco Museum of Modern Art

LOTTE JACOBI

Born: Thorn, West Prussia, 1896

Resides: Deering, NH

Education: Bavarian State Academy of Photography and University of Munich, 1925–27

Awards: National Endowment for the Arts, Photography, 1977

Selected Individual Exhibitions:
1948 Norlyst Gallery, New York
1952 Ohio University, College of Fine Arts, Athens
1957 Sharon Arts Center, Peterborough, NH (1974)
1959 Currier Gallery of Art, Manchester, NH (1984)
1960 Brandeis University, Waltham, MA (traveled)
1968 New England College, Henniker, NH (1972, 1975)
1973 Museum Folkwang, Essen, West Germany
1974 Stadtmuseum, Munich (1981)
Light Gallery, New York
1980 Smithsonian Institution, Washington, DC (traveled)

Selected Group Exhibitions:
1947 First Women's Invitational Exhibition, Camera Club, New York
1948 "In and Out of Focus," Museum of Modern Art, New York
1951 "51 American Photographers, Then and Now," Museum of Modern Art, New York
"Abstraction in Photography," Museum of Modern Art, New York
1955 "Subjecktive Fotografie #2," State School of Arts, Saarbrücken, West Germany
1960 "The Sense of Abstraction in Contemporary Photography," Museum of Modern Art, New York
1982 "Avant-Garde Photography in Germany 1919–1939," International Center of Photography, New York

KEN JOSEPHSON

Born: Detroit, MI, 1932

Resides: Chicago, IL

Education: BFA, Rochester Institute of Technology, NY, 1957
MS, Institute of Design, Illinois Institute of Technology, 1960

Awards: John Simon Guggenheim Memorial Fellowship, 1972
National Endowment for the Arts, Photography, 1975, 1979
Ruttenberg Arts Foundation, 1983

Selected Individual Exhibitions:
1966 Konstfackskolan, Stockholm
1971 Visual Studies Workshop,
Rochester, NY
Art Institute of Chicago
1973 Nova Scotia College of Design,
Halifax
1981 Young Hoffman Gallery, Chicago
1983 Museum of Contemporary Art,
Chicago (retrospective)
Selected Group Exhibitions:
1964 "The Photographer's Eye,"
Museum of Modern Art, New York
1977 "The Photographer and the City,"
Museum of Contemporary Art,
Chicago
"Painting in the Age of
Photography," Kunsthaus, Zurich,
Switzerland
1978 "Mirrors and Windows: American
Photography since 1960," Museum
of Modern Art, New York (traveled)
"Spaces," Museum of Art, Rhode
Island School of Design, Providence
1979 "American Photography," Art
Institute of Chicago
"Attitudes: Photography in the
Seventies," Santa Barbara Museum
of Art
1980 "The New Vision: Forty Years of
Photography at the Institute of
Design," Light Gallery, New York
"Invented Images," Art Museum,
University of California, Santa
Barbara
1982 "Work by Former Students of Aaron
Siskind," Center for Creative
Photography, University of Arizona
Art Gallery, Tucson
1983 "Harry Callahan and His Students:
A Study in Influence," Georgia State
University Art Gallery, Atlanta

BARBARA KASTEN

Born: Chicago, IL, 1936

Resides: New York, NY

Education: BFA, University of Arizona,
Tucson, 1959
MFA, California College of Arts and
Crafts, Oakland, CA, 1970

Awards: Fulbright Hays Fellowship,
Poland, 1971–72
National Endowment for the Arts,
Photography, 1978, 1980
John Simon Guggenheim Memorial
Fellowship, 1982

Selected Individual Exhibitions:
1972 Gallery of Sculpture, Warsaw,
Poland
Visual Studies Workshop,
Rochester, NY
1977 Simon Lowinsky Gallery, San
Francisco
1981 International Museum of
Photography at George Eastman
House, Rochester, NY
1982 Art Museum and Galleries,
California State University, Long
Beach
1985 Center for Creative Photography,
University of Arizona, Tucson

Selected Group Exhibitions:
1971 "Photomedia," Museum of
Contemporary Arts and Crafts, New
York

1973 "Fiber Works," Scripps College,
Claremont, CA
1975 "Gallery as Studio," Scripps
College, Claremont, CA
1977 "Callis, Kasten, Zimmerman,"
University of Southern California,
Los Angeles
"Point of View: Carson, Kasten,
Preston, Wolf," Los Angeles
Institute of Contemporary Art
1979 "Uniquely Photographic," Honolulu
Academy of Arts
1980 "Reasoned Spaces," Center for
Creative Photography, University of
Arizona, Tucson (traveling)
"Contemporary Photographs,"
Fogg Art Museum, Harvard
University, Cambridge
1982 "Color as Form: A History of Color
Photography," International
Museum of Photography at George
Eastman House, Rochester, NY
"Studio Work: Photographs by Ten
Los Angeles Artists," Los Angeles
County Museum of Art
1983 "Big Pictures by Contemporary
Photographers," Museum of
Modern Art, New York
1984 "Photography in California:
1945–1980," San Francisco
Museum of Modern Art (traveled)
1985 "Images of Excellence,"
International Museum of
Photography at George Eastman
House, Rochester, NY (traveled)

GYORGY KEPES

Born: Selyp, Hungary, 1906

Resides: Cambridge, MA

Education: MA, Academy of Fine Arts,
Budapest, 1928 (painting)

Awards: Typographical Arts Award,
American Institute of Graphic Art, 1947
John Simon Guggenheim Memorial
Fellowship, 1960

Selected Individual Exhibitions:
1952 San Francisco Museum of Modern
Art (1954)
1955 Stedelijk Museum, Amsterdam
1959 Baltimore Museum of Art
Hayden Gallery, Massachusetts
Institute of Technology, Cambridge
(1978)
1966 Phoenix Art Museum
1973 Museum of Science, Boston
1976 Kunstlerhaus, Vienna
1977 Bauhaus-Archiv Museum für
Gestaltung, Berlin

Selected Group Exhibitions:
1946 "Modern Art in Advertising,"
Designs for the Container
Corporation of America,
Massachusetts Institute of
Technology, Cambridge
1948 "Collage," Museum of Modern Art,
New York
1952 "Contemporary American Painting
and Sculpture," Krannert Art
Museum, University of Illinois,
Champaign
1956 Whitney Museum of American Art,
New York (1958)
1972 "Multiple Interaction," Museum of
Science and Industry, Chicago
(traveled)

1978 "14 New England Photographers,"
Museum of Fine Arts, Boston

ANSELM KIEFER

Born: Donaueschingen, Germany, 1945

Resides: Hornbach, Odenwald, West
Germany

Selected Individual Exhibitions:
1977 Bonner Kunstverein, Bonn
1978 Kunsthalle, Bern
1979 Stedelijk Van Abbemuseum,
Eindhoven, The
Netherlands
1981 Marian Goodman Gallery, New York
(1982, 1985)
Museum Folkwang, Essen, West
Germany
1982 Whitechapel Art Gallery, London
1983 Sonja Henie–Niels Onstad
Foundations, Oslo
1984 ARC/Musée d'Art Moderne, Paris
Israel Museum, Jerusalem
1986 Stedelijk Museum, Amsterdam

Selected Group Exhibitions:
1976 "Beuys und seine Schuler,"
Kunstverein, Frankfurt
1977 Biennale, Paris
1981 "A New Spirit in Painting," Royal
Academy, London
1982 "1960–80, Attitudes, Concepts,
Images," Stedelijk Museum,
Amsterdam
1983 "Expressions: New Art from
Germany," Corcoran Gallery of Art,
Washington, DC
1984 "Content: A Contemporary Focus,
1974–1984," Hirshhorn Museum
and Sculpture Garden, Washington,
DC
1985 "Carnegie International," Museum
of Art, Carnegie Institute,
Pittsburgh
1986 "Individuals: A Selected History of
Contemporary Art, 1945–1986,"
Museum of Contemporary Art, Los
Angeles

BARBARA KRUGER

Born: Newark, NJ, 1945

Resides: New York, NY

Education: Syracuse University, NY
1967–68
Parsons School of Design, New York,
1968–69
School of Visual Arts, New York,
1968–69

Awards: National Endowment for the Arts,
Conceptual/Performance/New Genres,
1983

Selected Individual Exhibitions:
1974 Artists Space, New York
1976 John Doyle Gallery, Chicago
1979 Franklin Furnace Archive, New
York
1980 P.S. 1, Institute for Art and Urban
Resources, Long Island City, NY
1982 CEPA/Hallwalls Gallery, Buffalo, NY
1983 Institute of Contemporary Art,
London
Annina Nosei Gallery, New York
(1984, 1986)
1984 Biennial, Sydney, Australia
Kunsthalle, Basel, Switzerland

Nouveau Musée, Lyon, France
1985 Los Angeles County Museum of Art
Wadsworth Atheneum, Hartford, CT
1986 Krannert Art Museum, University of
Illinois, Champaign-Urbana
Selected Group Exhibitions:
1973 Biennial, Whitney Museum of
American Art, New York (1983,
1985)
1977 "California Annual," San Francisco
Art Institute, San Francisco
1981 "19 Emergent Artists," Solomon R.
Guggenheim Museum, New York
1982 Biennale, Venice
"Image Scavengers," Institute of
Contemporary Art, Boston
"Frames of Reference," Whitney
Museum of American Art, New York
1984 "Sexuality and Representation,"
Institute of Contemporary Art,
London
"Content: A Contemporary Focus,
1974–1984," Hirshhorn Museum
and Sculpture Garden, Washington,
DC
1985 "Ecrans politiques," Musée d'Art
Contemporain, Montreal
"Kunst mit Eigen-Sinn," Museum
Moderne Kunst, Vienna
1986 "Spectrum: In Other Words,"
Corcoran Gallery of Art,
Washington, DC
"An American Renaissance,"
Museum of Art, Fort Lauderdale, FL

SYL LABROT

Born: New Orleans, LA, 1929
Died: New York, NY, 1977
Education: Yale University, 1948–49
University of Colorado, Boulder,
1956–57
Selected Individual Exhibitions:
1958 George Eastman House, Rochester,
NY
1960 Poindexter Gallery, New York
Selected Group Exhibitions:
1951 "Abstraction in Photography,"
Museum of Modern Art, New York
1960 "The Sense of Abstraction in
Contemporary Photography,"
Museum of Modern Art, New York
1967 "Photography in the Twentieth
Century," George Eastman House,
Rochester, NY, with the National
Gallery of Canada, Ottawa (traveled)
1974 "Photography in America,"
Whitney Museum of American Art,
New York

ELLEN LAND-WEBER

Born: Rochester, NY, 1943
Resides: Arcata, CA
Education: MFA, University of Iowa, 1968
(creative photography)
Awards: National Endowment for the Arts,
Photography, 1975, 1980, 1982
Selected Individual Exhibitions:
1973 International Museum of
Photography at George
Eastman House, Rochester, NY
1975 Sheldon Memorial Art Gallery,
Lincoln, NE

1977 Susan Spiritus Gallery, Newport
Beach, CA
1978 San Francisco Museum of Art, San
Francisco
1983 Shadai Gallery, Tokyo
1984 Los Angeles Center for
Photographic Studies
Selected Group Exhibitions:
1975 "Women in Photography," San
Francisco Museum of Modern Art
(traveled)
1979 "Translations," Herbert F. Johnson
Museum, Cornell University,
Ithaca, NY
"Electroworks," International
Museum of Photography at George
Eastman House, Rochester, NY
(traveled)
1985 "Extending the Perimeters of
Twentieth-Century Photography,"
San Francisco Museum of Modern
Art

WILLIAM LARSON

Born: Tonawanda, NY, 1942
Resides: Philadelphia, PA
Education: BS, State University of New
York, Buffalo, NY, 1964 (art)
MS, Institute of Design, Illinois
Institute of Technology, Chicago, 1967
(photography)
Awards: National Endowment for the Arts,
Photography, 1971, 1980, 1986
John Simon Guggenheim Memorial
Fellowship, 1982
Pennsylvania Council on the Arts, 1983
Selected Individual Exhibitions:
1973 Light Gallery, New York (1975,
1977, 1978, 1979)
1977 Art Institute of Chicago
1980 Los Angeles Institute of
Contemporary Art
1982 Center for Creative Photography,
University of Arizona, Tucson
1985 Institute of Contemporary Art,
University of Pennsylvania,
Philadelphia
Selected Group Exhibitions:
1968 "Vision and Expression," George
Eastman House, Rochester, NY
(traveled)
1969 "Portrait Photographs," Museum of
Modern Art, New York
1972 "The Expanded Photograph,"
Philadelphia Museum of Art
(traveled)
1972 "Sequences," Photokina, Cologne
1976 "Eye of the West: Camera Vision
and Cultural Consensus," Hayden
Gallery, Massachusetts Institute of
Technology, Cambridge
1978 "Mirrors and Windows: American
Photography since 1960," Museum
of Modern Art, New York (traveled)
1978 "Spaces," Museum of Art, Rhode
Island School of Design, Providence
1979 "Attitudes: Photography in the
Seventies," Santa Barbara Museum
of Art
1979 "Electroworks," International
Museum of Photography at George
Eastman House, Rochester, NY
1981 Biennial, Whitney Museum of
American Art, New York

1982 "Color as Form: A History of Color
Photography," International
Museum of Photography at George
Eastman House, Rochester, NY
(traveled)

CLARENCE JOHN LAUGHLIN

Born: Lake Charles, LA, 1905
Died: New Orleans, LA, 1985
Education: Self-taught in photography
Awards: National Endowment for the Arts,
Photography, 1973, 1976
Selected Individual Exhibitions:
1946 Walker Art Center, Minneapolis
Philadelphia Museum of Art, (1973,
retrospective)
1948 San Francisco Museum of Modern
Art
1950 Hayden Gallery, Massachusetts
Institute of Technology, Cambridge
1954 Cleveland Museum of Art,
Cleveland, OH
1957 Los Angeles County Museum of Art
1962 Smithsonian Institution,
Washington, DC
1973 "The Personal Eye," Philadelphia
Museum of Art (retrospective)
1976 Museum of Contemporary Art,
Chicago
Minneapolis Institute of Arts
Selected Group Exhibitions:
1955 "Four Photographers: Abbott,
Atget, Laughlin, Stieglitz," Yale
University Art Gallery, New Haven,
CT
1959 "Photography at Mid-Century,"
George Eastman House, Rochester,
NY
"Photographer's Choice," Indiana
University, Bloomington, IN
1975 "Puzzle Pictures," Museum of
Modern Art, New York
1976 "Photographs from the Julian Levy
Collection," Art Institute of Chicago
1978 "Forty American Photographers,"
E. B. Crocker Art Gallery,
Sacramento, CA

LOUISE LAWLER

Born: Bronxville, NY, 1947
Resides: New York, NY
Education: BFA, Cornell University, 1969
Awards: National Endowment for the Arts,
Photography, 1984
Selected Individual Exhibitions:
1982 ID Gallery, California Institute of
the Arts, Valencia, CA
1984 "Home/Museum—Arranged for
Living and Viewing," Matrix,
Wadsworth Atheneum,
Hartford, CT
Selected Group Exhibitions:
1978 Artists Space, New York
1981 "Photo," Metro Pictures, New York
"Erweiterte Fotografie,"
International Biennale, Vienna
1983 "Multiple Choice," P.S. 1, Institute
for Art and Urban Resources, Long
Island City, NY
1984 "Masking/Unmasking: Aspects of
Post-Modernist Photography,"
Friends of Photography, Carmel, CA
"Re-place-ment," Hallwalls,
Buffalo, NY

"New York, Ailleurs et Autrement," ARC/Musée d'Art Moderne, Paris
1985 "The Art of Memory/The Loss of History," New Museum, New York
1986 "The Real Big Picture," Queens Museum, Flushing, NY
"Damaged Goods," New Museum, New York

LES LEVINE

Born: Dublin, Ireland, 1935

Resides: New York, NY

Education: Studied at the Central School of Arts and Crafts, London

Awards: National Endowment for the Arts, Visual Artist, 1974
National Endowment for the Arts, Conceptual/Performance/New Genres, 1980

Selected Individual Exhibitions:
1964 Hart House, University of Toronto, Ontario
1965 Isaacs Gallery, Toronto (1970, 1973, 1977)
1966 Fischbach Gallery, New York (1967, 1968, 1969, 1970, 1973)
1967 Walker Art Center, Minneapolis
Museum of Modern Art, New York
1969 Biennale, Paris
Institute of Contemporary Art, Chicago
1971 Galerie de Gestlo, Hamburg, West Germany (1973, 1974, 1977)
1972 Finch College Museum of Art, New York
1973 Nova Scotia College of Art and Design, Halifax, Nova Scotia
1975 Anthology Film Archives, New York
1976 Wadsworth Atheneum, Hartford, CT
1977 Albright-Knox Art Gallery, Buffalo, NY
1979 Ronald Feldman Gallery, New York (1980, 1981)
Philadelphia Museum of Art
1985 Ted Greenwald Gallery, New York

Selected Group Exhibitions:
1966 "The Object Transformed," Museum of Modern Art, New York
1967 "Dada, Surrealism & Today," Museum of Modern Art, New York
1969 "Vision & Television," Rose Art Museum, Brandeis University, Waltham, MA
"Plastic Presence," Jewish Museum, New York (traveled)
Biennale, São Paulo, Brazil
1970 "Information," Museum of Modern Art, New York
1975 "Projects Video V," Museum of Modern Art, New York
1977 "Art in the Age of Photography," Kunsthalle, Zurich
Documenta 6, Kassel, West Germany
1980 "Explorations of a Medium," Rhenisches Landesmuseum, Bonn
1981 "Instant Photography," Stedelijk Museum, Amsterdam
1983 "Video Art: A History," Museum of Modern Art, New York
1984 "Content: A Contemporary Focus, 1974–1984," Hirshhorn Museum and Sculpture Garden, Washington, DC

1986 "Television's Impact on Contemporary Art," Queens Museum, Flushing, NY

SHERRIE LEVINE

Born: Hazelton, PA, 1947

Resides: New York, NY

Education: BA, University of Wisconsin, Madison, 1969
MFA, University of Wisconsin, Madison, 1973

Awards: National Endowment for the Arts, New Genres, 1985

Selected Individual Exhibitions:
1974 De Saisset Art Gallery and Museum, University of Santa Clara, CA
1977 Hallwalls, Buffalo, NY
1979 The Kitchen, New York
1981 Metro Pictures, New York
1983 Kuhlenschmidt Gallery, Los Angeles (1985)
1985 Block Gallery, Northwestern University, Evanston, IL
Baskerville + Watson, New York

Selected Group Exhibitions:
1977 "Pictures," Artists Space, New York
1980 "Pictures and Promises," The Kitchen, New York
1981 "Erweiterte Fotografie," International Biennale, Vienna
1982 Documenta 7, Kassel, West Germany
1984 "Art and Politics," Allen Memorial Art Museum, Oberlin, OH
"Difference: On Sexuality and Presentation," New Museum, New York
"Content: A Contemporary Focus, 1974–1984," Hirshhorn Museum and Sculpture Garden, Washington, DC
1985 "Talking Back to the Media," Amsterdam
Biennial, Whitney Museum of American Art, New York
1986 "As Found," Grey Art Gallery, New York University, New York
Biennale, Sydney, Australia

DAVID LEVINTHAL

Born: San Francisco, CA, 1949

Resides: New York, NY

Education: BA, Stanford University, Palo Alto, CA (studio art)
MFA, Rochester Institute of Technology, Rochester, NY (photography)
MS, Massachusetts Institute of Technology, 1981 (management science)

Selected Individual Exhibitions:
1972 New Gallery, San Francisco
1977 California Institute of Arts, Valencia, CA
1978 International Museum of Photography at George Eastman House, Rochester, NY
1985 Area X Gallery, New York
1986 University of Alabama, Birmingham

Selected Group Exhibitions:
1973 Yale University Art Gallery, New Haven, CT
1977 Carpenter Center, Harvard University, Cambridge

1983 "In Plato's Cave," Marlborough Gallery, New York
1986 "Signs of the Real," White Columns, New York

NATHAN LYONS

Born: Jamaica, NY, 1930

Resides: Rochester, NY

Education: BA, Alfred University, 1957

Selected Individual Exhibitions:
1959 George Eastman House, Rochester, NY
1960 Rochester Institute of Technology, Rochester, NY
1967 Jacksonville Art Museum, Jacksonville, FL
1972 Museum of Contemporary Photography, Columbia College, Chicago
National Gallery of Art, Ottawa (traveled)
1973 Addison Gallery of American Art, Phillips Academy, Andover, MA
1974 Light Gallery, New York
1975 Carl Siembab Gallery, Boston
1977 Library, University of Maryland, Baltimore County
1986 Catskill Center for Photography, Woodstock, NY

Selected Group Exhibitions:
1959 "Photography at Mid-Century," George Eastman House, Rochester, NY
1960 "The Sense of Abstraction in Contemporary Photography," George Eastman House, Rochester, NY
1964 "The Photographer's Eye," Museum of Modern Art, New York
1967 "Photography in the Twentieth Century," George Eastman House, Rochester, NY, with the National Gallery of Canada, Ottawa, (traveled)
1974 "Photography in America," Whitney Museum of American Art, New York
1977 "The Great West: Real/Ideal," University of Colorado, Boulder
1978 "Mirrors and Windows: American Photography since 1960," Museum of Modern Art, New York (traveled)
1982 "Target III: In Sequence," Museum of Fine Arts, Houston
1985 "American Images: Photography 1945–1980," Barbican Art Gallery, London

MIKE MANDEL

Born: Los Angeles, CA, 1950

Resides: Santa Cruz, CA

Education: BA, California State University, Northridge, CA, 1972 (philosophy)
MFA, San Francisco Art Institute, San Francisco, 1974 (photography)

Awards: National Endowment for the Arts, Photography, 1973, 1976 (with Larry Sultan)
National Endowment for the Arts, Works in Public Places (with Larry Sultan), 1976
California Arts Council, Special Projects (with Larry Sultan), 1978

Selected Individual Exhibitions:
1975 "Sixty Billboards," exhibited in Oakland, San Francisco, Emeryville, Santa Cruz, CA
1977 "Evidence," San Francisco Museum of Modern Art (traveled)
1980 "Whose News," billboard, San Francisco
1983 "A Few French Gestures," Centre Georges Pompidou, Paris (video) "Newsroom," University Art Museum, University of California, Berkeley
1985 "We Make You Us," billboard (seven locations)
Selected Group Exhibitions:
1976 "Photography and Language," La Mamelle Gallery, San Francisco
1980 "They Came to Shoshone," Sun Valley Center for the Arts, Shoshone, ID
1982 "Color as Form: A History of Color Photography," International Museum of Photography at George Eastman House, Rochester, NY (traveled)
1984 "Photography in California: 1945–1980," San Francisco Museum of Modern Art (traveled)
1985 "Immateriaux," Centre Georges Pompidou, Paris

MANUAL (Suzanne Bloom and Edward Hill)

Suzanne Bloom

Born: Philadelphia, PA, 1943

Resides: Houston, TX

Education: BFA, Pennsylvania Academy of the Fine Arts, Philadelphia, 1965 MFA, University of Pennsylvania, Philadelphia, 1968

Awards: National Endowment for the Arts, Video, 1976 National Endowment for the Arts, Photography, 1979

Edward Hill

Born: Springfield, MA, 1935

Resides: Houston, TX

Education: BFA, Rhode Island School of Design, Providence, RI, 1957 MFA, Yale University, New Haven, CT, 1960

Awards: National Institute of Arts and Letters, Macdowell Fellowship, 1964 National Endowment for the Arts, Photography, 1973

Selected Individual (MANUAL) Exhibitions:
1976 Cronin Gallery, Houston (1978, 1981)
1980 Museum of Fine Arts, Houston
1983 Visual Studies Workshop, Rochester, NY
1984 Hampshire College, Amherst, MA
1985 Northlight Gallery, University of Arizona, Tempe
1986 Tyler Museum of Art, Tyler, TX
Selected Group Exhibitions:
1975 "Video As An Art Form," Smith College Museum of Art, Northampton, MA
1977 "1977 Artists Biennial," New Orleans Museum of Art, Louisiana

1979 "Photographie als Kunst 1879–1979/Kunst als Photographie 1949–1979," Tiroler Landesmuseum Ferdinandeum, Innsbruck, Austria
1980 "American Color Photography," Rudolf Kichen Gallery, Cologne, West Germany
1981 "Color in Photography," Museum of Art, Rhode Island School of Design, Providence
1982 "Recent Color," San Francisco Museum of Modern Art "Target III: In Sequence," Museum of Fine Arts, Houston
1985 "Signs," The New Museum, New York
1986 "TV Generations," Los Angeles Contemporary Exhibitions, Los Angeles

ALLAN McCOLLUM

Born: Los Angeles, CA, 1944

Resides: New York, NY

Education: Self-taught in photography

Selected Individual Exhibitions:
1971 Jack Glenn Gallery, Corona Del Mar, CA (1972)
1973 Nicholas Wilder Gallery, Los Angeles (1974)
1980 Artists Space, New York Galerie Yvon Lambert, Paris
1981 Hal Bromm Gallery, New York
1983 Marian Goodman Gallery, New York
1984 Rhona Hoffman Gallery, Chicago (1985) Diane Brown Gallery, New York (1986) Richard Kuhlenschmidt Gallery, Los Angeles (1985)
Selected Group Exhibitions:
1971 "New Painting in Los Angeles," Newport Harbor Art Museum, CA
1972 "Art of the Seventies," Seattle Art Museum, WA
1974 "Contemporary American Painting," Krannert Art Museum, University of Illinois, Champaign-Urbana
1975 Biennial, Whitney Museum of American Art, New York
1983 "New York Now," Kestner-Geselschaft, Hannover, West Germany
1984 "Re-place-ment," Hallwalls, Buffalo, NY "Ailleurs et Autrement," Musée d'Art Moderne, Paris
1986 "Television's Impact on Contemporary Art," Queens Museum, Flushing, NY

RAY K. METZKER

Born: Milwaukee, WI, 1931

Resides: Chicago, IL

Education: BA, Beliot College, 1953 (art) MS, Institute of Design, Illinois Institute of Technology, Chicago, 1959 (photography)

Awards: John Simon Guggenheim Memorial Fellowship, 1966, 1979 National Endowment for the Arts, Photography, 1975 Hazlitt Memorial Award, 1980

Selected Individual Exhibitions:
1959 Art Institute of Chicago
1967 Museum of Modern Art, New York
1976 Picture Gallery, Zurich
1978 International Center of Photography, New York
1979 Light Gallery, New York
1980 Pennsylvania Academy of Fine Arts, Philadelphia
1983 Edwynn Houk Gallery, Chicago
1984 Laurence Miller Gallery, New York (1985) Museum of Fine Arts, Houston (traveling retrospective)
Selected Group Exhibitions:
1959 "Photography at Mid-Century," George Eastman House, Rochester, NY
1960 "The Sense of Abstraction in Contemporary Photography," Museum of Modern Art, New York
1962 "Photography USA," DeCordova Museum, Lincoln, MA
1967 "Photography in the Twentieth Century," George Eastman House, Rochester, NY, with the National Gallery of Canada, Ottawa (traveled) "The Persistence of Vision," George Eastman House, Rochester, NY
1968 "Photography as Printmaking," Museum of Modern Art, New York "Vision and Expression," George Eastman House, Rochester, NY
1975 "The Photographer's Choice," Addison Gallery of American Art, Phillips Academy, Andover, MA
1976 "Three Centuries of American Art," Philadelphia Museum of Art
1978 "Mirrors and Windows: American Photography since 1960," Museum of Modern Art, New York (traveled) "Forty American Photographers," E. B. Crocker Art Gallery, Sacramento, CA
1979 "Contemporary American Photographers: Curator's Choice, Venezia '79: La Foftografia," Venice
1980 "The New Vision: Forty Years of Photography at the Institute of Design," Light Gallery, New York "Deconstruction/Reconstruction: The Transformation of Photographic Information into Metaphor," New Museum, New York
1981 "Photography: A Sense of Order," Institute of Contemporary Art, University of Pennsylvania, Philadelphia "Erweiterte Fotografie," International Biennale, Vienna

DUANE MICHALS

Born: McKeesport, PA, 1932

Resides: New York, NY

Education: BA, University of Denver, 1953 (art)

Awards: National Endowment for the Arts, Photography, 1976

Selected Individual Exhibitions:
1963 The Underground Gallery, New York (1965, 1968)
1968 Art Institute of Chicago
1970 Museum of Modern Art, New York

1971 George Eastman House, Rochester, NY
1974 Light Gallery, New York (1975)
1976 Sidney Janis Gallery, New York (1978, 1980, 1983, 1985)
1977 Philadelphia College of Art
1980 Museum of Modern Art, Bogotá, Colombia
1982 Musée d'Art Moderne, Paris
1984 Museum of Modern Art, Oxford, England (traveled)

Selected Group Exhibitions:
1966 "Towards a Social Landscape," George Eastman House, Rochester, NY
1969 "Portraits," Museum of Modern Art, New York, NY
1970 "Be-ing Without Clothes," Hayden Gallery, Masachusets Institute of Technology, Cambridge
1974 "Photography in America," Whitney Museum of American Art, New York
1976 Wadsworth Atheneum, Hartford, CT
1977 Biennial, Whitney Museum of American Art, New York (1981) Stedelijk Museum, Amsterdam Documenta 6, Kassel, West Germany
1979 "Attitudes: Photography in the Seventies," Santa Barbara Museum of Art
"The Photographer as Printmaker" (organized by Art Council of Great Britain; traveled)
1982 "Target III: In Sequence," Museum of Fine Arts, Houston
"Surrealism," Tokyo Shimbun, Tokyo
1984 "Content: A Contemporary Focus, 1974–1984," Hirshhorn Museum and Sculpture Garden, Washington, DC
1985 "American Images: Photographs 1945–1980," Barbican Art Gallery, London

STAN MOCK
Born: New York, NY, 1941
Resides: Los Angeles, CA
Education: BA, University of California, Santa Barbara, 1964
MFA, Cranbrook Academy of Art, 1966
Awards: Ford Foundation, 1964
National Endowment for the Arts, Photography, 1982
Selected Individual Exhibitions:
1977 Art Space, Los Angeles
Selected Group Exhibitions:
1966 "Michigan Artists," Detroit Institute for Arts, Detroit
1967 "Seven Sculptors," J. B. Speed Art Museum, Louisville, KY (traveled)
1976 "Photo/Synthesis," Herbert F. Johnson Museum of Art, Cornell University, Ithaca, NY
"Imagination," Los Angeles Institute of Contemporary Art
1982 "Studio Work: Photographs by Ten Los Angeles Artists," Los Angeles County Museum of Art
1985 "Extending the Perimeters of Twentieth-Century Photography," San Francisco Museum of Modern Art

BRUCE NAUMAN
Born: Fort Wayne, IN, 1941
Resides: Pecos, NM
Education: BS, University of Wisconsin, 1964
MA, University of California, Davis, 1966
Awards: National Endowment for the Arts, Sculpture, 1968
Selected Individual Exhibitions:
1966 Nicholas Wilder Gallery, Los Angeles
1968 Leo Castelli Gallery, New York (1969, 1971, 1973, 1975, 1976, 1978, 1980, 1982, 1984)
1968 Konrad Fischer Gallery, Düsseldorf (1970, 1971, 1974, 1975–76, 1978, 1980, 1983)
1971 Ace Gallery, Vancouver, British Columbia (1974, 1976, 1978)
1973 Los Angeles County Museum of Art (traveling retrospective)
1975 Albright-Knox Art Gallery, Buffalo, NY
1976 Sperone Westwater Fischer Gallery, New York (1982, 1984)
1978 Minneapolis Institute of the Arts
1981 Staatliche Kunsthalle, Baden-Baden, West Germany
1982 Baltimore Museum of Art, Baltimore, MD
1986 Kunsthalle, Basel, Switzerland
Selected Group Exhibitions:
1966 "Eccentric Abstraction," Fischbach Gallery, New York
1967 "American Sculpture of the Sixties," Los Angeles County Museum of Art
1968 Documenta 4, Kassel, West Germany
1969 "Square Pegs in Round Holes," Stedelijk Museum, Amsterdam
1970 "Information," Museum of Modern Art, New York
"Against Order: Chance and Art," Institute of Contemporary Art, University of Pennsylvania, Philadelphia
Biennial, Whitney Museum of American Art, New York (1977, 1985)
1974 "Idea and Image in Recent Art," Art Institute of Chicago
"Art/Voir," Centre Georges Pompidou, Paris
1975 "Bodyworks," Museum of Contemporary Art, Chicago
1976 "The Artist and the Photograph," Israel Museum, Jerusalem
1980 "New American Filmmakers Series," Whitney Museum of American Art, New York
Biennale, Venice
1981 "Art in Los Angeles: 17 Artists in the Sixties," Los Angeles County Museum of Art
1982 "Antiform et Arte Povera, Sculptures 1966–69," Centre d'Arts Plastiques Contemporains de Bordeaux, Bordeaux, France
1982 Documenta 7, Kassel, West Germany
1984 "Content: A Contemporary Focus, 1974–1984," Hirshhorn Museum and Sculpture Garden, Washington, DC

JOYCE NEIMANAS
Born: Chicago, IL, 1944
Resides: Chicago, IL
Education: MFA, School of the Art Institute of Chicago, 1969
Awards: National Endowment for the Arts, Photography, 1979, 1982
Selected Individual Exhibitions:
1973 University of Rhode Island, Kingston, RI
1977 Tyler School of Art, Temple University, Philadelphia
1978 Los Angeles Center for Photographic Studies and Los Angeles Center for Contemporary Art
1979 Museum of Contemporary Photography, Columbia College, Chicago
1981 Oakland Museum, Oakland, CA
1984 Center for Creative Photography, University of Arizona, Tucson
1985 Museum of Art, Rhode Island School of Design, Providence
Selected Group Exhibitions:
1966 "Vision and Expression," George Eastman House, Rochester, NY
1970 "Into the Seventies," Akron Art Institute, Akron, OH
1977 "Language and Image," Santa Barbara Museum of Art
1979 "Attitudes: Photography in the Seventies," Santa Barbara Museum of Art
1980 "Contemporary Photographs," Fogg Art Museum, Harvard University, Cambridge
1981 "Contemporary Hand-Colored Photographs," De Saisset Art Gallery and Museum, University of Santa Clara, CA
"The Photographer as Printmaker" (organized by the Arts Council of Great Britain; traveled)
1983 "Big Pictures by Contemporary Photographers," Museum of Modern Art, New York
"Lensless Photography," Franklin Institute, Philadelphia

DENNIS OPPENHEIM
Born: Electric City, WA, 1938
Resides: New York, NY
Education: BFA, California College of Arts and Crafts, Oakland, CA, 1965
MFA, Stanford, Palo Alto, CA, 1965
Awards: John Simon Guggenheim Memorial Fellowship, 1971
National Endowment for the Arts, Sculpture, 1974, 1981
Selected Individual Exhibitions:
1968 John Gibson Gallery, New York (1969, 1970, 1974, 1975, 1977, 1979)
1969 Galerie Yvon Lambert (1971, 1975, 1977, 1980)
1971 Gallery 20, Amsterdam (1977)
1972 Tate Gallery, London
Sonnabend Gallery, New York (1973, 1981)
1973 Museum of Conceptual Art, San Francisco
1974 Stedelijk Museum, Amsterdam
1975 The Kitchen, New York (1979)

1976 Museum Boymans-van-Beuningen, Rotterdam, The Netherlands (retrospective)
1977 Galerie Hans Mayer, Düsseldorf
1978 Musée d'Art Contemporain, Montreal, Quebec (retrospective)
1979 Israel Museum, Jerusalem
1981 Lowe Art Museum, Miami
1982 Musée d'Art et d'Histoire, Geneva
1984 San Francisco Museum of Modern Art
Sander Gallery, New York

Selected Group Exhibitions:
1968 "Sculpture Annual," Whitney Museum of American Art, New York
1969 "Art by Telephone," Museum of Contemporary Art, Chicago
1970 "Against Order," Institute of Contemporary Art, University of Pennsylvania, Philadelphia
"Artists and Photographs," Multiples, New York
"Information," Museum of Modern Art, New York
"Arte Povera, Concept Art, Land Art," Musée d'Art Moderne, Turin, Italy
1974 "Interventions in Landscape," Hayden Gallery, Massachusetts Institute of Technology, Cambridge, MA
"Words and Works," The Clocktower, Institute for Art and Urban Resources, New York
1975 "Body Art," Museum of Contemporary Art, Chicago
"Video Art," Biennale, São Paulo, Brazil
1976 Biennale, Venice
1977 Documenta 6, Kassel, West Germany
Biennial, Whitney Museum of American Art, New York (1981)
1979 "Concept, Narrative, Document," Museum of Contemporary Art, Chicago
1980 "The Pluralist Decade," Biennale, Venice
"Ecouter pas les Yeux," Musée d'Art Moderne, Paris
1981 "Machineworks," Institute of Contemporary Art, University of Pennsylvania, Philadelphia
1984 "Content: A Contemporary Focus, 1974–1984," Hirshhorn Museum and Sculpture Gallery, Washington, DC
1986 "Television's Impact on Contemporary Art," Queens Museum, Flushing, NY

BART PARKER

Born: Fort Dodge, IA, 1934

Resides: Providence, RI

Education: BA, University of Colorado, Boulder 1956 (English literature)
MFA, Rhode Island School of Design, Providence, 1969 (photography)

Awards: National Endowment for the Arts, Photography, 1973, 1981

Selected Individual Exhibitions:
1966 Pratt Institute, Brooklyn, NY
1969 Art Institute of Chicago
1974 Friends of Photography, Carmel, CA
1976 Visual Studies Workshop, Rochester, NY

1982 University Art Museum, University of New Mexico, Albuquerque
1983 Nexus, Square Gallery, Atlanta
1986 Sante Fe Center for the Contemporary Arts, Santa Fe, NM

Selected Group Exhibitions:
1969 "Vision and Expression," George Eastman House, Rochester, NY
1971 "Into the Seventies," Akron Art Institute, Akron, OH
1972 "60s Continuum," International Museum of Photography at George Eastman House, Rochester, NY
1977 "Locations in Time," International Museum of Photography at George Eastman House, Rochester, NY
"Contemporary Photographers," Fogg Art Museum, Harvard University, Cambridge
"Extended Frame," Visual Studies Workshop, Rochester, NY (traveled)
1978 "The Photograph as Artifice," Art Galleries, California State University, Long Beach (traveled)
1979 "Multiple Frame," Creative Photography Gallery, Massachusetts Institute of Technology, Cambridge
"Divola, Henkel, Parker, Pfahl," Visual Studies Workshop, Rochester, NY (traveled)
1980 "Photography: Recent Directions," DeCordova Museum, Lincoln, MA
1981 "The Photographer as Printmaker" (organized by Arts Council of Great Britain; traveled)
1982 "Color as Form: A History of Color Photography," International Museum of Photography at George Eastman House, Rochester, NY; Corcoran Gallery, Washington, DC (traveled)
1986 "Cumming and Parker," Museum of Art, North Texas State University, Denton, TX

JOHN PFAHL

Born: New York, NY, 1939

Resides: Buffalo, NY

Education: BFA, School of Art, Syracuse University, 1961
MA, School of Communications, Syracuse University, 1968

Awards: Creative Artists Program Service (CAPS), 1975, 1979
National Endowment for the Arts, Photography, 1977

Selected Individual Exhibitions:
1970 University Art Galleries, University of New Hampshire, Durham
1976 Visual Studies Workshop, Rochester, NY
1978 Art Museum, Princeton University, Princeton, NJ
Phoenix Art Museum, Phoenix, AZ
1981 Friends of Photography, Carmel, CA
1983 Sheldon Memorial Art Gallery, Lincoln, NE
1984 University of New Mexico Art Museum, Albuquerque
Museum of Contemporary Art, La Jolla, CA
Los Angeles County Museum of Art
1986 Anderson Gallery, Virginia

Commonwealth University, Richmond

Selected Group Exhibitions:
1979 "Divola, Henkel, Parker, Pfahl," Visual Studies Workshop, Rochester, NY (traveled)
"American Photography in the Seventies," Art Institute of Chicago
"Object/Illusion/Reality," Art Gallery, California State University, Fullerton, CA (traveled)
1980 "Photography: Recent Directions," DeCordova Museum, Lincoln, MA
1981 "American Photographers of the National Parks," Corcoran Gallery, Washington, DC (traveled)
"The New Color Photography," Everson Museum of Art, Syracuse, NY (traveled)
1982 "Color as Form: A History of Color Photography," International Museum of Photography at George Eastman House, Rochester, NY
1985 "Extending the Perimeters of Twentieth-Century Photography," San Francisco Museum of Modern Art
"American Images: Photography 1945–1980," Barbican Art Gallery, London (traveled)

DOUG PRINCE

Born: Des Moines, IA, 1943

Resides: Syracuse, NY

Education: BA, University of Iowa, Iowa City, IA, 1965 (art)
MA, University of Iowa, Iowa City, IA, 1968 (photography)

Awards: Le Prix de la Ville d'Avignon, 1972
National Endowment for the Arts, Photography, 1977, 1980

Selected Individual Exhibitions:
1968 Gallery for the Advancement of Photography, Iowa City, IA
1973 Light Gallery, New York (1975)
1980 Witkin Gallery, New York (1983, 1986)
1983 Carl Solway Gallery, Cincinnati
1985 Museum of Art, Rhode Island School of Design, Providence

Selected Group Exhibitions:
1965 "Seeing Photographically," George Eastman House, Rochester, NY
1968 "Young Photographers," University of New Mexico, Albuquerque
1970 "Photography into Sculpture," Museum of Modern Art, New York
1973 "Extraordinary Realities," Whitney Museum of American Art, New York
"Light and Lens," Hudson River Museum, Yonkers, NY
1978 "Mirrors and Windows: American Photography since 1960," Museum of Modern Art, New York (traveled)
1980 "Photography: Recent Directions," DeCordova Museum, Lincoln, MA
1981 "The Photographer as Printmaker" (organized by Arts Council of Great Britain; traveled)

RICHARD PRINCE

Born: Panama Canal Zone, 1949

Resides: New York, NY

Awards: National Endowment for the Arts, Photography, 1984

Selected Individual Exhibitions:
1973 University of Massachusetts, Boston
1976 Ellen Sragow Gallery, New York (1977)
1978 Galerie Jollenbeck, Cologne, West Germany
1980 Artists Space, New York
 CEPA Gallery, Buffalo, NY
1981 Metro Pictures, New York (1982)
1983 Le Nouveau Musée, Lyon, France
 Institute of Contemporary Art, London
1985 International with Monument, New York

Selected Group Exhibitions:
1976 "New Forms in Printmaking," Whitney Museum of American Art, New York
1978 "Sculpture and Language," P.S. 1, Institute for Art and Urban Resources, Long Island City, NY
1981 "Pictures and Promises," The Kitchen, New York
1982 "Image Scavengers," Institute of Contemporary Art, University of Pennsylvania, Philadelphia
1984 "New York, Ailleurs et Autrement," Musée d'Art Moderne, Paris
 "The Heroic Figure," Contemporary Arts Museum, Houston
1985 "Strategies of Appropriation," Center for Contemporary Art, Sante Fe, NM (traveled)
 Biennial, Whitney Museum of American Art, New York
1986 "The Real Big Picture," Queens Museum, Flushing, NY
 Biennial, Sydney, Australia

SUSAN RANKAITIS

Born: Cambridge, MA, 1949

Resides: Inglewood, CA

Education: BFA, University of Illinois, Champaign-Urbana, 1971 (painting)
MFA, University of Southern California, 1977 (painting and photography)

Awards: National Endowment for the Arts, Photography, 1980
Graves Award in the Humanities, 1985

Selected Individual Exhibitions:
1978 Guggenheim Gallery, Chapman College, Orange, CA
1979 Orange Coast College Gallery of Photography, Costa Mesa, CA
1980 BC Space, Laguna Beach, CA
1981 Light Gallery, Los Angeles
1983 International Museum of Photography at George Eastman House, Rochester, NY
 Los Angeles County Museum of Art
1984 Light Gallery, New York
1985 Fisher Gallery, University of Southern California, Los Angeles

Selected Group Exhibitions:
1979 "Southern California Photography Survey," Fisher Gallery, University of Southern California, Los Angeles
 "The Image Considered: Recent Work by Women," Visual Studies Workshop, Rochester, NY (traveled)
 "Attitudes: Photography in the

Seventies," Santa Barbara Museum of Art
1981 "The Photographer as Printmaker" (organized by the Arts Council of Great Britain; traveled)
1984 "Contemporary Constructs," Los Angeles Center for Photographic Studies and Otis/Parsons Art Institute, Los Angeles (traveled)
1985 "Extending the Perimeters of Twentieth-Century Photography," San Francisco Museum of Modern Art
1986 "Contemporary American Photography," Min Gallery, Tokyo

ROBERT RAUSCHENBERG

Born: Port Arthur, TX, 1925

Resides: Sanibel, FL

Education: Studied at Kansas City Art Institute and School of Design, 1946–47
Studied at Black Mountain College with Josef Albers, 1948–49
Studied at Art Students League with Vaclav Vytlacil and Morris Kantor, 1949–50

Selected Individual Exhibitions:
1951 Betty Parsons, New York
1953 Stable Gallery, New York
 Galleria d'Arte Contemporanea, Florence
1955 Egan Gallery, New York
1958 Leo Castelli Gallery, New York (1959, 1960, 1961, 1963, 1965, 1967, 1968, 1969, 1971, 1973, 1974, 1975, 1977, 1980, 1983)
1962 Dwan Art Gallery, Los Angeles
1963 Galerie Sonnabend, Paris (1971, 1972, 1973, 1975, 1977, 1978)
 Jewish Museum, New York
1964 Whitechapel Art Gallery, London
1965 Walker Art Center, Minneapolis
 Moderna Muséet, Stockholm
 Museum of Modern Art, New York (1966, 1968)
1968 Stedelijk Museum, Amsterdam
1969 Castelli Graphics, New York (1970, 1974, 1979, 1982)
1970 Minneapolis Institute of Arts
1971 Art Institute of Chicago
1974 Israel Museum, Jerusalem
 Sonnabend Gallery, New York (1974, 1977, 1979, 1981, 1982, 1983, 1984)
1976 National Collection of Fine Arts, Washington, DC (traveling retrospective)
1980 Staatliche Kunsthalle, Berlin (traveled)
1981 Centre Georges Pompidou, Paris
 Tate Gallery, London
1984 Contemporary Arts Museum, Houston

Selected Group Exhibitions:
1959 Documenta 2, Kassel, West Germany
 Biennal, São Paulo, Brazil
 "Sixteen Americans," Museum of Modern Art, New York
1961 "American Abstract Expressionists and Imagists," Solomon R. Guggenheim Museum, New York
1964 Biennale, Venice
1968 Documenta 4, Kassel, West Germany

"Pop Art," Hayward Gallery, London
1970 "New York Painting and Sculpture: 1940–1970," Metropolitan Museum of Art, New York
1973 Biennial, Whitney Museum of American Art, New York
1974 "American Pop Art," Whitney Museum of American Art, New York (traveled)
1980 "Hidden Desires," Neuberger Museum, State University of New York, Purchase, NY
1982 "Attitudes/Concepts/Images," Stedelijk Museum, Amsterdam
 "Painter as Photographer," John Hansard Gallery, University of Southampton, England
1983 "The American Artist as Printmaker," Brooklyn Museum of Art, Brooklyn, NY
1984 "Blam! The Explosion of Pop, Minimal and Performance, 1958–1964," Whitney Museum of American Art, New York
1985 "An American Renaissance: Painting and Sculpture since 1940," Museum of Art, Fort Lauderdale, FL
1986 "The Real Big Picture," Queens Museum, Flushing, NY

LELAND RICE

Born: Los Angeles, CA, 1940

Resides: Emeryville, CA

Education: BS, Arizona State University, Tempe, AZ, 1964
MA, California State University, San Francisco, 1969

Awards: National Endowment for the Arts, Photography, 1978
John Simon Guggenheim Memorial Fellowship, 1979
James D. Phelan Award, Friends of Photography, 1986

Selected Individual Exhibitions:
1972 Friends of Photography, Carmel, CA
1973 Witkin Gallery, New York
1975 Visual Studies Workshop, Rochester, NY
1977 Hirshhorn Museum and Sculpture Garden, Washington, DC (traveled)
1979 Rosamund Felsen Gallery, Los Angeles (1981, 1985, 1986)
1980 Grapestake Gallery, San Francisco, CA

Selected Group Exhibitions:
1969 "Vision and Expression," George Eastman House, Rochester, NY (traveled)
1970 "New Realism: Four San Francisco Photographers," Witkin Gallery, New York
1972 "The Visual Dialogue Foundation," Friends of Photography, Carmel, CA (traveled)
1974 "Photography in America," Whitney Museum of American Art, New York
1978 "The Photograph as Artifice," The Art Galleries, California State University, Long Beach, CA (traveled)
 "Mirrors and Windows: American Photography since 1960," Museum of Modern Art, New York (traveled)

1979 "Attitudes: Photography in the
 Seventies," Santa Barbara Museum
 of Art
 "Object/Illusion/Reality," Art
 Gallery, California State University,
 Fullerton, CA (traveled)
1981 Biennial, Whitney Museum of
 American Art, New York
1982 "Color as Form: A History of Color
 Photography," International
 Museum of Photography at George
 Eastman House, Rochester, NY
 (traveled)
 "Studio Work: Photographs by Ten
 Los Angeles Artists," Los Angeles
 County Museum of Art
1987 "Berlinart 1961–1987," Museum
 of Modern Art, New York

HOLLY ROBERTS

Born: Boulder, CO, 1951

Resides: Zuni, NM

Education: BA, University of New Mexico,
 1973
 MFA, Arizona State University, 1981

Awards: Ferguson Grant, Friends of
 Photography, Carmel, CA, 1986
 National Endowment for the Arts,
 Photography, 1986

Selected Individual Exhibitions:
1983 Etherton Gallery, Tucson, AZ
1985 Marcuse Pfeifer Gallery, New York
1986 Northlight Gallery, Arizona State
 University, Tempe, AZ

Selected Group Exhibitions:
1984 "Works on Photographs," Santa Fe
 Center for Photography, Santa Fe,
 NM
 "Gender Construction," Ithaca
 College, Ithaca, NY
1985 "Southwest 85," Museum of Fine
 Arts, Santa Fe, NM
1986 "Crosscurrents II: Recent Additions
 to the Collection," San Francisco
 Museum of Modern Art

EDWARD RUSCHA

Born: Omaha, NE, 1937

Resides: Los Angeles, CA

Education: Attended Chouinard Art
 Institute, Los Angeles, CA, 1956–60

Awards: National Endowment for the Arts,
 Painting, 1967, 1968

Selected Individual Exhibitions:
1963 Ferus Gallery, Los Angeles, CA
 (1964, 1965)
1968 Rudolf Zwirner Gallery, Cologne,
 West Germany
1979 La Jolla Museum of Contemporary
 Art, CA
1973 Leo Castelli Gallery, New York
 (1974, 1975, 1980, 1981, 1984,
 1986)
1974 Santa Barbara Museum of Art
1975 Arts Council of Great Britain
 (traveled)
1976 Albright-Knox Art Gallery, Buffalo,
 NY
 Stedelijk Museum, Amsterdam
1980 Portland Art Museum, Portland, OR
1981 Arco Center for Visual Art, Los
 Angeles
1982 San Francisco Museum of Modern

Art (1983; traveled)
 Castelli Graphics, New York
1983 Contemporary Arts Museum,
 Houston

Selected Group Exhibitions:
1963 "Pop Art USA," Oakland Museum,
 Oakland, CA
1965 "Word and Image," Solomon R.
 Guggenheim Museum, New York
1969 "Conception," Stadtische Museum,
 Leverkusen, West Germany
1969 "Pop Art," Hayward Gallery,
 London
1972 Documenta 5, Kassel, West
 Germany
1974 "American Pop Art," Whitney
 Museum of American Art, New York
 "The Audacious Years,
 1961–1971," Newport Harbor Art
 Museum, Newport Beach, CA
1976 "Painting and Sculpture in
 California: The Modern Era," San
 Francisco Museum of Modern Art
1977 Biennale, Paris
 "The Extended Frame," Visual
 Studies Workshop, Rochester, NY
1978 "Artworks and Bookworks," Los
 Angeles Institute of Contemporary
 Art (traveled)
 "Mirrors and Windows: American
 Photography since 1960," Museum
 of Modern Art. New York (traveled)
1983 "Language, Drama, Source and
 Vision," New Museum, New York
1985 "Pop Art 1955–1970," Art Gallery
 of New South Wales, Australia
 (traveled)
 "An American Renaissance:
 Painting and Sculpture since 1940,"
 Museum of Art, Fort Lauderdale, FL

LUCAS SAMARAS

Born: Kastoria, Macedonia, Greece, 1936

Resides: New York, NY

Education: BA, Rutgers University, 1959
 Studied art history at Columbia
 University with Meyer Schapiro,
 1959–62

Selected Individual Exhibitions:
1955 Art Gallery, Rutgers University,
 New Brunswick, NJ
1964 Dwan Gallery, Los Angeles
1966 Pace Gallery, New York (1968,
 1970, 1971, 1972, 1974, 1975,
 1976, 1978, 1979, 1980, 1982,
 1984, 1985, 1986)
 Albright-Knox Art Gallery, Buffalo,
 NY
1970 Kunstverein, Hannover, West
 Germany
1972 Whitney Museum of American Art,
 New York (retrospective)
1975 Museum of Modern Art, New York
 Art Galleries, California State
 University, Long Beach, CA
1976 Institute of Contemporary Art,
 Boston
1977 Walker Art Center, Minneapolis
1982 Denver Art Museum (traveled)
1983 "Photographs: 1969–1983,"
 Centre Georges Pompidou, Paris
1984 International Center of
 Photography, New York
 Museum of Photographic Arts, San
 Diego, CA

"Polaroid Photographs
 1969–1983," Center for Creative
 Photography, University of Arizona,
 Tucson (traveled)

Selected Group Exhibitions:
1961 "Art of Assemblage," Museum of
 Modern Art, New York
1963 "Mixed Media and Pop Art,"
 Albright-Knox Art Gallery, Buffalo,
 NY
1965 "Young Americans," Whitney
 Museum of American Art, New York
1966 "The Object Transformed,"
 Museum of Modern Art, New York
1974 "Photography in America,"
 Whitney Museum of American Art,
 New York
1977 Documenta 6, Kassel, West
 Germany
1978 "Mirrors and Windows: American
 Photography since 1960," Museum
 of Modern Art, New York
1979 "The Decorative Impulse," Institute
 of Contemporary Art, University of
 Pennsylvania, Philadelphia
1980 "La Photo Polaroid," Musée d'Art
 Moderne, Paris
1982 "Color as Form: A History of Color
 Photography," International Center
 for Photography at George Eastman
 House, Rochester, NY (traveled)
1983 "Anxious Interiors," Laguna Beach
 Museum of Art, Laguna Beach, Ca
1986 "Altered Egos: Samaras, Sherman,
 Wegman," Phoenix Art Museum,
 Phoenix, AZ

NAOMI SAVAGE

Born: Princeton, NJ, 1927

Resides: Princeton, NJ

Education: Studied at the New School of
 Social Research, New York, with
 Berenice Abbott, 1943
 Studied with Man Ray, 1948–49

Awards: National Endowment for the Arts,
 Photography, 1971

Selected Individual Exhibitions:
1974 School of the Art Institute of
 Chicago
1975 Center for Photographic Studies,
 University of Louisville, KY
1977 Witkin Gallery, New York
1983 Noyes Museum, Oceanville, NJ

Selected Group Exhibitions:
1959 "Photography at Mid-Century,"
 George Eastman House, Rochester,
 NY
1960 "The Sense of Abstraction in
 Contemporary Photography,"
 Museum of Modern Art, New York
1969 "Two Generations of Photographs:
 Man Ray and Naomi Savage," New
 Jersey State Museum, Trenton, NJ
1976 "Photographic Process as a
 Medium," Art Gallery, Rutgers
 University, New Brunswick, NJ
1978 "Mirrors and Windows: American
 Photography since 1960," Museum
 of Modern Art, New York (traveled)
1981 "The Photographer as Printmaker"
 (organized by the Arts Council of
 Great Britain; traveled)
1982 "Contemporary Photography as
 Phantasy," Santa Barbara Museum
 of Art

SONIA LANDY SHERIDAN

Born: Newark, OH, 1925

Resides: Evanston, IL

Education: BA, Hunter College, New York, NY, 1945
MFA, California College of Arts and Crafts, Oakland, CA, 1960

Awards: John Simon Guggenheim Memorial Fellowship, 1973
National Endowment for the Arts, Public Media Grant, 1974
National Endowment for the Arts, Printmaking, 1981

Selected Individual Exhibitions:
1966 Rosenberg Gallery, Chicago
1973 Visual Studies Workshop, Rochester, NY
1976 Museum of Science and Industry, Chicago
1985 John Michael Kohler Art Center, Sheboygan, WI

Selected Group Exhibitions:
1964 "Software," Jewish Museum, New York
1972 "Photography into Art" (organized by the Arts Council of Great Britain; traveled)
1975 "Women of Photography: An Historical Survey," San Francisco Museum of Modern Art
1979 "Electroworks," International Museum of Photography at George Eastman House, Rochester, NY (traveled)
1980 "Photography: Recent Directions," DeCordova Museum, Lincoln, MA
1981 "Erweiterte Fotografie," International Biennale, Vienna
1984 "The Computer and Its Influence on Art and Design," Sheldon Memorial Art Museum, Lincoln, NE (traveled)
1985 "Extending the Perimeters of Twentieth-Century Photography," San Francisco Museum of Modern Art

CINDY SHERMAN

Born: Glen Ridge, NJ, 1954

Resides: New York, NY

Education: BA, State University College, Buffalo, NY, 1976

Selected Individual Exhibitions:
1979 Hallwalls, Buffalo, NY
1980 Contemporary Arts Museum, Houston
The Kitchen, New York
Metro Pictures, New York (1981, 1982, 1983, 1985)
1982 Stedelijk Museum, Amsterdam (traveled)
1983 St. Louis Art Museum, St. Louis, MO
1984 Akron Museum, Akron, OH (traveled)
1985 Westfalischer Kunstverein, Munster, West Germany
1986 Wadsworth Atheneum, Hartford, CT

Selected Group Exhibitions:
1978 "Four Artists," Artists Space, New York
1980 "Ils se Disent Peintres, Ils se Disent Photographes," Musée d'Art Moderne, Paris
1981 "Young Americans," Allen Memorial Art Museum, Oberlin, OH

"Autoportraits," Centre Georges Pompidou, Paris
1982 "Eight Artists: The Anxious Edge," Walker Art Center, Minneapolis
Biennale, Venice
Documenta 7, Kassel, West Germany
"Image Scavengers," Institute of Contemporary Art, University of Pennsylvania, Philadelphia
1983 "Directions 1983," Hirshhorn Museum and Sculpture Garden, Washington, DC
Biennial, Whitney Museum of American Art, New York (1985)
1984 Biennale, Sydney, Australia
"Content: A Contemporary Focus, 1974–1984," Hirshhorn Museum and Sculpture Garden, Washington, DC
1985 "Carnegie International," Museum of Art, Carnegie Institute, Pittsburgh, PA
1986 "Self-Portrait," Museum of Modern Art, New York
"Altered Egos: Samaras, Sherman, Wegman," Phoenix Art Museum, Phoenix, AZ
"Television's Impact on Contemporary Art," Queens Museum, Flushing, NY

ARTHUR SIEGEL

Born: Detroit, MI, 1913

Died: Chicago, IL 1978

Education: Studied photography under Moholy-Nagy at New Bauhaus School, Chicago, 1937–38

Selected Individual Exhibitions:
1949 Wayne State University, Detroit
1954 Art Institute of Chicago (1967)
1955 George Eastman House, Rochester, NY
1981 Chicago Historical Society
1982 Edwynn Houk Gallery, Chicago

Selected Group Exhibitions:
1950 "Six States of Photography," Milwaukee Art Institute, Milwaukee, WI
1957 "Abstract Photography," American Federation for the Arts (traveled)
1967 "Photography in the Twentieth Century," George Eastman House, Rochester, NY, with the National Gallery of Canada, Ottawa (traveled)
1974 "Photography in America," Whitney Museum of American Art, New York
1975 "Color Photography," International Museum of Photography at George Eastman House, Rochester, NY
1977 "The Photographer and the City," Museum of Contemporary Art, Chicago
1981 "The Photographer as Printmaker" (organized by the Arts Council of Great Britain; traveled)
"The New Bauhaus," Light Gallery, New York
1983 "Photogram," Fotomuseum in Muncher Stadtmuseum, Munich, West Germany

LAURIE SIMMONS

Born: New York, NY, 1949

Resides: New York, NY

Education: BFA, Tyler School of Art, Temple University, Philadelphia, PA, 1971

Awards: National Endowment for the Arts, Photography, 1984

Selected Individual Exhibitions:
1979 Artists Space, New York
P.S. 1, Institute for Art and Urban Resources, Long Island City, NY
1981 Metro Pictures, NY (1983)
1983 CEPA Gallery, Buffalo, NY
1985 Weatherspoon Art Gallery, University of North Carolina, Greensboro, NC
1985 Tyler School of Art, Temple University, Philadelphia

Selected Group Exhibitions:
1979 "Photographie als Kunst 1879–1979/Kunst als Photographie 1949–1979," Tiroler Landesmuseum Ferdinandeum, Innsbruck, Austria
1980 "Invented Images," University Art Museum, University of California
1981 "Pictures and Promises," The Kitchen, New York
"Erweiterte Fotografie," International Biennale, Vienna
1982 "Image Scavengers," Institute of Contemporary Art, University of Pennsylvania, Philadelphia
1983 "Images Fabriques," Centre Georges Pompidou, Paris (traveled)
1984 "Masking/Unmasking: Aspects of Post-Modernist Photography," Friends of Photography, Carmel, CA
1985 Biennial, Whitney Museum of American Art, New York
1986 "The Real Big Picture," Queens Museum, Flushing, NY
"Photographic Fiction," Whitney Museum of American Art, Fairfield County, Stamford, CT

AARON SISKIND

Born: New York, NY, 1903

Resides: Providence, RI

Education: BS, City College of New York, New York (social science)

Awards; National Endowment for the Arts, Photography, 1976

Selected Individual Exhibitions:
1941 Photo League, New York
1947 California Palace of the Legion of Honor, San Francisco
1948 Black Mountain College, Berea, NC
Egan Gallery, New York
1952 Portland Museum of Art, Portland, OR
1954 George Eastman House, Rochester, NY
1955 Art Institute of Chicago
1958 San Francisco Museum of Modern Art
1962 John Gibson Gallery, New York
1963 George Eastman House, Rochester, NY (traveled)
1973 Museum of Art, Rhode Island School of Design, Providence (retrospective)
1978 Light Gallery, New York

1979 Museum of Modern Art, Oxford, England
1983 Center for Creative Photography, University of Arizona, Tucson (traveled)
1986 Los Angeles County Museum of Art

Selected Group Exhibitions:
1950 "Fifty-One American Photographers," Museum of Modern Art, New York
1952 "Then (1839) and Now (1952)," Museum of Modern Art, New York
1957 "Abstract Photography," American Federation of the Arts "Aaron Siskind and Harry Callahan," U.S. Department of State (traveled)
1959 "Photography at Mid-Century," George Eastman House, Rochester, NY (traveled)
1964 "The Photographer's Eye," Museum of Modern Art, New York "The Painter and the Photograph," Rose Art Museum, Brandeis University, Waltham, MA (traveled)
1977 "Masters of the Camera," International Center of Photography, New York
1978 "Harry Callahan and Aaron Siskind," Hayden Gallery, Massachusetts Institute of Technology, Cambridge, MA
1980 "Photography of the Fifties," International Center of Photography, New York
1981 "The Portfolio as Object," Center for Creative Photography, University of Arizona, Tucson
1983 "Phototypes: The Development of Photography in New York City," Whitney Museum of American Art, New York

SANDY SKOGLUND

Born: Boston, MA, 1946

Resides, New York, NY

Education: BA, Smith College, 1968 (studio art)
MA, MFA, University of Iowa, Iowa City, IA, 1972 (art) (painting)

Awards: National Endowment for the Arts, Photography, 1981

Selected Individual Exhibitions:
1980 Real Art Ways, Hartford, CT
1981 Castelli Graphics, New York (1986) Addison Gallery of American Art, Phillips Academy, Andover, MA Fort Worth Art Museum, Fort Worth
1982 Minneapolis Institute of Art, Minneapolis Matrix, Wadsworth Atheneum, Hartford CT
1983 Leo Castelli Gallery, New York
1984 Galerie Watari, Tokyo
1986 Sharpe Gallery, New York

Selected Group Exhibitions:
1980 "Contemporary Photographs," Fogg Art Museum, Harvard University, Cambridge
1981 Biennial, Whitney Museum of American Art, New York "New American Colour Photography," Institute of Contemporary Art, London

"The New Color Photography," Everson Museum of Art, Syracuse, NY (traveled)
1982 "Color as Form: A History of Color Photography," International Museum of Photography at George Eastman House, Rochester, NY (traveled)
1986 "Photographic Fictions," Whitney Museum of American Art, Fairfield County, Stamford, CT

HENRY HOLMES SMITH

Born: Bloomington, IL, 1909

Died: Bloomington, IN, 1986

Education: Attended School of the Art Institute of Chicago, Chicago, IL, 1929–30
BS, Ohio State University, Columbus, OH, 1933

Awards: DFA, Maryland Institute College of Art, 1968
DFA, Philadelphia College of Art, Philadelphia, 1982
DFA, Indiana University, Bloomington, 1983

Selected Individual Exhibitions:
1946 Illinois Wesleyan University, Bloomington, IL
1947 Indiana University, Bloomington
1958 State University of New York, New Paltz, NY
1960 Akron Art Institute, Akron, OH
1962 Institute of Design, Illinois Institute of Technology, Chicago
1972 New Orleans Museum of Art, LA Center for Photographic Studies, University of Louisville, Louisville, KY
1973 Indiana University, Bloomington (retrospective)
1978 Fine Arts Museum, Indiana University, Bloomington
1983 Philadelphia College of Art, Philadelphia

Selected Group Exhibitions:
1951 "Abstraction in Photography," Museum of Modern Art, New York
1959 "Photographer's Choice," Indiana University, Bloomington, IN "Photography at Mid-Century," George Eastman House, Rochester, NY (traveled)
1960 "The Sense of Abstraction in Centemporary Photography," Museum of Modern Art, New York
1961 "Twentieth Century American Art," Kalamazoo Art Center, Kalamazoo, MI
1967 "Photography in the Twentieth Century," George Eastman House, Rochester, NY, with the National Gallery of Canada, Ottawa (traveled)
1980 "Photography of the Fifties," Center for Creative Photography, University of Arizona, Tucson "The New Vision: Forty Years of Photography at the Institute of Design," Light Gallery, New York "The Photographer's Hand," International Museum of Photography at George Eastman House, Rochester, NY (traveled)

KEITH A. SMITH

Born: Tipton, IN, 1938

Resides: Rochester, NY

Education: BA, School of the Art Institute of Chicago (art education)
MS, Institute of Design, Illinois Institute of Technology (photography)

Awards: John Simon Guggenheim Memorial Fellowship, 1972, 1980
Creative Artists Program Service (CAPS), 1976
National Endowment for the Arts, Photography, 1979
New York Foundation for the Arts, 1985

Selected Individual Exhibitions:
1968 Art Institute of Chicago
1970 George Eastman House, Rochester, NY Visual Studies Workshop, Rochester, NY (1976)
1971 Light Gallery, New York (1974, 1976)
1978 Museum of Contemporary Photography, Columbia College, Chicago

Selected Group Exhibitions:
1975 Museum of Modern Art, New York (with Sonia Sheridan)
1978 "Fantastic Photography in the USA," Canon Gallery, Amsterdam
1978 "Mirrors and Windows: American Photography since 1960," Museum of Modern Art, New York (traveled)
1979 "Attitudes: Photography in the Seventies," Santa Barbara Museum of Art
1981 "The Photographer as Printmaker" (organized by the Arts Council of Great Britain; traveled)
1983 "Self as Subject: Visual Diaries by Fourteen Photographers," University of New Mexico, Albuquerque

MICHAEL SNOW

Born: Toronto, Ontario, 1929

Resides: Toronto, Ontario

Education: Studied painting and sculpture, Ontario College of Art, Toronto, 1948–52

Awards: John Simon Guggenheim Memorial Fellowship, 1972

Selected Individual Exhibitions:
1957 Isaacs Gallery, Toronto, Ontario (1958, 1960, 1962, 1964, 1966, 1969, 1970, 1979, 1982, 1984, 1986)
1964 Poindexter Gallery, New York (1965, 1968)
1965 Ontario Universities, Ontario (traveling retrospective)
1970 Art Gallery of Ontario, Toronto Biennale, Venice
1974 Walker Art Center, Minneapolis
1976 Museum of Modern Art, New York
1978 Centre Georges Pompidou, Paris (traveled)
1983 Frederick S. Wight Art Gallery, University of California, Los Angeles

Selected Group Exhibitions:
1957 Biennale of Canadian Painting,

National Gallery of Canada, Ottawa (1959, 1965)
1959 Carnegie International, Museum of Art, Carnegie Institute, Pittsburgh (1964)
1966 "The Satirical in Art," York University Art Gallery, Toronto, Ontario
1967 "National Gallery of Canada Exhibition," Musée d'Art Moderne, Paris
1968 "Canada 101," Edinburgh Festival, Edinburgh, Scotland
1969 "Anti-Illusion: Procedures and Materials," Whitney Museum of American Art, New York
1970 "Information," Museum of Modern Art, New York
"3-D into the '70s," Art Gallery of Toronto, Ontario
1975 "A Response to Environment," Rutgers University Art Gallery, New Brunswick, NJ
1977 Documenta 6, Kassel, West Germany
1979 "Re-visions: Projects and Proposals in Film and Video," Whitney Museum of American Art, New York

FREDERICK SOMMER
Born: Angri, Italy, 1905
Resides: Prescott, AZ
Education: MS, Cornell University, Ithaca, NY, 1927 (landscape architecture)
Awards: National Endowment for the Arts, Photography, 1973
John Simon Guggenheim Memorial Fellowship, 1974
DFA, University of Arizona, 1979
Distinguished Career in Photography, Friends of Photography, 1983
Selected Individual Exhibitions:
1946 Santa Barbara Museum of Art
1949 Charles Egan Gallery, New York
1957 Institute of Design, Illinois Institute of Technology, Chicago
1963 Art Institute of Chicago
1968 Philadelphia College of Art
1972 Light Gallery, New York (1977, 1979)
1979 Art Museum, Princeton University, NJ
1980 California State University, Long Beach, CA (retrospective)
International Center of Photography, New York
1985 Pace/MacGill Gallery, New York
Selected Group Exhibitions:
1949 "Realism in Photography," Museum of Modern Art, New York
1950 "Photography at Mid-Century," Los Angeles County Museum
1951 "Abstraction in Photography," Museum of Modern Art, New York
1953 "Contemporary Photography," National Museum of Modern Art, Tokyo
1956 "Contemporary American Photography," Musée d'Art Moderne, Paris
1960 "The Sense of Abstraction in Contemporary Photography," Museum of Modern Art, New York
1965 "Photography in America 1850–1965," Yale University Art Gallery, New Haven, CT

1974 "Photography in America," Whitney Museum of American Art, New York
1976 "Photographic Process as Medium," Rutgers University Art Gallery, New Brunswick, NJ
1978 "The Photograph as Artifice," Art Galleries, California State University, Long Beach (traveled)
1981 "The Photographer as Printmaker" (organized by the Arts Council of Great Britain; traveled)

EVE SONNEMAN
Born: Chicago, IL, 1946
Resides: New York, NY
Education: BFA, University of Illinois, Champaign-Urbana, IL, 1967
MFA, University of New Mexico, Albuquerque, NM, 1969
Awards: National Endowment for the Arts, Photography, 1971, 1978
Polaroid Corporation, 1978
Selected Individual Exhibitions:
1970 Cooper Union, New York
1976 Leo Castelli Gallery, New York (1978, 1980, 1982, 1986)
1980 Minneapolis Institute of Arts
1982 Hudson River Museum, Yonkers, NY
1984 Centre Georges Pompidou, Paris
Santa Barbara Museum of Art
1985 Museum of Modern Art, Costa Rica
Selected Group Exhibitions:
1976 "Artists Who Photograph," Hallwalls, Buffalo, NY
1977 "Locations in Time," International Museum of Photography at George Eastman House, Rochester, NY
Biennale, Paris
1978 "Mirrors and Windows: American Photography since 1960," Museum of Modern Art, New York (traveled)
1979 "Attitudes: Photography in the Seventies," Santa Barbara Museum of Art
"The Altered Photograph," P.S. 1, Institute for Art and Urban Resources, Long Island City, NY
"Photographie als Kunst 1879–1979/Kunst als Photographie 1949–1979," Tiroler Landesmuseum Ferdinandeum, Innsbruck, Austria
1980 Biennale, Venice
1982 "Color as Form: A History of Color Photography," International Museum of Photography at George Eastman House, Rochester, NY (traveled)
"The New Color," International Center of Photography, New York
"Counterparts," Metropolitan Museum of Art, New York (traveled)
"Target III: In Sequence," Museum of Fine Arts, Houston
1983 "Radical Space/Rational Time," Henry Art Gallery, Seattle, WA
1985 "Extending the Perimeters of Twentieth-Century Photography," San Francisco Museum of Modern Art
1986 "Television's Impact on Contemporary Art," Queens Museum, Flushing, NY

LARRY SULTAN
Born: New York, NY, 1946
Resides: Green Brae, CA
Education: BA, University of California, Berkeley, CA, 1968 (political science)
MFA, San Francisco Art Institute, 1973
Awards: National Endowment for the Arts, Photography (with Mike Mandel), 1973
National Endowment for the Arts, Works of Art in Public Places (with Mike Mandel), 1976
California Arts Council, Special Projects (with Mike Mandel), 1978
National Endowment for the Arts, 1980
John Simon Guggenheim Memorial Fellowship, 1983
Selected Individual Exhibitions:
1974 University Art Gallery, University of California, Berkeley
1975 "Sixty Billboards," exhibited in Oakland, San Francisco, Emeryville, Santa Cruz, CA
1977 "Evidence," San Francisco Museum of Modern Art (traveled)
San Francisco Museum of Modern Art
Center for Creative Photography, University of Arizona, Tucson
Los Angeles Institute for Contemporary Art
1978 Fogg Art Museum, Harvard University, Cambridge
1979 Museum of Contemporary Art, Chicago
1980 "Whose News," billboard, San Francisco
1981 Light Gallery, Los Angeles
1983 "A Few French Gestures," Centre Georges Pompidou, Paris (video)
"Newsroom," University Art Museum, University of California, Berkeley
1984 Galerie Agathe Gaillard, Paris (with Mike Mandel)
1985 "We Make You Us," billboard (seven locations)
Selected Group Exhibitions:
1972 "Octave of Prayer," Hayden Gallery, Massachusetts Institute of Technology, Cambridge
1973 Focus Gallery, San Francisco
1976 Fogg Art Museum, Harvard University, Cambridge
1976 "Photography and Language," La Mamelle Gallery, San Francisco
1979 "Attitudes: Photography in the Seventies," Santa Barbara Museum of Art
1980 "Beyond Color," San Francisco Museum of Modern Art, San Francisco
1981 Biennale, Paris
1982 "Color as Form: A History of Color Photography," International Museum of Photography at George Eastman House, Rochester, NY (traveled)
1984 "Photography in California 1945–1980," San Francisco Museum of Modern Art (traveled)

VAL TELBERG
Born: Moscow, Russia, 1910
Resides: Sag Harbor, NY

Education: Studied chemistry at
Wittenberg College, Springfield, OH,
1928–32
Studied at the Art Students League, New
York, 1942

Awards: Yaddo Fellowship, 1953

Selected Individual Exhibitions:
1948 Brooklyn Museum, Brooklyn, NY
1950 San Francisco Museum of Art
Santa Barbara Museum of Art
Munson-Williams-Proctor Institute,
Utica, NY
1951 Smithsonian Institution,
Washington, DC
New York Public Library, New York
(traveled)
1965 Parrish Art Museum, Southampton,
NY
1966 Hudson River Museum, Yonkers,
NY
1983 San Francisco Museum of Modern
Art
1984 Laurence Miller Gallery, New York

Selected Group Exhibitions:
1948 "In and Out of Focus," Museum of
Modern Art, New York
1950 "Fifty-One Young Americans,"
Museum of Modern Art, New York
1951 "Abstraction in Photography,"
Museum of Modern Art, New York
1960 "The Sense of Abstraction,"
Museum of Modern Art, New York
1982 "Form, Freud & Feeling," San
Francisco Museum of Modern Art
"Assembled Photographs," Catskill
Center for Photography,
Woodstock, NY
1985 "The Surrealist Impulse," Jones
Troyer Gallery, Washington, DC

EDMUND TESKE

Born: Chicago, IL, 1911

Resides: Los Angeles, CA

Education: Self-taught in photography

Awards: Taliesin Fellowship, 1936–37
National Endowment for the Arts,
Photography, 1975

Selected Individual Exhibitions:
1950 Third Street Gallery, Los Angeles
1961 Pasadena Art Museum, Pasadena,
CA
Santa Barbara Art Museum
1970 Art Institute of Chicago (1982)
1971 International Museum of
Photography at George Eastman
House, Rochester, NY
Witkin Gallery, New York
1974 Municipal Art Gallery, Barnsdall
Park, Los Angeles
1977 Visual Studies Workshop,
Rochester, NY
1985 Atelier Gallery, University of
Southern California, Santa Monica

Selected Group Exhibitions:
1960 "The Sense of Abstraction,"
Museum of Modern Art, New York
1962 "Contemporary Photographers,"
Art Gallery, University of California,
Los Angeles
1963 "Six Photographers," University Art
Museum, University of Illinois,
Champaign-Urbana, IL
1970 "Continuum," Downey Museum of
Art, Los Angeles

1973 "Light and Substance," University
Art Museum, University of New
Mexico, Albuquerque, NM
1974 "Photography 1974," Los Angeles
County Museum of Art
1981 "The Photographer as Printmaker"
(organized by the Arts Council of
Great Britain; traveled)

LEW THOMAS

Born: San Francisco, CA, 1932

Resides: Houston, TX

Education: BA, University of San
Francisco, 1963

Awards: National Endowment for the Arts,
Photography, 1975, 1980, 1986
National Endowment for the Arts,
Conceptual/Performance/New Genres,
1979

Selected Individual Exhibitions:
1973 De Saisset Art Gallery and Museum,
University of Santa Clara, Santa
Clara, CA
1974 San Francisco Art Institute
1979 Washington Project for the Arts,
Washington, DC
1980 Center for Creative Photography,
University of Arizona, Tucson
1981 Galleries of Fine Art, Ohio State
University, Columbus
1986 University Art Gallery, University of
Texas, Arlington

Selected Group Exhibitions:
1976 "Photography and Language," La
Mamelle, San Francisco
1978 "Mirrors and Windows: American
Photography since 1960," Museum
of Modern Art, New York (traveled)
1980 "Absage an das Einzelbild,"
Fotografische Sammlung Museum
Folkwang, Essen, West Germany
1981 "Erweiterte Fotografie,"
International Biennale, Vienna
1983 "Big Pictures by Contemporary
Photographers," Museum of
Modern Art, New York
1984 "Photography in California:
1945–1980," San Francisco
Museum of Modern Art (traveled)
1986 "Stills: Cinema and Video
Transformed," Seattle Art Museum,
WA

RUTH THORNE-THOMSEN

Born: New York, NY, 1943

Resides: Denver, CO

Education: BFA, Southern Illinois
University, Carbondale, IL, 1970
(painting)
BA, Columbia College, Chicago, 1973
(photography)
MFA, School of the Art Institute of
Chicago, 1976 (photography)

Awards: Illinois Arts Council, Project
Completion Grant, 1980
National Endowment for the Arts,
Photography, 1982

Selected Group Exhibitions:
1979 Fine Arts Gallery, University of
Nevada, Las Vegas
1980 Allan Frumkin Gallery, Chicago, IL
1981 CEPA Gallery, Buffalo, NY

1982 Art Institute of Chicago
Museum of Contemporary
Photography, Columbia College,
Chicago
1983 Marcuse Pfeifer Gallery, New York
1985 E. J. Bellocq Gallery, Louisiana
Tech University, Ruston, LA

Selected Group Exhibitions:
1977 "The Photographer and the City,"
Museum of Contemporary Art,
Chicago
1979 "Attitudes: Photography in the
Seventies," Santa Barbara Museum
of Art
1981 "Photographic Reflections of a
World of Illusion and Fantasy," San
Francisco Museum of Modern Art
1985 "Extending the Perimeters of
Twentieth-Century Photography,"
San Francisco Museum of Modern
Art

JERRY UELSMANN

Born: Detroit, MI, 1934

Resides: Gainesville, FL

Education: BFA, Rochester Institute of
Technology, Rochester, NY, 1957
(photography)
MS, Indiana University, Bloomington,
1958 (audiovisual communications)
MFA, Indiana University, Bloomington,
1960 (photography)

Awards: John Simon Guggenheim
Memorial Fellowship, 1967
National Endowment for the Arts,
Photography, 1973

Selected Individual Exhibitions:
1960 Indiana University, Bloomington
1961 University of Florida, Gainesville
Illinois Institute of Technology,
Chicago
1967 Museum of Modern Art, New York
(traveled)
1968 Minneapolis Institute of Arts
1970 Philadelphia Museum of Art
(traveling retrospective)
International Museum of
Photography at George Eastman
House, Rochester, NY (traveled)
1972 Witkin Gallery, New York (1975,
1977, 1980)
Art Institute of Chicago
1977 San Francisco Museum of Modern
Art (retrospective)
1982 Witkin Gallery, New York
(retrospective)
Center for Creative Photography,
University of Arizona, Tucson
1984 International Museum of
Photography at George Eastman
House, Rochester, NY (traveled)

Selected Group Exhibitions:
1959 "Photography at Mid-Century,"
George Eastman House, Rochester,
NY (traveled)
1967 "Photography in the Twentieth
Century," George Eastman House,
Rochester, NY, with the National
Gallery of Canada, Ottawa (traveled)
"The Persistence of Vision," George
Eastman House, Rochester, NY
1970 "Into the Seventies," Akron Art
Institute, Akron, OH
1974 "Photography in America,"

Whitney Museum of American Art, New York
1978 "Mirrors and Windows: American Photography since 1960," Museum of Modern Art, New York (traveled)
1981 "The Photographer as Printmaker" (organized by the Arts Council of Great Britain; traveled)

GER VAN ELK
Born: Amsterdam, The Netherlands, 1941
Resides: Amsterdam, The Netherlands
Education: Studied art history at Immaculate Heart College, Los Angeles 1961–63
Studied art history at University of Groningen, Groningen, West Germany, 1965–66
Selected Individual Exhibitions:
1970 Art & Project, Amsterdam (1972, 1977, 1979, 1982)
1972 Nova Scotia College of Art, Halifax, Nova Scotia
1973 Stedelijk Van Abbemuseum, Eindhoven, The Netherlands
1974 Stedelijk Museum, Amsterdam
1975 Museum of Modern Art, New York
Palais des Beaux-Arts, Brussels
1977 Rheinisches Landsmuseum, Bonn, West Germany
1980 Kunsthalle, Basel
Biennale, Venice
1981 Musée d'Art Moderne, Paris
1982 Serpentine Gallery, London
1983 Matrix, University Art Museum, University of California, Berkeley
Wadsworth Atheneum, Hartford, CT
Marian Goodman Gallery, New York (1984, 1986)
Selected Group Exhibitions:
1969 "When Attitude Becomes Form," Kunsthalle, Bern (traveled)
1970 Tenth Biennale, Tokyo
1972 Documenta 5, Kassel, West Germany
1977 "Europe in the Seventies: Aspects of Recent Art," Art Institute of Chicago (traveled)
Documenta 6, Kassel, West Germany
1978 Biennale, Venice
1979 "Concept, Narrative, Document," Museum of Contemporary Art, Chicago
1982 Documenta 7, Kassel, West Germany
1983 Museum of Art, Rhode Island School of Design, Providence
1984 Art Institute of Chicago

TODD WALKER
Born: Salt Lake City, UT, 1917
Resides: Tucson, AZ
Education: Studied at the Art Center School, Los Angeles, CA, 1939–41
Studied at Glendale Junior College, 1939–40
Awards: Florida Council for the Arts, Individual Fellowship, 1976
National Endowment for the Arts, Photography, 1982
Selected Individual Exhibitions:
1963 California Museum of Science and Industry, Los Angeles

1970 Friends of Photography, Carmel, CA (1985)
1971 Museum of Contemporary Photography, Columbia College, Chicago
1972 Light Gallery, New York
1974 Visual Studies Workshop, Rochester, NY (traveled)
1977 Center for Creative Photography, University of Arizona, Tucson
1984 Utah Museum of Fine Art, Salt Lake City, UT
Selected Group Exhibitions:
1963 Biennale, Venice
1971 "Photo/Graphics," George Eastman House, Rochester, NY (traveled)
"Women," Museum of Modern Art, New York
1973 "Light and Lens," Hudson River Museum, Yonkers, NY
1974 "Photography in America," Whitney Museum of American Art, New York
1977 "Animation, Recherche, Confrontation," Musée d'Art Moderne, Paris
1978 "On the Offset Press," Lightwork Gallery, Syracuse, NY
1979 "Attitudes: Photography in the Seventies," Santa Barbara Museum of Art, CA
1980 "Photography: Recent Directions," DeCordova Museum, Lincoln, MA
1981 "The Photographer as Printmaker" (organized by the Arts Council of Great Britain; traveled)
1984 "Photography in California: 1945–1980," San Francisco Museum of Modern Art (traveled)
1985 "Computer Photographs," Philadelphia College of Art, Philadelphia

ANDY WARHOL
Born: Pittsburgh, PA, 1928
Died: New York, NY, 1987
Education: BFA, Carnegie Institute of Technology, Pittsburgh, 1949
Selected Individual Exhibitions:
1952 Hugo Gallery, New York
1962 Ferus Gallery, Los Angeles (1963)
1964 Galerie Sonnabend, Paris (1965, 1967, 1974)
Leo Castelli Gallery, New York (1966, 1969, 1977, 1982)
1968 Moderna Museet, Stockholm (traveled)
1970 Pasadena Art Museum, Pasadena, CA (traveled)
1972 Walker Art Center, Minneapolis
1975 Baltimore Art Museum, Baltimore
1976 Stadtische Kunsthalle, Düsseldorf
1978 Kunsthaus Zurich, Zurich (retrospective)
1979 Whitney Museum of American Art, New York
1980 Stedelijk Museum, Amsterdam
Jewish Museum, New York
1985 Castelli Uptown, New York
Selected Group Exhibitions:
1962 "My Country 'Tis of Thee," Dwan Gallery, Los Angeles
1963 "Six Painters and the Object," Solomon R. Guggenheim Museum, New York

"Popular Art," Nelson-Atkins Gallery, Kansas City, MO
"Pop Art USA," Oakland Museum, Oakland, CA
"The Popular Image," Institute of Contemporary Art, London
1964 "The Painter and the Photograph," University of New Mexico, Albuquerque
1966 "The Photographic Image," Solomon R. Guggenheim Museum, New York
"Multiplicity," Institute of Contemporary Art, Boston
"Recent American Painting," Museum of Modern Art, New York (traveled)
1969 "New York Painting and Sculpture: 1940–1970," Metropolitan Museum of Art, New York
Biennial, Whitney Museum of American Art, New York
1972 "Grids," Institute of Contemporary Arts, University of Pennsylvania, Philadelphia
1973 "Art in Space, Some Turning Points," Detroit Institute of Arts
1974 "American Pop Art," Whitney Museum of American Art, New York
1978 "Art About Art," Whitney Museum of American Art, New York
1980 "Hidden Desires," Neuberger Museum, State University of New York, Purchase, NY
1981 "Inside Out: The Self Beyond Likeness," Newport Harbor Art Museum, Newport Beach, CA (traveled)
1982 Documenta 7, Kassel, West Germany
"Zeitgeist," Internationale Kunstausstellung, Berlin, East Germany
1983 "Trends in Postwar American and European Art," Solomon R. Guggenheim Museum, New York
1984 "Content: A Contemporary Focus, 1974–1984," Hirshhorn Museum and Sculpture Garden, Washington, DC
"The New Portrait," P.S.1, Institute for Art and Urban Resources, New York
"Blam! The Explosion of Pop, Minimal and Performance, 1958–1964," Whitney Museum of American Art, New York
1985 "Repetitions: A Post-Modern Dynamic," Hunter College Art Gallery, New York
"An American Renaissance: Painting and Sculpture since 1940," Fort Lauderdale Art Museum, FL
1986 "The Real Big Picture," Queens Museum, Flushing, NY

WILLIAM WEGMAN
Born: Holyoke, MA, 1943
Resides: New York, NY
Education: BFA, Massachusetts College of Art, Boston, MA, 1965 (painting)
MFA, University of Illinois, Champaign-Urbana, IL, 1967 (painting)
Awards: National Endowment for the Arts, Video, 1975

Creative Artists Program Service (CAPS), 1979
National Endowment for the Arts, Photography, 1982

Selected Individual Exhibitions:
1971 Galerie Sonnabend, Paris (1973)
 Pomona College Art Gallery, Pomona, CA
1972 Konrad Fischer Gallery, Düsseldorf (1975, 1979)
1973 Los Angeles County Museum of Art
1976 The Kitchen, New York
1979 Holly Solomon Gallery, New York (1980, 1982, 1984, 1986)
 Fine Art Galleries, University of Wisconsin, Milwaukee (retrospective)
1982 Walker Art Center, Minneapolis (traveled)
1985 Lowe Museum of Art, Miami

Selected Group Exhibitions:
1969 "Art by Telephone," Museum of Contemporary Art, Chicago
 "Other Ideas," Detroit Institute of Arts, Detroit
1972 Documenta 5, Kassel, West Germany
1973 "Whitney Annual," Whitney Museum of American Art, New York
1974 "Idea and Image in Recent Art," Art Institute of Chicago
1975 Matrix Program, Wadsworth Atheneum, Hartford, CT
1976 "Video Art: An Overview," San Francisco Museum of Modern Art
1977 "The Word as Image," Museum of Contemporary Art, Chicago
1978 "Contemporary American Photo Works," Museum of Fine Arts, Houston
1979 "The Altered Photograph," P.S.1, Institute for Art and Urban Resources, Long Island City, NY
1980 "Invented Images," University Art Museum, University of California, Santa Barbara
1981 Biennial, Whitney Museum of American Art, New York
1983 "Big Pictures by Contemporary Photographers," Museum of Modern Art, New York
1984 "Alibis," Centre Georges Pompidou, Paris
 "Content: A Contemporary Focus, 1974–1984," Hirshhorn Museum and Sculpture Garden, Washington, DC
1985 "New American Video Art: A Historical Survey, 1967–1980," Mandeville Art Gallery, University of California, San Diego
1986 "Altered Egos: Samaras, Sherman, Wegman," Phoenix Art Museum, Phoenix, AZ

JEFF WEISS

Born: Bronx, NY, 1942

Resides: Los Angeles, CA

Education: BS, University of Michigan, Ann Arbor, MI, 1964 (zoology)

Awards: Vermont Council on the Arts, Individual Artist Fellowship, 1975
National Endowment for the Arts, Photography, 1981

Selected Individual Exhibitions:
1984 1708 E. Main Gallery, Richmond, VA
1985 Camerawork Gallery, San Francisco
1986 Burnett Miller Gallery, Los Angeles

Selected Group Exhibitions:
1970 "Jerry Uelsmann/Jeff Weiss," Halstead 831 Gallery, Birmingham, MI
1971 "Jeff Weiss/Roland Freeman," National Collection of Fine Arts, Washington, DC
1975 "Four Photographers," Hampshire College, Northampton, MA
1982 "Altered States," University Art Gallery, University of Illinois, Champaign-Urbana
1986 "Cultural Identities," Center for Contemporary Art, Santa Fe, NM
 "Stills: Cinema and Video Transformed," Seattle Art Museum, Seattle, WA

ROGER WELCH

Born: Westfield, NJ, 1948

Resides: New York, NY

Education: BFA, Miami University, Oxford, OH, 1969
MFA, Art Institute of Chicago, 1971

Awards: Creative Artists Program Service (CAPS), 1973, 1976
National Endowment for the Arts, Sculpture, 1974, 1980

Selected Individual Exhibitions:
1971 112 Greene Street, New York (performance)
1972 Sonnabend Gallery, New York (performance)
1973 Konrad Fischer Gallery, Düsseldorf
 Nova Scotia College of Art, Halifax, Nova Scotia
1974 University of Rhode Island, Kingston
1977 Albright-Knox Art Gallery, Buffalo, NY
1980 Museo de Arte Moderno, Mexico City (retrospective)
 P.S.1, Institute of Art and Urban Resources, Long Island City, NY
1982 Whitney Museum of American Art, New York
1986 Ted Greenwald Gallery, New York

Selected Group Exhibitions:
1972 Documenta 5, Kassel, West Germany
 Spoleto Festival, Spoleto, Italy
1974 "Interventions in Landscape," Hayden Gallery, Massachusetts Institute of Technology, Cambridge
 "Narrative Art," Palais des Beaux-Arts, Brussels
1975 "Word, Image, Number," Sarah Lawrence College, Bronxville, NY
1976 "Foto & Idea," Galleria Comunale d'Arte Moderna, Parma, Italy
1977 Documenta 6, Kassel, West Germany
 "Words," Whitney Museum of American Art, New York
 "American Narrative/Story Art: 1967–1977," Museum of Fine Arts, Houston (traveled)
1979 "Concept, Narrative, Document," Museum of Contemporary Art, Chicago

1980 "Film as Installation," The Clocktower, Institute for Art and Urban Resources, New York
1981 "Four Artists and the Map—Jasper Johns, Nancy Graves, Roger Welch, and Richard Long," Spencer Museum of Art, University of Kansas, Lawrence
 "Alternatives in Retrospect—An Historical Overview 1969–1975," The New Museum, New York
1984 "A Decade of New Art," Artists Space, New York

JAMES WELLING

Born: Hartford, CT, 1951

Resides: New York, NY

Education: BFA, Carnegie-Mellon University, Pittsburgh, 1972
MFA, California Institute of the Arts, Valencia, CA, 1974

Selected Individual Exhibitions:
1981 Metro Pictures, New York (1982)
1982 Philadelphia College of Art, Philadelphia
1984 CEPA Gallery, Buffalo, NY
1986 Cash/Newhouse (1986)

Selected Group Exhibitions:
1981 "Love Is Blind," Castelli Graphics, New York
 "Erweiterte Fotografie," International Biennale, Vienna
1983 "In Plato's Cave," Marlborough Gallery, New York
1984 "Still-Life in Photography," Rotterdamse Kunststiching, Rotterdam, The Netherlands
 "New York: Ailleurs et Autrement," Musée d'Art Moderne, Paris
1985 "Louise Lawler, Laurie Simmons, James Welling," Metro Pictures, New York
1986 "Paravision," Margo Leavin Gallery, Los Angeles

ALICE WELLS (Alisa Wells)

Born: Erie, PA, 1929

Resides: Sante Fe, NM

Education: BA, University of Pennsylvania, 1949
Studied with Ansel Adams, 1961
Studied with Nathan Lyons, 1961–62, 1965–66

Awards: Creative Artists Program Service (CAPS), 1972
National Endowment for the Arts, Photography, 1973

Selected Individual Exhibitions:
1967 Aquinas Academy, Rochester, NY
1970 Visual Studies Workshop, Rochester, NY
 Art Gallery, State University of New York, Buffalo, NY
1973 Museum of New Mexico, Sante Fe, NM

Selected Group Exhibitions:
1963 "Alice Wells/Nathan Lyons," Institute of General Semantics, New York
1965 "Contemporary Photography Since 1950," George Eastman House, Rochester, NY (traveled)
1973 "Light and Lens," Hudson River Museum, Yonkers, NY

1975 "Women of Photography: An Historical Survey," San Francisco Museum of Modern Art
1981 "The Photographer as Printmaker" (organized by the Arts Council of Great Britain; traveled)
1983 "Target III: In Sequence," Museum of Fine Arts, Houston

LYNTON WELLS

Born: Baltimore, MD, 1940

Resides: New York, NY

Education: BFA, Rhode Island School of Design, Providence, RI, 1962
MFA, Cranbrook Academy of Arts, Bloomfield Hills, MI, 1969

Awards: Creative Artists Program Service (CAPS), 1973
National Endowment for the Arts, Painting, 1975
New York State Council on the Arts, 1977

Selected Individual Exhibitions:
1969 Cranbrook Academy of Arts, Bloomfield Hills, MI (1972)
1971 Everson Museum of Art, Syracuse, NY
1975 Andre Emmerich Gallery, New York
1977 Galerie Andre Emmerich, Zurich
1980 "Lynton Wells/Paintings 1971–1978," Art Museum, Princeton University, NJ (traveled)
1982 Holly Solomon Gallery, New York (1983)
1984 Sable Castelli Gallery, Toronto, Ontario

Selected Group Exhibitions:
1970 "Figures/Environments," Walker Art Center, Minneapolis
"Photography into Sculpture," Museum of Modern Art, New York
1973 Biennial, Whitney Museum of American Art, New York
1974 "Recent Abstract Painting; Pratt Institute, Brooklyn
1976 "Photo/Synthesis," Herbert F. Johnson Museum, Cornell University, Ithaca, NY
1978 "Aesthetics of Graffiti," San Francisco Museum of Modern Art
1981 "The Markers," San Francisco Museum of Modern Art
1982 "Post-Minimalism," Aldrich Museum of Contemporary Art, Ridgefield, CT
1984 "Painting/Photography," Thorpe Intermedia Gallery, Sparkill, NY

MINOR WHITE

Born: Minneapolis, MN, 1908

Died: Cambridge, MA, 1976

Education: BS, University of Minnesota, 1933 (botany)

Awards: John Simon Guggenheim Memorial Fellowship, 1970
DFA, San Francisco Art Institute, 1976

Selected Individual Exhibitions:
1948 San Francisco Museum of Art (1950, 1952)
1950 Photo League, New York
1954 George Eastman House, Rochester, NY (1955)
1957 Limelight Gallery, New York
1960 Art Institute of Chicago
1968 Ringling Museum of Art, Sarasota, FL
1969 Art Museum, Princeton University, NJ
1970 Center for Photographic Studies, University of Louisville, KY
Philadelphia Museum of Art
1975 Light Gallery, New York
1976 Photography Place, London
1984 Philadelphia Museum of Art (traveling retrospective)

Selected Group Exhibitions:
1953 "How to Read a Photograph," San Francisco Museum of Art
1954 "Camera Consciousness," George Eastman House, Rochester, NY
1956 "Lyrical and Accurate," George Eastman House, Rochester, NY
1959 "Photography at Mid-Century," George Eastman House, Rochester, NY
1960 "The Sense of Abstraction in Contemporary Photography," Museum of Modern Art, New York
1963 "Photography in the Fine Arts," Metropolitan Museum of Art, New York
1964 "The Photographer's Eye," Museum of Modern Art, New York
1965 "Photography in America, 1850–1965," Yale University Art Gallery, New Haven, CT
1967 "Photography in the Twentieth Century," George Eastman House, Rochester, NY, with the National Gallery of Canada, Ottawa (traveled)
1968 "Light 7," Hayden Gallery, Massachusetts Institute of Technology, Cambridge
"Photography as Printmaking," Museum of Modern Art, New York
1970 "Octave of Prayer," Hayden Gallery, Massachusetts Institute of Technology, Cambridge
1974 "Celebrations," Hayden Gallery, Massachusetts Institute of Technology, Cambridge
"Photography in America," Whitney Museum of American Art, New York
1976 "Masters of the Camera," International Center of Photography, New York

NEIL WINOKUR

Born: New York, NY, 1945

Resides: New York, NY

Education: BA, Hunter College, New York, 1967

Awards: National Endowment for the Arts, Photography, 1984

Selected Individual Exhibitions:
1985 Museum of Art of Bahia, Salvador, Brazil
1986 Barbara Toll Gallery, New York

Selected Group Exhibitions:
1982 "Lichtbildnesse: Das Porträt in der Fotografie," Rheinisches Landesmuseum, Bonn, West Germany
1983 "Three-Dimensional Photography," Castelli Graphics, New York
1984 "Family of Man: 1955–1984,"

P.S.1, Institute for Art and Urban Resources, Long Island City, NY
"Face to Face: Recent Portrait Photography," Institute of Contemporary Art, University of Pennsylvania, Philadelphia
1985 "Seduction," White Columns Gallery, New York

JOEL-PETER WITKIN

Born: Brooklyn, NY, 1939

Resides: Albuquerque, NM

Education: BFA, Cooper Union School of Fine Art, 1974
MA, University of New Mexico, Albuquerque, NM, 1976
MFA, University of New Mexico, Albuquerque, NM, 1981

Awards: Creative Artists Program Service (CAPS), 1974
National Endowment for the Arts, Photography, 1974, 1980, 1981, 1986
Ford Foundation Grant, Photography, 1977

Selected Individual Exhibitions:
1976 University Art Museum, University of New Mexico, Albuquerque
1980 P.S.1, Institute for Art and Urban Resources, Long Island City, NY
1983 Kansas City Art Institute, Kansas City, MO
Stedelijk Museum, Amsterdam
1984 Pace/MacGill Gallery, New York (1985)
1985 San Francisco Museum of Modern Art (traveled)

Selected Group Exhibitions:
1981 "Photographer as Printmaker" (organized by the Arts Council of Great Britain; traveled)
"The Markers," San Francisco Museum of Modern Art
1983 "Images Fabriques," Centre Georges Pompidou, Paris
1984 "The Human Condition," San Francisco Museum of Modern Art
"Content: A Contemporary Focus, 1974–1984," Hirshhorn Museum and Sculpture Garden, Washington, DC
1985 Biennial, Whitney Museum of American Art, New York
"American Images: Photography 1945–1980," Barbican Art Gallery, London
"Extending the Perimeters of Twentieth-Century Photography," San Francisco Museum of Modern Art
1986 Biennal, Sydney, Australia
"Photographic Fictions," Whitney Museum of American Art, New York

JOHN WOOD

Born: Delhi, CA, 1922

Resides: Alfred, NY

Education: Studied at University of Colorado, Boulder, and Institute of Design, Illinois Institute of Technology, Chicago

Selected Individual Exhibitions:
1953 Avant Arts Gallery, Chicago

1958 Art Gallery, Alfred University,
 Alfred, NY
1969 Hayden Gallery, Massachusetts
 Institute of Technology, Cambridge
1972 Visual Studies Workshop,
 Rochester, NY (1977, 1981)
1980 Paul Cava Gallery, Philadelphia
 (1982)
1983 Thomas J. Watson Library,
 Metropolitan Museum of Art, New
 York
1984 Lightsong Gallery, Tucson, AZ
1986 WPA Gallery, Washington, DC
 Robert B. Menschel Gallery,
 Syracuse University, Syracuse, NY

Selected Group Exhibitions:
1967 "The Persistence of Vision," George
 Eastman House, Rochester, NY
 "Photography in the Twentieth
 Century," George Eastman House,
 Rochester, NY, with the National
 Gallery of Canada, Ottawa (traveled)
1969 "Vision and Expression," George
 Eastman House, Rochester, NY
1972 "The Multiple Image," Hayden
 Gallery, Massachusetts Institute of
 Technology, Cambridge (traveled)
1978 "Spaces," Museum of Art, Rhode
 Island School of Design, Providence,
 RI
1979 "Electroworks," International
 Museum of Photography at George
 Eastman House, Rochester, NY
 (traveled)
1980 "Photographer's Hand,"
 International Museum of
 Photography at George Eastman
 House, Rochester, NY (traveled)
1981 "The Photographer as Printmaker"
 (organized by the Arts Council of
 Great Britain; traveled)
1983 "Books Alive," Metropolitan
 Museum of Art, New York
1986 "In Context: Contemporary Artists'
 Books and Their Antecedents,"
 Athenaeum, Alexandria, VA

Bibliography

BOOKS AND CATALOGUES

Ackley, Clifford S. *Private Realities: Recent American Photography.* Boston: Museum of Fine Arts, 1974.

Ansel Adams: Images 1923–1974. Boston: New York Graphic Society, 1974.

Altered Landscapes. Introduction by Jim Alinder. Palatka, FL: Fine Arts Gallery, Florida School of Arts, 1978.

Alternatives in Retrospect: An Historical Overview, 1969–1975. Essay by Mary Delahoyd. New York: New Museum, 1981.

American Photography: The Sixties. Lincoln: University of Nebraska, Sheldon Memorial Art Gallery, 1966.

The Art of Memory / The Loss of History. Essays by William Olander and Abigail Solomon Godeau. New York: New Museum, 1985.

Assemblage in California: Works from the late 50's and early 60's. Essays by John Coplans on Wallace Berman and Philip Leider on Bruce Conner. Irvine, Ca: Art Gallery, University of California, Irvine, 1968.

Attitudes: Photography in the 1970's. Santa Barbara: Santa Barbara Museum of Art, 1980.

John Baldessari. Essays by Marcia Tucker and Robert Pincus-Witten. New York: New Museum, 1981.

Baltz, Lewis. *The New Industrial Parks near Irvine, California.* New York: Castelli Graphics, 1974.

Barthes, Roland. *Camera Lucida, Reflections on Photography.* New York: Hill and Wang/Farrar, Straus & Giroux, 1981.

Benjamin, Walter. "The Work of Art in the Age of Mechanical Reproduction." *Illuminations,* edited by Hannah Arendt. New York: Schocken Books, 1969.

Bossen, Howard. *Henry Holmes Smith: Man of Light.* Ann Arbor: University of Michigan Research Press, 1983.

Bullock, Barbara. *Wynn Bullock.* San Francisco: Scrimshaw Press, 1971.

Bullock-Wilson, Barbara. *Wynn Bullock, Photography: A Way of Life.* Edited by Liliane DeCock. Dobbs Ferry, NY: Morgan & Morgan, 1973.

Callahan, Harry. *Photographs: Harry Callahan.* Santa Barbara: El Mochuelo Gallery, 1964.

Caponigro, Paul. *The Wise Silence: Photographs by Paul Caponigro.* Essay by Marianne Fulton. Boston: New York Graphics Society, and Rochester, NY: International Museum of Photography at George Eastman House, 1985.

Chiarenza, Carl. *Aaron Siskind: Pleasures and Terrors.* Boston: New York Graphic Society, 1982.

Coke, Van Deren. *The Painter and the Photograph: From Delacroix to Warhol.* Revised edition. Albuquerque: University of New Mexico Press, 1972.

———. *Young Photographers.* Albuquerque: University Art Museum, University of New Mexico, 1968.

———. *Fabricated to Be Photographed.* San Francisco: San Francisco Museum of Modern Art, 1979.

———. *Jack Fulton's Puns & Anagrammatic Photographs.* San Francisco: San Francisco Museum of Modern Art, 1979.

———. *SECA Photography Invitational.* San Francisco: San Francisco Museum of Modern Art, 1980.

Coleman, A. D. *Light Readings: A Photography Critic's Writings 1968–1978.* New York: Oxford University Press, 1979.

Concept, Narrative, Document: Recent Photographic Works from the Morton Neumann Family Collection. Introduction by Judith Tannenbaum. Chicago: Museum of Contemporary Art, 1979.

Contemporary Trends. Essays by Van Deren Coke, A. D. Coleman, and Bill Jay. Chicago: Chicago Photographic Gallery of Columbia College, 1976.

Content: A Contemporary Focus, 1974–1984. Essays by Howard N. Fox, Miranda McClintic, and Phyllis Rosenzweig. Washington, D.C.: Hirshhorn Museum and Sculpture Garden, 1984.

Continuum. Downey, CA: Downey Museum of Art, 1970.

Coplans, John. *Andy Warhol.* New York Graphic Society, 1978.

Crone, Rainer. *Andy Warhol.* New York: Praeger, 1970.

The Crowded Vacancy: Three Los Angeles Photographers. Davis: Memorial Union Art Gallery, University of California, Davis, 1971.

Cumming, Robert. *Robert Cumming Photographs.* Edited with an essay by James Alinder. Carmel, CA: Friends of Photography, 1979. Published as number 18 of *Untitled.*

Curran, Darryl, et al. *Untitled 11: Emerging Los Angeles Photographers.* Carmel, CA: Friends of Photography, 1977.

Deconstruction, Reconstruction: The Transformation of Photographic Information into Metaphor. Essay by Shelley Rice. New York: New Museum, 1980.

Diamondstein, Barbaralee. *Visions and Images: American Photographers on Photography.* New York: Rizzoli International Publications, 1981.

Enyeart, James, et al. *Heinecken.* Carmel, CA: Friends of Photography, 1980.

Featherstone, David. *Untitled 19: Vilem Kriz: Photographs.* Carmel, CA: Friends of Photography, 1979.

Fichter, Robert. *Robert Fichter: Photography and Other Questions.* New York: Freidus Gallery, 1982.

Hollis Frampton: Recollections/Recreations. Essays by Bruce Jenkins and Susan Krane. Buffalo, NY: Albright-Knox Art Gallery, and Cambridge, MA: MIT Press, 1984.

Frankel, Dextra. *Object Illusion Reality.* Fullerton, CA: Art Gallery, California State University, Fullerton. 1979.

Friedlander, Lee. *Lee Friedlander Photographs.* New City, NY: Haywire Press, 1978.

———, and Jim Dine. *Work from the Same House: Photographs & Etchings.* London: Trigram Press, 1969.

From the Collection of Sol LeWitt. Essays by Andrea Miller-Keller and John B. Ravenal. New York: Independent Curators Inc., and Hartford, Conn.: Wadsworth Atheneum, 1984.

Fulton, Hamish. *Camp Fire.* Eindhoven, Holland: Stedelijk Museum, 1985.

Gassan, Arnold. *A Chronology of Photography: A Critical Survey of the History of Photography as a Medium of Art.* Athens, OH: Arnold Gassan Handbook Company, 1972.

Gauss, Kathleen McCarthy. *New American Photography.* Los Angeles: Los Angeles County Museum of Art, 1985.

———. *Studio Work: Photographs by Ten Los Angeles Artists.* Los Angeles: Los Angeles County Museum of Art, 1982.

Gee, Helen. *Helen Gee and the Limelight: A Pioneering Photography Gallery of the Fifties.* New York: Carlton Gallery, 1977.

———. *Photography of the Fifties: An American Perspective.* Tucson: Center for Creative Photography, University of Arizona, Tucson, 1980.

Gibson, Ralph. *The Somnambulist.* New York: Lustrum, 1970.

Glenn, Constance W. *Centric 2: Barbara Kasten: Installation/Photographs.* Long Beach, CA: Art Museum and Galleries, California State University, Long Beach, 1982.

Goldberg, Vickie. *Photography in Print: Writings from 1916 to the Present.* New York: Simon and Schuster, 1981.

Goldin, Nan. *The Ballad of Sexual Dependency.* New York: Aperture, 1986.

Green, Jonathan. *American Photography: A Critical History 1945 to the Present.* New York: Harry N. Abrams, 1984.

———, ed. *Camera Work: A Critical Anthology.* Millerton, NY: Aperture, 1973.

Grids: Format and Image in 20th Century Art. Essay by Rosalind Krauss. New York: Pace Gallery, 1978.

Groover, Jan. *Jan Groover.* Washington: Corcoran Gallery of Art, 1976.

Hagen, Charles. *Barbara Blondeau.* Rochester, NY: International Museum of Photography at George Eastman House, 1976.

Hall, James Baker. *Minor White: Rites & Passages.* Millerton, NY: Aperture, 1978.

———, ed. *Ralph Eugene Meatyard.* Millerton, NY: Aperture, 1974.

Haskell, Barbara. *Blam! The Explosion of Pop, Minimal, and Performance, 1958–1964.* Essay by John G. Hanhardt. New York: Whitney Museum of American Art and W. W. Norton, 1984.

Hill, Paul, and Thomas Cooper, eds. *Dialogue with Photography.* New York: Farrar, Straus & Giroux, 1979.

Hockney, David. *Cameraworks.* New York: Knopf, 1984.

———. *David Hockney Photographs.* New York: Petersburg Press, 1982.

Hunter, Sam, ed. *An American Renaissance: Painting and Sculpture Since 1940.* Museum of Art, Fort Lauderdale. New York: Abbeville Press, 1986.

Hutchinson, Peter. *Alphabet Series.* New York: John Gibson Gallery, 1974.

———. *Peter Hutchinson: Selected Works 1968–1977.* New York: John Gibson Gallery, 1977.

Image Scavengers: Photography. Essays by Paula Marincola and Douglas Crimp. Philadelphia: Institute of Contemporary Art, University of Pennsylvania, 1982.

Infotainment: 18 Artists from New York. Essays by George W.S. Trow and Thomas Lawson. New York: J. Berg Press, 1985.

An Inquiry into the Aesthetics of Photography. Toronto: Artscanada, 1975.

Jenkins, William. *The Extended Document: An Investigation of Information and Evidence in Photographs.* Rochester, NY: International Museum of Photography at George Eastman House, 1975.

Johnson, William S., and Susan E. Cohen. *The Photographs of Todd Walker.* Tucson: Museum of Art, University of Arizona, 1979.

Ken Josephson. Essays by Carl Chiarenza and Lynne Warren. Chicago: Museum of Contemporary Art, 1983.

Kahmen, Volker. *Art History of Photography.* New York: Viking Press, 1974.

Katzman, Louise. *Photo/Trans/Forms by Judith Golden and Joanne Leonard.* San Francisco: San Francisco Museum of Modern Art, 1981.

———. *Photography in California, 1945–1980.* New York: Hudson Hills Press and the San Francisco Museum of Modern Art, 1984.

Kozloff, Max. *Photography & Fascination.* Danbury, NH: Addison House, 1979.

Krauss, Rosalind. *The Originality of the Avant-Garde and Other Modernist Myths.* Cambridge, MA: MIT Press, 1985.

Krims, Les. *Fictcryptokrimsographs.* Introduction by Hollis Frampton. Buffalo: Humpy Press, 1975.

————. *Making Chicken Soup*. Buffalo, NY: 1974.

Laughlin, Clarence John. *Clarence John Laughlin: The Personal Eye*. Introduction by Jonathan Williams. Millerton, NY: Aperture, 1973.

————. *Ghosts along the Mississippi*. New York: Bonanza Books, 1961. Reprint and revision of 1948 edition.

Levine, Les. *Using the Camera as a Club*. New York: Museum of Mott Art Inc., 1976.

————. *Blame God: Billboard Projects*. London: ICA, 1985.

Life Library of Photography: *The Art of Photography; The Camera; Caring for Photographs; Color; Documentary Photography; Frontiers of Photography; Great Photographers; The Great Themes; Light and Film; Photographing Children; Photographing Nature; Photography as a Tool; Photojournalism; The Print; Special Problems; The Studio; Travel Photography; Photography Year 1973, 1974, 1975, 1976, 1977, 1978, 1979.* New York: Time-Life Books, 1970–79.

Lipman, Jean, and Richard Marshall. *Art about Art*. New York: Whitney Museum of American Art and E. P. Dutton, 1978.

Lyons, Nathan. *Contemporary Photographers: Toward a Social Landscape*. New York: Horizon Press, and Rochester, NY: George Eastman House, 1966.

————. *Photography 63*. Rochester, NY: George Eastman House, 1963.

————. *Photography in the Twentieth Century*. New York: Horizon Press in collaboration with George Eastman House, Rochester, NY, 1967.

————, ed. *Aaron Siskind Photographer*. Rochester, NY: George Eastman House, 1965.

————, ed. *The Persistence of Vision*. New York: Horizon Press in collaboration with George Eastman House, Rochester, NY, 1967.

————, ed. *Photographers on Photography: A Critical Anthology*. Englewood Cliffs, NJ: Prentice-Hall, and Rochester, NY: George Eastman House, 1966.

————, ed. *Vision and Expression*. New York: Horizon Press, 1969.

Maenz, Paul, and Gerd De Vries. *Anselm Kiefer*. Essay by Gudrun Inboden. Cologne, Germany: Paul Maenz Gallery, 1986.

Mandel, Mike, and Larry Sultan. *Evidence*. Santa Cruz, CA: Self-published, 1977.

Mann, Margery, and Anne Noggle. *Women of Photography: An Historical Survey*. San Francisco: San Francisco Museum of Modern Art, 1975.

McCray, Marilyn. *Electroworks*. Rochester, NY: International Museum of Photography at George Eastman House, 1979.

McShine, Kynaston, ed. *Joseph Cornell*. New York: Museum of Modern Art, 1980. Essays by Dawn Ades, Carter Ratcliff, P. Adams Sitney, Lynda Roscoe Hartigan.

Michals, Duane. *Photographs/Sequences/Texts: 1958–1984*. Oxford: Museum of Modern Art, 1984.

————. *Real Dreams*. Danbury, NH: Addison House, 1976.

————. *Sequences*. Garden City, NY: Doubleday, 1970.

Millard, Charles W. *The Photography of Leland Rice*. Washington, DC: Hirshhorn Museum and Sculpture Garden, Smithsonian Institution, 1976.

Momentbild: Kunstlerphotographie. Essay by Carl Haenlein. Hannover, Germany: Kestner-Gesellschaft, 1982.

Moore, Sarah J. *Joyce Neimanas*. Tucson: Center for Creative Photography, 1984.

The Multiple Image. Introduction by Bart Parker. Providence: University of Rhode Island, 1972.

The New Vision: Forty Years of Photography at the Institute of Design. Millerton, NY: Aperture, 1982.

Newhall, Beaumont. *The History of Photography from 1839 to the Present*. Fifth revised edition. New York: Museum of Modern Art, 1982.

————. *Photography at Mid-Century*. Rochester, NY: George Eastman House, 1959.

————, ed. *Photography: Essays & Images*. New York: Museum of Modern Art, 1980.

Newhall, Nancy, ed. *The Daybooks of Edward Weston*, 2 vols. Millerton, NY: Aperture, 1973.

Newton, Charles. *Photography in Printmaking*. London: Victoria and Albert Museum, 1979.

Parker, Fred. *Attitudes: Photography in the 1970's*. Santa Barbara: Santa Barbara Museum of Art, 1979.

————. *California Photographers 1970*. Davis: Memorial Union Art Gallery, University of California, 1970.

————. *Sequence Photography*. Santa Barbara, CA: Santa Barbara Museum of Art, 1980.

Petruck, Peninah R. *The Camera Viewed: Writings on Twentieth-Century Photography*, 2 vols. New York: E. P. Dutton, 1979.

Pfahl, John. *Altered Landscapes*. Introduction by Peter Bunnell. Carmel: Friends of Photography, 1981. Published as number 26 of *Untitled*.

Philips, Donna-Lee, ed. *Eros & Photography*. San Francisco: Camerawork/NFS Press, 1977.

The Photographer and the American Landscape. New York: Museum of Modern Art, 1963.

A Photographic Patron: The Carl Siembab Gallery. Boston: Institute of Contemporary Art, 1981.

Plagens, Peter. *Sunshine Muse*. New York: Praeger, 1974.

Doug Prince: Photo Sculpture. New York: Witkin Gallery, 1979.

Private Realities: Recent American Photographs. Boston: Museum of Fine Arts, 1974.

Radical Rational/Space Time: Idea Networks in Photography. Essays by Paul Berger and Leroy Searle. Seattle: Henry Art Gallery, University of Washington, 1983.

Robert Rauschenberg. Essay by Lawrence Alloway. Washington, D.C.: Smithsonian Institution, 1976.

The Real Big Picture. Essay by Marvin Heiferman. New York: Queens Museum, 1986.

Richardson, Brenda. *Gilbert and George.* Baltimore: Baltimore Museum of Art, 1984.

Rose, Barbara, ed. *Readings in American Art 1900–1975.* New York: Praeger, 1968. Revised edition, 1975.

Rosenblum, Naomi. *A World History of Photography.* New York: Abbeville Press, 1984.

Ruscha, Edward. Series of 12 books, including: *Twenty-six Gasoline Stations,* 1967; *Nine Swimming Pools,* 1968; *Every Building on the Sunset Strip,* 1968; *A Few Palm Trees,* 1971; *Colored People,* 1971.

Samaras, Lucas. *Lucas Samaras: Photo-Transformations.* Long Beach: The Art Galleries, California State University, 1975.

———. *Samaras Album: Autointerview, Autobiography, Autopolaroid.* New York: Whitney Museum and Pace Gallery, 1971.

Sandback, Amy Baker, ed. *Looking Critically: 21 Years of Artforum Magazine.* New York: Artforum, and Ann Arbor: UMI Research Press, 1984.

Scharf, Aaron. *Art and Photography.* Baltimore: Penguin, 1969. Revised edition, 1969.

A Second Talent: Painters and Sculptors Who Are Also Photographers. Ridgefield, CT: Aldrich Museum of Contemporary Art, 1985.

Cindy Sherman. Introduction by Peter Schjeldahl, afterword by I. Michael Danoff. New York: Pantheon Books, 1984.

Siskind, Aaron. *Aaron Siskind: Photographs, 1966–1975.* Introduction by Thomas B. Hess. New York: Farrar, Straus & Giroux, 1976.

———. *Places: Aaron Siskind Photographs.* Introduction by Thomas B. Hess. New York: Light Gallery and Farrar, Straus & Giroux, 1976.

Smith, Henry Holmes. *Photographer's Choice.* Bloomington, ID: Indiana University, 1959.

Sobieszek, Robert A. *Color as Form: A History of Color Photography.* Rochester, NY: George Eastman House, 1982.

Sommer, Frederick. *Frederick Sommer.* Philadelphia: Philadelphia College of Art, 1968.

———. *Frederick Sommer at Seventy-Five: A Retrospective.* Edited by Constance W. Glenn and Jane K. Bledsoe. Long Beach: California State University, 1980. Catalogue for exhibition organized by Leland Rice.

———. *Venus, Jupiter & Mars: The Photographs of Frederick Sommer.* Edited by John Weiss. Wilmington: Delaware Art Museum, 1980.

Sontag, Susan. *On Photography.* New York: Farrar, Straus & Giroux, 1977.

Spaces. Interview of Aaron Siskind by Diana L. Johnson. Providence: Museum of Art, Rhode Island School of Design, 1978.

Steinitz, Kate Trauman. *Kurt Schwitters: A Portrait from Life.* Berkeley: University of California Press, 1968.

Sweetman, Alex. *Center of the Eye.* Aspen: Aspen Center for the Visual Arts, 1983.

Szarkowski, John. *William Eggleston's Guide.* New York: Museum of Modern Art, 1976.

———. *Looking at Photographs: 100 Pictures from the Collection of The Museum of Modern Art.* New York: Museum of Modern Art, 1973.

———. *Mirrors and Windows: American Photography since 1960.* New York: Museum of Modern Art, 1978.

———. *The Photographer's Eye.* New York: Museum of Modern Art, 1966.

———, ed. *Callahan.* New York: Museum of Modern Art, and Millerton, NY: Aperture, 1976.

Edmund Teske. Barnsdall Park, CA: Los Angeles Municipal Art Gallery, 1974.

Thomas, Lew, ed. *Photography and Language.* San Francisco: Camerawork Press, 1976.

———. *Structural(ism) and Photography.* San Francisco: NFS Press, 1978.

Three Photographers: Darryl Curran, Robert F. Heinecken, Bart Parker. Northridge, CA: Fine Arts Gallery, San Fernando Valley State College, 1970.

Trachtenberg, Alan, ed. *Classic Essays on Photography.* New Haven, CT: Leete's Island Books, 1980.

Traub, Charles, ed. *The New Vision: Forty Years of Photography at the Institute of Design.* Essay by John Grimes. Millerton, NY: Aperture, 1982.

Tucker, Anne Wilkes. *Unknown Territory: Photographs by Ray K. Metzker.* Millerton, NY: Aperture, and Houston: Museum of Fine Arts, 1984.

———, ed. *Target III: In Sequence: Photographic Sequences from The Target Collection of American Photography.* Essay by Leroy Searle. Houston: Museum of Fine Arts, 1982.

———, ed. *The Woman's Eye.* New York: Knopf, 1973.

Uelsmann, Jerry N. *Jerry N. Uelsmann.* Introduction by Peter Bunnell. Fables by Russell Edson. New York: Aperture, 1970.

———. *Jerry N. Uelsmann: Silver Meditations.* Introduction by Peter Bunnell. Dobbs Ferry, NY: Morgan & Morgan, 1975.

———. *Jerry N. Uelsmann: Twenty-five Years. A Retrospective.* Boston: New York Graphic Society, 1982.

Upton, John. *Minor White, Robert Heinecken, Robert Cumming.* Long Beach, CA: Fine Arts Gallery, California State University, Long Beach, 1973.

———. *The Photograph as Artifice.* Long Beach, CA: Fine Arts Gallery, California State University, Long Beach, 1978.

Viewpoint: The Artist as Photographer. Summit, NJ: Summit Art Center, 1984.

The Visual Dialogue Foundation. Carmel, CA: Friends of Photography, 1972.

Wallis, Brian, ed. *Art after Modernism: Rethinking Representation.* New York: New Museum of Contemporary Art, and Boston: David R. Godine, 1984.

Walsh, George, Colin Naylor, and Michael Held, eds. *Contemporary Photographers.* New York: St. Martin's Press, 1982.

Wegman's World. Essays by Lisa Lyons and Kim Levin. Minneapolis: Walker Art Center, 1983.

Weiss, John, ed. *Venus, Jupiter and Mars: Frederick Sommer.* Wilmington: Delaware Art Museum, 1980.

White, Minor. *Minor White: Rites and Passages. His Photographs Accompanied by Excerpts from His Diaries and Letters.* Millerton, NY: Aperture, 1978.

———. *Mirrors Messages Manifestations.* Millerton, NY: Aperture, 1969. Reprinted, 1982.

Wise, Kelly, ed. *The Photographer's Choice: A Book of Portfolios and Critical Opinion.* Danbury, NH: Addison House, 1975.

Witkin, Joel-Peter. *Joel-Peter Witkin: Photographs.* Pasadena, CA: Twelvetrees Press, 1985.

Witkin, Lee D., and Barbara London. *The Photograph Collector's Guide.* Boston. New York Graphic Society, 1979.

Hagen, Charles. "Robert Heinecken: An Interview." *Afterimage,* no. 3 (April 1976), pp. 9–12.

Heinecken, Robert F. "I Am Involved in Learning to Perceive and Use Light." *On Change & Exchange, Untitled 7/8,* Carmel, CA: Friends of Photography, 1974, pp. 44–46.

Krauss, Rosalind. "Sculpture in the Expanded Field," *October,* no. 8 (Spring 1979), pp. 31–44.

Ratcliff, Carter. "Tableau Photography: From Mayall to Rodan, Its Roots and Its Reason." *Picture,* no. 18 (1981), pp. 4–19.

Rice, Leland. "Los Angeles Photography: c. 1940–60." *The Los Angeles Institute of Contemporary Art Journal,* no. 5 (April/May 1975), pp. 28–36.

Szarkowski, John. "A Different Kind of Art." *The New York Times Magazine,* April 13, 1975, pp. 16–19, 64–68.

———. "Photography and the Mass Media." *Aperture* vol. 13, no. 3 (1967), unpaginated.

Welish, Marjorie. "The Specter of Art Hype and the Ghost of Yves Klein." *Sulphur,* no. 12 (UCLA), 1982.

"Wynn Bullock." *Camera,* no. 1 (January 1972), pp. 24–33.

ARTICLES

Andre, Carl. "A Note on Bernhard and Hilla Becher." *Artforum,* vol. 11, no. 4 (Dec. 1972), pp. 59–61.

Bunnell, Peter C. "Photographs as Sculpture and Prints." *Art in America* (Sept./Oct. 1969), pp. 56–57 and 60–61.

Coke, Van Deren. "Creative Photography 1956." *Aperture,* no. 4 (1956), pp. 4–29.

Collins, James. "The Importance of Not Being Earnest About Photography." *James Collins.* Milan: Giancarlo Politi Editore, and London: ICA, March 1978, pp. 62–66.

Crimp, Douglas. "Pictures." *October,* no. 8 (Spring 1979), pp. 75–88.

———, "The Photographic Activity of Postmodernism." *October,* no. 15 (Winter 1980), pp. 91–101.

Drohojowska, Hunter. "No More Boring Art" (A profile of John Baldessari). *Artnews,* vol. 85, no. 1 (Jan. 1986), pp. 62–69.

Finkel, Candida. "Photography as Modern Art: The Influence of Nathan Lyons and John Szarkowski on the Public's Acceptance of Photography as a Fine Art." *Exposure,* no. 18 (1981), pp. 22–37.

Green, Jonathan. " 'Aperture' in the '50s: The Word and the Way." *Afterimage,* no. 6 (March 1979), pp. 8–13.

Grimes, John. "Arthur Siegel: A Short Critical Biography." *Exposure,* vol. 17, no. 2 (Summer 1979).

Grundberg, Andy. "Another Side of Rauschenberg." *The New York Times Magazine,* October 18, 1981, pp. 42–46, 113, 118–19.

———. "The Crisis of the Real: Post-Modernism and Photography." *Views* (Fall 1986), supplement pp. 2–6.

PERIODICALS

Afterimage. Rochester, NY. A newspaper-format monthly from the Visual Studies Workshop.

Aperture. Published quarterly under the editorship of Minor White, New York and Millerton, NY: 1952–1975. Michael E. Hoffman, editor, 1975 to date. See particularly *Aperture,* no. 100 (Fall 1985). Articles on and by Richard Prince, John Baldessari, Joel-Peter Witkin.

Artforum, vol. 15, no. 1 (Sept. 1976). Special photography issue, with essays by Max Kozloff, Colin L. Westerbeck, Jr., Nancy Foote, A. D. Coleman, and Aaron Scharf.

Exposure. A quarterly journal of the Society for Photographic Education. Published since 1968.

MISCELLANEOUS

Krims, Les. *The Deerslayers,* 1972; *The Incredible Stack O'Wheat Murders,* 1972; *The Little People of America,* 1972. Boxed portfolios.

Index

Note: Page numbers in *italics* refer
to illustrations or their captions.